Bird of Paradox

Bird of Paradox

The Unpublished Writings of Wilson Duff

Edited by E. N. Anderson

hancock

house

ISBN 0-88839-360-1
Copyright © 1996 E. N. Anderson

Cataloging in Publication Data
Duff, Wilson, 1925-1976
 Bird of paradox
 ISBN 0-88839-360-1

 1. Indian art—Northwest Coast of North America. I.
Anderson, Eugene N. (Eugene Newton) 1941- II. Title.
E78.N78D83 1995 709'.01'1097111 C95-910642-1

Production: Lorna Brown and Nancy Miller
Editing: Colin Lamont
Cover Design: Karen Whitman
Cover Picture: Courtesy of The Museum of Anthropology, University of B.C.,
 the Glenbow Box.

Published simultaneously in Canada and the United States by

HANCOCK HOUSE PUBLISHERS LTD.
19313 Zero Avenue, Surrey, B.C. V4P 1M7
(604) 538-1114 Fax (604) 538-2262

HANCOCK HOUSE PUBLISHERS
1431 Harrison Avenue, Blaine, WA 98230-5005
(604) 538-1114 Fax (604) 538-2262

Contents

*For the survivors
and especially for
Sea Otter and Raven
and all the sea otters
and all the ravens.*

Preface

Wilson Duff was one of the leading academic experts on the arts and cultures of the Native American peoples of the Northwest Coast of North America. Dying by his own hand at the relatively young age of fifty-one, he tragically cut short a brilliant exploration of Northwest Coast art and its meaning and cultural context. As anthropology and art history become increasingly conscious of the importance of meaning and context in understanding humanity and human creation, Duff's work seems ever more important. Duff concerned himself with relationships—with the dynamics of structural systems. He sought the causes and motives, conscious and unconscious, that lay behind the iconic and iconographic structures visible in Northwest Coast art. He studied the polysemy of symbols, the logic of referents, the complex and multivocal ways in which Northwest Coast peoples used art to communicate emotion, social structure and human concerns. He probed deeply into the possible levels of meaning—cosmological, social and personal—that lay behind the art, and into the nature of art as discourse in a world where it, not writing, was the privileged vehicle for conveying the messages of the human spirit. In the process, he was a pioneer in opening the anthropological study of traditional aesthetic materials to influences from psychological and art-historical bodies of theory.

His work is important far beyond the British Columbian coastal region where he spent his life. Students of art everywhere can profit from the insights of one who combined meticulous scholarship with courageous originality of thought. Indeed, Duff's ideas may prove to be of most value to students of art whose concerns lie far from the Northwest or from traditional art. Had he lived, his contributions would have attracted wide attention for their theoretical importance. Claude Levi-Strauss wrote: "Thinking of Duff as I knew him, of his

vast knowledge that forever disappeared with him since he committed so little of it to writing, I wonder if it was not, after all, this desperate quest for infinite mysteries—perhaps because they were above all an exigency of his mind, (*une exigence de son esprit*)—that killed this unaffected, charming, altruistic and kind man, who was also a great scholar (Levi-Strauss 1981:260, tr. Monique Layton)." Fortunately, more of Duff's thought survived than Levi-Strauss realized, and we can now draw on material that ranges from solid scholarship to poetry and fantasy.

After receiving a master's degree in anthropology from the University of Washington, he joined the staff of the British Columbia Provincial Museum (now the Royal British Columbia Museum), ultimately serving as curator of anthropology. In 1965, he moved across the water to the University of British Columbia, where he was a professor in the Department of Anthropology and Sociology. At this time his interests shifted from a broad concern with archeology, history and ethnography to a very specific focus on art, especially Haida art of the nineteenth century. This he attempted to understand—to decode its meanings for its original audience. In 1972, after learning from students about recent developments in the theory of art, he embarked on a serious campaign of using all the recent analytical tools at his command, applying them exhaustively to what he saw as the key works of northern Northwest Coast art. During all this time he kept up a very active teaching schedule, and continued to publish thorough and highly respected scholarly works on many aspects of Northwest Coast culture. But he became more and more absorbed in the art and in the strange world that produced it, and drew farther and farther from the world around him.

On August 8, 1976, a half hour before midnight, he shot himself in his university office. It was the only time his shotgun was ever fired. The reasons will never be fully known. As in all suicide cases, they are complex and deep, the interactions of lifelong personality conflicts with current situational factors. This is not the place for a psychological autopsy, nor could I (who was never fortunate enough to meet him) conduct one. His papers show, among other things, a lifelong problem in finishing anything. He was careful to the point of perfectionism, the more so as his work moved into challenging and uncharted waters. At the museum he had apparently been happy

and fulfilled in his curator's job. The University brought new requirements, such as teaching. By all accounts an excellent teacher, he poured enormous effort into his courses and lectures. A just and fair-minded man, he was often picked to serve on committees. These added pressure to a life increasingly stressed by depression and mood swings.

A myth grew up around his life and sudden death (Suttles 1983b:87). The myth varies with the teller, but centered on Duff's absorption into the Haida world and his difficulties in writing about his experiences with it. The facts are at once more ordinary and more complex. Duff's suicide was a very typical one, not a romantic and unique act. In the 1970s, the modal suicide in North American society was exactly Duff's case: a male in his fifties, at the peak of a working career but with a history of depression, feeling overwhelmed by the pressures of life (cf. Hendin 1982). On the other hand, Duff's death, like all suicide cases, had its unique features, and one of them was his absorption into a strange and mystic world where ravens foretell death and otters steal one's soul. In any case, as Wayne Suttles said in his sensitive review of the Duff memorial volume edited by Donald Abbott (1981): "...suicide is a statement that is intended to be heard. And whatever that statement was, Wilson Duff should be allowed to make it (Suttles 1983b:87)." That statement was complex and personal, but in the end there is little to add to the total fact of death. Wilson Duff was here—generous scholar, widely respected teacher, benefactor of Native American art in many ways; now he is gone, and his contributions must to some extent be resurrected.

Duff was an extremely careful and thorough scholar. Beginning in 1972, he began to speculate on the deep meanings of Northwest Coast art. Here he was forced to venture into uncharted waters, without any chance of clear proof. This deeply troubled him. Most art historians and aesthetic anthropologists take delight in constructing more or less plausible theories in the absence of total proof, but Duff did not; he sought through every possible method of knowing, and tried to build up firm evidence for his ideas. However, the more interesting and original his ideas were, the more difficult of proof they became. His notes show a continual wrestling with this problem, so intractable for all speculative anthropologists. Finishing

manuscripts became more difficult, and he published little of his insights. *Images: Stone: BC* and his paper of 1976 (Duff 1981, 1983) provide the major exceptions; note that the 1976 paper appeared only posthumously.

At his death, he left a vast mass of unpublished materials: completed articles, beginnings of books and articles, working notes, letters and a number of brilliant and unexpected poems. Virtually all of this material dates from 1972 through 1975. Apparently all that he wrote in 1976 was destroyed; a few sheets found in his wastebasket after his death are all that survive, except for the paper mentioned above. Some of the earlier material was already in press and appeared in due course. Of the rest, the more finished pieces were collected and published, along with a great variety of memories and tributes and other contributions by friends, in the memorial volume, *The World Is As Sharp As a Knife* (Abbott 1981). The title was Wilson Duff's favorite line, a Haida proverb recorded by Franz Boas: "It is said that 'our world is as sharp as a knife...We must take care that we do not deviate from the straight course, for else we would fall off and die (Boas 1889:845; cf. Boelscher 1988).'" The rest remained in an old trunk kept by Duff's daughter Marnie. In 1984, I was alerted to the existence of this material by Evelyn W. Pinkerton. Reading the Abbot volume proved to be a deeply moving experience, and I decided to find out all I could about Wilson Duff and his work. Dr. Pinkerton and I contacted Marnie Duff, and received permission to examine the material. This led to a long and warm association with the Duff family, and to many months spent in the home of Marnie and her daughter Raven, poring over the storehouse of documents in the old trunk. It also led to my own travels into the uncharted northern seas of Haida art. I talked with many friends and students of Duff, and with many experts on Northwest Coast art. I spent hundreds of hours in museums and collections. Yet I remain no expert in the field, though my memories do extend far enough back to recall Mungo Martin carving at the Provincial Museum in 1960. This book is Wilson's, not mine, and I intrude as little as possible. I have felt it necessary to provide introductory and background material, but I leave a full study of Duff's life and work (let alone a full analysis of Haida art) to others better qualified.

This book consists of the remaining Duff materials that are in a

state that is finished enough to have something to offer to scholars of art. This means, basically, several papers on Haida art and the beginning of a book on the art of the Edenshaw family of Haida artists. However, I have also studied the remainder of the materials in the trunk—rough notes, working papers and personal documents. These sketch out a theory of art that, while never brought to consummation, has a great deal to offer the world. After much soul-searching and consultation with the Duff family and with Duff's former students, especially Marjorie Halpin, I have left most of this unpublished. This material is of several kinds. First, there is a set of working notes on theory in art and art history. Second, there are outlines of his projected works. Third, several of his poems that were not published in the Abbott volume. Fourth, Duff left his notebooks—thousands of pages of rough notes, ideas, tentative beginnings, aphorisms, chains of logical or intuitive association, tests of ideas, and similar materials. Many of these are highly poetic. Most of the notebooks are filled with speculations about the logic and structure of the art. The majority of this material consists of long chains of extensions of logical paradigms, hypothesizing relationships and equations. Such chains are difficult to follow or reproduce and are not transcribed here. Duff finished and published a few of them in *Images: Stone: BC* (Duff 1975:43, 89, 146-149).

All these materials were part of a project whose main products were to be a book on meaning in Haida art and a book on the works of Albert Edward Edenshaw (fl. mid-nineteenth century) and his nephew Charles Edenshaw (ca. 1839-1920), whom Duff saw as the greatest known Haida artists. Both books were part of a single agenda: to understand Haida art—to subject it to the same sort of intense psychological and critical scrutiny that has been given to European or Chinese art of the classical periods. Today, serious students of art would not find this revolutionary. However, when Duff began his research in the 1950s, Northwest Coast Indian art was "primitive." The vast majority of viewers saw it as mere craft: the product of childlike savages who did it to kill time, or at best "socially functional" art that rose no higher than portraying crests and other symbols of social structure. To Duff and a very few close associates—Bill Holm, Bill Reid and a few others—belongs much or most of the credit for bringing us to see that Northwest Coast art

had its psychological insight, its complex meaning systems, and its great individual artists who added their own intense experiences. Even the great Claude Levi-Strauss, whose work paralleled Duff's both in time and in content, did not combine such detailed and individualized investigation with such a broad vision of artistic meaning. Before Duff, Holm and Reid, even works of known authorship were listed in books simply as "Haida" or "Kwakiutl." Today, anonymous works are painstakingly analyzed in the hopes of determining individual styles, and we hear of anonymous artists known by such names as "the Master of the Black Field." (This, of course, follows the model familiar in studies of European art of the medieval period.) In particular, Duff sought for the dynamic psychology behind the art, and for the ways the artists expressed it—consciously and unconsciously. He also sought their philosophy of art, and through that, their philosophy of life.

Yet most of his speculation remained unfinished and unpublished, and—sadly—much must still so remain. Cryptic entries and brief, uncompleted speculative chains hint at far deeper insights and theories, but Duff's tragic, premature death deprives us of these. Expert scholars may still find much of value in the old trunk.

Even what is published here is, of course, unfinished. Yet I have found it valuable—indeed, a wonderful experience. Many others have urged me to get out everything I could. Marnie Duff, in particular, has been always encouraging, especially through her confidence that her father really wanted to see these ideas reach the world.

The contributions of this material are many. To me, the most important are, first, a comprehensive theory of art that brings together depth psychology and structural analysis in a single dynamic system; and, second, a method of analysis that relies on intuition (poetic, mystical, hypnogogic and even shamanic) as well as formal logic to generate hypotheses, and on unstinting self-examination and self-knowledge as well as scholarly methods in attempting to test them. Duff used his whole mind in his work, and threw his whole self into it. He knew himself perhaps too well; the quest for total knowledge is a dangerous, even deadly, one. He did not survive long enough to be wholly successful in his quest. He leaves us with many ideas to test, and with a set of methods and techniques for going farther.

The present book consists of selections from the unpublished material. I have silently corrected a very few spelling errors (Duff almost never misspelled, even in rapid notes), and normalized punctuation. Occasionally, I have selected from or abridged passages, as indicated by ellipses. All publication is by kind permission of Marnie Duff, with whom I have discussed and checked everything in this volume.

An important source of ideas and details was the corpus of theses done under Duff's direction, or with important influence from him. I am grateful to the University of British Columbia library for facilities. Particularly valuable were theses by Calkowski (1974), Gould (1973), Halpin (1973), Hopffgarden (1978), McLaren (1977), Pritchard (1977), M. Reid (1981), K. S. Reid (1976), Rumley (1973) and Shane (1978).

In a work of this kind, one becomes particularly dependent on a multitude of others for assistance. I have been extremely fortunate in receiving so much help and cooperation. Many people who knew Wilson Duff or his work have given unstintingly of their time, energy and personal memories and insights. I am deeply grateful to them all.

In particular, I wish to thank most of all the Duff family, especially Marnie and Raven, and also Tom and Helen Duff, Ron Duff, Winifred Duff Chalke and many others. I have also a special debt to Evelyn Pinkerton for help and support all along the way, as well as with the initial contacts.

Among scholars who were associates, colleagues, or students of Duff, I have received especially valuable help from Roy Carlson, Tricia and Nick Gessler, Marjorie Halpin, Bill Holm, Wolfgang Jilek and Louise Jilek-Aall, Graham and Elizabeth Johnson, Michael Kew, John Pritchard, Bill and Martine Reid, Robin Ridington, Audrey Shane, Mary Lee Stearns, Wayne Suttles, Nancy Turner and Roy Vickers. Marjorie Halpin in particular served as careful editor and advisor, sharing her insights into Northwest Coast art and into Duff's life and theories. For further explanation of the mysteries of Northwest Coast art and culture, I am deeply grateful to Kitty Bernick, Gary Edenshaw (Guujaw), Ron Hamilton (Ki-Ke-Na), Rose Head, Alan Hoover, Nelson and Alfred Keitlah and their families, William McLennan, Renee Taylor, Victoria Wyatt (who has

been particularly helpful with the manuscript), and others too numerous to mention. With some I spent days, with others only a few minutes; but I learned a great deal from all.

I am very grateful to the Museum of Anthropology, University of British Columbia, and the British Columbia Provincial Museum for allowing me full and free access to their files and records, including Duff materials therein. I am especially grateful to them and their patient and unfailingly helpful staff persons, for permission to reproduce photographs. I am deeply grateful also to the British Columbia Provincial Archives, the American Museum of Natural History, the Alaska State Library, the Musee de l'Homme, David Hancock and Aldona Jonaitis for permission to reproduce photographs.

I

An Introduction to Wilson Duff

1

A Look at Wilson Duff

Wilson Duff's vita gives the skeleton of a life. Born in Vancouver: March 23, 1925. Married: Yes (separated). Children: Two. BA: University of British Columbia, 1949. MA: University of Washington, 1951. Thesis: "The Upper Stalo Indians," under Dr. Erna Gunther; it was subsequently published as *Anthropological Paper Number One* of the British Columbia Provincial Museum in 1952. He was curator of anthropology at the Provincial Museum in Victoria—now the Royal British Columbia Museum—from 1950 to 1965, in which year Harry Hawthorn was instrumental in bringing him in as Associate Professor to the Department of Anthropology and Sociology at the University of British Columbia. (He had taught part-time at the University of Victoria in 1964-65.) In his life he published three books and thirty-two articles. Four more articles appeared after his death, along with a short story and several poems in the collection dedicated to his memory that Donald Abbott assembled (Abbott [ed.] 1981), and the heart of his correspondence with Lilo Berliner, in an article by Phyllis Webb (1982). He received the usual grants and awards of a major scholar of his time and place. He was widely respected, and regarded as a leading academic authority on Northwest Coast Indians and their art.

At his death, he left several unfinished works, and thousands of pages of notes and short manuscripts devoted to Haida art. Most of the work that was publishable form has appeared already or is found in the present volume. The chief exception is *The Indian History of British Columbia*, Vol. 2, dealing with archaeology. It was left at the Provincial Museum in 1965, almost completed. Apparently he never took it up again. Since archaeology in British Columbia was in its infancy then and has progressed enormously since, this manuscript (a synthesis, not a report of original field work) is of limited use today.

Wilson Duff's scholarly life began with intensive ethnographic research on the Salish. His first serious work was his master's degree research on the Stalo (Duff 1952)—a term he popularized for the Salish of the lower Fraser River, who speak the Halkomelem language.

He focused his master's thesis on the Upper Stalo, those from Chilliwack upriver to the area of Yale and Hope, where they meet the Interior Salish peoples. By the time he received the degree, he was already at the museum. Here he did research on the Salish of the Victoria area, who spoke Straits, a language fairly close to Halkomelem. (Both languages are now virtually extinct.)

He concentrated on spirit dancing, the climactic religious activity of these peoples. For years he visited almost every dance in the area, often with Michael Kew, a colleague at the Museum and later at the University. Dr. Kew is a specialist on the Salish and one of the leading authorities on their culture. Duff's meticulous notes on the winter dances he saw now lie in the museum archives.

Others were involved in the research, and the present Curator of Ethnology there, Peter MacNair, continued the spirit-dance watch for some years after Duff left. Unfortunately, nothing was published of these observations, at first because "tamanous" (spirit) dancing was made illegal, along with potlatching, in British Columbia in the nineteenth century by a series of acts that were the result of action by the less-enlightened Christian missionaries and politicians of the time. It was repealed in 1951 (by significant omission from a revised Indian Act), but by then Duff and his fellow observers were caught up in other things. His notes reveal what must have been an exciting time. He often drove busloads of Native people with him from

Victoria to wherever the dance was to be. The Halkomelem and Straits Salish communities of southern Vancouver Island scheduled dances at different places throughout the winter season. There, as elsewhere on the coast, winter is the season of rituals, summer the time of serious, intensive food collecting. Winter is the time of night and of gathering and showing sacred power; summer the time of day and using that power in the practical matters of living.

Meanwhile, archaeology and museum work were revealing fascinating stone-sculpture traditions centering on these Salish homelands. Duff's next major work was a study of this stonework (Duff 1956). He was to return to it in his last and greatest published work (Duff 1975). In the early 1950s, also, he did some ethnographic research on the Carrier Athabaskans of interior British Columbia, but he never followed up this interest (Duff 1951; later notes in RBCM).

Even as his works on the Stalo and on stonework were appearing, he was off on a new and fateful mission. In 1953, 1954, 1956 and 1957, he was central to a major effort to salvage the totem poles of the deserted villages of the Haida Indians on the Queen Charlotte Islands.

Disease, shifting patterns of trade, and social factors had led the Queen Charlottes Haida to collect in two surviving communities, Masset and Skidegate, both on Graham Island. (A small group of Haida also survives on the islands of southern Alaska—nearer to Graham Island than the Canadian mainland. This group had emigrated from northern Graham Island in the eighteenth century. Duff was later to visit them also.)

The magnificent towns of the southern Charlottes were rotting back to the soil. With the help of Haida people and of other museum workers, Duff and his group salvaged poles from several abandoned villages in the southern Charlottes. It was a spiritual quest. Days alone in Tanu with no evidences of human life except a plane far overhead, more days in the surviving Haida towns interviewing elders, and weeks of rain and mud and terrifically hard physical effort had profound psychological effects. Bears came close to him. Haida elders told him they would never stay alone in the old villages, for fear of bears and ghosts. Some say the ghosts never quite left him alone afterward. Getting permission from the elders to take the poles,

recompensing the families that had moved from the old villages, and identifying the poles and their histories led him to talk for days with Henry Young, Solomon Wilson, Arthur Moody and other great figures from that period of Haida culture.

Henry Young said that only three of four persons could talk with him in the old, formal, ritual Haida. Now all are gone, before any modern linguist could study that arcane world. A Mrs. Tulip (not otherwise identified in the notes) gave Wilson the name "Gwaigwanthlan." This was the name of the great nineteenth-century chief and artist known in English as Albert Edward Edenshaw, and its bestowal on Duff was another fateful event. Finally the poles were safely in the museum. Yet a moral quandary remained, and was to grow over the years. Duff believed, more firmly than most, in leaving Indian art in Indian hands. In the 1950s there was simply no way of preserving the poles in the Queen Charolottes, and Haida and museum workers agreed that the poles should be saved. Subsequently, ways of storage were developed, and also a museum was founded on the Islands (its first curator was a Duff student: Patricia Gessler [1981]). Many poles reside there now. Duff felt less and less comfortable with the choice of removal. He never revisited the Charlottes, even during the years when he was most absorbed in Haida art.

His next major project was a history of the Indians of British Columbia. Serious work on this seems to have followed a trip through the Interior in 1962, which gave him experience with areas he had not worked in before. He collected much material from the Athabaskan and Interior Salish peoples. In 1964, he published the first volume of the projected history: *The Indian History of British Columbia, Vol. 1, The Impact of the White Man.*

In 1965 when he moved to UBC, a second volume on archaeology was well into draft stage. Also, massive files had been assembled on groups throughout the province, primarily on their groups and settlements. The project did not survive the move. A shorter, but still major project that did survive was research on the Indians of the Victoria area and their loss of lands to the whites; this research was published in a major monograph, *The Fort Victoria Treaties* (1969). A third effort in this period of Duff's life was the earlier work *Histories, Territories and Laws of the Kitwancool* (1960), which

consisted mainly of statements by the Kitwancool people themselves.

All these works, and many minor pieces during that decade, focus on the problems of getting a fair deal for the British Columbia Indians in matters of land. Except for the Fort Victoria Treaties, which were rather casual affairs that covered little of the province and were often violated by the whites, none of the British Columbia Indians (except a few in the far northeast) signed any treaties regarding their land. Indian title is still hotly contested in British Columbia.

Duff tried as hard as anyone in his day to get this situation changed—not only writing extensively but also serving as an expert witness for the Nishga people in their Sisyphean labors to get aboriginal title into consideration by the courts. He was instrumental in getting them far enough to be able to go to Canada's Supreme Court and win a split decision there, in 1973.

In 1971, he reported to government agencies in connection with the proposed west coast National Park on Vancouver Island (now the Pacific Rim National Park). He provided expertise for other claims and cases (see Abbott 1981 for fuller stories, especially Berger 1981).

At UBC, Duff's long interest in Northwest Coast art rapidly expanded to take over his life. The first and perhaps major turning point seems to have come with his collaboration with Bill Reid and Bill Holm on the landmark exhibition and catalogue, *Arts of the Raven*, at the Vancouver Art Gallery. (This is not an "art gallery" in the U.S. sense, i.e. a small private facility, but Vancouver's huge and excellent public art museum.) This was a particularly large and impressive effort, with international significance in the worlds of art and anthropology.

It also involved development of close cooperation between the three greatest younger experts in the field. Bill Reid is Haida on his mother's side, German and Celtic on his father's, and is possibly the greatest living exponent of Northwest Coast traditional art. His work is not wholly traditional, having been influenced by modern European-style fine arts, but represents a continued evolution of the tradition (long influenced by outsiders' art).

Bill Holm, now curator emeritus of the Washington State Museum, was then just becoming famous through his book *Northwest Coast Indian Art* (1965), which analyzed the rules of northern North-

west Coast art so well that it became the guide to young Indian carvers; it is found today in most households and studios where native Northwest Coast art is produced. He was also an accomplished carver and dancer himself. Though not a Native American by birth, he was so important in the artistic revival on the coast that he was honored by a Bill Holm dance mask in Kwagyul style. He thus was assimilated to the supernatural beings and the heroes of old.

Wilson Duff himself did some excellent carving, especially of Northwest-style masks, but he was less a "doer" and more an analytic scholar. As a combination, these three men were ideal. (One wishes that other art museums would combine doers and scholars on the same panel.) Duff had already reviewed Holm's book (1966); he was later to write an introduction for the catalogue of a major show of Reid's work (1974).

In 1969, the Musee de l'Homme in Paris issued a book, *Masterpieces of Indian and Eskimo Art from Canada*, which had a long section on the Northwest Coast by Duff. Also in that year, Duff was senior author of *Totem Pole Survey of Southeastern Alaska* with Jane Wallen and Joe Clark; the Alaska State Museum issued this work. Duff published little else about art during his life, but from 1970 he directed his efforts increasingly toward it. By 1972, he had become obsessed with explaining it, and had come to restrict his universe to the northern style, especially to the Haida.

The work of the Edenshaw family came to epitomize this. A very important short paper, "Levels of Meaning in Haida Art" (1972) was circulated in draft form to the anthroplogy department and to friends, but never went any farther.

The last major work Duff published was the exhibition catalogue *Images: Stone: BC* (1975). The idea had come to him two or three years earlier to assemble British Columbian Indian stonework in an exhibition that would focus on its artistic values rather than its archeological and culture-historical interest.

In this book he could state his agenda and demonstrate how his thinking was then operating. Introducing it, he wrote: "The question I must ask is 'what do the images mean?' and it is a question that demands answers in words, the language of thinking. It is a hazardous enterprise for one who values a reputation for scholarly discipline, because of course we do not really 'know' what they 'mean.'

It would be difficult enough—and terribly disconcerting—to explain what the images of our own culture 'mean,' because most of their meanings, most of the time, are left below or beyond the view of ordinary waking consciousness. It is doubly difficult to explain the images of a different culture, whose unspoken visions and premises we may not share.... But I think it is a risk worth taking.... This stone art, Northwest Coast Indian art in general, and other arts equally remote from our own experience have remained as closed books for all too long, resisting our efforts to find the deeper meanings which we feel intuitively to be there (Duff 1975:12-13)."

He went on to note that he and his students had been engaged in the search for such deep agendas, probing down into meanings that had not been recorded by early ethnographers but that could be discerned by comparative study of the material.

Wilson Duff's last work was a paper he gave at a conference on Northwest Coast art that was organized and chaired by Roy Carlson of Simon Fraser University. This paper was published posthumously (Duff 1981, 1983).

As Duff moved deeper and deeper into his strange Haida world, he seemed to feel himself getting farther and farther from "closure" on any academic writing project. Such writing as he did complete was primarily poetic: a wide range of poetry, and the amazing "teaching story" he called *Nothing Comes Only in Pieces*, written during the end of 1974 (a note on Jan. 6, 1975, records it as "finished" that day). None of this was published during his life, but the story and most of the poetry appeared in the Abbott anthology (1981).

The story combines characters (real and archetypal) Duff met in the Charlottes, with Haida mythology and his own speculations on the Haida cosmos. It hovers between realism and fantasy. Compact, understated and intensely poetic, it deals with the breakdown of meaning in modern Native American life. Duff's insights into art ride over his long-standing, deep concern with the fate of modern Indians.

Duff's poetry ranges from slight pieces and taglines to sustained efforts. Again they are tight, understated and powerful; the passion seeming enormously stronger for being held in and directed toward ends that seem at first minor or "merely intellectual." They remind

me of that other tragic and suicidal Northwesterner, Theodore Roethke.

Duff's handwritten notes and manuscripts from 1972 to 1976 follow a rough evolution. Finished, typed manuscripts date primarily from 1972 or 1975. The long, speculative chains in which Duff plays with combinations and permutations of forms, logical evolution of images, and questions of equation and contrast become most dominant in 1974, but are always part of the corpus (the last ones were found in his office after his death).

The most poetic and mystical writings date from late 1974 through 1975. During these years he was probing more and more deeply into questions of person, structure and context; of social conduct and its problems; of artistic resolution of the contradictions of life. The constant human questions of life and death, sex and loss became more urgent.

Duff felt a need to understand how the artists—as human persons and as bearers of Haida or Tsimshian or Salish—dealt with these questions and coped with their dynamics. He tried to understand the world of a Haida artist, and at the same time to understand his own personhood. The notes become a search into self, and a dialogue between self and Haida artistic experience.

2

The Northwest Coast

This brief introduction discusses certain issues of special concern to Wilson Duff. There is neither space nor need to give a full account of Northwest Coast cultures (see Drucker 1955, McFeat [ed.] 1966 for general surveys of the cultures; Holm 1965, Stewart 1979, for the art).

The coast of North America is remarkably uniform from Humboldt Bay, California, to Yakutat Bay, Alaska. It is a rugged, rocky coast, broken from Washington north by fjords, some enormous. Mountains rise extremely steeply from the coast, sometimes towering several miles almost straight out of the water. The continental shelf is not usually far off, and the Queen Charlotte Islands' west scarp drops in one great scarp from 4,000 feet above sea level to two miles below it. Great rivers breach the mountain wall at regular intervals, and alternate with smaller streams.

Everywhere, the land is covered thickly with evergreen forest— or it was until Anglo-American civilization launched one of the world's most shortsighted and ill-advised campaigns of overcutting. A strip of Sitka spruce, *Picea sitchensis*, runs along the shore. Behind it are forests of red cedar, *Thuja plicata*; yellow cedar, *Chamaecyparis nootkatensis*; western hemlock, *Tsuga heterophylla*; true firs, *Abies spp.*; Douglas fir, *Pseudotsuga mensiezii*; and locally

many other species of conifers. A few deciduous trees are characteristic, especially red alder, *Alnus rubra*; willows, poplars and maples; they occur mainly in sites too recently disturbed for the conifer forest to have taken hold.

Species progressively drop out in the less favorable parts of the coast (far north, high mountains, etc.). Thus the red cedar, prime wood for arts and crafts where it occurs, does not grow in the northern parts of the coast and is rare or absent in other difficult areas; it is a tree of deep soil, established forest land, heavy rainfall and moderate temperatures.

This forest harbors little edible matter. Deer, elk, bear and other game are locally common, but rare or absent in many areas. Plant foods are primarily roots such as cinquefoil or silverweed, *Potentilla spp.*; and streambank clover, *Trifolium wormskioldii*; and berries of many species (mainly *Rubus spp.* and *Vaccinium spp.* or near relatives). These and the game occur mainly in open areas. The vast majority of the food of the Native peoples of the Northwest came from the water, and most of it was salmon. Five species of salmon abound: chinook or spring *Oncorhynchus tshawytscha*; sockeye, *O. nerka*; coho or silver, *O. kisutch*; chum, *O. keta;* and pink or humpback, *O. gorbuscha.*

The odd scientific names are of Siberian folk origin. I have listed them in approximate descending order of size; chinooks can be mammoth, pinks are usually small. The sockeye was usually preferred by Native people, primarily because it has the highest calorie value. The oil that gives it the calories also gives it rich flavor and good preserving qualities. At the other end in the preference scale was usually the chum, often known as "dog salmon" (fit only for dogs), though some groups preferred it, often because they lived in areas where it preserved better than the others.

Each salmon species has its own very distinct ecology. Indeed, each run has its distinctive features; the Indians had to be acutely aware of all these. Salmon, of course, live in the sea most of their lives but run up the rivers to spawn. Some runs made the rivers seem literally "more fish than water," as early settlers put it.

The teeming millions of fish are unimaginable now except in a few places (such as the Naknek River in Alaska and the Adams River in B.C.) where conservation has preserved something of the former

legions. In most of the northwest, salmon are reduced to 1 to 5 percent of former numbers, and in many streams they are extinct. (Bruce Brown's excellent book *Mountain in the Clouds* [1983] gives some typical stories of incredible stupidity leading to salmon extinction.) Many of the resources are even more depleted, and salmon have perhaps been overemphasized in the literature.

Salmon were the chief fish food of all Northwest Coast tribes except the Makah and possibly the Haida, but a vast range of other water creatures abounded: sturgeon and trout ran with the salmon or stayed in fresh water, while halibut, rockfish, various "cod," etc. occurred in the sea, as well as whales, seals, sea lions, shellfish, seaweed, sea urchins, sea cucumbers and many other fine foods.

All-important was the oily ooligan, also spelled "eulachon," restricted to a few large rivers. Trade for this vital calorie and vitamin source was and is an important feature of northwest life. Whaling was particularly important on the west coasts of Vancouver Island and the Olympic Peninsula.

These resources supported a fairly dense population, living wholly without domesticated resources except dogs and, locally, tobacco. The population was housed in large plank houses arranged in substantial towns—though the towns were usually deserted in summer, as everyone dispersed to get food. Much of this food was stored, since winter is a time of short days and torrential cold rains when food-getting activities are limited.

Their society was elaborate for "hunting and gathering" societies, however the Northwest peoples are better compared to agricultural peoples, since the fish were as abundant and predictable as farm crops—and as difficult to produce, if one takes storage into account, for they had to be smoked and/or dried, often difficult in the wet climate.

Social groups were divided into ranks or even classes. Chiefs and rich persons were important and could expect to receive vast wealth in food and art goods. At the other extreme, slaves constituted a separate class in most areas. They were usually war captives or children thereof, and had a life of toil, amassing surplus for their high-class masters. There is no serious question that the slaves constituted a true class, in the Marxian sense, among groups from Washington State to southern Alaska (see Ruyle 1973).

In most of this area, the chiefs and the rich made up a named social category; were entitled to an extremely disproportionate share of the group's production; controlled such key matters and fishing sites and gear (to say nothing of rituals and titles); led war parties; married among themselves; and were thought to be far above mere commoners. Whether these elite figures constituted a "class" or not is still under some debate. They were very close to the dividing line that separates elders of kinship groups from an actual ruling class. Resolving the debate to everyone's satisfaction would depend on data on ownership and control that we rarely have (at least in published form), to say nothing of the need for better agreement on definitions of "class."

We do know that among groups that were well described rather early, such as the Coast Salish, Nuu-chah-nulth, Kwagyul, Haida and Tsimshian, the elite had very considerable control of the means of production and of the goods produced thereby. They also could command with real authority. (Among many interesting accounts, one early and revealing document is unique in being written from a slave's point of view. An English seaman, John Jewitt, was captured and enslaved by a Nuu-chah-nulth chief in 1803. His account is certainly of a class society, but he may have exaggerated [Jewitt 1980].)

This relatively differentiated society seems to have been a cultural elaboration on the requirements of salmon management. Salmon had to be conserved. Except for the groups at the lower reaches of the large rivers, fishing out a stream could be done quite easily with Native technology. Human populations were high enough, and lavish enough with their fish (at potlatches and feasts), to decimate the smaller stocks of salmon and other anadromous or freshwater fish. There were few great rivers and hundreds of small streams. Groups such as the Haida had no access to big rivers. Many myths warn against the evils of too-efficient weirs, and the like.

Some fishing spots were far better than others, and these were owned by villages or kingroups and managed by the leading men thereof. Some gears were large and elaborate: big canoes, seine and reef nets, weirs, traps. They too were owned by villages, kingroups, families or (perhaps) even individuals, and took a great deal of cooperative labor to create and maintain. Also, salmon had to be

smoked and dried. This could be more time-consuming and labor-intensive than catching them in the first place. It was typically done by women and slaves, while the elite looked on and directed.

Similar frantic activity when the runs are in can be observed today at Bristol Bay, Alaska: boats fishing almost round the clock, canneries running flat-out with labor imported from as far as the Philippines. The scene at a big run 300 years ago would have been less visible from a distance, but probably even more grueling and exhausting for the participants. Last and not least, the salmon and other storable goods provided a very tempting target for raiders, and the good fishing sites were worthy of conquest.

The stereotype of primitive war—raiding for glory and vengeance but not for wealth—definitely does not apply to the Northwest, as Drucker and Heizer point out (1967, cf. Drucker 1955; cf. also the many ethnic spreads such as the Haida conquest of the southwest corner of the Alaskan Archipelago from the Tlingit). The winter villages were defensive, often stockaded and fortified, and there were recognized war leaders. All these factors required strong leadership and tight organization. (It was apparently tighter in the northern coast.)

They did not, however, permit the formation of stable, powerful states or anything approaching them. Thus a village and its elite were always in somewhat precarious state: moving often, impoverished at irregular intervals, competing with other villages, and subject to raids that could be from quite far away (especially if slaves were the target). A chief's position was high but insecure. This had enormous effects on art and society.

In addition to locality and class (or rank), kinship gave structure to society: patrilineal among most Salish, bilateral among the Nuu-chah-nulth, Kwakiutl and some neighbors, matrilineal among the northern tribes. This was variety enough, but each language-group added more complexity.

The Nuu-chah-nulth extended kinship in all directions so far that the whole ethnic group could almost be seen as one family. It is even more a family today; population reduction was so drastic in the late nineteenth century that most Nuu-chah-nulth are traceably related to each other. Chiefs could easily draw followers away from each other by activating various kin-lines.

The Kwagyul were divided into groups often called "numaym." The northern peoples were divided into matrilineages grouped into wider exogamous descent groups. These latter were "phratries" among the Tlingit and Tsimshian, who shared a single four-phratry system. (Some authorities reduce this to three for at least some Tsimshian.) The Haida collapsed the four into two (or, perhaps, retained an earlier system that the mainland groups had subdivided), thus having "moieties" ("sides" in Haida English). Independent of kinship but recruited typically along kin lines were the secret societies: ritual and ceremonial organizations, the most important traditionally believed to have begun among the Heiltsuk. They were actively spreading among other groups when the whites arrived on the scene. Intermarriage, visiting and other contacts were frequent between different groups, and led to a good deal of mutual borrowing and accommodation in social-structural and other cultural matters.

Also, naturally, kinship loyalties got in the way of village solidarity. Some villages were little more than physical aggregates of descent groups that might be quite competitive. Others solved the problem by being made up solely of kin (Easy for the Nuu-chah-nulth!). Others successfully integrated people of various ancestries.

Within the area of Duff's research there were five unrelated language families. Duff's later research focused on the Haida, who inhabit the Queen Charlotte Islands, and since the eighteeth century, the nearest parts of the Alaska Archipelago as well.

Haida is a single language unrelated to any other (J. Enrico, pers. comm.; Krauss 1979). (Swanton (1909a) linked it to Tlingit on the basis of several similar words, but we now know these are recent borrowings, and modern scholars deny any relationship [Levine and MacNair 1979]. Certainly it would be hard to imagine two more different-seeming languages.) North of it, the Tlingit language is spoken throughout the Alaska Panhandle; it appears to be related to Athapaskan in the Na-Dene Phylum.

Nearby in the Skeena drainage are the Tsimshian languages: Coast Tsimshian, Southern Tsimshian, Gitksan, and Nishga (a.k.a. Nisga'a, Niska or Nass). The Tsimshian languages are thought to be distantly related to the Penutian languages of California and Oregon, but this could be challenged (Campbell and Mithun 1979). Gitksan

and Nishga are in fact dialects of one language, though the two groups have a certain traditional rivalry. Upriver from the Gitksan is yet another language family, Athapaskan, represented by the Wet'suwet'en (and Babine), formerly and incorrectly considered a dialect of the Carrier language. The Wet'suwet'en have adjusted so happily and peaceably to the Gitksan that the latter called one group of them Hagwilget, which means "nice agreeable people." Both language-groups now work together on a single tribal council.

Moving south, we find the Wakashan languages. "Wakash!" was recorded by Vancouver as a word meaning "good!" or "hurrah!", a pleasant source for a language-family name. Wakashan includes the various languages lumped as "Kwakiutl" and "Nootkan" in the literature. Few people are now happy with those names. "Kwakiutl" is a poorish way of writing a name now more usually and accurately written "Kwagyul" (or similar spellings), which applies to one group on Vancouver Island. With several other groups it shares the Kwakwala (Southern Kwakiutl) language. These groups are now beginning to call themselves Kwakwaka'wakw ("speakers of Kwakwala"). North of them, the Heiltsuk and Haisla speak related languages.

A dialect of the Heiltsuk language is Owikeno, spoken by the Rivers Inlet people. Their modern history is instructive. Once rich, powerful, artistically brilliant and central in position on the coast, they were reduced by introduced disease to a tiny remnant by 1900. They rallied and did well in the fishery, only to see the fantastically rich Rivers Inlet sockeye runs virtually destroyed in a few years by overfishing, which the government signally failed to control. (The Indians had conserved it for thousands of years.) They are now a scattered remnant, and Rivers Inlet is isolated, a literal backwater. Poverty and despair grip many of the survivors, with both their traditional culture and their initially successful accommodations to white culture destroyed.

"Nootkan" has been a cover term for three closely related tongues: Nuu-chah-nulth, Nitinat and Makah. (The last two are dialects of a common language.) The name "Nootka" was applied to them by one of those ridiculous mistakes so common in early exploration.

The story runs that Captain Cook, landing at Yuquot, asked

"What is the name of this place?" while making a more or less circular motion with his hand. The people thought he was asking if he could sail around their island home, and replied "Yes, you can go around." "Go around" sounds like "Nootka," and it became the English name of the place and its people, eventually extended to their linguistic relatives (cf. Kirk 1986). The "Nootka" speakers proper refer to themselves in English as the Westcoast (or West Coast) People, and in their own language as Nuu-chah-nulth, a recently coined term meaning a "mountain profile" (Halpin, pers. comm.) and by implication something like "people of these mountains" or "people on this side of the mountains" (cf. Latin *cismontanus*). Both terms refer to their home on western Vancouver Island, where they are still virtually the sole inhabitants of much of that wild, rain-soaked coast.

Finally, the Salish language family is large and far-flung, extending from Vancouver Island south into Oregon on the coast, and north to central British Columbia in the interior.

The Salish language family was thought by Sapir to be distantly related to Algonkian. This hypothesis has recently been defended by Joseph Greenberg (1987) but many do not accept it (Campbell and Mithun 1979); Sapir included Salish, Wakashan and Chemakuan, spoken by two small Olympic Peninsula groups, in the "Mosan" grouping within the Algonkian macro-phylum. Salish languages fall into a number of very separate subgroups. The great B.C. Interior group of languages is related, though not very closely, to the coastal tongues. Other branches are farther related, particularly at extreme north and south. Salish is probably distantly related to Wakashan. Bella Coola, the most divergent of the Salish languages, is an outlier to the northwest of the main territory. It lies at the head of a very long fjord. Seaward, north and south, are Wakashan speakers; inland are the Chilcotin people, of Athabaskan language. The Bella Coola seem to have come from the interior. They may have moved up recently from the south or been cut off by recent Chilcotin migrations from other, interior Salish groups. Within the coastal British Columbia world studied by Wilson Duff, the Salish languages are Comox (east central Vancouver Island, facing mainland coast); Squamish (south of it on the mainland); Halkomelem (lower Fraser River and east Vancouver Island south of the Comox); and Straits (Juan de Fuca

Straits, San Juan Islands, and headlands of the coast, straddling the international border). It will be noted that sea, not land, holds these groups together. Island Halkomelem routinely crossed the Gulf of Georgia and even went well up the Fraser in their yearly fishing rounds, and the Straits people were at least as mobile.

Greenberg (1987) has recently demonstrated possible links between most Native American languages in an Amerind family. This would include, in the Northwest, the Tsimshian, Wakashan and Salish. So far, few experts have accepted these linkages. The Eskimo-Aleut and Na-Dene are outside this proposed grouping. Greenberg tentatively leaves the Haida with the Na-Dene, following Sapir who followed Swanton, but he has not examined the evidence in detail, largely because little recent linguistic work on the Haida has been published (Greenberg, pers. comm.). Certainly, Greenberg's case for an Amerind unity is considerably stronger in South and Central America than in the north.

By Greenberg's reckoning, and by many or most others, the Northwest Coast (in the wide sense, stretching from Aleut and Chugach Eskimo territory down through northwest Washington with its strange and residual Chemakuan languages) appears to display the greatest linguistic diversity in the hemisphere. This strongly suggests to Greenberg that a coastal route was used by Native Americans entering the continent, a point also argued by Fladmark (1986). Duff too saw much migration and influence from the north (unpublished notes; cf. Kirk 1986, who draws on some of these notes).

Considerable ethnic shifting has taken place on the Northwest Coast. Much of it was accompanied by violence. The Haida took most of Prince of Wales Island from the Tlingit just before whites came, and the Tsimshian had been gaining at Tlingit and Athabaskan expense on the mainland. The Tlingit meanwhile expanded north, both by outright migration and by linguistic conversion of Athabaskan peoples. (One ethnographer found a family in which the grandparents spoke Athabaskan, the parents Tlingit and the children English; McClellan 1975.)

After the fur trade began, guns permitted much more rapid and savage spread. The Kwagyul moved south against the northern Comox, who meanwhile moved south themselves, exterminating or

assimilating more southerly speakers of the same language. Since the Nuu-chah-nulth had been expanding from the west even earlier, the Pentlatch dialect of Comox became extinct; surviving Pentlatch now are assimilated into the (northern) Comox or the Opitchesat band of Nuu-chah-nulth. For millennia there had been shifts among the Salish; cultural boundaries archaeologically identifiable are often quite different from present ones.

On the other hand, some groups, and perhaps all, have maintained stable centers. The Haida may have reached the Queen Charlottes dryshod during the Ice Age; Hecate Strait is shallow and was mostly dry land (if partly ice-covered) when sea levels lowered. They remained fairly isolated until maritime technology reached a point where canoes could easily cross the extremely dangerous seas. (The Queen Charlottes are not even visible from the mainland, though they are visible from some south Alaskan islands.) This may not have happened until two or three millennia ago. In general, the extreme distinctiveness of languages and culture on the coast bespeak long isolation and independent development.

Archeology reveals a long period of adaptation to the coast (Carlson (ed.) 1983; Fladmark 1986; Kirk 1986). Humans entered the area as the glaciers melted ten thousand years ago. (There are no evidences whatsoever of earlier occupation. The area was almost totally ice-covered during major glacial advances.) Roving bands of hunters slowly settled. Unfortunately we know little of the early stages of the process, since rising sea-levels have drowned out the presumed migration routes and coastal camp sites. In the Interior, big-game hunters were becoming flexible foragers at this time. Over the last 7,000 or 8,000 years, evidence is better for the coast, and reveals a slow process of development of what we now see as the typical culture.

Flaked stone tools gradually gave way to ground stone; villages grew bigger and more permanent; art became more spectacular. By about 1,500 years ago, something like the current Northwest Coast culture was firmly in place. Ground stone had almost totally replaced flaked. Woodworking tools reached modern levels of sophistication—and they were very sophisticated indeed. Large winter village sites and smaller summer campsites reveal the present economic pattern. The bow and arrow had come; bows and arrows are late

arrivals in North America, probably not reaching the Northwest till about this time. Nets, matting and basketry flourished.

Waterlogged sites have preserved some of it, including a large and varied assemblage up to 3,000 years old from a site still occupied by the Musqueam Band of Halkomelem Salish. They still use some of the same techniques, though others have dropped from use, perhaps indicating a minor population shift. A wooden carving dredged accidentally from the Skagit River shows recognizable Northwest Coast art to be equally old. The Makah village of Ozette, buried by a landslide 450 years ago (Kirk with Dougherty 1978), has yielded a splendid array of artifacts essentially the same as those of eighteenth-century Makah. Due to the quick decay of wood in that damp climate, we have few other direct evidences, but totem poles, huge longhouses and so forth can be inferred for northern groups.

The earliest voyagers from Europe, in the late eighteenth century, found them and wondered at them. Vancouver noted the house of the Nuu-chah-nulth chief Maquinna had a beam 100 feet long and five feet thick (Pethick 1980); Simon Fraser found a Salish longhouse 604 feet by forty feet in the early nineteenth century. With the coming of iron tools and other riches, an explosion of art took place, but the great tradition had long been established. (An earlier view, identified with Marius Barbeau, held that Northwest Coast art was a post-White flowering. This is now conclusively disproved.)

Little can be said so far about regional traditions in prehistoric times, except in far southwest British Columbia. Excavations in the Fraser Delta have been especially productive, showing a Locarno Beach Phase from 1,500 B.C. followed by the Marpole Phase till 400 A.D. and essentially modern material thereafter (see Fladmark 1986). Progressive adaptation to sea is indicated. The Marpole Phase already has rich art. Rapidly increasing knowledge of the nearby coasts, the Olympic Peninsula and Vancouver Island show roughly the same sort of sequence (see MacMillan and St. Claire 1982; Kirk with Daugherty 1978). Up coast, far more sporadic excavations show a similar pattern.

The most important single find from the point of view of art, and of Duff's work, was a cache of stone clubs at Hagwilget, dated about 1,500 to 2,000 years ago, at or just before the beginning of the modern period. They are magnificently carved, showing a highly

refined, mature art style related (but not closely) to more southerly styles of the period and to later Northwest Coast art. Several very similar artifacts have turned up throughout what is now Tsimshian territory. Perhaps the clubs are associated in some way with Tsimshian entrance to the region; they are about the right age, if the inferred time of separation of Tsimshian languages means anything.

The Queen Charlotte Islands follow the usual time frame, but show one sharp difference from the rest of the coast: there are few deep middens or other evidences of long-continued site occupation. This is partly due to modern destruction.

Part of Queen Charlotte City, and Masset's Haida community, are built on deep middens and have destroyed much of them. Local farmers and gardeners mine middens for rich, high-pH soil (pers. obs.). But the difference is real. Haida villages, though large and incredibly rich in woodwork, moved frequently. This was partly due to rather weak political control, in which a "town chief" tried to run things but often lost support of major factions.

More serious, I believe, is the food problem on the Charlottes. Haida population reached high levels in the relative safety of the islands, and resources were thin and not very concentrated. There are no huge salmon rivers, but rather a whole galaxy of smaller streams. There are no ooligan, and historic Haida had to voyage to the Nass River to get this vital resource. Much of the food came from the sea; with the Makah of the Olympic Peninsula, the Haida may have been alone on the coast in depending more on strictly marine resources than on anadromous fish. In a generation, a given site would be eaten out thoroughly, and people would have to go for miles to find chitons, rockfish, clams, halibut and so forth. Moreover, no one site was much better than any other, with a few exceptions (such as Masset in the north and Anthony Island in the south). So the Haida moved frequently.

Elsewhere on the Northwest Coast, there were many moves and many scattered small sites, but the incredible concentration of resources at certain points on the straits and major rivers lead to relative stability, and many villages stand on old, deep middens.

A river that had all the salmon species and ooligans too, such as the Nass or Bella Coola, would be particularly apt to concentrate population. Many island sites show even more focus, since there

might be only one place on an island that combined a good harbor, good fishing and good shelter from raids and war. The last of these factors was often stressed by Native people talking to early ethnographers.

Population was dense on the coast. The Haida had 6,000 to 8,000 on the Charlottes and perhaps 2,000 more in Alaska. There were over 80,000 people on the British Columbia coast (Duff 1963:39). These population figures are conservative. Recent research indicates much higher figures are likely (M. Halpin, pers. comm.). In any case, introduced diseases during the nineteenth century reduced all groups by 90 to 95 percent. The Haida, for instance, mustered only 588 by 1915 (Duff 1964:39), and many of these were mixed-bloods.

Some groups (notably the Pentlatch, Tsetsaut and Nicola) disappeared entirely, the few survivors merging with neighboring tribes.

Many groups consolidated, survivors being thrown together on tiny reserves and intermarrying, with much loss or at best homogenization of culture.

Thus the many Haida groups, speaking several dialects, came to live in only three major communities, Masset and Skidegate in Canada and Hydaburg in Alaska, preserving only the dialects proper to the aboriginal villages at these sites.

The history of white contact is as unedifying as it is in most of the New World: early conflict and massacres followed by expropriation and exploitation. The Indians were given tiny reserves. Unlike the situation in most of the New World, the British Columbia peoples did not even get the benefit of treaties, except in the extreme northeast and southwest. In most of the province the land was simply taken. The question of aboriginal title remains open.

The Indians were given tiny village sites and fishing spots; the large reservations seen in the United States do not exist in B.C. The fishing spots would have been more valuable if the Indians had secured their rights to some of the fish, but even this was denied them. There is little hope of a decision like that of Judge Boldt in Washington State, restoring treaty rights over fish. Legal action does go on, however, for some protection of traditional hunting and fishing was guaranteed (see e.g. Berger in Abbott [ed.] 1981). Recent court decisions establish at least the possibility of claims. However, on the whole, the whites came and took the fish. The Fraser River

36

stocks are protected by international treaty that sets the U.S. and Canada at vigilance, and the runs have held up fairly well, but pollution may soon change that. Otherwise, the B.C. fisheries, especially for anadromous fish, are ravaged—down 90 to 100 percent from traditional times in most areas (cf. Morrell 1985 for the Skeena River).

The Indians adjusted to the white economy at first. The fur trade was good to them; they trapped fur, raised potatoes, kept small stores, supplied fish, sailed canoes for traders and much more. Then came a period of exploitation of fish and forests, and of farming with its seasonal labor needs (especially for hop-pickers in the lower Fraser Valley). Furs, fish and forests were decimated by the last quarter of the twentieth century, and high-capital, low-labor technology often left little place for Native peoples. Economic and social problems continue to be acute. Revival of traditional art has provided the best hope for many. A worldwide, sophisticated market now exists, and good work (indeed, even less-good work) commands high prices.

The standard history of the fate of the B.C. Indians in an Anglo world is still Wilson Duff's book of 1964: *The Indian History of B.C., Vol. 1, The Coming of the White Man.* A thorough, balanced, accurate account with what remain the best figures on population published to date, it is a monument to Duff's scholarly and literary ability.

The high ratio of people to resources in the Pacific Northwest has never received adequate attention. The few survivors left by the time ethnographers appeared on the scene could not threaten the stocks of game and fish that had once flourished. However, with current knowledge we can see that the population had been far greater, and had been dense for a couple of millennia. Especially in fragile and modestly endowed areas like the Queen Charlottes, the Native populations were more than adequate to overdraw the resources. This would be doubly true for resources that were very popular and very localized or scanty, such as sockeye on the Charlottes and on Vancouver Island, and ooligan everywhere. Yet when the whites arrived, they found salmon common in every stream, and the land, in general, stocked with about all it could hold of fish and game. This was not for lack of technology, either; Indian fish weirs

attracted fierce white attacks by the 1870s because they were so efficient (Langdon 1977).

Even such huge rivers as the Fraser and Skeena could be over-fished with aboriginal technology. 1) Most fish spawned in small, vulnerable headwaters and sidestreams. 2) The technology included trawling, and the enormous reef nets (gill nets hung over reefs) of the Straits Salish. These could evidently catch fish in quantity. 3) The longer the river, the more people along it; any fish ran a gamut of many tribes. Folktales along the Fraser include a plot-type in which a hero from upriver destroys too-effective weirs made by villains downriver (Hill-Tout 1978:31). Today, Indians with traditional technology, and white men borrowing it, have all too often "robbed creeks"—taken all the fish in small streams, eliminating their runs.

We have many evidences of seasonal and periodic hunger. Francis Poole, mining on the Charlottes in the nineteenth century (and after the big epidemics), saw that the Haida foodstores were reduced to dried berry cakes and small roots by early spring (Poole 1872). The Skeena fish run failed one year about the same time, and the Indians along it took refuge with relatives on the Nass and elsewhere (John Pritchard, pers. comm). It is important to note that they did not call in potlatch debts and demand others to bring food to them! They did as most people everywhere would, and sought charity of kin. Many other famines, shortfalls and seasonal hungers are reported (Piddocke 1969).

Moreover, the entire culture of the Northwest Coast shows an almost obsessive concern with food and eating, and by far the most reasonable explanation is that food was chronically short and a subject of constant concern. Everyone must have had the experience of serious hunger. Famine foods were well known (see e.g. Turner and Efrat 1982:29,37). Shortages did not necessarily follow from absolute lack of resources; storms could keep people from food-getting or ruin storage, raids could destroy or carry off food supplies, prolonged damp spells could rot stored foods, usually cold or warm years could delay or advance fish runs and play havoc with the annual round of the people, and so on.

This being so, conservation had to be practiced. We have many evidences of careful resource management, worked out and enforced by chiefs or councils of high-ranking people (Anderson 1986; Mor-

rell 1985). Unfortunately, no thorough description is possible, since the relevant mechanisms were gone by the late nineteenth century when good descriptions of the cultures begin to appear. But there is no doubt that conservation was important, and little doubt that it was enforced through traditional authority channels and was a major factor in maintaining them. This is all of significance for the art, which served to express the concepts behind status-ranking. In the visual art it is hard to trace conservation directly, though I suspect it is there; in oral literature, there are countless expressions of it, especially condemnations (explicit or implicit) of overfishing and of wasting food.

There is a myth in the scholarly literature of fantastic abundance of food resources in the Northwest Coast. This myth is based on observations of the huge runs of anadromous fish that once packed the rivers. Indeed, the Northwest is richer than the Kalahari or the Australian desert—the typical habitats of anthropologists who study hunters and gatherers. But its abundance has been overrated.

Anyone seeing, for example, the huge salmon runs of the Fraser must remember that these fish will soon be scattered over a quarter of British Columbia. Moreover, the runs are of brief duration. Several species run only every few years: the pink salmon every second year (with a much smaller year-class in the alternate year), the sockeye every four, the spring every four to eight. Every year has a run, but some years have much bigger runs. Runs may collapse without warning, due to conditions still hard to explain. Sea temperatures, predator abundance, competition from other fish (especially on the fry, parr and smolts) and other factors are important. Landslides may close off spawning streams. Artificial fertilization of Kennedy Lake, Vancouver Island, produced at first an increase in salmon, but then an increase in stickleback which outcompeted young salmon and/or ate salmon eggs, and the fishery crashed (Al Keitlah, Tom Reimchen, pers. comm.). No doubt natural eutrophication caused such crashes on occasion. Anyone seeing pictures of the fantastic Adams River major sockeye run should remember that it is a matter of a few weeks every four years, and that it was virtually wiped out by the Hells Gate landslide of 1913 (human stupidity produced that landslide, but natural landslides are frequent enough). Only diligent conservation and artificial fixing of the slide damage

brought the Adams run back, and the process took decades. The entire Skeena River run failed one year in the nineteenth century (John Pritchard, pers. comm.), only a few of the tens of millions of fish returning.

Second, the major fish runs are about all the landscape has to offer. Coniferous rainforest is poor hunting and gathering country. The trees, filled with natural insecticides and herbicides, provide little, if any, food for any animals. Game and plant resources are commonest to meadows, streambanks and other openings, and these are few. Moreover, a hunter crashing through the windfalls and thickets cannot easily see or stalk game. Amazingly, a few groups (such as the Mowachat, "people of the deer," one of the Nuu-chah-nulth bands) did depend heavily on game. But the vast majority of people shunned the forests and lived on the larger waters.

Third, the real sleeper in the abundance myth is the problem of calories. Most of the available foods are a dieter's dream but a hunter's nightmare. Berries run 200-400 calories per pound, marine animal flesh 300-500, salmon 400-600 except for very fat pieces. The sockeye, which make especially long journeys, regularly run to 800-1000 calories per pound of meat when they enter the rivers, but they use it up as they swim upstream. Any salmon near its spawning grounds will be low in fat—at most 400-500 calories per pound of meat. Naturally, downstream sockeye were usually the choicest fish.

The calorie needs were hard to meet. Evelyn Pinkerton has experimented with subsistence hunting-and-gathering on the Queen Charlotte Islands and talked with many others who did so, and has guided me in some brief testing of my own. The consensus is that without the deer—which is introduced and depends heavily on logged areas and people's gardens for food—survival is difficult indeed. Salmon are decimated on the Charlottes, so the situation is not aboriginal, but still a day spent gathering marine resources is revealing. One returns with a huge bag of crabs, limpets, snails, small shrimp, small fish, chitons, seaweed, edible strand plants and so on, and is impressed; but then one finds that almost all the weight is shell, and that what remains is low in calories. One can barely carry a meal's worth of strand food, and learns to sympathize with the women who had to forage for it in aboriginal times.

This is doubly serious because of the high calorie requirements

40

of aboriginal life on the coast. Fishing by hand under stormy winter conditions requires at least 5,000-6,000 calories per day for a 75 kg adult. (This is not sitting by a hook and line on a bank, but managing a nonmotorized boat and hauling nets by hand in rough waters.) The climate of the Northwest Coast both restricts action and raises calorie needs. Not only is the climate cold, wet and stormy; the rain, which can last almost without intermission for weeks, makes aboriginal clothing relatively useless. The warm furs and skins of the B.C. Interior were worse than useless on the coast, becoming waterlogged quickly. Loose robes of insulating cedarbark could not keep out constant rain (nothing can) but at least held body heat. One was constantly being re-wetted by cold water, however. Water carries heat far more effectively than air and thus chills the body far faster and more thoroughly. Even without rain, the coastal air is humid enough to be a serious problem, except in a few special areas. (Summer on the Gulf of Georgia can be hot and dry, and of course even more so in the Interior.) The cedar robes were difficult to work in, and men tended to work nude, even in winter.

Judging from the incredible accounts of food consumption in the early days, they did this by training their bodies to metabolize at high rates, keeping up body heat by burning more fuel. We shall never know, but certainly the training of youths involved forcing them to endure frequent cold baths (often to the point of numbness), nudity in winter, and the like. Anyone with experience of traveling on wintry seas on the coast will find it hard to believe that the near-nude paddlers of old did not have high metabolic rates.

Moreover, the diet tended to be high in protein. A mostly protein diet is dangerous, overloading the kidneys with nitrogenous waste products and leading to high blood pressure and heart failure as the heart tries to pump blood faster through the kidney filters. Many Americans died from the high-protein diets that were faddish in the 1970s.

There was only one possible way to survive on the Northwest Coast: eat a great deal of fat. Indeed, life could become a somewhat obsessive search for food in general and fat in particular. Early accounts of Northwest natives, particularly the most sea-oriented (such as the Nuu-chah-nulth/Makah), register uniform amazement at the popularity of oil and the amounts used. Fish was dipped in oil,

berries and roots were mixed with it, or it was simply drunk straight. At feasts and eating contests, it was often drunk literally by the bucketful. Drinking glasses of it was common into this century. Even today, traditional feasts and home meals are often accompanied by ooligan oil (or Mazola, the substitute of choice) as a dip for foods. The problem is that oil is not only hard to get, it is sharply localized. It came primarily from ooligans—confined to a few major rivers—and sea mammals, which are difficult to hunt. The intrepid Nootkan-speaking groups indulged in extensive whaling. (No ooligans occur in their territory.) Drucker, in his study of them (1951), concluded that whaling was a minor source of food, but he was dealing with heavily acculturated informants who had whaled after the Anglo whaling fleets had almost eliminated the animals from that area. Subsequent research, especially archaeological work at Ozette but also the work of the Nuu-chah-nulth historian John Jacobson (ms. in Duff files), show that whales were taken often enough to be a major food source, perhaps the major one.

Today, with the gray whale back up to a significant (if probably small) percentage of its former numbers, and the traditionally preferred larger whales protected, we can observe how they take shelter in bays and protected waters, such as the sounds of Nuu-chah-nulth country. Here they allow such close approach that boat tours now give tourists the opportunity to pet gray whales! Jacobson reports that the whalers of old were similarly able to come right up to their prey. However, much danger still attended whaling, for a hit whale might swamp the canoe or tow it far out to sea. Drucker's informants reported having to paddle for four days to get back to land, after one encounter; those who have been in those waters in an open boat can fully appreciate the problem of survival under such circumstances.

Elsewhere, seals, sea lions and ooligan were easier to get than whales. Ooligan oil was widely traded. The Haida voyaged to the Nass River for it, several dozen miles over one of the most treacherous and dangerous bodies of water on the coast. They faced desperate want when weather prevented the trip. "Grease trails" to the Interior were major routes, followed by early Anglo explorers. It is hard to imagine just how important ooligan oil was in precontact times, but it must have been essential to maintaining the large populations found by early explorers. Those who controlled a good ooli-

gan river could expect to do very well indeed in trading. We know very little about aboriginal ooligan runs, but they must have failed occasionally, with catastrophic results.

Ancel Keys, working with conscientious objectors during World War II, found that prolonged, low-calorie diets lead to obsessive concern with food and eating. (All of us who have had to lose a good deal of weight have some mild awareness of this.) Colin Turnbull, studying the Ik people of Africa during a time when they were starving, found the whole suite of features Keys noted among volunteers—all the more significant since Turnbull was then unaware of Keys' research (Turnbull 1972 and pers. comm.). The feasting, the tales of Raven's greed, and the fixation on mouths, food and eating in Northwest Coast art seem to evidence a similar dynamic. People had experienced famine, or at least hunger. They had also experienced plenty: a huge salmon run after a bad couple of years, a whale after a long stormbound spell, the return of the ooligan after an unusually rough winter. The easiest way to store food is as fat on one's own body, and feasting is a natural enough response to sudden wealth of good food.

Unfortunately, we do not know much about fluctuations in traditional abundance. Suttles (1960) and Piddocke (1969) attempted to construct theories of potlatching and society on the basis of assessing this. Their case remains unproved (Orans, 1975; John Pritchard, pers. comm.) and must probably remain so forever. Early accounts speak of hunger and famines but give no figures or details. All we know is that resources varied. Obviously the situation was much more precarious in some areas than in others. The west coast of Vancouver Island had few sockeye except the Barclay Sound/Somass River run, no ooligans, no sturgeons, few land animals, and some of the most unspeakable weather in the world. By contrast, the Fraser Delta had everything, including quite game-rich mountains around it, and a climate that permitted foodgathering almost every day of the year. Perhaps because of this, the west coast seems to have had a quite high level of social organization compared to the Fraser Delta. Perhaps it made more sense to organize in the former, to scatter out in small villages in the latter. Theories of social organization (and its artistic expression) based on ecology must remain forever tentative and speculative.

In any case, the abundance of the Northwest Coast was a some-time thing. When the runs were in, people were literally wallowing in food. When the runs failed, starvation faced everyone. It is against this background that we examine the art of the Northwest: its splendor, its diversity, its sheer volume and of course its fascination with mouths and food.

3

Northwest Coast Art

Northwest Coast art is of enormous antiquity. Archaeological finds have extended back our knowledge of the style and its development, though the record is extremely fragmentary, because most the art has always been made from perishable materials. However, excavation of wet sites (where waterlogged soil preserves wood and fire) has given us 3,000-year-old baskets, 2,000-year-old wood artifacts, and the like—enough to prove that ethnographic items were the culmination of a long development. The stone and wood items we have are about what one would expect of ancestors. They do not show the specific elaborations of the modern materials; they show similar treatments, simpler but still exquisite in many cases. They are not identical to the simpler modern items; they have their own motifs and images, more or less related to modern ones. Tracing the relationships (stylistic and thematic) was a lifelong interest of Wilson Duff; indeed, this seems to be what drew him from archeology to art.

Art was noticed by the first visitors to the coast. The Spanish discoverers of the Queen Charlotte Islands (in 1774) did not land there, but even so the Haida paddled out in canoes and traded ornate boxes and fabrics with them (Fisher 1977:2). Early drawings of poles

there and on Vancouver Island are now well-known. About the same time, the Russians expanding through Alaska reached the Tlingit, and began collecting art objects. The ensuing fur trade led to a great increase of art in most areas, though not the south. This was perhaps mainly because the people acquired large numbers of iron tools. (A few iron tools, possibly made from pieces salvaged from Japanese wrecks, were observed among the Native peoples by the first white explorers.) Also, general increases in wealth and decreases in population led to more competition for status—and thus for its symbols. It is not true that the fur trade led to whole new types of art (such as totem poles), as early scholars thought. But relatively sparse monumental art became abundant, and smaller objects were more intricately worked. The striking and unique art of the Northwest Coast has attracted world attention through its combination of dramatic intensity with controlled, precise line. The huge beasts and strange beings, so fierce and terrifying yet so perfectly and precisely delineated, take on a reality of their own. This was not an abstract creation of beauty for the delectation of a few aesthetes. It was a major means of communicating the basic social and personal statements. All the most pressing and involving questions of individuals-in-society were discussed in the symbolic language of the art.

Northwest Coast art has attracted more attention, probably, than any other art produced by hunting and gathering peoples. Much of this has been superficial. To the casual observer, the art has all the stereotypic traits of The Primitive. However, from the very beginning of anthropological field research, the Northwest Coast was fortunate enough to attract many of the finest ethnographers in the history of anthropology, and many of them were especially interested in art. The tradition begun by Franz Boas and John Swanton continued through such notables as Claude Levi-Strauss as well as Wilson Duff, and continues still through the work of his students and colleagues, as well as many other scholars. Art historians such as Bill Holm, Victoria Wyatt and Aldona Jonaitis have specialized in Northwest Coast art.

Most important of all, perhaps, the Native peoples of the coast have been quite articulate about their art—at first through the medium of conscientious ethnographers, more recently in their own proper persons. Bill Reid, Douglas Wilson, Ron Hamilton

(Hupquatchew) and Roy Vickers—all of whom acknowledge some degree of support from Wilson Duff—are only a few of those who have given us their own thoughts on traditional and recent creation (e.g. Abbott (ed.) 1981; Drew and Wilson 1980; Holm and Reid 1975; de Menil and Reid 1971; Shadbolt 1986; and this is by no means a complete survey).

As Duff pointed out (see below), the first phase of art study was primarily directed at simple description of what was represented. This was the period dominated by Boas and his students (e.g. Boas 1927; Swanton 1905, 1908a, 1908b), though others made important contributions in the same general realm of discourse (e.g. G. Emmons' famous unpublished mss., many of them now in the Royal British Columbl Museum, where Duff as well as many others of us drew on them substantially).

There was some speculation about the deep structure of the art, and certainly a good deal written about its explicit or exoteric meaning, but little of the deep study characteristic of serious art history. That had to wait for actual art-historical attention. Bill Holm in his classic work of 1965 constructed a grammar of one subset of the art, the "flat style" of the northern coast peoples. He was able to show that the characteristic style of decorating flat surfaces followed clear and rarely violated design principles (Holm 1965). His work may not have been totally exhaustive, and the violations are of interest in their own right, but the work has been widely followed—by Duff among others, in most of his notes. Holm has gone on to characterize characteristic ethnic variations in this and other subtraditions, and to study individual artists and their particular ways of using traditional principles and motifs (e.g. Holm 1981). Even the earliest ethnographers noted that Northwest Coast art had its masters and its individualists.

Now, with heightened consciousness of the individualism and variability of traditional art, Holm's lead is being followed in many subsequent studies. Meanwhile, Levi-Strauss and Duff led the way in trying to place Northwest Coast art in world context and understand its deeper meanings.

At this point it may be useful to supply a very brief, general introduction to Northwest Coast art. The literature on the art is so vast, and also so easily accessible and comprehensive, that the reader

may be referred to a number of other overview works (among them Gunther 1966; Holm 1965; Inverarity 1950; and Stewart 1979 supply particularly useful introductions). It is neither within my competence nor within the reasonable scope of this book to supersede those sources.

Northwest Coast art forms a single body of more or less closely related styles. Usually, the Northwest Coast is taken to include the range of peoples from the Tlingit south through the coastal tribes of Oregon. The boundaries are not clear, since all groups influenced each other, guaranteeing that styles shade off into each other.

The classic traditions were confined to people who actually lived on tidewater; interior groups, however influenced by the coast, had their own styles. Virtually nothing is known of the coastal Indians of Oregon, and northern California is artistically closer to the rest of that state than to the true Northwest, so for most purposes our world is limited to the coasts of Washington, British Columbia and the panhandle of Alaska. The importance of comparison northwestward through southern Alaska and across Bering Strait into Asia has, however, been stressed since the days of Boas, and has recently been given renewed attention (Fitzhugh and Crowell 1988). The link with Asia and Alaska, however, is clear and dramatic. There is still a case to be made for the influence of Shang Dynasty Chinese art on the Northwest Coast (Fraser 1962), though cautious scholars do not accept a direct link. The influence is real, but very indirect, being mediated through the intermediate groups (the Siberian and Alaskan native peoples) over thousands of miles and thousands of years (Fitzhugh and Crowell 1986).

One area of current research involves the relationships of the art styles found among the Eskimos of the Bering Straits area from about 500 B.C. to 1000 A.D., in particular the old Bering Sea style (ca. 300 B.C. to 500 A.D.; Fitzhugh and Kaplan 1982; Fitzhugh and Crowell 1986; Wardwell 1986). This style is characterized by animal transformations, animals devouring prey and other Northwest-Coast-like themes, and its lines are highly reminiscent of the ovals, U-shapes, split Us, and other characteristic patterns of northern Northwest Coast art. It seems to be an intermediary between Siberian art styles and later Northwest Coast styles. This should not

surprise us; the groups were near each other, and much influence is known to have flowed from north to south.

The relationship of Eskimo-Aleut whaling and that of the Nuu-chah-nulth, noted by Duff, is noted by more recent scholars as well (Fitzhugh and Crowell 1988). The Yupik Eskimo share with the Nuu-chah-nulth an equation of wolves and killer whales. As Duff often commented in his notes, the northern, Eskimo-derived influence on Northwest Coast culture seems extremely important. More research will have to be done to clarify what is parallel invention and what is indirectly shared.

On the whole, the Northwest Coast seems to have been primarily a donor to the interior groups, though there are many exceptions to this; perhaps the most interesting is the mysterious replacement of a distinctive but characteristically coastal style of basketry by a thoroughly interior style among the Coast Salish of British Columbia at some obscure point in the past (Kathryn Bernick, pers. comm.). Influences from culture areas to the south seem to have been few or lacking north of the Columbia River.

Within this area there is, of course, a considerable diversity. On the whole, art style sorts with language or language-group, but there are some very conspicuous exceptions. The most striking of these is the style with which Wilson Duff was most concerned: that of the northern Northwest Coast. This style was shared among the Haida, Tlingit, Tsimshian and Haisla—four totally unrelated languages (at least according to most linguists). There were regional differences that sorted with the languages, but only the expert can accurately place northern Northwest Coast pieces, and sometimes even the experts are in disagreement, as in the case of Duff's favorite box.

Duff was largely concerned with the northern style. Within it, he concentrated on the Haida. Their version of the style is a balanced, dignified, massive form. Totem poles and other three-dimensional art works show a heavy but fluid molding. Heads are typically as big as bodies. The flat style is graceful, highly abstract more often than not, and characterized by wide formlines.

Compared to it, Tsimshian art forms something of a "classical" pole. Three-dimensional works are softly rounded and quite realistic, and often have a gentle quality unusual on the Coast. The flat art is beautiful and complex, but usually almost impossible to distinguish

from that of neighboring groups (unlike the quite distinctive sculpture).

Tlingit art is harsher, more angular, more contrasting and more often wildly shamanistic. Even non-shamanic pieces are often conspicuously asymmetrical or dramatic. The art is less stylized and homogeneous than other northern groups' work.

The next style southward is that of the classic "Kwakiutl" peoples, more accurately speakers of the central and southern members of that language group. The classic terms "central Kwakiutl" and "southern Kwakiutl" are being replaced by more accurate terms. The term "Kwakiutl" is a bad spelling of the name of the Kwagyul or Kwakyul people, one division of the "southern Kwakiutl" of anthropological fame. The extension of one band's name to an entire language group is now discouraged, and more accurate naming is in progress. Central Kwakiutl is divided into Heiltsuk and Owikeno. The "southern Kwakiutl" are increasingly coming to refer to themselves as the Kwakwaka'wakw—this being the proper name of the "southern Kwakiutl" language. Pending wide adoption of this term, the present book continues to use "Kwakiutl" for the art style.

The Salish peoples to the south possess a set of closely related styles. The Nuu-chah-nulth have their own style, obviously related to both Kwakiutl and Salish, but easily distinguishable. It has been classed with the Kwakiutl in a Wakashan style, but the relationship here is linguistic, not visual; the Nuu-chah-nulth and their close relatives the Ditidat and Makah share a unique style that has received little attention. In general, but by no means in all cases, the art becomes less spectacular and dramatic in these southern groups. It is usually a more intimate, low-key art, lacking (until modern times) such things as the huge totem poles that have made the Kwakiutl and northern styles famous.

At present, we have far less material from these Salishan (and neighboring) groups than from those north and west of them. This is partly because, as Duff points out often in his notes, the coming of the whites led to an increase in art among the northern and central groups, but a decrease among the southern ones. This, in turn, resulted from the fact that whites were heavily involved in trading for furs and other goods with the former, but did not settle in any numbers in their territories; conversely, the latter peoples endured

early and intensive settlement without a period of relative isolation and lucrative trade.

The trade brought iron tools, copper, paints and the like, which released a creative explosion when injected into a traditional system; moreover, it vastly increased the wealth, fighting abilities and instability of the political system (see Fisher 1977). Settlement, by contrast, brought primarily oppression and pressures to assimilate; at best, it did not provide great stimuli for art. In any case, the best-known Northwest Coast art today is that of the Kwakiutl style (see esp. Hawthorn 1967, 1979; Holm 1983), followed by the Northern style.

This is changing, and the Northern style is the subject of significant current research, e.g. by William McKennan of the University of British Columbia's Museum of Anthropology.

Northwest Coast art is identifiable as a unit because of a number of shared features of form and content. These have been discussed elsewhere (e.g. Boas 1927; Gunther 1966; Holm 1965, 1983, 1984, 1987; Jonaitis 1986; Levi-Strauss 1958, 1982). Totem poles (Barbeau 1929, 1950, 1953; Keithahn 1963; Malin 1986; Smyly and Smyly 1981) and house fronts, as well as interior house posts (roof supports) and the screens that wall off the back from the front regions of the house, are the most important arenas of art. They communicate the social position of the house's inhabitants. Masks (King 1979; Malin 1978) are typical distinctive forms, being used in rituals where natural and supernatural beings are imitated or invoked.

Enormously important are arts devoted to food and eating: food bowls, food containers, dishes, spoons and the like (cf. Walens 1981). Boxes to contain wealth objects are important and comprise some of the most superbly decorated pieces, including the box on which Duff spent so much attention (see below). Speakers' staffs constitute a minor form. Ornaments and jewelery were well represented, especially after precious metals entered the Northwest; apparently some of the first silver coins to appear were turned into silverwork. Similarly, large copper plates from the bottoms of ships were turned into symbols of wealth and person. (They may have aboriginal roots, but we have no evidence.) Weavings such as blankets and costume parts are also important, and typically underem-

phasized (but see Gustafson 1980; Johnson and Bernick 1986; Samuel 1982). Basketry and cedarbark arts were extremely well developed—among the finest in the world.

Among the Haida, a man would often paint decorations on a spruce-root basketry hat made by his wife; we know that Charles Edenshaw did this. In addition to these important categories of art objects, anything and everything could be decorated.

Some of the finest examples of Northwest Coast art are mauls, mat creasers, canoes and even stones for lifting in tests of strength. Pictographs and petroglyphs decorate the rocks.

Nor was the human body neglected; face-painting and tattooing have rarely been developed to higher levels anywhere in the world. Anything that would hold still long enough was a field for superb art. The extreme development of visual art on the Northwest Coast begs many questions. No one has advanced a generally accepted theory to account for this explosion of art. (Iron tools greatly increased the amount of woodwork done, but the art was well established long before the whites came.)

Duff's theory is probably the best to date: lacking writing, the Native people worked out their communication of basic human and philosophical concerns through art. But why so much of it? And why so much that is purely formal, without visible philosophic import? And why was so much effort expended on so many individual pieces? Duff asked these questions, and answered that there must be underlying philosophical and psychological messages, previously not understood. He devoted his life to elucidating these messages (see Duff 1981).

A whole separate category of art is that relating to shamanhood: charms, costumes and headgear. Halibut hooks and some other classes of "useful" art portray magic themes related to shamanic concepts. In the northern style, this includes much reference to the terrifying land otter who steals souls, and to skeletal beings and skeletalized beings. Skeletal land otters are particularly evocative forms.

It is sufficient here to mention a few matters that will be relevant in further discussion. Northwest Coast art focuses on animals, especially relatively large and powerful ones, and on humans and humanoid beings. These are represented in varying degrees of abstraction,

from quite realistic (if simplified and not absolutely naturalistic). The abstraction consists of progressive geometrization. The animals, humans and rarely vegetal and geographic motifs dissolve into rectilinear or curved forms. Very characteristic are oval and U-shaped forms, in which the tension of a long straight or slightly curved line suddenly breaks into a sweeping curve. Animals are broken into geometric forms in a characteristic "distributive" way, and eventually blend into patterns that are purely abstract.

Among recognizable forms, split representations, puns and other visual tricks are exceedingly common. Things transform into each other, most dramatically in the transformation masks, in which a face opens to reveal another face within. Bodily features are typically rendered as faces or eyes, a dramatic visual highlighting for which John Rowe (1962) has revived the old English word "kenning." (As the existence of an old name suggests, kenning was popular in pre-state Celtic and Germanic art, another of the startling parallels between Northwest Coast and early Northwest European cultures.) Genitalia in particular are apt to be rendered as mouths if female, heads if male (at least so Duff believed). This kenning can elaborate into fantastic creations in which animals are made up of smaller animals that are in turn made up of animal elements. Often the split representation of one animal can also be seen as two animals facing each other, as in ancient Chinese and southeast Asian art.

Animals and humans usually display teeth, claws, sharp beaks or other weaponry. They may display wealth goods instead; humans may hold coppers instead of clubs. Open mouths, joined tongues, swallowing and devouring, and mutual biting form a sequence or syndrome. In general, there is a sense of destructive and militant power. However, it is controlled, and the art has also a classic dignity. There is a considerable variation in this regard from group to group. The Kwakiutl style is the most flamboyant, dramatic and vivid. The Salish is the most reserved, being a calm, often strictly geometric style with little (if any) of the biting and attacking theme visible.

These differences do not relate to any obvious differences in emotion or personality between the groups, but they most definitely do relate to the social construction of supernatural experience, as will appear.

Many critics have stressed the predatory, violent, ferocious quality of Northwest Coast art, but Duff stressed its control and smoothness.

For him, the Haida Raven was "Raven by Robert's Rules of Order." The art followed conventions and rules quite narrowly, in spite of a great deal of improvisation and individuality. It is characterized by smooth, tight, hard-edged lines and considerable technical mastery. Present-day Native people (at least those I have met) are apt to discuss these technical aspects more than the emotional power. They are apt to notice, even more, the explicit social messages about crests and ownership that are carried in the art.

Evaluating a piece or discussing their own creations, modern carvers talk about how well the style is followed, how much distinctiveness is accommodated within that style, and above all how perfectly the technical control is used. The ideal piece is a flowing unity, visually pleasing or striking. It is complex enough to be rich, but unified and elegantly simple enough to strike the eye, at first, as simply a good design. The elements that go into producing a rich yet striking design must be appreciated through finer inspection. William McLennan points out (pers. comm.) that the older masterpieces are never quite symmetrical. Variations of design elements, line thickness, and indeed all elements of the pattern lead to dynamic and exciting effects. Often the piece appears symmetrical to the casual observer, but with a tension and vibrancy lacking in truly symmetrical, static works. Modern pieces often strive for perfect symmetry, producing a flat, merely-decorative appearance that lacks the power of the old. One speculates that the early artists recognized that such effects, attended unconsciously by the viewers, made those viewers feel that the work had a real supernatural power in it.

4

Art and Religion

In understanding the art, one must remember that religion was not separable from everyday life. As in much of native North America (Hultkranz 1979), there was no such sharp division of "sacred" and "secular" as one finds in modern world religions. (That separation follows the rise of Church and State as actual polities, and especially the eighteenth-century rebellions against both.) Among modern communicants of the world religions, economic activity in particular is usually separated from religion and opposed to it as "greed" or at best "worldly" activity. Among ancient and folk religions generally, the opposite is true. The crux of the religion is precisely in the most "practical" actions.

On the Pacific Northwest, these included hunting, fish-catching, food preparation, economic exchange, healing the sick, and ensuring family continuation through reproduction. Much ink has been spilled over whether the potlatch is basically religious (e.g., Goldman 1975) or basically economic, ecological, and materialistic (Suttles 1960; Piddocke 1969). This opposition derives strictly from modern Judeo-Christian attitudes, and has no value for understanding the Pacific Northwest (as Goldman and Suttles, at least, are aware). To cite one surviving Christian institution: is the Sunday church dona-

tion of a devout Christian an economic or a religious act? The answer, of course, is that its religiosity is its economicity, and vice versa. It is a holy act precisely because it is a gift of value. Dropping a counterfeit bill in the collection plate would be not only useless, but sacrilegious.

The heraldic art was sacred; the beasts it portrayed were not just crest animals, as in European heraldic art—they were supernatural power-beings and divine relatives of earthly descent groups. (Some European heraldic art may have had a similar origin, of course, as when the sacred Celtic oak tree became the clan crest for the Andersons.)

The Northwest Coast peoples share with many other American Indians an opposition that looks superficially like a sacred/secular one, and has sometimes been so translated (e.g. Jonaitis 1986). This is the opposition between the nonordinary or wild world and the everyday human world. However, as Duff pointed out in his notes, both are sacred (see Marjorie Halpin's review of Jonaitis; Halpin 1988). Mythic time, mythic beings, the wilderness, ceremonies and shamanic activities define the former; everyday social activities the latter. The shaman presided over the former; the chief, whom Duff saw as having priestly functions, presided over the latter. Intense interaction between human society and the wild world frequently occurs, as when a hunter or fisherman takes a great or dangerous quarry such as a deer, bear, halibut or large salmon—particularly if the quarry is the first of the season. First salmon rites and, locally, other first-capture rites are general. Even more intense interaction takes place when young people seek visions or initiation. They go alone to the wilderness for spirit quests, or are taken to it and instructed as part of initiation into secret societies, shamanhood, or other nonordinary commitments. In a brilliant study, Jonaitis (1981) has shown that Tlingit halibut hooks were carved with thoroughly shamanic art, although they were utilitarian objects. She hypothesizes (citing Malinowski's classic work, 1948) that this is related to the danger and uncertainty of halibut fishing, and to the fact that it is carried out by a lone individual (usually) and on the wild sea. Thus our contrast is between the human community and the wild, not between nonshamanic and shamanic art, *per se*.

A closely related distinction is between ritual and nonritual. The

Kwakiutl summer season is *baxus*, the season of ordinary practical activities. Winter is *tsetseqa*, the season of "imitations," when great and awe-inspiring ritual dramas reproduce mythic times (see Goldman 1975). A chief during winter ceremonies was called not by the usual term for "chief," but by the term *paxala* (which also means "shaman") for the duration of his tenure as a master of ritual. The Tsimshian make a related distinction between chief as ordinary leader (*semoiget*) and as master of ritual (*wihalait*, "great dancer" or "holy one"). Here the chief's ritual title is derived from the word *halait*, which applies to the holy or shamanic ceremonies and their powerful gear (a shaman was a *swensk halait*, "blowing power-manifester," because of his use of sucking and blowing in curing; Halpin 1984:282-283). A chief, and other men of any standing, possessed at least one *naxnox:* "supernatural power or power-being." He would have acquired it by heredity or by personal visionary encounter. This power-being he would impersonate at formal dances; these masked *naxnox* dances were the only occasions on which Tsimshian people normally wore masks (Halpin 1973, 1981, 1984).

For the chiefs, the contrast of relatively secular summer with highly sacred winter was more relevant than it was for the shamans, who could be called to cure at any time.

The chief is the preeminently social person, not only leader of a social unit but also the paragon of etiquette, good manners and restraint in time of peace and the paragon of fierceness and violence in any conflict. This ideal was, by all accounts, closely approximated by real chiefs, and any chief who did not so act was in danger of losing his position. (In addition to the cited studies by Halpin, there are several particularly revealing studies of public order and of chiefs. Perhaps most notable are chiefly autobiographies, *Smoke from Their Fires* [Ford 1941] and *Guests Never Leave Hungry* [Spradley 1969]. See also Cove and McDonald 1987.)

The shaman, by contrast, was the paragon of wildness. Often, he self-consciously played a permanent role: dressing strangely, leaving his hair matted and filthy in societies that highly valued neat coiffure, outrageously demanding payment in societies where generosity and undemandingness were valued, spending days in the wilderness, and so forth (see Jonaitis 1986). This established clearly his

identification with the wild/mythic cosmos and his separation from the everyday social one. In western terms, it gave him the ability to call up and deal with the deep, inner, personal feelings of his patients; he seems to have been basically a psychotherapist who specialized in getting depressed, neurotic or otherwise mentally hurt people in touch with their autonomy, individuality and intense emotions and moods.

In societies as highly socialized as the Northwest, this was far more important than in the individualistic, autonomous modern world. The complementarity of chief and shaman were revealed by the fact that they were often close relatives (Oberg 1973). The best study of a Northwest Coast shaman is Jenness' record of the life of the Coast Salish shaman Old Pierre (Jenness 1952). Nothing comparable exists for the quite different shamanism of the northern groups, but excellent accounts can be found, particularly in de Laguna's monumental work on the Yakutat Bay Tlingit (de Laguna 1972) and in Barbeau's records of "medicine men" (Barbeau 1958).

Duff saw the chiefs as an emerging priesthood; this may be extreme for most groups, but he was thinking primarily of the Tsimshian, for whom it seems to have been particularly close to the truth. Their construction of the contrast of social-ritual-leader and shaman is described by Halpin (1984), John Pritchard (pers. comm.), etc.

These oppositions are self-consciously mediated in religious activity. Rituals reproduce mythic times and characters, but are highly social. They are intended to regulate, integrate and give order to the *entire* cosmos (wild and ordinary). Shamans deal with, often stay in, and are ultimately buried in the wilderness, but they are specifically charged with importing its power for the benefit of society. Chiefs are the epigones of society, but they must spend much time in the wild, training and purifying themselves (M. Halpin, pers. comm.), and getting their visions and powers.

These fundamentals are shared by all Northwest groups, though with considerable variation in detail. They are keys to understanding Northwest Coast thought. There is one idea even more fundamental: the concept of spiritual power or spiritual presence. All things without exception have some degree of spiritual nature. Most of them, especially those that are powerful in human eyes, have considerable spiritual effectiveness which can be harnessed and used by appropri-

ate people through appropriate rituals or disciplines. Some beings transmitted their power to mythic ancestors, becoming crests, the markers and power-givers of lineages and other social units. Others gave their power to secret societies, dancing groups and the like, to be invoked in rituals. Still others give their power to shamans, to use in healing and manipulating the present-day world. The Great Transformer, the "Bird of Paradox" in Duff's words, Raven Himself, does all three; otherwise, there is some specialization. Widely over the coast, bears, beavers, whales and eagles are crest animals, while river otters, octopi and other inedible and uncanny creatures are shamanic. The variation is too great, however, to permit much generalization here.

Northwest Coast religion and art are, to a great extent, a discourse about power. Power is manifested in actual ability to do work in the day-to-day world, but is grounded in spiritual and numinous qualities. Such forces were found mainly in the wild world. Humans who sought power (and most Native people did, at one time or another) retreated to the wilderness. There they got various forms or manifestations of it from the wild things: usually animals, but often plants, geographic features or "supernatural" beings.[1] (So they are called in the literature, but the people did not consider them as sharply distinguished from the natural as the English word implies. They had more power than, and were less often seen than, ducks and fish; but they were not super-natural, "above nature," they were part of the cosmic order.)

This belief in power was a rather distinctive manifestation of the complex of beliefs, universal in Native America, of the power quest and the spirit guardian (the best review of which, especially for situating the Northwest Coast in perspective, is still Benedict 1923). Concept of power varied from culture to culture. Some had one word, such as the Kwakwala term *nawalak*; others had several for different forms of power. The Haida word *sgaana* means "power," and also "killer whale"—the power animal par excellence (Boelscher 1988; Swanton 1909a). Some groups saw it as a spiritual universal, pervading all nature; others saw different powers in each class of beings. An individual who wanted to do anything, or get anything, needed to endure privations in wild places until some power-giver was moved by pity or similar emotion, and bestowed on

him some particular vocation. Most typically, this was healing. On the Northwest Coast, however, it was very often wealth. It might be the ability to carve; the Haida had a Master Carver who bestowed this (Swanton 1909a). It might be skill and luck in hunting, fishing or war. Among the Salish, it included even the ability to win eating contests (Collins 1974) or stay free from fleas (Elmendorf 1960).

To the social scientist, this may seem no more than a validation, in society's eyes, of the natural inclination of the visionary. To the people, it was an intensely involving emotional matter. To many, it still is, for the tradition is not dead (though I will use the past tense herein, recognizing that societies based on concepts of power are now much changed). Normally, an adolescent would retire to the wild for days or months, taking cold baths and living on a minimum of food and drink. Often other mortifications of the flesh took place. This built up endurance, made the whole event memorable, and (above all) produced a state of physical and mental stress in which visions occurred. Some individuals may have had little visionary experience. Those more richly endowed with mystical and meditative good fortune met tremendous ranges of experience.

Sensitive individuals had many experiences throughout their lifetime; such people were the ones whose power was most often effective in healing. Chiefs' heirs got visions of wealth; strong men might get power to hunt; women got power to gather roots or weave. The circumstances made such accomplishments more meaningful and important than they would have been if they had been mere matters of personal whim or economic need. Life had meaning—in the fullest sense of the term, as used by Frankl (1984) and others. One of the reasons for the collapse of so many Indian communities in modern times is the loss of the vision quest, while revival of spirit questing restores coherence (Jilek 1982). Nothing else has taken its place as meaning-giver and validator in the lives of many.

Wilson Duff felt the lack of it in his own life, and commented wryly on it: "The best cure for male menopause: a spirit quest at puberty (Abbott [ed.] 1981:314)." His notes reveal more anguish than the understated poem reveals. In summary:

1. Power is ability to transform or affect something.
2. Different kinds of power can, to at least some extent, be

transformed into each other. Physical force (power to do work), emotional force (power to affect someone emotionally), curative power (ability to heal or help) and supernatural or spiritual power are apparently sometimes equated.

3. Each species, each class, each individual has its particular power, allowing it to do what it characteristically does. Salmon can swim better than humans; devil's club can cure some diseases; mountain goats can leap among crags impassable to other beings; shamans can go into a trance and see sources of illness.

4. Humans can receive power (beyond what they are born with) from natural and supernatural entities. To do so, they must fast, go into the wilderness, and in general go alone and vulnerable into the realms of the creatures whose power they seek.

5. Almost anything worthwhile—becoming a good fisherman, becoming a curer, acting as a good chief—requires such power questing.

6. Transfer of power, and transformation of power, is thus basic to society.

7. It is shown and validated by the power-holder when he or she actually transforms something: cures the sick, carves a log into a canoe, becomes (or imitates) a spirit by ritual dancing, catches a whale.

Wilson Duff was totally uninvolved in any organized religion. His daughter Marnie Duff recalls growing up without any discussions of that, with little knowledge of any religion, and with no concept of evil and sin. Even the desacralized Christian values system common to most ex-Christian homes in North America was not stressed, though obviously present. Yet Duff was an intensely religious man, ultimately a mystic. His religion seems to have been close to Northwest Coast spirituality, and indeed he had danced in a guardian spirit while among the Salish.

Northwest Coast art, and the Eskimo-Aleut traditions that have been rather closely related to it for thousands of years, focus on this interpowering, this perceived validation of self through connection with the animal world and the cosmos in general. It is routinely and universally symbolized by transformation. Most often this is animal

into human, part-animal part-human, or human and animal mutually eating, striving or touching. Tongues—visual emblems of speech and song—may have symbolized power, or sexuality (Duff notes). Transforming materials into containers was also a symbolic matter (Duff notes; Halpin, pers. comm.). Eating was incorporation and also a statement about power. Vomiting and leaving a house could be equated (see text cited in Cove and MacDonald 1987). Defecating and excrement also had symbolic connections with transformation (Walens 1981).

In general, the whole act of eating, digesting and defecating became a metaphor for transformation and for the powers that drive it. The meanings of the whole process have been explored in detail for the Kwagyul by Walens (1981). Walens' book has attracted some controversy simply because the cosmology he portrays seems so farfetched, but in fact he stays fairly soberly within the ethnographically recorded data, and the book is considerably less speculative than such "materialist" analyses as Suttles (1960) or Piddocke (1969).

The Kwagyul are the most caught up in the metaphor of any Northwest group, or at least the best described in these terms, but the analysis can be applied with some adjustment to the others as well. Eating is not the only metaphor of transformation. Sexual congress, birth and death, and initiation can all equal each other.

Animal/human transitions may be implied in art by figures with attributes of both. Monsters are frequent: they are composites of the most dramatic attributes of two or more "real" creatures, and are also of exaggerated fearsomeness. Thus the *wasgo* (Haida) is a giant sea wolf with killerwhale-like fins, which eats whales. The thunderbird is like an eagle, and takes whales just as eagles take salmon. It also controls lightning and thunder. There is a finned sea-grizzly that also takes whales as real bears take salmon, and controls wealth. Monsters can be animated snags and the like. They are different from the rather amorphous supernatural beings, most of which were transformed into rocks, rivers and the like during the creation-time. Duff saw monsters as a sort of logical extension of the world, realizing possibilities for combination.

In art, the theme of transformation is found on perhaps the majority of decorated objects. Animals and humans transform into

each other. Each joint can be shown as a face or eye. Large areas are filled with faces. One animal's tail is the head of another. "Transformation masks" are those that have parts that can open and close, transforming the mask from one face or form to another. Parts can belong to several beings.

More generally, Northwest Coast art is intended to affect the viewer strongly. I am grateful to Marjorie Halpin for pointing out to me the relevance of Robert Plant Armstrong's book, *The Affecting Presence* (1971), to Northwest Coast art and Duff's views thereon. The goal of art is to affect the viewer—on the Northwest Coast, to affect the viewer very "powerfully" indeed. The artist is communicating about power (his own or his chiefly employer's); he is also communicating the power itself. To the extent that the artist can strike the viewer, power is literally transferred. There is a clear equation: affecting presence = supernatural power = social power. Emotional power is, to varying degrees, supernatural or spiritual; it can enable the viewer to accomplish great things, or it can merely impress him. (Note that the English language is no stranger to the general concept. A great work of art is described as "striking, authoritative, impressing, telling, powerful, majestic, magical," and so on. One may even recall that both "glamour" and "grammar" are cognate with Middle English *gramarye* "witchcraft.")

Thus an artist had to have supernatural power to create. Among the Haida, Master Carver was one of the greatest deities (Swanton 1909a). He gave power for making both utilitarian items like canoes and "purely" artistic items. A good canoe involved the same kind of power as a good mask or pole. The difference between power to fish and trade and power to validate social and political status was merely one of subspecies. In a sense there was no "fine art," and everything was useful; an artist might be seen as strictly a technician (see Stott 1975). But he was, in the felicitous phrase of Rothenberg (1968), a "technician of the sacred."

It is possible that all art was useful—showing, transferring or using power. Also, the better the work, the more power it controls. A soulcatcher that is a tour-de-force of artistic skill has more power (other things being equal) than a poorly made one. (Of course, other things are not always equal; the poor one may have proved its

effectiveness, or been owned by a long line of successful shamans, or the like.)

Art objects that show fusions of different classes of being thus may have cosmological significance. Writers, including Wilson Duff, have used the word "punning" for this process, but the English word is unsatisfactory. It connotes humor, and much of this art is sacred rather than silly—kenning rather than mere punning.

Northwest Coast origin myths, like those of the rest of western North America, are mainly about transformation. Usually they center around one great Transformer, either Raven or a being that is sometimes a Raven. He changes the world to its present state, fit for humans, by a long series of tricks. He steals fire and water and light, turns supernatural beings into geographic features and markers, creates lands, and generally makes things they way they are. Indeed, things were not so much "created" as "transformed," and the process does not stop.

Transformation is the change of X into Y; alternatively, "copresence" (M. Halpin, pers. comm.) may be intended in many kennings. This opened, for Duff, the still wider question of oppositions and their resolution. Northwest Coast art was heavily concerned with relationships—not static structures, but dynamic interplays. The Northwest Coast has been the happy hunting ground of Levi-Strauss (1982), his followers and his critics (e.g. Thomas, Kronenfeld and Kronenfeld 1976).

Certainly there are oppositions, mediations and ambiguities beyond counting. This, of course, mapped social reality; art served to mark what was important in the world. This involved such matters as the parallelisms between human and nonhuman oppositions.

For instance, spouse exchange between groups is often quite explicitly equated with oppositions in the natural world. Descent groups are named after animals and other beings that seem to be in complementarity. (However, many crests seem to have been selected with no thought of structural sets; Boelscher 1988.) The nature/culture opposition is abundantly discoverable, e.g. in the almost-congruent opposition of wild world and social world. The ambiguous nature of the dog reveals much about these (Amoss 1985; cf. Douglas 1971). Creatures that mediate several realms, such as the kingfisher which nests in the underworld (in a burrow), flies through the air and

dives into water, have great magical powers (cf. Gould 1973, Jonaitis 1986). Land otters, frogs and octopi are other realm-mediators of widespread significance. They are associated with shamanism.

Relatively more ordinary but also more ferocious and predatory beings are associated with social power: bears, eagles, wolves and the like. They become the crests of social groups. Often a crest will be an elaborated form or derivative of such an animal. The ineffable Raven is the only being that seems to be equally common as shamanic and social symbol among the northern groups. Frog, Raven's complement (at least to Duff), has both roles too. Raven is the shamanic transformer. He is also the mediator of land and sea and of social and wild worlds, since he eats foods from all of these. Significantly, he is the only being other than humans that is at home in all those realms. Bears, eagles and so on have their religious significance as well, but in art it has become secondary to their value as heraldic markers.

Over the millennia, many of these beings took on various forms and extensions. They became polysemous symbols. There are, for example, many forms and names of the Haida Raven. An ordinary raven on the beach is *xoya*. In the northern Haida realms, for some reason (probably religious) the Tlingit word *yel* came into use, and has now displaced the native word completely. As mythic transformer, he is *Nankilstlas*, "he whose voice is obeyed."

In the myths about his very early career, before he got to the state of transforming, he was *Nankilstlas-lingai*, "He who is going to be, He whose voice is obeyed" (Duff notes; Swanton 1909a, 1909b). Other mythic settings gave him other attributes, places, names. Naturally, he could be used in one form or another to symbolize a wide range of matters: social, religious, individual.

An artist would have dozens of animals, many of which had dozens of manifestations, to invoke. Each animal would have many meanings. The artist was free to add personal meanings. Thus complete decoding of a work of art would involve knowing not only the whole range of local symbolic meanings of, say, the flying frog, but also the fantasies, secret jokes, and family esoterica that only the artist knew. It follows that we can never fully decode any serious piece of Northwestern art. (This should not stop the attempt, any more than western critics' ignorance of the artists' "real" intention

stops them from speculating on the Mona Lisa's smile or Hamlet's madness.) In short, structures were real, but not rigid or static. Practice took over, both adding and subtracting, so that the structures were dynamic and never fixed. (See Boelscher 1988, but she may possibly over-argue the point, almost denying the existence of structure; whatever may be true of the social order, the art was highly structured, though individual artists added their own interpretations and agendas.) Duff saw the art as far more dynamic and individually-transformed than Levi-Strauss seems to have done; for Duff, individuals used the style not only to represent logical schemas but to express their own insights and powerful feelings. This he thought was especially true of the masterworks. As a great Renaissance Italian religious painting is more than a mere reproduction of an icon, so the masterpieces of Northwest Coast art went beyond static structure and into the dynamics of human and human-nonhuman relationships.

Some animals become especially rich symbols. Duff's keys were the raven and the frog. They are crest animals, emblems of whole groups; they are important in myth; yet they are also terrifying creatures of the dark world. Duff held that if we understand their role in the art, we will understand much or most of what the Haida and their neighbors had to say about the world. He saw the raven in particular as the master; Raven (or Raven/Frog) held the "$e=mc^2$," as he saw it, of the Northwest Coast concept of power. In Duff's Freudian-influenced view, the outrageously phallic, greedy raven was in structural opposition to the apparently sexless frog, which seems little more than a wandering mouth (cf. Walens 1981).

Throughout the north, cautionary myths were told of villages destroyed by the frogs because thoughtless children killed one of that race. The frog in question is the wood frog, *Rana sylvatica*, which ranges north to Alaska (Stebbins 1966). Certain published sources that claim the absence of frogs in the area are incorrect. The animals are often extremely abundant. They do not occur on the immediate coast and islands. The western toad, *Bufo boreas*, does, but is rarely if ever portrayed; the images are unmistakably true frogs. This means that the Haida had to have been copying mainland models, for the frogs now so common on the Queen Charlotte Islands are not native, having been introduced for insect control in the early twenti-

eth century. To the Haida, frogs were strange and not very familiar creatures.

Finally, transformation comes to be a symbol for the way sin and the way it has many symbols packed into one icon. The artist is a powerful transformer, with spirit-vision power or the supernatural help of Master Carver. He (or, more rarely, she) transforms cedar into art, symbol into form, many symbols into one image.

Wilson Duff's speculations take off from this basis. He became first interested, and later obsessed, with the social and personal meanings that artists packed into their works. Learning that many recent artists worked a good deal of their cosmology and philosophy into their work, he assumed that the great artists of old must have done much more. They would have packed their entire philosophical world into their work. He took it as his calling—in the full religious sense of that word—to find and interpret those meanings. In the process he used first the standard techniques of scholarship, then the original and highly debatable methods of Levi-Strauss and the structuralists, and finally his own poetic and mystical inspiration. This last took on great significance as he discovered Jungian psychology.

He learned that one can rely on one's unconscious for intuition about symbols. Jung thought that the human mind has certain built-in paths of thought (archetypes) that typically and naturally are expressed in certain symbols. Thus it is natural to assume that we all carry in our heads an archetypal mother, and symbolize her by paintings of a mother and child or even of a feminized Earth. Duff was intrigued with the Jungian theory that we are prone to symbolize Self as a stone. He highlighted this in his copy of *Man and His Symbols* (Jung [ed.] 1964) while he was working on the catalogue *Images: Stone: B.C.* (1975).

Jungian thought gave Duff a way to overcome the secrecy and sheer loss of knowledge that blocks our way into classic Northwest art. He used dreams, dreamlike "hypnogogic" states, and meditation to access his unconscious, with its store of symbols and of intuitive insight into others' symbolization. If one accepts Jung's premises, this is a straightforward and scientific way to work. Contrary to the allegations of certain critics, Duff was not merely speculating or fantasizing. He was following a widely used and theoretically well-grounded method of research. However, the Jungian method is

somewhat more than that. As seen in the major work of Jung's that Duff used—*Symbols of Transformation* (Jung 1956)—Jung checked his insights against a vast store of data. He accepted the particular symbolic significance of an image in a patient's dream *if* it fit with the significance of that image in classical mythology, Christian usage (especially medieval and Renaissance), folklore and folk usage, and—when possible—etymology.

Jung felt that the evolution of many Indo-European words into modern derivatives closely paralleled the "logic" of dreams. He also checked them against knowledge of the thought-patterns of other patients and persons in disturbed or altered states of mind. These things Duff did not fully do. He checked his intuitions back against a rather limited corpus of myth, and against what he knew of Northwest Coast society and of art in general. Thus his intuitions do appear more speculative and less grounded than the true Jungian method, or any method, would canonically allow. This does not vitiate them; it merely puts the burden of further proof on us who find value in them.

His intent was to use all possible lines of insight to tease out the full range of possible meanings in the art. Duff seems to have worked from an assumption that anything really widespread or basic in world philosophy would be in Northwest philosophy too, and that his job was to find it. The extreme polysemy and use of kenning in the art lent credence to this belief. Duff used what power he had to find the ways that individual artists dealt with this in individual works.

Shamanic power, too, was communicated by art, but this art was often terrifying and was connected with weird matters and with the dead. Shamanic art of the Northern style shows beasts such as river otters, octopi and kingfishers, not shown in the great public art (Jonaitis 1986). (At least among the Tlingit and Haida this was so. The Tsimshian groups would occasionally show otters, as in the spectacular totem pole, featuring a river otter, that guards the entrance to the Musee de l'Homme in Paris.) Art relating to healing and medicine is typically anomalous, converging on the shamanic, since shamans were healers.

Among the Kwakiutl peoples, secret societies took over most of the roles and functions of individual vision-questing initiates, and this seems to me a plausible explanation for the relatively dramatic, weird, dazzling quality of Kwakiutl public art and the lack of a

shamanic tradition as separate and sharply demarcated from other ritual as that which existed among, say, the Tlingit. The Kwakiutlan descent system, which guarantees a considerable amount of jockeying for power, is also related to the complexity of art and ceremony (see the excellent account in Levi-Strauss 1982). Among the Salish, visionary healing functions were identified with families more than with individuals. Healing visions and their powers were passed lineally, or at least members of the lineage were expected to acquire the appropriate spirit power when they had their vision quests. Secret words of power might also be inherited.

The most vivid and dramatic art of the British Columbia Coast Salishan peoples was connected with these family mysteries (see Levi-Strauss 1982 for a particularly fine discussion, but also Holm and Reid 1975; Kew 1980; Kew and Kew 1981; Suttles 1983). Salish individual visions were secret and not normally represented in art, though artists often alluded cryptically to their vision powers in small ways. In general, neither this nor chiefly power were great drives to creativity in the south. Moreover, the early decline of the southern nations guaranteed that the art—made almost entirely of perishable materials, as elsewhere on the coast—did not survive. A few archeological items and early collections show that it was once rich and complex, but we know rather little of this earlier glory. Further study will hopefully reveal much more about it.

5

Assessing the Art

The whole Northwest Coast, except perhaps the almost un-
known peoples of Oregon, produced so much good art that the
sheer quantity and quality demands consideration in worldwide
perspective.

The Coast nations ranged from small chiefdoms to highly ranked
village-level societies. They were characterized by a rather high
level of warfare, and not just revenge raiding; there was active
conquest, domination and economic appropriation of wealth and
slaves. Philip Drucker, who knew war well from active service in
WWII, reviewed the matter in *To Make My Name Good* (Drucker
and Heizer 1967). Duff himself had occasion to study such matters;
he and others, for instance, established that the Tsisha'at Nuu-chah-
nulth had expanded against the Salishan peoples of the Port Alberni
area, conquering and absorbing them. The Opitchesha'at people
today are to some extent Nuu-chah-nulthized Salish by descent
(Duff, unpublished notes).

This change shows up rather strikingly in the archeological
record (MacMillan and St. Claire 1982). The Haida replacement of
Tlingit in the southwest Alaska Archipelago, just before white con-
tact, was another relevant case—one from which we have many
colorful and circumstantial war stories (Swanton 1909a).

The logic of the system is simple, given these two conditions. A chief must attract enough followers to give him an advantage in the strife—at least enough to protect himself and his village. To do this, he must be generous, he must have a reasonable claim to hereditary title, he must have a reasonable claim to supernatural power (usually over and above that inherited with the titles), and he must be a good leader, administrator, warrior and politician. Naturally, it was a tall order to combine all this in one man (or, rarely, woman), but there were those who managed it. The more he could be seen as good (generous, particularly) to his friends, and terrifying to his enemies, the better his chances. (For particularly good accounts of this in practice, see Drucker 1955 and the second volume of Cove and MacDonald 1987.)

Particularly critical was attracting people with special skills—typically thought of as supernaturally given in vision quests. Among these skills was carving. A master carver who could make a faster, more seaworthy war canoe than others' was obviously a very good man to have in the village. Thus chiefs, carvers, shamans and anyone with power would naturally do all they could to display it. Great art not only displayed the power, it also validated, expressed, and even communicated it. Recall that it communicated the power directly; it did not merely talk about it. The power is felt (several Northwest Coast Native people have described this sensation to me).

Contemporary Northwest Coast Native people make a clear distinction between mere aesthetic or awe-struck responses and the actual experience of power. Outside observers may see the second as only a stronger form of the first, but Native individuals I have questioned maintain that there is something beyond aesthetics, something quite tangibly different, in certain works of art.

Even a relative skeptic (and there were presumably some in the old days) would have seen the poles, chests and housefronts of a great chief as proof that he or she could command wealth and skill. Labor, both in quantity and quality, had to be available to produce these goods. Potlatches in which wealth goods were given away or destroyed showed that labor was available in such lavish quantities that it could safely be thrown away. Drucker and Heizer (1967) remind us that this could be a serious matter. A chief had to reward his followers, or at least show them his importance. If he disposed of

all his wealth potlatching, his followers were apt to desert, leaving him highly vulnerable. This was "fighting with property" in a far more immediate and compelling sense than Helen Codere (1950) realized. A chief who could dispose of wealth and stay rich was obviously a man of consequence. Thus, chiefs did all they could to attract artists and stockpile vast amounts of art goods along with other wealth.

Accounts of the Haida suggest an unstable, competitive society in which small-scale units (villages and small village groups, or even subsets of one village community) strove against each other (Swanton 1909a; Duff notes). Other groups had broadly similar organization, but with a range from relatively more sizable and stable groups to the small groups of some Athabaskan peoples. Art was the chief(ly) political discourse. If ever there was a discourse on power, in Foucault's sense, this was it.

Strikingly, literature on the Northwest Coast peoples rarely stresses the importance of conflict—especially armed conflict—in their lives, and its vital importance in determining such key institutions as art and the potlatch, which expressed power and might and also served often to relieve tension or substitute for fighting (Codere's famous quote about "fighting with property" inevitably comes to mind; Codere 1950). Only Drucker and Heizer (1967) have fully joined with this issue.

Yet even the most cursory reading of the great collections of texts by Swanton, Beynon, de Laguna, Boas and others will amply show the social, economic and psychological importance of raid and war as well as of competition in trade and potlatching. Even though war seems to have been no more frequent than in our own society— that is, about once a generation for a given polity—it colored all that was done in the intervening years.

Chiefs had to maintain their strength and their defenses. The Kwagyul were not "paranoid," as Benedict (1934) thought; they were genuinely at risk! Part of the neglect of war is due, one suspects, to a commendable desire among early anthropologists to escape the "malevolent savages" legend so enthusiastically propagated by early-day whites. In fact, war was not constant or even necessarily frequent. It was the threat of war, and of lesser feuds, that was everpresent.

In so far as this is true, one would expect to find complex, brilliant and sophisticated art in other chiefdoms (or the like) characterized by frequent war, by entailed generosity (merit feasts and the like), by settled villages with considerable economic resources, and by a need to stockpile skilled craftspersons for strategic reasons. Such patterns are well described for Bronze and Iron Age north Europe, for up-country Southeast Asia, for the "Kafirs" of Afghanistan, for the early steppe peoples of central Asia, and for the Maya—to name but a few. The best comparative study available focuses on comparing the Northwest Coast and the Maori (Rubel and Rosman 1971; cf. Rosman and Rubel 1971; art is not specifically dealt with here, but the Maori were significantly artistic).

Civilizations characterized by small warring units, such as West Africa and south India in historic times, show interesting parallels. Particularly interesting is the tendency for many of these traditions, such as those of ancient Europe and Siberia, to concentrate heavily on animals biting and attacking each other. There is little doubt that the Siberian styles are directly related to those of the Northwest Coast, and of Europe too, but we do not deal here with simple "diffusion." There had to be some reason why such art was found among chiefdoms but not among socially simpler people next door. All this is not to deny the very real and independent aesthetic sense of the peoples involved. Art was not just a reflex of society; it was consciously designed to be beautiful, wonderful, striking, pleasing and impressive. But it served social functions, and these account for the sheer volume of the stuff and its social prominence.

Anomalous and uncanny animals associated with shamanism and witchcraft appear in shamanic art, just as the spectacular predators become "natural symbols" (Douglas 1970) for chiefs and lineages. Few human food animals are portrayed—no deer or elk, few salmon. The beasts in the art are those that kill and devour, as humans do, such natural prey. We move among eagles, wolves, bears, killer whales and the giant whale-eating thunderbird. Devouring, and thus mouths, teeth and tongues, form a complex that is a commanding master metaphor for power over someone or something, or control in general, or initiation, or incorporation, or even power transfer (Walens 1981). If Duff is correct about the sexual

nature of much Northwest Coast art, there may be a connection with marriages and the politics of lineage affiliation.

In short, Northwest Coast art was primarily a discourse on supernatural power, and especially on the display of that power to validate status. Logically, then, it follows that art should be most spectacularly displayed when status is changed, especially in an upward direction. The greatest displays of dancing, masks, headdresses and other goods, the great raisings of poles, the great distributions of art goods and other wealth, took place when someone took a new title ("new name").

Most particularly, they took place at life-crisis rites: birth, puberty, marriage and death. At such times, chiefs would take new titles. At puberty, for instance, both the pubescent individual and his or her father and immediate relatives might all take new titles. Carrying the logic further, it follows that funeral or commemorative potlatches should tend to be the most spectacular, since these were the times when a title was formally adopted by a successor. In the Northern coast, these commemorative festivals were the principal occasions for potlatches. By contrast, the Kwakiutl groups potlatched on somewhat more occasions, but each time someone had to assume a new title.

* * *

This brings us to the question of western influence on the art. The terrible reduction in population of the Kwakiutlans led to a vast number of titles being distributed among a relatively small number of people. At the same time, wealth grew because of trade with and work for the Whites and because of new fishing opportunities, and, of course, because there were so many fewer people to divide the bounty. Thus potlatching went into a positive feedback loop in the late nineteenth century (Codere 1950; Drucker and Heizer 1967), providing a great stimulus for artistic production.

Another stimulus was direct production for White markets. From the first the Russian, Anglo, Spanish, French and other traders and settlers on the coast were intrigued with the art. By the early nineteenth century it was becoming well known, and by the late nineteenth it was already world-renowned. Museums from St. Pe-

tersburg to Berlin to New York bid against each other for the finest pieces, resorting to every trick to get the finest pieces (Fitzhugh and Crowell 1988; Jonaitis 1988; Kaplan and Barnes 1986).

The Salishans had been too traumatized to rally in art until later, but the others—especially the Northern groups and the Kwagyul proper with their immediate neighbors—profited. Most successful of all, perhaps, were the Haida.

They had a number of advantages, not least of which was the deposit of black argillite on Slatechuck Creek near Queen Charlotte City, which provided them with a soft, beautiful material for carving. It was little used (if it was used at all) in precontact times, but by the 1830s it was being turned into carvings for the tourist trade (see Barbeau 1957, Drew and Wilson 1980, MacNair and Hoover 1984, Sheehan 1981). The Haida produced some items for their own use, but argillite has always been an art for sale. This is only the most obvious of a long list of materials made for the outside world.

Long before the whites came, the coast peoples were trading fine manufactures to each other and to the interior; the whites provided a vastly expanded market.

Currently, revitalization of Native cultures and development of more sophisticated non-Native markets have combined to produce a renaissance of Northwest Coast art. Demand within the communities continues, also. Many new forms have been created, ranging from silver and gold jewelry (which began to be made as soon as the very first ships brought precious metals to the coast in the eighteenth century) to the much newer silkscreen prints (see e.g. Hall et al. 1981; MacNair et al. 1984; Shadbolt 1986).

In the early twentieth century, the art declined rapidly in quantity (and—many would say—in quality in many cases), but it has revived since the 1950s. Wilson Duff had a great deal to do with this (Abbott (ed.) 1981). Today, Native people create as a way to show Indianness, to validate their status as Indians, and to make political statements about that status. They also, of course, earn money by sales, and they can fulfill social obligations at potlatches and other occasions. (Significantly, their Anglo neighbors rarely create, finding it an uncongenial way to make a living—too much work for too little reward, and work that is often considered unmanly or un-Anglo at

that; pers. obs. and field data.) Thus the art still serves political and economic power, and still actively creates that power.

* * *

One final, critically important basic fact about the social place of art needs to be remembered at all times. This art was not seen, conceived or treated as a set of detached objects. Today, it is mostly consigned to museum display cases or to household or park equivalents thereof. Objects are seen as curious, isolated objects. This is absolutely not the way it was regarded by its makers and original users. For them, it was a living, vibrant, integral part of ritual and ceremony and of daily life. Wealth goods were and are often kept in chests between performances; or masks may rarely be hung on the wall for display, but only between the great rites in which they were and are worn by brilliantly costumed dancers who integrated them with dance and song into a total performance.

The work of art was the full ceremony; that is, the ceremony itself was a single work. The dances, songs, masks, costumes, myths and tales, public speeches and the ideology that validated them added up to create a unified whole. A mask or Chilkat blanket is a "work of art" in the same way that a detached hand or a skeleton is a full human being. This may sound extreme to the naive, but anyone who has attended a Northwest Coast ceremony will know exactly what I mean. Even the permanent display art, the totem poles and housefronts, were first erected at the climaxes of tremendous ceremonies. Thereafter, they participated in everyday life: welcoming guests, watching over the birth and growth of children, serving as centers for further ceremonies. Boxes that we now see as isolated museum pieces held treasured wealth goods and reposed in places of honor about the house. The whole interior of the house, in fact, was a work of art itself—not only arranged beautifully, but designed and planned according to cosmological and myth-validated guidelines.

At Duff's old home, the Royal British Columbia Museum, one can enter a Kwakwaka'wakw house that was left by Chief Jonathan Hunt to the museum, and see something of the old glory; and one can watch an ever-more-frayed copy of dance sequences from Edward Curtis' film, *In the Land of War Canoes....* running over and over.

Some shred of the old world comes back. Meanwhile, modern ceremonies are routinely videotaped by the Native people themselves, as a record of social activities, or sometimes for museum record.

Finally, one other key point about this aspect of the art emerges from visits to Native artists' homes and workshops. In these, art is always in progress. People are almost constantly working on things—carving, polishing, sketching, trying out, planning dances to show off the work. The smell of cedar shavings is as characteristic as the smells of broiling salmon or ooligan oil. People still work the old way: as irresistible creative spirit moves them. A man will try a few tentative cuts, move off despondently for coffee, pace around the room, give up, go out and socialize; in a few hours he will drift back in with only the barest hint of new-found purpose, and work with steady, one-pointed concentration for hour after hour after hour; then perhaps drop the piece entirely for a week, work on something else, go visit a neighbor, anything; then return and start the cycle again.

Anyone familiar with the way creative artists work will not be surprised, but local Anglos (children of the eight-hour day and the forty-hour week) can never quite get used to it. The village, in the old days, was one great studio. Things were in process all the time. There is still an air of proud hope about a Northwest Coast workshop—a sense that far more than cedar-carving is going on. Humanity is recreating itself in the conscious light of supernatural powers and in the great social networks of eagles and ravens, bears and mountains, whales and winds. Nowhere is the "social construction of reality" (Berger and Luckmann 1966) more literally a construction process.

Northwest Coast art can be compared with Elizabethan drama, Yazoo Delta blues in the early twentieth century, and T'ang Chinese court poetry: a relatively small group of people created a great deal, in a particular medium. Why do some times and places stimulate the creation of great art on a truly incredible scale? The first approximation to an answer is that in these societies art is life—or, at least, a privileged mode of discourse for communicating one's deepest and most complex feelings. This statement merely raises a host of more difficult questions, but, for the present, we can do no more:

"But we, who now behold these present days,
Have eyes to wonder, but lack tongues to praise."

6

Wilson Duff's Theories of Northwest Coast Art

It is still necessary to justify *any* search for meaning in North-west Coast art. The position is widely held, and not only by artistic philistines, that the Native people made their art for fun, to kill time or "for art's sake." One hears the line: "They had nothing else to do in the long winters." Among more serious students, many of the greatest scholars of the tradition, from Franz Boas to Bill Holm, have been formalists—interested in the styles more than in the meanings communicated.

Duff's studies (among others) dispel the belief that it could have been mere decoration. It is about crests, mythic figures and magical power-creatures. Most often, it is about the great figures of the most important myths: Raven, Bear-Mother, the wealth-bringing monster, and so on. A modern, Christian Native who knows only one or two words of his or her language may evoke these forms out of pure decoration, but a traditional artist could not. He (most artists were male, especially those who carved the great crest art) would have been literally psychologically incapable of carving a raven solely for decoration, just as a devout Catholic would be incapable of carving a crucifix without thinking of its religious import, or as a Buddhist

sculptor would be unable to produce a Buddha-image without making religious associations. A vast and rich web of powerful association, strengthened literally every day of the artist's life, would automatically come to mind, in the Northwest as in most societies. There is also no serious doubt that art was, as Duff held, made to display tribal philosophy. (Only the most extreme racist would regard the deep, complex and subtle worldview-systems of Native America as mere "primitive cosmology" rather than philosophy.) The art was talking about the worldview; it was also revealing that worldview and expressing personal truths grounded therein.

Duff felt that a great artist such as Albert Edenshaw or his nephew Charles Edenshaw would most certainly have packed a great deal more than, say, fishing magic into the art. Again, cross-cultural comparison suggests that artists in similar cultures put not only their people's lore, but also their own speculations and syntheses of it, into their work. Moreover, of course, an artist is revealing his own immediate interpretation of the lore and of the proper ways to portray it. Duff was aware of Reichel-Dolmatoff's work on the Desana (Reichel-Dolmatoff 1966), which documents this. He was possibly aware also of the work of the Griaule group on the Dogon (Griaule l965), or Cushing on the Zuni, among others.

In any tradition, there will be such distinctions between exoteric and esoteric knowledge. There will also be unique individuals, like Ogotemmeli among the Dogon, who go beyond the standard lore to create their own syntheses and extensions of tradition, and are true philosophers. There seems little doubt that Charles Edenshaw, at least, was indeed of this type. His major works are often strange and unique. Consider the plate that holds Haida version of Rodin's *The Thinker* sitting off-center on a carved whale. The figure is riding in a ridiculous canoe (the plate), and yet on a whale. He is also Raven in a "fisherman" episode from Haida myth. Duff had a wonderful time thinking about him. Certainly Edenshaw, who was well taught in Western culture and could quote Shakespeare as well as Haida myth, did not invoke this image lightly. (Duff discovered a contemporary account of one of Edenshaw's relatives using quotes from Shakespeare in a wedding oration.)

Whether or not we can ever understand the philosophy behind Haida art, it is there, informing the works. They were made to

communicate—to present a rich, complex, sophisticated, elaborate worldview—just as were the better-known artistic creations of the Navaho, Zuni, Huichol, Desana and other Native Americans.

Wilson Duff never published his full theory, but it emerges clearly in his notes and writings. Much of it was made explicit in 1975. Some of it was summarized in a series of typewritten "notes to my self" in August of that year. More appeared in *Images: Stone: BC*. His 1976 paper gives a brief overview (Duff 1981, 1983). A more systematic account may be extracted, and this I attempt to do in what follows.

For Duff, the basic question was the meaning of the art. He felt that Bill Holm had captured certain laws of form and shape, and he tended to leave to the early ethnographers their speculations on the literal, iconographic content of the art. What he sought was insight into the deeper meanings, both conscious and subconscious, for which the literal content and the abstract form were the metaphors. Thus he wrote in *Images: Stone: BC*: "I had been engaged with my students in the discovery of a level of meaning of which we formerly had only hints. It is not something that invalidates previous understandings of its meanings: that it had stylized ways of representing animal forms, and that these served the purpose of family crests and referred back to myths. It is just that a great deal more seems to be going on than that. The additional level of meaning is a system of inner logic which resides in the style and in the internal structure of individual works of art. It is as though each is an equation wrapped as a single bundle. It constructs its statements upon the interplay between its parts, and between the literal and metaphoric meanings of its images.... (Duff 1975:13-14)." He pointed out that stone is a difficult material to work, and if the Native peoples had meant only to play with form, they would surely not have expended so much effort. Stone sculpture, everywhere, tends to be a way of preserving discourse on basic human truths.

"Meaning" is a slippery word. In modern social science, it denotes everything from total personal involvement with something (what Victor Frankl means in *Man's Search for Meaning* [1984]) to the cold, rationalistic computer-concepts of artificial-intelligence theory. Recent anthropological enquiry has dealt with "meaning" at great length, but without defining the word. Duff also begged that

question. As I understand him, he defined "meaning" quite broadly, to include every message—conscious and subconscious—that artists put into their works. He was aware that the viewer could read still other messages into the work, but he usually disregarded this; since he was interested in the Haida and their culture (not in modern Anglo responses to it), his concern was with the messages actually sent (in some sense) by the artists or their employers. He was, necessarily, concerned with at least one Anglo viewer: himself.

* * *

He stated his final theories of art, in summary form, in the paper he read in 1976 (Duff 1981, 1983). In this paper, he stayed as conservative as possible; even so, the paper was too radical for some in the audience.

He began by making Erwin Panofsky's distinction—or Duff's version of it—between iconic and iconographic levels of signification in art. To Duff, this meant a distinction between the representation itself and the symbolism thereof; between the bear and its function as a clan crest, between the otter and its status as a power animal. Naturally, most of the interest in art usually attaches to the iconographic meanings, but earlier ethnographic research on Northwest Coast art focused more on the iconic. Yet informants often disagreed about that, leading Duff to believe that they did not particularly care. Whether an abstract design was "bear" or "whale" was less interesting that what it showed about balance or distribution or social plan. Moreover, a masterpiece would be more than a picture of a whale.

Thus, he said of Northwest Coast art in general: "it is my hypothesis that further agendas were also at work in it, such that it was coming to express more powerful symbols and therefore deeper and more general meanings. In addition, it was becoming an autonomous, non-verbal medium for thinking in images (Duff 1983:47)." The simpler explanations, including sheer aesthetic effect, were "not sufficient for two reasons. One is that they don't seem to allow us to tie this great art style in with any of the general theories of art in the world.... Furthermore the explanations that we currently have don't

seem to do justice to what we feel are the masterpieces of Northwest Coast art (Duff 1983:49)."

Duff had to invoke certain specialized concepts of his own, to describe the art. One was the armature. "Armatures are the structural relationships between symbols. They are the ways of making visual equations. They are the predicates of statements in which symbols are the subjects (Duff 1983:48)." Most simply, this referred to certain set, formal structural units in Northwest Coast art: well-established binary pairings, trinities, particular kennings, reciprocal relationships. But Duff felt strongly that there were far more complex concepts of predication behind this—that symbols were not only being combined for purely aesthetic or conventional reasons, but also were invoked to create or imply whole statements that were self-referential, mythic and ultimately deeply philosophic. Armatures were the formal visual conventions that expressed these.

Another was the paradigm. In Duff's terms, as relating to art, paradigms were "the forms in which specific problems get worked out in the art. Each paradigm is related to an artefac type (e.g., spoon paradigms, house-post paradigms) (Duff 1983:48)."

In Northwest Coast art, horn spoons are always of a certain characteristic shape and have a canonical decoration format. This combination comprises the paradigm, which could have its own meaning, and then have further significations attached by the various ways artists worked with it. One wonders if subparadigms are implied; for instance, the mask paradigm is a very broad category. The twin stone masks, so important in *Images: Stone: BC*, were to Duff the supreme exemplars of the mask paradigm. Levi-Strauss (1981) saw them as dance masks and as intertribal "conversations" (M. Halpin, pers. comm.), but Duff saw in them great statements of philosophy and of the nature of humanity, seeing, and power. Since we know that blocked vision was an exceedingly important theme in Eskimo as in Northwest Coast art (see e.g. Fitzhugh and Crowell 1988), Duff is more likely right in this case. But were these masks also a kind of summing up of the mask paradigm? Surely Duff would have seen Salish Sxwaixwe masks or Kwakiutl transformation masks as very different indeed, probably representing other subparadigms.

Duff had his own working definition of the Northwest Coast

image: "a system with content and structure which is presumably subject to a structural analysis (Duff 1983:51)." It is, therefore, the basic iconographic unit: a representation of an animal, thing, complex intertwined set of animals, animal with kennings or the like—a representation that obviously has, and is intended to have, a unity within the larger work of art. Images are often hard to define; where do they begin and end on a complex work like a totem pole? Usually, however, a work of art has one representation or is divided (as most totem poles are) into separate units that feature one major animal or spirit and perhaps some associated creatures. These units appear to be single images, and are ethnographically known to be so in most cases. Thus in the Northwest Coast the image, as a unit, is clearly real and separable most of the time. When it is not, there is reason to suspect deliberate merging and fusing of icons or images. An image, however defined, and even if it is incomprehensible to us, "it has content, it has arrangement, it has structure and should therefore be subject to a structural analysis (Duff 1983:51)." Images and the ambiguities therein were themselves complex messages: "Images are seeming contradictions. Images hold ideas apart so that they can be seen held together. 'Imaging' is reflecting. 'Imaging' is relating. 'Imaging' is recognizing. 'Imaging' is 'meaning.' Images *are* meanings, which come out in the thinking (Duff 1975:16)."

One important type of image or stylistic device he called the "double twist." This was, focally, a visual device in which "part becomes whole, literal becomes metaphoric" (Duff notes, ca. Sept. 1975). Usually these are images that Duff identified as Freudian symbols; an animal or structure is a symbol for a sexual organ, which is itself symbolic or a part/whole trope. An example (in the notes) is a club that is both phallic and a man without a phallus (his phallus is the club).

In practice, Duff spent most of his time studying particular pieces, seeing them as particular instantiations of armature and paradigm; or he studied the total significance of raven, bear and other mythic figures in art, myth and thought. After all, the artists worked this way: applying a particular theme to a particular object. Yet, as Duff pointed out, often the theme is not really discoverable.

The most important example of this, in Duff's world, was a box from the collections of the American Museum of Natural History.

This box is painted in the "flat style" of the northern Northwest Coast, and is generally considered to be one of the greatest masterpieces in that style. Boas figured and discussed it in his book *Primitive Art* (1927); Bill Reid sought it out for the *Arts of the Raven* exhibit that he, Duff and Holm organized in Vancouver in 1967 (Duff, Holm, and Reid 1967; Reid 1981).

The box has since been exhibited and figured again (Wardwell 1978:100; this is the best published picture of it). It has sunk back into obscurity, packed in cellophane in the museum (Reid 1981). It is of obscure origin and theme; the design elements are so abstracted and complexly combined for visual effect that no one has worked out its precise meaning. Charles Edenshaw saw it as "four interpretations of the raven as culture-hero (Boas 1927:275-276)." Boas saw this as "entirely fanciful (Boas 1927:275)" and commented that "...a safe interpretation is impossible.

"It seems plausible that in this case also the attempt at decoration was much more important than the attempt at interpretation (Boas 1927:275)." Duff, who thought the box was painted by Charles' uncle Albert Edward Edenshaw, of course followed Charles' interpretation. However, the box was collected by George Emmons from Tlingit who disclaimed any role in painting it but said that it seemed to represent the seal—which, indeed, the first and third sides do appear to portray. But representation is clearly sacrificed here to a higher agenda. In fact, the design is so abstract that the artist may well have been saying something about balance, tension and visual excitement, rather than "talking about" a particular creature. Did this balance and style mirror the proper conduct of a Haida man in society, or the cosmic order? Or was it all of the above?

Similarly, the individual images on a totem pole or a house front become emblems of a coherent story, the record of the house that the totem pole marks. Here, at least, we are on safe ground, for the Native peoples could and did read their totem poles and tell the stories to visitors. Sometimes a pole told a particular story; more often it portrayed a variety of crests with associated stories. "House" had the same double meaning on the Coast that it did in medieval Europe; it was both a dwelling and a defined, emblem-marked descent group (see Levi-Strauss 1982). Art recorded the house's history. However, it did more. To some extent at least, it recorded the

emotions, aspirations and philosophies of the people within. Here ethnography fails us, and Duff felt the challenge to go on, to try to understand how and what art communicated in these realms.

* * *

Wilson Duff's own "hidden agenda" was, first of all, a desire to understand and respect the "Indian" heritage. His work of protecting totem poles, his strong advocacy of "Indian" rights, his support of carvers and artists was the active part of a life spent in trying to understand and to establish Native art as a part of the worldwide human legacy. The driving dynamic behind his desire to understand Native art in terms of panhuman theories and approaches is a desire to have the Indians seen as fully human, with human feelings and abilities, and with a genius all their own to add to the world summation of works of the human spirit.

Duff also felt a strong loyalty to Canada. He served in World War II, and his notes speak frequently of a sense of obligation to the nation and province, especially since they were paying his salary. This heavy sense of responsibility was linked to his perfectionism, and thus—ironically—to his difficulties in writing. But it also led him to do his utmost to make a real contribution as museum curator and later as professor to recompense the people who had supported him.

Finally, a very important feature of Duff's thought links artistic creation, cosmological organization and personal coping. Duff saw artists as working out their personal problems, questions and contradictions through art. Not only did art communicate cosmology, social structure and emotional experience; the process of creating it actually allowed artists to deal with, work through, and resolve their personal tensions and problems. As a good anthropologist, Duff saw these personal questions as socially constructed. The artists had to deal with the contradictions their society provided for them, such as the potential conflict of loyalties in a matrilineal society between father and mother's brother. Feelings about panhuman concerns— life and death; sex and marriage; birth and change—were mediated through social and cultural systems. The artist had to deal with his

culture's traditional ways of viewing these matters, and deal with the contradictions that arose therefrom.

Duff had a strong sense of working through his own personal and social problems through his work. He concluded that Northwest Coast artists must have done the same. Although his notes do not so indicate, I assume that this view must have been based in part on his actual experiences, since he knew many Native artists personally.

Duff's theorizing really began from Bill Holm's analysis of the structure of Northwest Coast art (Holm 1965), and from the joint work with Holm and Bill Reid on the *Arts of the Raven* show (Duff, Holm and Reid 1965). That show launched a concern with identifying individual artists by their characteristic style.

From here, Holm continued to develop his analysis of style, and of what stylistic traits separate masterworks from ordinary works (Holm and Reid 1975) as well as what traits distinguish communities and individuals. Holm and Reid tend to assume that much of the art was visual play, art for art's sake, or exploration of the possibilities of the style, with no deeper agenda. Where deeper agendas are unmistakable, as with shamanistic art, they are acutely aware of the ethnographic facts, but do not tend to follow up in depth the thought behind the work to the extent that Duff attempted. A sort of agreement arose from the exhibition: Reid continued to be the artist, doing and feeling rather than analyzing; Holm followed up the stylistics; Duff dived into the deeper meaning.

Duff did go somewhat beyond Holm's superb analysis of style, introducing his own concepts of paradigm and armature. From here he could take off into depth psychology, and thence into realms of logic and paradox. He had to concern himself with whether the messages he saw were actually intended (at some level) by the Haida, or were purely creatures of his own mind. This was one of the questions he never satisfactorily resolved—a question which concerned and troubled him. His colleagues raised it to him, and he had only partial answers. This is, of course, the common fate of all interpreters of myth and art, from Plato and Confucius to Geertz and Levi-Strauss.

Duff's view of "meaning" thus falls somewhere between Frankl's and the computer-hackers'. Duff found Franklian "meaning" in his research—his whole investigation of Haida art. He never

cites Frankl, but knew something of Frankl's philosophy, since he worked with Wolfgang Jilek, a former student of Frankl's (Jilek, pers. comm.). He rarely concerned himself with the general question of how Haida found meaning in their total lives. He took it for granted that birth, death, sex and survival were meaningful in that deep sense, but did not enquire deeply into love, hate, power and its transformations, or other themes of Haida myth and human existence.

Duff's thought required a system, one which predicted that certain meanings would be important, others ancillary. This sort of system he found in Freudian (and, to a lesser extent, Jungian) psychology. He assumed the truth of much of the framework of this psychological body of theory, and thus naturally inferred it for the Haida.

A corollary of this search for meaning was a concern with the relationship between meaning and structure. The first, most basic building block in Duff's theory was the concept of "structural symbolism," which he got from his student Laura Greenberg. Ultimately, it is a Levi-Straussian concept. She found that the forms of the art themselves had meaning. The patterns communicated ideas of order, system, correctness—a substantial amount of the Northwest Coast worldview. Much speculation went into the question of how structure reflected meaning.

Duff's search, then, was for the messages sent by Northwest Coast artists, and encoded in the mazes of bears, ravens formlines, ovoids, houses and poles that were the texts of their discourse. He sought the covert meanings and the ways they were mapped out through the art. He separated three analytic categories: form, iconography and iconics (Panofsky 1962). The latter two correspond, roughly, with the distinction between denotation and connotation. For Duff, the iconography was the animals (or other natural beings) represented. The iconic level was the level in which the more important messages were conveyed.

Since the very first anthropological investigations, it has been clear that the real reasons for the bears, ravens and whales on Northwest Coast art was not to portray bears, ravens and whales. The first and most explicit meaning of these representations was their social significance: they served as crests or labels for social groups. Soon

it became obvious that they were important actors in myths, and that they had magical or supernatural powers that they could transfer to humans or use to affect humans. Much effort went into analyzing these aspects of art. Duff saw his mission as carrying exploration farther, into the less explicit messages buried deep in the iconics.

Duff saw the development of art studies on the Northwest Coast as having three stages. The first sought to understand the iconography, and to record the most explicit, culturally wide-shared messages. This was the age of Franz Boas, George Emmons, John Swanton, Marius Barbeau and the other father-figures of Northwest Coast academic studies. Second came a phase of structural studies: Bill Holm's work on form, Claude Levi-Strauss' epochal researches on social structure and its mapping out through the oppositions in art and myth. The third stage would be a deeper, more insightfully penetrating analysis of the full depths of meaning: what Duff called "hidden agendas." These included individual or esoteric meanings (as opposed to widely shared ones), subconscious and unconscious agendas (Freudian and Jungian), and—above all—the whole philosophy and worldview that informed the art. He saw himself as a pioneer of this realm. One influence in this was his colleague Robin Ridington, a pioneer of "the anthropology of experience" (see Ridington 1988).

In hindsight, we can see that Duff was indeed a pioneer of a coming trend. The usual progression of understanding is from surface to depth. (This is not to deny the importance of "surface to surface" issues!) Since Duff's time, deep analysis of the art and myth has been continued not only by his students but by many scholars from quite different backgrounds.

7

Deeper Interpretations

In looking at iconics, Duff developed a broad theory of what to seek and where to seek it. This theory was never finalized. He drew on a number of approaches. I find it useful to classify the messages he sought; perhaps the following scheme (my own, not his) will be useful to others.

1. Messages carried by the style. Laura Greenberg's "structural symbolism" led him to seek deep meanings in the style itself. The precise, exquisitely controlled lines certainly carry different sense of life from, say, the wild splashes of Jackson Pollock.
2. Messages about society. As Duff knew, reading the crests and labels was only the beginning.
3. Messages about cosmology and worldview, often carried by reference to myths that explained the world: Raven seeking women, or stealing the light, for instance.
4. Basic human truths: Life and death, love and fear, birth and rebirth, sexuality and power, social life and autonomy. These were the most important meanings of all, not only because they are intrinsically significant to everyone, but also because they allow the art to be placed in panhuman perspective, and considered along with European or Chinese art as part of humanity's

true heritage. This was a key point for Duff, who hated to see the great art of the Northwest Coast relegated to curio or anthropological-curiosity status. (Today, few would think doing so, but this is largely because of the efforts of Duff and his associates. Before these men and women became active, even anthropologists usually regarded Northwest Coast art as "ethnographic" material, not to be considered together with "real" art.)

5. Individual messages: the additional, personal messages that great artists inject into their work. For Duff, the difference between good art and great art lay not only in superior execution but also in these additional, richer messages. Many of them, he felt, were self-reflexive: meditations on the artist's own life and creativity. Duff thus devoted himself to understanding the work of the great Haida uncle-nephew pair, Albert Edward Edenshaw and Charles Edenshaw. He ascribed much of the greatest Northwest Coast work to them, and so felt that understanding them and their work was crucial. Some would now hold that Duff was overenthusiastic in his ascriptions, though Charles Edenshaw created much superb work.

6. Multiple meanings were packed into each masterwork. A piece would be a series of puns or kennings, and the multiple meanings would be systematized. The particular mix of meanings is, itself, a part of the meaning. In following out these trails of meaning, Duff put together his own unique framework, based on several existing bodies of theory. In his notes, he indicates where he got his major working ideas. He recurs to them constantly. A brief review of these is desirable here, for reference. Certainly the most important were those that spoke to him of basic human nature. He was trying to connect Northwest Coast art with universal human truths and their artistic expressions. Within this pool, overwhelmingly most basic was Freudian theory. He read Freud; he read much Freudian literature; he read Groddeck (1961); he read anthropological applications of Freudianism, notably George Devereux. He was also influenced by (or at least refers in his notes to) the work of Theodore Thass-Thienemann (1967, 1973), who combines language interpretation with phenomenology and linguistics. Duff did not deal with the minutiae of the theory, though he had a file of reprints from *American*

Imago and similar sources. Similarly, his notes reveal that he encountered ideas and writings by Gurdjieff, Karen Horney, George Devereux, Abraham Maslow and Sandor Ferenczi, but he did not cite specific works by these scholars. They fed into a general pool of ideas relating to the question of whether people find genitals beautiful or ugly, whether they hide them in art and how much art is a management of sexual display.

He was concerned with elucidating the more or less covert sexual symbolism of Northwest Coast art. He followed Freudian theory in seeing the core of the human mind as filled with dark, guilty, disruptive passions, especially sexual, which had to be beautified and sublimated in art to be expressed. A key assumption here is that people everywhere (not just turn-of-the-century Viennese) see sex as an explosive and dangerous thing that should be kept hidden. While the Northwest Coast Indians were certainly far less inhibited than the Viennese of Freud's early days, they were by no means flower children either. Sex was indeed perceived as social dynamite —necessary but explosive, and requiring strict control. Open, realistic portrayal of sexual parts in art was not common, leading Duff to seek deeper.

Much of his research became a quest for covert sexual reference. He found that missionary influence had led to suppression of what sexual explicitness there had been in Northwest Coast art. He rediscovered the obscure articles of James Deans, a local traveler who was perhaps the only nineteenth-century visitor to the Northwest Coast who had an interest in the sexual aspects in art. Deans' most striking account is of an explicitly phallic pole in the Queen Charlotte Islands. When he revisited the site a few years later, he found the phallic figure had lost its genitals. Inquiring, he was told that when the village converted to Christianity several men came out and used rifles to *shoot the genitalia away* (Deans 1891). Surely this is the ultimate comment on the white man's effect on Native culture. Its Freudian significance was not lost on Duff.

Even before the missionaries, sex was a subject for strange puns and covert reference. An archeological piece of uncertain date, the Sechelt Image, was of particular interest to Duff. It is a large boulder of the sort used as a test of strength by recent Native people. (Strong

men see how long they can hold up such boulders.) It is carved into a massive crouching figure that is both a man holding a huge phallus and a mother holding a baby. What is a phallus from one perspective becomes a baby from another. This figure came to Duff's mind when he read, in Groddeck, of the "individuum"—the human who combines male and female, or male-female-child. Groddeck saw the Pieta figures of Europe as so doing; one thinks also of Hindu figures of bisexual gods. Duff saw the "sexlessness, neotenic proportions, generic quality, lack of expression" of many Northwest Coast figures as relating to this "mother-father-child," and thought "Raven-as-human" might be such a being, a "bland blend" (Duff notes, Sept. 1975).

Duff also focused his attention on certain archeologically recovered pieces—such as the strange stone clubs, many of them explicitly phallic, from the upper Skeena River, and the strange stone bowls (almost certainly ritual) from the Fraser area (Duff 1975). The bowls show wombs and vaginas, and sometimes seem to have phallic attributes as well. In these and many other cases, explicitly sexual art is common in early times. Yet in ethnographic times, there was little sexuality in Northwest Coast art.

In a passage often quoted by Duff in his notes, an eighteenth-century French explorer notes the smallness of the sex organs on Haida art (Fleurieux 1801). Duff came to focus on "the significance of the missing part" (a phrase that recurs over and over in his notes) and on the ways that genitalia had become cryptic. Archeologically, bowls in the shape of seals are often explicitly and unmistakably representations of the external female genitalia; are modern seals to be seen as feminine? Or as related somehow to feminine qualities? (Duff 1975; also notes.)

There is little question that mouths and wombs are equated in Northwest Coast art, for in many items the mouth of one animal is the genital opening of another (Walens 1981). Beaks, snouts and tongues are often clearly phallic. How often? Duff could not decide. Bears could be female symbols, as when the entrance of a Tsimshian house is through a bear that is in the position where one would expect the vagina of the larger bear whose portrait covers the housefront. Do bears always have a feminine connotation? Obviously not in the case of the overtly sexual scenes representing the Bear-Mother myth,

in which a male bear captures and mates with a human female (Barbeau 1953). Not, also, in the case of the famous Nishga grizzly bear house that "ate" and then "vomited out" a number of Haida women hostages (Cove and MacDonald 1987, vol. 2:194-199). Responding to a perceived slight by the Haida, the Nishga returned the insult by using the women sexually and then returning them to the Haida through the wooden jaws of the bear.

In contrast, the Northwest Coast raven seemed to Duff to be usually male and clearly phallic—no one could mistake the significance of that huge all-devouring beak, even without the explicit equation of "eating" and "sexually using" that is common in Northwest Coast languages (cf. again Cove and MacDonald 1987, Walens 1981). Yet Duff's notes reveal much questioning on Raven and his mother; who or what was his mother? Do Tsimshian and Haida chiefly headdresses represent Raven being born? Is Raven's mother latent in some portrayals of Raven? These and related questions occur frequently in the notes.

In some cases, there is no question that sexuality is symbolized abundantly, most often by metaphors related to eating. In other cases there are serious questions. Duff saw sexuality in the joined tongues so common on Haida panel pipes and some other Northern artifacts. These joined tongues have been thought to represent transfer of spiritual power, and more generally of communication, and many authorities are willing to leave it at that; but sexuality is possible, a permanent ambiguity (Bill Reid, pers. comm.). On the other hand, the panel pipes are often sexual. Moreover, and I do not know if this has been pointed out before, there are panel pipes among southeastern U.S. Indians, and these may have served as the original models for the Haida; the southeastern ones include explicit sexual scenes of the sort Duff as well as Barbeau (1953) found in Haida pipes (see e.g. D'Emilio and Freedman 1988: plate 3 following p. 108).

Of course, finding the hidden sexual meanings of symbols is neither confined to Freudians nor exhaustive of Freudian theories of art. Freudians see art as a way of sublimating the id, allowing its dark and selfish desires to be translated into beauty. The beauty hides, disguises or represents in acceptable form the ugly, primal reality. Most of Duff's notes are written from this perspective: art as sublimation, as a way of extracting beauty from the ugliest of things and

the ugliest of desires. However, toward the end of his life, in a kind of epiphany, he came to believe that the beauty was the fundamental point; that art was truly about beauty. The "ugly" things were only one possible subject—and, in any case, they might not be so ugly after all. His notes reveal that, around 1975, he changed in this regard: from a position that art covered over, with beauty, the ugly genitalia, he came to feel that genitalia were not (necessarily) ugly, that art was not (necessarily) an attempt to cover over anything, and that beauty, not the hidden ugly fact, was the basic thing.

At this time, when the framework of Freudian theory has been called into serious question (to put it mildly; see Eysenck 1985, Grunbaum 1984), it is hard to remember the impact it had on anthropology and art studies. The overwhelming majority of psychological writings on art available in Duff's time were written from Freudian or related perspectives. There were, in fact, few other traditions of "deep-reading" art that seemed to be "scientifically" grounded. Duff came to make use of Freud's erstwhile disciple, Carl Jung (who seems to have stood the test of time better than Freud himself); but Duff was really more interested in the dark animal drives than in imagined archetypes.

Duff was concerned with art as representation of sexuality, and here Freud's claims are more widely accepted (as opposed to the powerful death wish, the extreme importance of sex as overwhelming force in life and mind, the all-importance of early experience, the Oedipus and Electra complexes, the basic selfishness of the id; see Grunbaum 1984). Duff's perceptions about the sexual symbolism of art do not depend on acceptance of the entire Freudian psychodynamic canon. It seemed reasonable to assume that concern with life and death, with mating and birth, were there in the art. Freudian theory served to focus Duff's attention on these questions and on the dynamic, emotional nature of human responses to them and to life in general.

The other great Freudian concern, death, was also of key importance. Duff followed Freud in seeing sex and death as humanity's really basic concerns. Whether this is so or no, death (like sex) is clearly a matter of importance even for non-Freudians, and it is plentifully represented in Northwest Coast art and myth. Devouring, overcoming and destroying are themes that recur over and over in

myths and ceremonies, and of course are artistically represented in great detail. Duff speculated considerably in his notes on the ways in which sex and death were brought together. The Skeena war clubs—phallic, yet clearly deadly—seemed to him particularly significant. The "eating" metaphor in contemporary art forms is also unmistakably relevant.

Quite apart from sex and death was another Freudian concept: paleologic. This rather little-known idea of Freud's was developed by Silvano Arieti (1956, 1967) in relation to anthropological art, and Duff used Arieti's concepts almost continually. In this view, logical thought deals with the subjects of the familiar syllogism, whereas paleologic deals with what is *predicated* on the subject. "All men are mortal; Socrates is a man; therefore Socrates is mortal" is logic. Paleologic would be: "All men are mortal; salmon are mortal; therefore salmon are men." Or: "lightning breaks rocks and is thus powerful; this piece of art affects me powerfully; thus art and lightning are equated." Paleologic is thus a special kind of analogy, and is one of the processes of analogic thought. Paleologic is said to be typical of the child, the "primitive," and the schizophrenic; Freud and his followers tend toward a belief that children, traditional people and the mentally ill share a mental universe, while normal adults in modern society share a different and opposed one. This belief has, of course, been quite conclusively disproved. No known common ground links all traditional peoples—let alone children and the variously ill—while excluding healthy modern adults. This fact, however, does not mean that paleologic does not occur a thought-process. The reverse is more likely true: All of us—and perhaps artists more than others—do frequently reason from such generalization of predicated qualities and actions.

Duff went far beyond Freud and Arieti in this area. For Duff, art lives by analogy and frequently works to show disembodied predicates. Much of the abstraction in Haida art he saw as attempts to portray predicates freed from their noun subjects. The simplest of predications, sheer existence, was portrayed. "Equal to" was represented in art by symbols. Concepts like "acts on," "should be," and "should do" were portrayed by abstract forms and arcane symbolism. Duff's account of relevant subject/predicate pairs was:

Subject	Predicate
whole (gestalt)	unitary part....
form	conduct
appearance	behavior, conduct, attributes
being	doing
one	all
topic	all the things to say about the topic
(nature)	(culture)
'look like'	'act like'

(Duff notes, ca. 1975)

On the subject of Arieti's model, Duff wrote in his notes: "Making classes of subjects because they have like predicates is an error of logic but a logic still present in schizophrenia, dreams, art. A logic used when anxiety must be relieved. Why could not that logic become explicit, used, exploited to give memory, in Haida art?" It could provide "generalizations about conduct which must mean idealizations of conduct."

For Freud, art was a form of sublimation. Repressed material could come out, transformed into beauty. At first Duff saw art as a cover, a concealer, of ugly or taboo matters. However, his emphasis on this changed. On July 31, 1975, he wrote in his notes: "Today I think I have come to a turning point, or come full circle. The deeper meanings of the art which I have been intuitively pursuing turn out to be the lesser part of it. They are there, and they are the controlling images, and they refer to the darkest ugliness and guilt of human fantasy (fiction). They refer to the oedipal theme, the primal scene, the primal guilt, the epitome of ugliness (parents' genitals), the epitome of shame (seeing them), the epitome of unfounded guilt (I didn't really kill my father and commit incest with my mother, as my id has assumed). But I had assumed that these were the 'real' meanings, just guised in metaphor and euphemism. This is not the correct way to place the emphasis. In human terms, the guise is more important than the brute fact. Into the guise is poured all that man knows of beauty. Art is beautiful metaphor and beautiful euphemism. The essential thing is the beauty.... It is constructed of skill, taste, wisdom, and compassion."

Art then is as basic as the morbid matter of the id, if not more so.

"Art is an act of love, and reassurance. Art is the making of beautiful masks, and its essence is the very beauty of the masks. Art is the making of beautiful disguises, and its essence is whatever it is that makes the disguises beautiful. Style is the beauty in the system. It is the tacit answer to the id inside." Later, he went on to develop these ideas. "Art is wish. Its method is to 'turn the problem around,' show the wish as fulfilled, and then try to show the circumstances that would bring that about.... Art is hypothesis as well as wish. And it only takes two hypotheses to calm the deepest human anxieties.

1. Let opposite be same (therefore end is beginning, death is birth).

2. Let the individual (me) be the individuum (foetal parent). (Therefore I span death.)

He thought he could see these themes coming up over and over again, in various ways, in the prehistory and history of Northwest Coast art. A few days later, he wrote in his notes on the art:

It incorporates old solutions from past millennia, arrived at and incorporated into the style. The old lingam-yoni equations of the Hagwilget clubs live on as the substructure of Haida frontal poles and spoon handles. The Frog solution lives on by repetition compulsion as decoration in a minor key. The sublime *triune-individuum* of the human figure and human face (male-female-child-adult) lives on to be brought to perfection in Oyai's frontlets, to stand on Tsimshian poles as the impassive sexless human figure, as the human groundplan for Haida frontlets and in fact for most figures on Haida poles; as the vulviphallic eye, as bilateral symmetry, as the coper arrangement, as the Haida box design.

Style incorporates old cliches. Old cliches have deep wisdom in them, which tends to get forgotten in everyday life.... Certain arenas stay alive as the working grounds for the deep agenda. One of these, in recent times, was the nose-beak-mouth arena of the human-bird-whale face....

Duff took less from Jungian theory. He sought for archetypes, and inquired into the matter of the quest for self, but he did not carry out a full Jungian agenda. (By contrast, almost every page of his notes refers directly or indirectly to the Freudian framework.) He seems not to have seen much in Northwest Coast art that required a Jungian explanation. There were, to be sure, human figures (at least some of which can be seen as mother-figures), world-trees, and other

familiar worldwide symbols. Duff did not speculate deeply on these; for instance, he did not discuss the double-headed serpent (so common in Northwest Coast art) in connection with Old World equivalents. (Many other scholars have done so, ever since the nineteenth century, and Duff must have been familiar with their writings.)

He speculated on the bear as Great Mother (following Neumann 1955—a book his notes show that he read in 1975), but on the whole his major debt to Jung was a more general one: he followed Jung in emphasizing the extreme importance and diversity of fantasy, dream and vision. Jung, and Duff, stressed the necessity of these for normal human social thought and behavior, and their essential unity with art. Art and myth are seen as, essentially, a socially negotiated fantasy-world. The themes that come out in dream and daydream are expressed, with more conscious dressing-up.

* * *

Duff's view of basic humanity was of a being torn by life's great oppositions: life and lifelessness, birth and dying, male and female. Like Levi-Strauss, he saw Northwest Coast culture as dealing with such oppositions by relating them to a number of important but less central ones: moieties and other social-structure phenomena, eater-eaten, creation-transformation/destruction, Frog-Raven, land-water, Raven-Bear and so on. Duff saw humans as continually concerned with the great paradoxes, and with life and death above all. He saw the art as an intellectual working out of these oppositions and paradoxes.

Duff's view differed from Levi-Strauss'. Levi-Strauss' structural theory has two weaknesses that Duff did not share. First, Levi-Strauss' humans are (as he supposes) intensely rationalistic and intellectualizing. They meditate on new and better ways to make neat, clear, philosophically stated oppositions. Emotion, passion and the whole of the tortuous inner workings of mind were downplayed in Levi-Strauss' highly Platonic view. Second, as a partial corollary, Levi-Strauss had only a very weak sense of prioritization in his scheme. The basic oppositions of life-death and male-female were of central importance to him (as to Freud), but as key problems to solve more than as key areas of intense emotional tension.

By contrast, Duff provides a genuinely impassioned view. His

Freudian grounding allowed him to deal with people as creatures driven by more than logic. It also, of course, provided him with a theory of what was the real, basic, driving dynamic of human life and thought. Duff would have been delighted by the phenomenological, hermeneutic and semiotic trends in aesthetic anthropology since his death, but would have felt they needed a genuine dynamic. He would have felt that they give no clue as to what are the basic wellsprings of human action and thought. "Meaning," "personhood," and "symbol" are concepts he would have seen as useful in talking about human emotions and drives—but he would still have seen those deep, intense rivers of the mind as his proper subject for study.

From Levi-Strauss, and from the art itself, Duff acquired a dualistic structuralism. It should be recalled that Levi-Strauss drew much of his theory of dyadic oppositions from the frequent symmetrical dualism of Northwest Coast art. (Recent specialists such as Marjorie Halpin, Ron Hamilton and William McLennan point out that symmetry was not exact and artists often deliberately compromised it for effect. The general point stands; and, after all, one must "expect" symmetry to be excited by its controlled violation.)

The oppositions with which Duff worked were, most importantly:

> Birth-death-reincarnation
> Life-death (and eros-thanatos, which somewhat conflates all the first four)
> Male-female
> Power-weakness
> Humans-nonhumans
> Land-water
> Present-past-future
> Part-whole
> Forgetting-remembering
> Knowing-unknowing
> Esoteric-exoteric
> Subject-predicate

These he saw being mapped out, in Haida society and myth, by such typical oppositions as:

The moieties (Eagle side-Raven side)
Half, one and two (part, unity and duality)
Paradoxes of all kinds, analogies, metaphors, "double-twists"
Formlines-spaces (and "formspaces")
Black-red
Phallic-vulvic
Up-down-sideways
Raven-bear, raven-frog and so through all possible oppositions of animal pairs
Copper structure (triune: thesis-antithesis-synthesis in many forms)
Beak-mouth
Head-body
Mouth (etc.)-genitals
Presence-absence
Inside-outside
Question-answer
Largest-smallest
Container-contained (hence metonymies of all kinds)
Agent-recipient and mutually-interacting-agent pairs, notably:
Eater-eaten
Killer-killed, destroyer-destroyed one
Partners in sexual intercourse
Light-dark

Duff derived his interest in oppositions partly from Levi-Strauss, but it is perhaps more reasonable to say that both men derived that interest from Northwest Coast art—from the artists themselves, in fact. By contrast with Levi-Strauss, Duff was far more concerned with reciprocal acts, with the Freudian concerns (male-female, eros-thanatos), and above all with the dynamic tension of paradox, contradiction and *coincidentia oppositorum*. In contrast, Levi-Strauss presents a comparatively flat system of rather arbitrary oppositions—the world frozen into static, neat, black and white spaces. Duff gives us a world of continual tension, held together by reciprocal acts, with sexual

intercourse as the most important both in reality and in metaphor.

The great all-important drive behind the concern with oppositions is the terrible tension we feel about death, and the constant, inevitable tension between birth and death, creation and destruction. As he points out in the notes, the Haida lived much closer to this "knife"-edge than we do. Hunters and fishers, they lived by taking lives, and knew that their own lives could be cut short at any time by an unexpected storm, a wounded bear, a sudden enemy attack or a hungry winter. They had to act with supreme care, with perfection—balancing on the knife-blade. Levi-Strauss too has tensions and struggles in his system, but it is the intellectual tension of two elders deciding where to send their granddaughters in marriage, to even out exchanges of women.

Duff's tension is agonizing: the pain of Bear-Mother suckling her breast-biting cubs and watching her brothers kill her husband. Levi-Strauss' world is cool and rational; Duff's is shifting, passionate, terribly beautiful.

* * *

Duff was not so much "following Levi-Strauss" in looking at the art, though Duff does frequently acknowledge the debt. (Levi-Strauss also acknowledged his own debt to Duff, and sent one of his own best students, Martine von Widerspach-Thor [later Martine Reid], to study under Duff's direction.) The truth was that both of them were following the art. The true founders of structural anthropology, with its focus on dyadic oppositions, include the anonymous mythmakers of the Haida, Kwakiutl and Tsimshian. One important concept that Duff did get from Levi-Strauss was that of traditional culture and art as *bricolage*—inspired improvisation, using whatever came to hand. The artist was seen as an improviser, rather than a follower of a set algorithm, or alternatively a self-conscious "creator" of a "new" work. Duff did relatively little with the concept, apparently finding it hard to apply or prove.

Finally, basic to the Northwest Coast—if not to all human society—is power and its uneven distribution. Supernatural power, social power (rank and class), emotional force and physical power

(ability to accomplish something through either strength or skill) are all partially equated on the Northwest Coast, and there is an extreme concern with all of them. Of these, social rank is most obviously important to the art (though many would argue that the other types of power are really more basic to it). Duff was not as concerned with power as with sex and death. He could not ignore it, but he did not seek out the literature on the subject or use it in analyzing the art

Several specific theoretical terms entered the Duff tool kit. J. L. Fischer's classic article, "Art Styles as Cultural Cognitive Maps" (1961), was one of these. Fischer held that art styles map out cultural values and basic organizing principles. Another was Arthur Koestler's concept of "bisociation" (Koestler 1964); creation by putting together two things, or parts from two things, that no one had thought of combining before. (This is similar to Barnett's theory of innovation [Barnett 1953].) Duff not only saw bisociation as a typical innovative technique; he saw it as a standard way of dealing with paradox and dyadic opposition in art. This linked him to a body of theory about resolving oppositions by combining (bisociating) the opposites or symbols of them. Duff does not use the term *coicidentia oppositorum*, but he must have been familiar with it from the writings of Jung and Eliade. He does refer to the Chinese *yin-yang* symbolism, and the Hindu symbolism of *lingam* and *yoni* and of the bisexuality of divinity; all these were relevant to Freudian as well as logical concerns.

At first, Duff seems to have believed the distinction between a "primitive" worldview of paleologic and fantasy and a more modern one characterized by analytic, deductive thinking. Soon, however, he came to follow Levi-Strauss (*La pensee sauvage*, 1962) in seeing both forms of thought as typical of all societies, more or less. Perhaps he realized that analogies can be recast as syllogisms, and vice versa, without too much mental effort. In any case, it brought the Haida closer. If we all use paleologic, seeing any similarity as an intriguing and possibly-significant analogy, or at least a possible symbol, then Haida symbolic and metaphoric art becomes more directly comprehensible and relevant to us. The ancient Haida communicated in ways we can understand.

The style of northern Northwest Coast art seemed to Duff a highly formal system, communicating its own message of a formal,

ordered society: "Raven by Robert's Rules of Order." He often uses the structure of academic committees as a model. The structure and procedure of the committees is itself part of their message. Curiously, he rarely remarks on the tension between the highly formal style and the savage, devouring content it frequently holds.

Finally, Duff was always sensitive to the beauty of art and the power of the artist invoking it. Late in life, he came to see that art was not just a beautiful cover for an ugly fact; its beauty was more than cover. Perfection of form and line, evocation of the aesthetic affect of the viewer, was a goal that had its own direct, primary validity—an irreducible part of the message.

In short: Art, for Wilson Duff, was a way of creating beauty according to socially negotiated rules of order. It was also a medium for communicating facts about deep human truths and concerns; about the exploration of these in myth, religion and philosophy; and about the social order. Individual artists would add their own meanings: their own philosophical and self-reflexive speculations, and their own emotional intensities. Whether it spoke of hunting or potlatches or the act of creation, the art never strayed from a grounding in ultimate existential concerns. The great artists, therefore, also had to be great philosophers.

* * *

Duff's thinking shows striking parallels to the "post-structuralist" thinkers of France, and most especially to Jacques Lacan. There is no evidence that Duff had ever heard of Lacan, but the combination of Freudian base and structuralist interpretive framework is the same. Duff was not interested in deep-reading Freud as Lacan was; Duff was using Freudian ideas from the master himself or from Groddeck, Arieti, Devereux and others. On the other hand, Duff had Haida art—and more: he had all he knew, from ethnography and from personal experience, of the powerful Northwest Coast philosophic tradition. The likeness is in the basis for thought, the "bisociation" of Freud and structural analysis.

Both Duff and Lacan found themselves led to an oracular, difficult, mystical style in which puns and wordplay often figured. I believe this is due, in both cases, not merely to a felt need to

exemplify some of the complexities of the worlds they discussed. They both came to feel that communication, mind, language and art simply *are* that way. A discourse about the deep aspects of human understanding is not true to its subject *unless* it is cast in highly complex linguistic forms, and *unless* it involves conscious and hidden mind, and also action and passion. Duff would not have agreed with Roland Barthes about the supremacy of *Finnegan's Wake* among texts, but he found in Haida art a text that seemed to him as cryptically significant and rich. He would not have agreed with Derrida about the essential emptiness or inconsistency of all texts, but he certainly delighted in unraveling Haida structures and showing how they mediated oppositions, failed to be consistent in their systems, responded by dynamically varying the parameters, and finally produced more vital texts than any simple application of structure could have done.

Some of Duff's strangest notes point toward true deconstructions of Haida pieces, but Duff believed that the Haida had their world under considerable conscious control; he would never have allowed as much significance to the marginalia as Derrida. The real parallel is with Lacan. One senses that both Lacan and Duff were striving for some transcendence of Freud and of structuralism, a view of mind that would go on to fuller and deeper concern for the richness of human experience. One can only wonder what would have happened if Duff had lived to incorporate and apply Lacan's ideas. How he would have delighted in contrasting the matrilineal, art-centered Haida world with Lacan's "phallogocentric" Europe. One can only wonder, also, what he would have made of the recent speculations by French thinkers (and their followers) about the role of literacy and writing. He saw Haida art as structured communication, parallel to writing but essentially different. How would he have thought of the effects of writing on the culture?

8

A Final Assessment

Duff worked largely by the traditional methods of art history, especially textual research and museum experience with specimens. He did almost no actual field work on art. Almost all his field experience was archeological or, in his early years, traditional ethnography. His contact with the Haida came in his journeys to salvage totem poles from the Queen Charlotte Islands, more an archeological than an ethnographic undertaking. He had frequent contact with Native artists, but in the context of Vancouver and the university, not often in the Native communities.

Many of these individuals were and are extremely articulate about their work—more so than most Anglo artists (see Duff, Holm and Reid 1967; Holm and Reid 1975; Drew and Wilson 1980). But they do not participate in the full traditional worldview, and they are apt to talk, like artists everywhere, about technical details more than about deep meanings. (If one asks, one often gets a variant of the classic line: "If I could tell you in words, I wouldn't have to carve it.") He knew the ethnographic and historical literature on his area as few other scholars have done. Unfortunately, he found it rather limited from his point of view. No one in the old days thought to ask the Native people about their art, beyond superficial questions of

representation and immediate social symbolism. We have little of the personal reflections of the artists. (For some idea of what we have lost, see Jenness 1955; Maud 1982; Miller 1988.)

He worked by studying texts and talking to students, but above all by intuition and logic. His notes fall into a very characteristic pattern. He would either learn a new theory or have a new flash of intuition; then he would logically extend the idea, applying to everything possible and trying to develop corollaries and logical applications. He would see how far the concept of (say) ternary structure could go, applying it to The Box, the Raven Screens, the Edenshaw comports and so on; then to the standard iconographic motifs (ravens, bears, the odd little face he called Mighty Mouse, and all). He would play with all possible permutations and combinations of motifs and ideas. These logical and applicational chains go on for many pages, until they trail off into extensions too remote to be worth further consideration, and finally end with question marks. Dated entries show that they often extended over many days. (They do not appear in this book, however, being almost impossible to transcribe, and being typically abandoned unless they produced a real conclusion. Many depend on rough sketches and cryptic notes that cannot be reproduced.)

Over the years, he specialized more and more on the masterworks of Haida art. Except for comparisons (especially with Tsimshian and Kwakiutl) he came to range less and less widely on the coast. His early interest in the Salish peoples seems to have almost disappeared, though it surfaces again in *Images: Stone: BC* (Duff 1975).

Duff did some creation of his own. He made at least four exquisite masks, in a more Tsimshian than Haida style, and did some other carving. His poetry and his one strange, mythlike short story were explicitly ways of knowing and ways of experiencing. Like many modern anthropologists (see Prattis [ed.] 1985) he felt that he had to follow up the kind of insightful knowing that characterizes poetic composition.

Bill Reid and Bill Holm, both excellent artists, clearly influenced him and made him aware of the need to know a subject actively and creatively as well as abstractly and intellectually.

Another technique used by Duff was meditation and mystic

experience. He was not trained in any traditional meditative discipline (such as Tantrism or Taoism) and did not read much of the literature; he was a spontaneous adept, gaining understanding of his experiences from reading such authors as Eliade and Jung. Through students he discovered Hindu practise, especially Vedanta, and talked to colleagues knowledgeable in that; this provided serious intellectual grounding for the method. Wolfgang Jilek and Louise Jilek-Aall, psychologists who studied anthropology under Duff's tutelage, remember him asking them if spontaneous insight in dreams could be a worthwhile way of knowing.

They told him of Kekule and the benzene ring, and other stories of major scientific discoveries that came in dreams and visions. This was very important to Duff, whose notes after that spoke frequently of Kekule (W. Jilek, L. Jilek-Aall, pers. comm.; Duff notes). He recorded several of his dreams in his notes; some he felt to be major personal experiences, changing his life and his perception of art. He drew very heavily on hypnagogic and hypnopompic experiences— that is, on the sensations and realizations one has in the drowsy states of falling asleep and of waking up, respectively. Hypnopompic merging from a dream into wakefulness seems to have been especially "privileged" as a time for him to have ideas he found valuable. All insights were checked against what he knew from his creative activity, from history and ethnography, from Native friends, and from any other sources. He did not engage in undisciplined speculation (as do so many "interpretive" anthropologists).

Ideally, all insights had to meet the tests of logical consistency and ethnographic validity. This was why he published so few of his thoughts from his last years; few of them met his rigorous standards. None of them became "facts" for him, except the very general concepts (e.g. the importance of sex and the multivocality of meanings). Even the most tightly controlled were no more than speculations. The notes show that his failure to make his intuitions meet his standards of proof was one of the factors in his final depression.

The use of intuition, dream and visionary experience as ways of knowing was, of course, characteristic of the Northwest Coast people themselves. They gave the same privileged status to visionary knowledge that we do to verified scientific research. They relied on vision quests, dreams, trances and other ecstatic states to obtain

knowledge necessary for creating art. They knew the difference between external and internal reality, but (unlike modern westerners) they privileged the latter perhaps more than the former, and believed it to be in much closer touch with the former than many modern westerners would accept, though, at the same time, they were acutely conscious of nature and its realities.

Indeed, they could not afford the luxury of ignoring internal truth and waiting for experimental verification of every point. A hunter, trapper or fisherman must be constantly monitoring the environment, consciously and subsconsciously. Any unusual motion, any subtle cue, has to be noticed. Most or all "intuition" is a reaction to, or inference from, such subconscious cues or half-aware conclusions. Hunters must act on these without waiting for full, conscious proof of everything; they must go with their best guess as to where the game is, or when the fish will run. They are forced to involve their total selves—conscious and unconscious—in the desperate quest for food. Robin Ridington has described the ways in which the Beaver, just outside the Northwest Coast area, dream the trails and locations of game (Ridington 1982, 1988), evidently relying on such subconsciously noted cues and on integrating them during sleep.

Also, Northwest Coast peoples had (partially in consequence to their need to develop the intuitive side of their minds) a demanding social life that was heavily based on visionary experiences. Visions validated personal predispositions and realizations. Trance and vision were not considered to be "altered" or "paranormal" states, but were perfectly normal and were highly important. Duff knew (except, perhaps, in his most remote meditations) that he could not enter the world of a nineteenth-century Haida, but he knew that he could get a better view of it if he at least shared as much as he could of common human experience. He also felt that by meditating on particular pieces he could enter into an intense empathy with the creator.

Duff is not the only Northwest Coast specialist to use meditation and mystical insight as a method. Among others, John Cove is the most explicit (Cove 1987:164-177) and his discussion is highly relevant here. He found that meditation (under some Tantric guidance) did not produce striking new insights, but cleared his mind and helped it focus. Like Duff (and many other scientists), he came to dream of his work and get some insights from dreams. But he found

that mysticism provided a supplement rather than great revelations. Cove, unlike Duff, had substantial formal training in meditative traditions.

At this point it is necessary to clear up some confusion about meditation and the experiences felt by adepts. Mystic insight is not some kind of special "altered state of consciousness" that is arcane, weird or pathological. It is a perfectly normal state, no more "altered" than any other normal variation of thinking. About 30 percent of Americans have had strong mystical experiences, and about 5 percent do so regularly. However, the success rate of meditators at predicting the future, finding lost objects, actually describing the real landscape they have "flown" over, and so forth, is markedly low. Meditation is a way of disciplining the mind, not a way of knowing the outside world.

Meditation does, however, provide several advantages that make it valuable to the scientist. Mystic experience and meditation are particularly valuable in providing insight into one's own mind, and thereby into minds in general. Human thought processes and emotions can be explored in great detail, again with the caveat that all conclusions must be tested by conventional means if they are to be held as externally "valid."

Of course, many or most conclusions are rather refractory to the test. With practice one can learn to dream while awake, for instance, which is obviously a good way to learn about dreaming. (Strong stimulant drugs such as LSD produce the same result, apparently directly stimulating REM-sleep-like mental activity. The dreams are usually distorted and non-normal, however.) Duff (and Cove) hoped to replicate the experiences of Indian shamans. This can be done, to the extent that the replicator has learned the shaman's culture. Mystic experience does not make one a shaman, but it can give one an experiential understanding of one type of shamanic discipline.

Duff used such mental disciplines, along with poetry, dreams and psychoanalysis, to generate hypotheses about the minds of the northern artists—to see what it really feels like to be a shaman or traditional artist or the like. For these purposes, mysticism is a valuable tool. Such sober use should not be confused with the hallucinations of drug users, the illusions of seers or the delusions of schizophrenics; the experiences are quite different.

The West Coast artist Ron Hamilton (Ki-ke-in, earlier Hupquatchew) can recall Duff turning down an opportunity to visit the newly discovered and incredibly rich Ozette site (Hamilton 1981:46). Duff said he would prefer to stay home and "commune with the old man" (A. E. or Charles Edenshaw). Anthropologists find this hard to understand; art historians may sympathize with Duff. Marjorie Halpin (pers. comm.) suggests that this was perhaps one reason he never revisited the Queen Charlottes.

Duff's notes refer to "coming-in" and "going-out" days. On the former inspiration and ideas flowed into him, and he was calm and peaceful. On the going-out days, he was driven and agitated; words and thoughts flowed urgently out onto pad after pad of yellow ruled paper. Sometimes bouts of hopelessness interrupted the work, especially as he contemplated the problems of proving his insights.

Wilson Duff was a meticulous scholar and felt the need of making a convincing case for his material. Furthermore, his colleagues in the field were urging him in that direction. Yet his speculations were growing more and more involved and original, farther and farther from the data. This was as true of those based on straightforward structural analysis as of the ones based on mystical insight. He was a perfectionist, unable to stop short, publish a "state of play" book and go on to a different task. He felt a compelling need to prove his case, finish his agenda, validate his insights and method. Yet the same agenda took him farther and farther beyond the conventional and testable frontiers. In the end, he died between these poles.

* * *

An obvious problem of assessment occurs in dealing with material such as the Duff papers. We are given many insights, written as positive and usually unqualified assertions, but never proved. Sometimes they are contradicted or qualified by later assertions. Obviously this material must be used with caution. Yet, the inspired intuition of an expert with a lifetime of experience is not to be lightly dismissed. Duff's notes frequently contain brief notices that one or another of his insights has been confirmed by careful, painstaking proof—usually from another hand. Some Duff insights that have received some confirmation include the strong northern input to Northwest Coast culture,

especially Nuu-chah-nulth but also the whole subtradition (cf. Fladmark 1986); the long development and early sophistication of Northwest Coast art; the early importance of art of the Salish area (now relatively minor); and the importance of individual great artists (though Duff may have exaggerated this).

Some insights that seem likely to receive support include the importance of sexuality in the art (cf. Walens 1981), the use of the art as a symbol system to talk about philosophical concepts (at least including power and transformation), and the self-consciousness of the artist's pursuit of philosophical and cosmological goals in art.

Other insights come under question but are at least worth serious further study. These would include, for example, Duff's theory that the early Haida panel pipes that scramble themes from white scrimshaw art are deliberate comments on the "nonsense" of the white world and its sharp contrast with the "sense" of the traditional Haida cosmology and style. Duff played with this idea, but left it for his student Carol Sheehan to develop, which she did as part of a major study (Sheehan 1981). The Duff-Sheehan "white man's nonsense" idea was then critiqued by MacNair and Hoover (1984:206-207), who point out that it is not definitely established and that the Haida could have been simply fooling around with a new medium. Further research may resolve this, but at present either option is hard to prove. Last, some of Duff's testable hypotheses are currently less than accepted, including his ascription of a large number of nineteenth-century objects to A. E. Edenshaw. However, Duff's unproven statements are worthy of serious consideration. It is difficult to test statements about art. Much of the seminal thought in critical and anthropological writings on art is similarly hard to test, or—if tested—found wanting.

For the Northwest Coast, we have, for instance, Levi-Strauss' study of the myth of Asdiwal. This analysis attracted much attention, but was painstakingly dismantled by three of my colleagues (Thomas, Kronenfeld, and Kronenfeld 1976). Unfortunately, real resolution of questions about old Northwest Coast art is often impossible. It would depend on thorough, detailed ethnographic enquiry of a sort that was not done. Particularly with the Haida, who were profoundly affected by nineteenth-century white contact, even the earliest serious ethnography was too late to find answers to all the

questions Duff asked. Nor was it done with an eye toward discovering the philosophy of the artists.

The best work was that of John Swanton, in his twenties and on his first research voyage. Given these limits, his work is quite incredibly good, but it cannot answer the questions Duff asked about the meaning of life and death, the cosmology and the roles of art in Haida society before white contact. The Tlingit and Tsimshian are better known, but still there is much left unrecorded. We need only remember the running battles about the presence of "class" in the Northwest and the purpose of the potlatch (Orans 1975) to see how much latitude the ethnographic record allows us. Under the circumstances, we can take two reasonable courses.

First, following the old ethnographers such as Boas, we can confine our attentions solely to what can be perfectly demonstrated. This limits us to rather bare, external statements that do little to advance our knowledge of the human spirit.

Second, we can build from what we do know, and infer on the basis of inspired reinterpretation of the art and the old ethnographies. This was the method of Wilson Duff. Once more, it should be carefully distinguished from spinning beautiful dreams on the basis of exiguous knowledge. To do it right, one must know the material well enough to feel confident that one is not only aware of the details but also capable of putting oneself in the place of the artists—thinking like them, acting as they did. Like Bill Holm, though to a lesser extent, Duff carved and danced. He knew his material not only intellectually but also physically.

Ultimately, for him, it was useful (but not essential) to involve the visual and motor parts of the brain by such direct participation. Much of Duff's speculation depends (explicitly or implicitly) on the assumption that the artist's hand and eye express subconscious and semiconscious feelings and concepts that could not or would not be expressed in language. Anyone who knows artists—not solely Northwest Coast Native ones—will have a good sense of this. Much mental activity is expressed directly through the visual channel, rather than being verbalized.

Recent advances in brain physiology show that the distinction of right and left is too simple; there is more going on, and less communication between different modes of brainwork, than we thought

(Gazzaniga 1985). We can now see that drawing on analytic, visual, mystical-intuitive, motor, and other faculties of thought is probably necessary for any understanding of art.

Ideally, insights are gained through the visual and intuitive channels and tested by rational and analytic methods. It is here that ethnography limits us, and here that Wilson Duff came up against many blank walls. Like the existential questions posed by the art, the question of verifiability remained intractable. The more interesting, novel, and important his insights, the less they could be demonstrated.

On the other hand, the Tsimshian material collected by William Beynon and Marius Barbeau is so extensive and well-recorded that it provided Duff's student Marjorie Halpin with the opportunities to do many of the things Duff wished to do for the Haida (Halpin 1973, 1981, 1984, 1988). The recent publication of the William Beynon manuscripts (Cove and MacDonald 1987) provides us with easy access to these materials for further study with Duff's ideas in mind.

There is a problem with what constitutes "proof," or even believable argument, in writings on the arts. Many postmodern critics, in fact, tend to dismiss scientific canons of proof as irrelevant or even pernicious in this regard (G. Gugelberger, M. Kearney, pers. comm.) Writers state their interpretations as if these were facts: Rembrandt's line *is* (not "may be considered") "authoritative," and so on. If art criticism is no more than reframing common knowledge, this is pardonable, but otherwise it can be defended only as a convenience possibly necessary to save us from being bored to death by qualifying phrases.

More serious studies resort to evidence, but almost invariably the evidence is selected and arranged to argue a point. No attempt is made to deal with all available evidence, to handle it statistically or by other normal means of establishing proof. Frequently there is no attempt to deal with counter-hypotheses. This allows writers to play somewhat fast and loose with the evidence. The question of how to prove contentions about Northwest Coast culture is best treated in regard to the potlatch—an event intimately connected with art, if often otherwise explained; the controversies swirling around the potlatch have produced many papers that make important statements about what constitutes proof in ethnology (Orans 1975). Many a time

an ethnologist must be satisfied with making a "plausible" case for a position, and trying to deal with counter-hypotheses as they arise.

The situation is not always bleak. Bill Holm's analyses of style provide comprehensive principles that can be followed to see if they work; this is being done. They allow us not only to produce, analyze and evaluate Northwest Coast art but also to identify individual styles (Holm 1965, Holm and Reid 1975, Holm 1983).

Duff's notes state that he hoped to do for meaning what Holm has done for form; this proved a hard task. What Holm was able to do was develop a series of formal elements and combining rules that parallels the formal principles of language. As in deciphering a lost script, he could "read" existing pieces to see if they were grammatical. He could also make his own works of art, following the principles he isolated. (In fact, the evolution of his ideas ran the other way: he induced the rules from his own learning of the crafts.) Further development from his work is ongoing.

With the exception of Holm and those influenced by him, proof in studies of Northwest Coast art has generally resided in appeal to ethnography, including early chance observations of ship captains, collectors and the like. This is a dangerous enterprise, since informants are not always accurate. For instance, Duff was able to find many errors in the work of Marius Barbeau, even when Barbeau relied on informants. Barbeau, in strange territory (like the Queen Charlotte Islands) and away from such trusted and trustworthy friends as his Tsimshian informant William Beynon (Halpin 1978), was sometimes apt to write down anything he heard—vague and misremembered statements along with accurate ones—and to build conclusions on such slender foundations. Nor was he the only man to make mistakes. Duff found dubious statements in many works, including Boas'.

This gives us all the more reason to rejoice in what insights we can get from Wilson Duff. In so far as critics like Barthes and Derrida are right, there is not necessarily one privileged reading of a text in any case. Whether or not the Haida got the same messages from The Box that Duff did, Duff's insights have their own interest. His views are valid in and for themselves, as the experience of one sensitive observer with deep knowledge of the objects.

9

Notes on Specific Objects

Duff's student Carol Sheehan McLaren wrote her M.A. thesis on the amhalait, completing it the year after he died (1977). She noted the striking similarity of amhalaits throughout the whole Northwest Coast (north of the Nuu-chah-nulth and most Salish, who lacked true amhalaits). The object appears to have diffused from the Tsimshian, along with the rest of the chiefly regalia and the high-chief rituals. The Tsimshian, in historic times, had the most clearly "class" society on the Northwest Coast. This seems to have been a reflection of an exceptionally differentiated precontact society, though the fur trade led to increased wealth, power, and relative status for the chiefs.

The power symbolism of the amhalait is explored in detail by McLaren. The eagle down symbolized power manifesting itself by creating peace, order, harmony and health (it was used in curing ceremonies as well as being shaken from amhalaits). The whole costume was a marker of order, worn at stages in rituals where chiefly power and the social order were being reaffirmed, as opposed to e.g. the chthonic forces let loose in secret society mask-dances and the like. Chiefs after death were laid out in state in this costume (especially among the Tsimshian, Haisla, Haida and Tlingit) contrasts with the wild diversity of masks and associated gear.

Duff saw the costume, including the amhalait and raven rattle, as loaded with covert and not-so-covert sexual symbolism. Gould and McLaren sedulously avoid this. It is somewhat surprising that two of his best and closest students did not follow him here. Perhaps they were following his caution in stating these views without further evidence.

The AE Box was found by Bill Reid, in storage at the American Museum of Natural History, and was immediately spotted as a true masterwork. It became a favorite of Reid and an obsession for Duff, who saw it as "the final exam of Northwest Coast art."

The panel pipes are Haida argillite carvings originally inspired by scrimshaw pipes and made for sale to seamen and other white travelers. They are the subject of several books and articles, one of which (Sheehan 1981) is directly inspired by Duff's work.

Shakespeare's Bear Mother is probably the most famous work of Haida art: an argillite carving by one Skaoskay (Shakespeare was a collector) that shows the Bear Mother in agony, suckling her cubs while they bite her nipples. The tension between mother love and mother pain—a powerful human universal—is well expressed. This piece is standardly used in general survey courses to represent "American Indian" art. It is, in fact, highly influenced by European art and rather atypical for Haida.

In Duff's shorthand, CE is Charles Edenshaw; AE is Albert Edward Edenshaw, Charles' maternal uncle. He and Ginawan were major carvers of the nineteenth century, and some of their totem poles have been identified.

Tanoo (Tanu) is one of the most artistically important Haida sites: a nineteenth-century village, abandoned due to population decline and a felt need to be nearer the centers of trade and contact. Its surviving poles were salvaged by Duff and his associates in the 1950s. The gentle, toothless bears of Tanoo poles are appealing and yet magnificent; they are unexcelled anywhere in Northwest Coast monumental art.

Here and in the following passage, several of Charles Edenshaw's works are mentioned, including the Raven comport, a large argillite work in the University of British Columbia Museum of Anthropology.

II

The

Wilson Duff

Material

10

Haida Art

Editor's Introduction

The core of Duff's work was, of course, his analysis of Haida art, especially of the art he ascribed to Albert Edward Edenshaw and his nephew and successor Charles Edenshaw.

Duff's surviving unpublished writings on the Haida are of three kinds. Partly finished manuscripts and outlines are discussed in the next section. More extensive are the great folders full of working notes—the yellow pads that Marnie Duff remembers as being always in his hands. These notes provide the richest source, both in quantity and in originality, of Duff's ideas; but they are, of course, not finished work. They are steps toward a monumental synthesis that was left tragically unfinished. I have selected very little from this vast mass. I have picked only what was more or less finished: longer statements that were written in polished style, less polished items that still carry through a thought, and epigrams. Most of the material in the notebooks consists of thoughts that were better elaborated later or that progressed into the endless chains of postulated equations and other structural relationships.

Particularly useful are the "Notes to My Self" written in late summer of 1975. These are, on the whole, the best summary of Duff's

final thoughts on art. Most of them are included in the general section on art, above, but several concern the Haida specifically. After writing these, Duff got caught up in a busy year. Notebook entries continue to the end of 1975 and then stop short. Nothing was kept from whatever he wrote in 1976, except, of course, the publish-ed paper. A few scraps found in his office after his suicide indicate that he continued to work, but he was blocked by academic cares during the school year and, apparently, by depression during the summer; he produced little and was not satisfied with that. Thus the writings from late summer of 1975 are all we have of summation for his life's work. Most of them turn on general questions of art, but by then he was so caught up in Haida art, and specifically in the work of the Edenshaws, that the generalizations were all made with both eyes firmly fixed on applying them to Edenshaw materials.

One major interest of Duff's is unrepresented here: Haida argil-lite pipes. His thinking on these has been thoroughly expounded by his former student, Carol Sheehan (a.k.a. Carol McLaren), in her work on the subject (Sheehan 1981).

The Artistic Haida: An Historical Sketch

Already accomplished artists at the time when the first Europe-ans arrived, the Haida responded to the new conditions of fur trade times by becoming even more productive in sculpture and painting. A sketch of the historical circumstances of the period between the 1780s and 1900 helps to understand the kinds and distributions of Haida art in the world's museums. For a very short period the Haida monopolized the maritime fur trade on their part of the coast, and the result was that they became suddenly rich in new kinds of wealth, and quickly acculturated. But it was not many years before the trading ships found their way to the main fur sources on the mainland, and the Haida found themselves bypassed, with only meager fur sources in their own territories, and found themselves poor. One of their responses was to increase their production of their arts and crafts to trade to the mainland tribes, and to make 'curios' of argillite and other materials to sell to the whites. Another was to travel more actively to the places where the trade was cen-

tered—Port Simpson, Sitka, Victoria—with a consequent "spreading of their wares" over a wider area.

The white men were avid collectors from the beginning. At first they were simply curio-seekers, and were not in the least interested in recording information about the curios, much less their makers. Later they came as collectors for museums, but neither did they show much concern for distinguishing between locally made and traded objects, nor for learning about the artists. The museum records reflect their shortcomings.

That the art styles of the Haida and their neighbors had already been developed and that most if not all of the art forms were being made before the time of contact has by now been clearly enough established (Holm, 1965:3-7; Keithahn, E.). It remains only to supply some more specific details with regard to the Haida. The historical accounts are clearest for the villages on either side of Dixon Entrance, which were the most frequently visited by the earliest trading vessels. In 1778 Dixon himself, though he did not come to anchor and was not in view of any of the main villages, collected several small objects including the now-famous sculptured wooden bowl which is currently in the British Museum (Inverarity, 1950, Fig. 195; Holm, 1965, p.4).

When later explorers or fur traders took the time to go ashore to the villages they saw several forms of art. The most appreciative early account is from the French captain Etienne Marchand and others of his crew, who explored and charted Cloak Bay in August 1791 (Fleurieu, 1801). One of his general comments was that "...what must astonish most,...is to see paintings every where, every where sculpture, among a nation of hunters" (*op cit*, p. 419).

At Dadens, on the south shore of Langara Island, were two large houses with tall sculptured portal poles, which they described in detail and referred to as "superb portals in sculpture" (*op cit*, p. 403). These same poles were mentioned, described and sketched by several early visitors. They were the "great wooden images of Tartanee" near Douglas' anchorage in Henslung Bay in 1789. Ingraham in his journal for 1791 also described them. John Bartlett in the same year described one of them:

> The entrance was cut out of a large tree and carved all the way up and down. The door was like a man's head and the passage into the house

was between his teeth and was built before they knew the use of iron (in Snow, 1925, p. 306).

He also made an atrociously poor sketch of the house and pole (Snow, p. 36; Barbeau, 1950, p. 804; see also Duff, 1964, p. 89). The journal keeper of the *Eliza* in 1799, who judging from his sketch of Kiusta was a much better illustrator (in Barbeau, 1950, p. 815), stayed for the night in one of the houses with its owner Altatsee, and in the morning "to save the length of description" (p. 21) made a sketch of the two houses, but the sketch unfortunately seems to have been lost.

At that time Kiusta and Kaigani had no such portal poles, perhaps because they were newer villages and used primarily in summer. Other Haida villages of the time did have portal poles: Hoskins, at Masset in 1791, recorded:

> ...their head villages are neatly and regularly built the houses end with pitched roofs in front is a large post reaching above the roof neatly carved but with the most distorted figures at the bottom is an oval or round hole which is either the mouth or belly of some deformed object this serves for a doorway (in Howay, 1941, p.233).

By two or three decades later, the main villages had become forests of totem poles. Camille de Roquefeuil, at Masset in 1818, found the village "particularly remarkable for the monstrous and colossal figures which decorate the houses of the principal inhabitants, and the wide gaping mouths of which serve as a door" (1823, p. 88). In 1829 Rev. J. S. Green found Skidegate "almost enchanting"; before the doors of many of the thirty or forty houses stood "a large mast carved in the form of the human countenance, of the dog, wolf, etc., neatly painted (Green, 1915:84). Clearly this form of Haida art proliferated in the prosperous years following the first arrival of the trading ships.

To return to Dadens, early observers also found sculptured human figures commemorating the dead. Chief Altatsee showed the officers of the *Eliza* a pair of ancient images near the two houses and said they "were intended to represent two Chiefs, that were his relatives (or rather they were his ancestors for they looked as if they were upwards of a hundred years of age) that had been killed in Battle (*Eliza*, p. 21)." Captain Chanal, an officer with Marchand in 1791, examined a carved figure with its hands placed on an instrument something like a harp (Fleurieu, p. 418): this may have been

another memorial figure. At a village near Kaigani in 1829, Rev. Green saw such a figure associated with a mortuary:

> As I was going from house to house, I saw a bust at the mouth of a cabin, curiously carved and painted. I asked what it was. My Indian guide said it was Douglas, a chief of the tribe, who not long since had died in a drunken frolic. He went with me to examine it. He drew back the board which closed the mouth of the tomb. The remains of the chief were deposited in a box, or coffin, curiously wrought, and gaily painted. They usually deposit their dead in similar boxes, though they commonly elevate them several feet from the ground (Green, 1915:66).

That carved chests were used as coffins in 1791 is affirmed in an entry in Ingraham's journal. He examined two grave houses full of coffins, which were boxes "made in the neatest manner, carved and decorated with sea otter's teeth" (in Barbeau, 1950:806). Marchand's crews also saw a type of tomb consisting of four posts bearing two feet above the ground "a sarcophagus wrought with art and hermetically closed" (Fleurieu, p. 408).

Chests used for the storage of supplies and valuables were also seen inside the houses by early observers. The writer of the *Eliza* journal visited the houses of the chiefs of Kiusta, Dadens and Kaigani (Cunneah, Altatsee and Cow). Chests were drawn forward to the fire for him to sit on, and he was shown the treasures kept inside (Eliza:20, 21, 23, 28). He failed to mention whether or not they were decorated, however.

On the west end of Lucy Island, in Parry Passage between Dadens and Kiusta, was some sort of building which was visited by Captain Chanal in 1791. He at first thought it was palisades, the work of Europeans, but on going ashore found that:

> ...they form the enclosure of a platform of moderate elevation, resting on one side against the rock, and supported at certain distances by stakes, rafters, and other pieces of wood forming the frame of a building, well put together and well contrived: he ascended it by a staircase made out of the trunk of a tree. (Fleurieu, 395).

He saw that it was an old structure and could not have been European-made. "He here remarked several boxes without a lid, the use of which the islanders explained: these perform the office of a drum from which they draw a sound, by striking with the fist against

the outer sides." He did not record whether these box drums were decorated.

But what particularly attracted the attention of the French, and well deserved to fix it, were two pictures each of which eight or nine feet long, by five feet high, was composed only of two planks put together. On one of these pictures, is seen represented, in colors rather lively, red, black, and green, the different parts of the human body, painted separately; and the whole surface is covered with them. The latter picture appears to be a copy of the former, or perhaps it is the original: it is difficult to decide to which of the two belongs the priority, so much are the features of both effaced by age. (396)

Though having the appearance of a fort of some kind, Captain Chanal judged from what the natives indicated "that it was rather a place consecrated to religious ceremonies, or public diversions." Ingraham, the same year, apparently considered it a fort, for he showed the island as "Hippah" Island on his chart of the harbor. James G. Swan, there with Chief Edenshaw in 1883, was told it had been a "doctor's house." Whatever the structure was, the paired mural paintings were like painted house screens later seen in Tlingit houses (Holm, p.5).

Inside one of the Dadens' houses, Captain Chanal saw another painted mural somewhat like those he had seen in the other building, which "occupied the head of the apartment" (418). It was a complex, symmetrical human figure painted in black, red and "apple green." (Holm, p.6) From these descriptions there is no doubt that the distinctive painted style of the Haida was already developed, as well as the style of sculpture, for these examples were aged at the time.

It is also well established from the early accounts that at the time of contact the Haida traveled widely along the coast for trade and war, and that an immediate effect of the fur trade was to increase the tempo (amount) of such journeying. The trading vessels quickly overtaxed their local sources of sea otter pelts, and they increased trade with tribes less accessible to the sailing ships, serving as middlemen and trying unsuccessfully to preserve a monopoly. The situation as it existed in 1799 is explicitly clear from the *Eliza's* journal. Its writer considered Cunneaw of Kiusta to be the oldest and most respected chief on the northern coast:

...indeed we never visited a place on the Coast but what we found

they knew him or his tribe by woeful experience, having often made expeditions to the northward when at war, as far as Sheetkah/Sitka/, plundered their Villages and brought of numbers of prisoners (p. 24).

Among the treasures of the chiefs were white ermine skins from Chilkat, which they received from "Northern Chiefs as a mark of Friendship, when they are trading among them" (28). It was only when drunk that the chiefs would reveal the sources of their traded furs: Altatsee finally told of going "a vast distance to a place inland" where they had to push their canoes up fresh water rapids (the Nass River, which the *Eliza* soon visited). His brother then admitted that most of the skins were obtained from a group called Coca\katlanes (Tongass Tlingit), but that he dared not, on threat of death, pilot them there. With another pilot the ship did go to these places, in spite of Chief Cow's warnings that there were no skins there, and that there was so much sickness there that they would lose all their men, and finally a plea not to spoil the market (p. 29). The Haida fears were well founded, as before long the ships passed them by, and brought their brief and prosperous monopoly to an end.

The early years of the maritime fur trade, when ships flocked to the Haida villages, were times of intense interaction. The first encounters set the tone of relations and the kinds of acculturation for many decades to follow. Where armed conflicts took place, as at Ninstints ("Koyah's", see Duff and Kew, 1957) and Cumshewa, the enmity tended to escalate, and had fully persisted until about 1860. But where friendly relations were established in the beginning and maintained through the fur trade period, the acculturative effects on the Haida were very pronounced. The villages remained regular ports of call, and sources of pilots and crewmen. Skidegate was one such village. The best example of friendship and early acculturation, however, was with the people of Dixon Entrance who came to be known as the Kaigani. Their initial friendship resulted form the memorable meeting of Captain Douglas and Cunneah, the ranking chief of the area.

In August of 1788, cruising southward, Douglas discovered a harbour at Kaigani which he named Port Meares. Its inhabitants, "the most liberal, unsuspicious, and honest Indians he had ever known," helped tow him into the harbour, and he dined three of the chiefs on board (Meares, p. 165). The following June he returned to

the area and anchored in Parry Passage, where "Blakow-Conee-haw," one of his friends of the year before, came aboard:

> ...and welcomed the arrival of the ship with a song, to which two-hundred of his people formed a chorus of the most pleasing melody. When the voices ceased, he paid Captain Douglas the compliment of exchanging names with him, after the manner of the chiefs of the Sandwich Islands (Meares, ,p.221).

The chief thereafter greeted ships by crying out "Douglas-Con-neha, What's your name?" (Bishop, , p. 102). He apparently never missed an opportunity to tell the story. When the *Eliza's* journalist visited his house in 1799:

> ...the Old man told me a long story about the first vessels that visited the Islands. Cap. Douglass as well as I can learn was the first that visited this port, and laid the foundation for a firm friendship with the tribe by his kind behavior towards them, and to this day his memory is much revered among them. Cunneaw and he made an exchange of names, and the Old Man as often calls himself Douglass as Cunneaw, and always if he is asked his name by white people tells them it is Douglass Cunneaw (p. 24).

The story and the name were passed down with the chieftain-ship, and later became the property of A. E. Edenshaw (since Cun-neah had been his "uncle"), who told the tale to all who would listen. With the name seems to have gone some sort of obligation of friend-ship with the white men.

The Kaigani chiefs had European suits of clothes by 1789, dined and slept aboard the visiting ships, spoke tolerably good English, cultivated a taste for New England rum by 1799, served as pilots. In 1825 John Scouler recorded that they were the only natives trusted by the American ships (OHQ:192), though by then the ships also frequented Skidegate. By 1835, many of the Kaigani men had served aboard vessels for sea otter hunting expeditions in California waters, and had visited the Sandwich Islands (Work:20). They became so-phisticates early, knew the white man's wealth, and could never again be content to revert to the Haida life they had known before.

It is not the usual view of history to describe the Haida of that period as living in poverty, but by 1825, in terms of the fur trade, they were. Overhunting had reduced the sea otters in their own waters almost to extinction, and their islands yielded few other types of furs.

127

The trading ships had found their own way to the Nass and other mainland sources. The result was stated with remarkable clarity by John Scouler, who was on the coast in 1825:

> In former times, when the sea-otter-abounded,/the Haida/were among the most wealthy on the coast: since the sea-otter has been destroyed, the Hydahs have become poor, and have been reduced to other plans in order to procure blankets. They fabricate most of the curiosities found on the coast, but their staple article is the potato, which they sell in great quantities to the mainland tribes...They also manufacture and export canoes (Scouler, 840:219).

Coak Bay, formerly so busy, was no longer an important port of call. In his 1832 journal of the *Lama,* Captain McNeill gave recorded directions for entering the principal harbors, and of "Hansling" (Henslung Bay near Dadens) he noted "there is but few natives who live here in the fishing season, and the place hardly worth visiting" (McNeill, 1832). The early trade which had made them wealthy and taught them to want many of the white man's goods, had now almost completely passed them, the Haida, by.

It was not a situation which could be passively accepted by the Haida. Their history through the next several decades would indeed be misunderstood except as strong and definite responses to it. As Scouler observed, they took to the growing of potatoes and the fabrication of "curiosities" for sale, and stepped up the production of their specialties such as canoes. In addition they traveled more, waged more wars, and engaged in other forms of enterprise from piloting to prostitution. It was a tragic period of their history, because it reduced them almost to extinction, but it was also a period of their greatest artistic extension (production).

One hardly thinks of the Haida as horticulturists. Yet aboriginally they had been the cultivators of the native chewing "tobacco" of the northern coast, which they traded to the Tsimshian and Tlingit. In 1789, Captain Douglas saw newly sown gardens at Dadens. He did not recognize them as tobacco gardens, but assumed they had been planted by Captain Gray of the *Washington* who had been there three weeks before (which was not the case, as Gray had not anchored on his visit three weeks before), and "from the same benevolent spirit Captain Douglas himself planted some beans, and gave the natives a quantity for the same useful purpose" (Meares:227). Other early

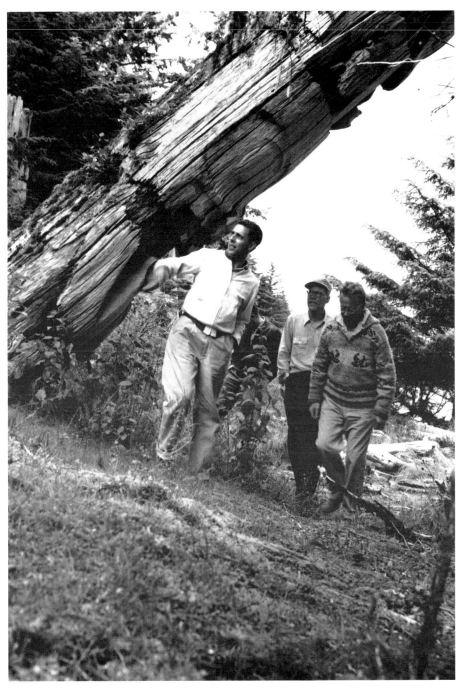

Wilson Duff, left, during the salvage project. This photograph among others documents extraction and removal of poles from Haida Gwai during the 1955 and 1957 expeditions.

Courtesy of the Royal British Columbia Museum, Victoria, B.C. PN 9050.

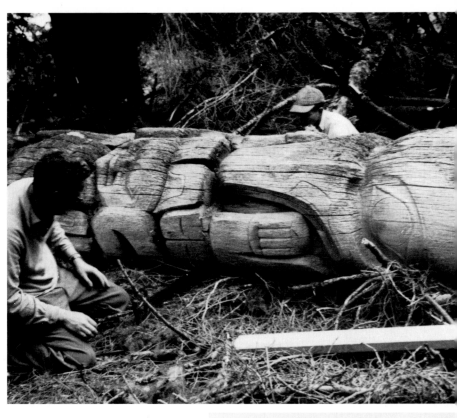

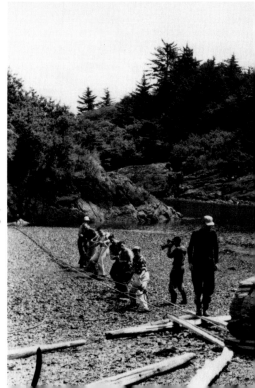

Above: Duff and assistant with totem pole
being prepared for removal.
*Courtesy of the Royal British Columbia
Museum, Victoria, B.C. PN 13975-D*

Pole, boxed for transport, being swung aboard ship.

Courtesy of the Royal British Columbia Museum, Victoria, B.C. PN 7422

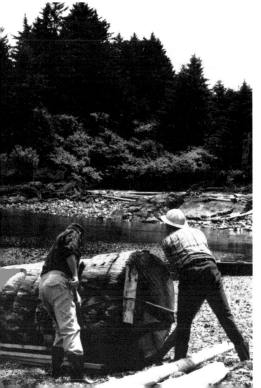

Pole on location.

Sculptured figures at abandoned village.
Courtesy of the Royal British Columbia Museum, Victoria, B.C. PN 295

Solomon Wilson, Duff's Haida informant, photographed by Duff as they left a village during the salvage work. *Courtesy of the Royal British Columbia Museum, Victoria, B.C. PN 7595*

Masset in 1884. The well-named Monster House in the foreground was the famous house of Chief Weah; its frontal pole was thought by Duff to have been carved by A. E. Edenshaw.
Photo: Robert Maynard, 1884

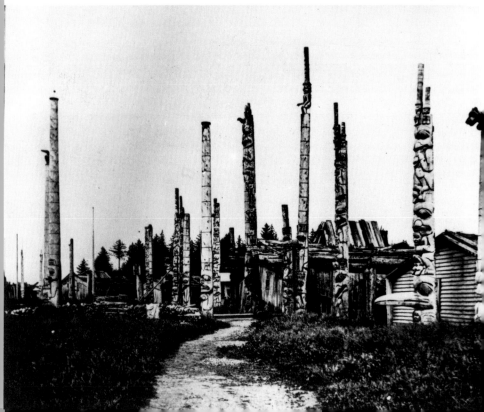

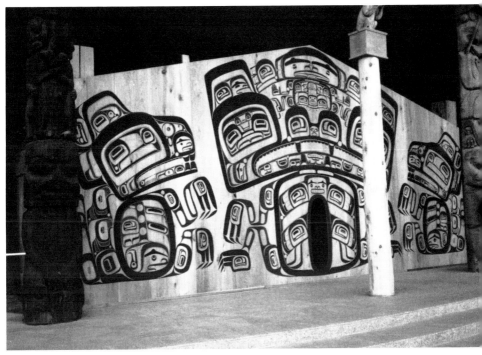

This spectacular reconstruction of a Tsimshian house front was done by contemporary Tsimshian artists under direction of William McLennan of the Museum of Anthropology at the University of British Columbia. The house front appeared to be a set of blank boards, but when McLennan photographed it under ultraviolet light the design reemerged. Here, the house front is shown among Tsimshian poles in the Museum of Anthropology. One wishes that Duff could have seen and commented on this piece.

Courtesy of the Museum of Anthropology, University of British Columbia

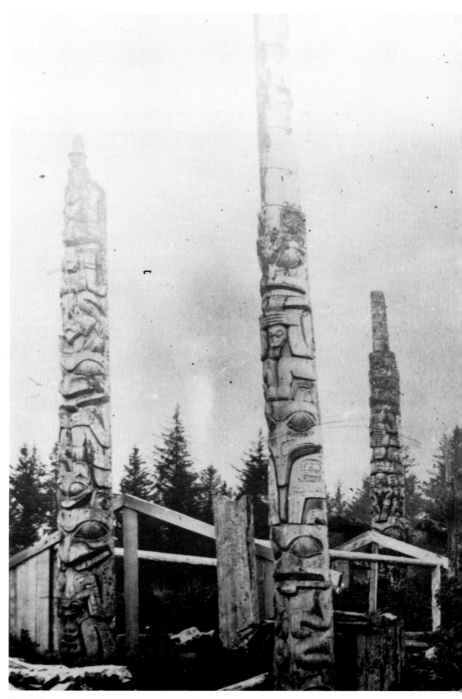

Haida houses.

Courtesy of the Royal British Columbia Museum, Victoria, B.C. PN 14

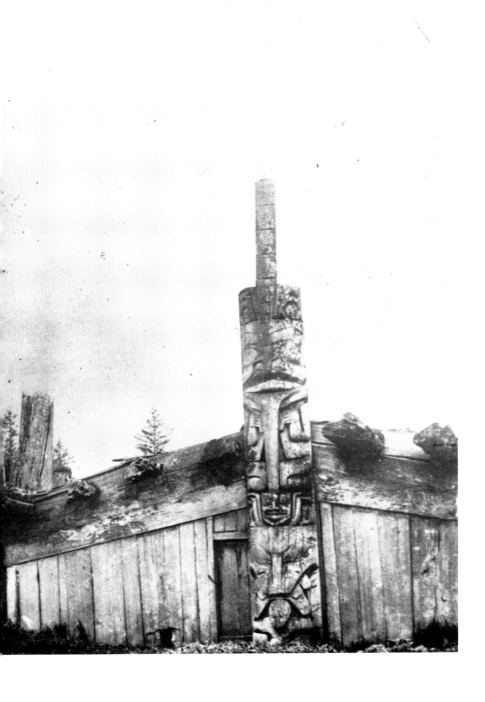

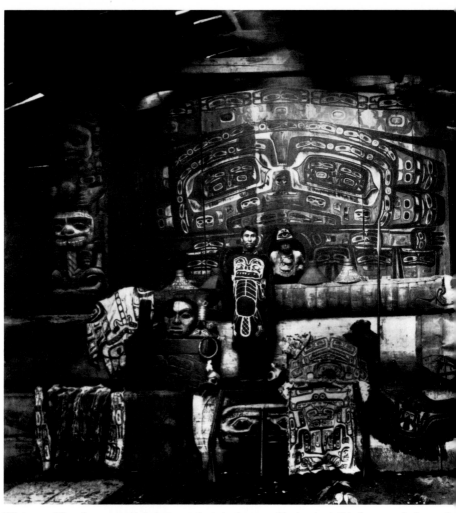

Winter and Pond, commercial photographers in Juneau, Alaska, took this famous photograph around 1895. It shows the interior of the house of Chief "Klart-Reech" of the Ganaxtedi clan. The Rain Screen stands behind the Woodworm feast dish. Poles, dishes and equipment including a giant wooden head are displayed, as well as the heirloom costumes of the men.

Courtesy of the Alaska State Library; no. PCA 87-13

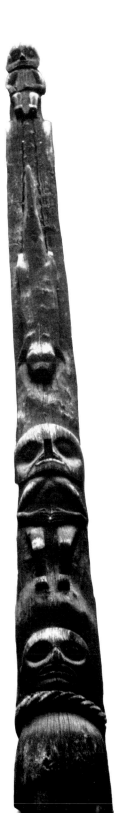

Tsimshian [?] pole,
interesting because it has the
only representation known to
me of a land otter in secular
(nonshamanic) art. Duff did
not comment on this piece
and may not have known it.
Musee de l'Homme, Paris.

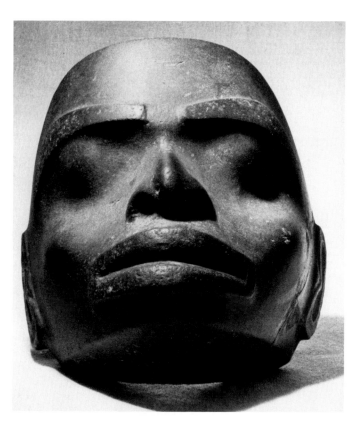

The closed-eye stone mask from Kitkatla. Tsimshian style. Compare with the photographs of this mask and its open-eyed companion in *Images: Stone: BC* (Duff 1975).
Courtesy of Musee de l'Homme, Paris

Raven rattle, Haida. This is the type analyzed by Duff, who saw the joined tongues as phallic. Others have seen them as symbolizing communication or the transfer of shamanic power. (These explanations are not necessarily mutually exclusive.)

Courtesy of Musee de l'Homme, Paris

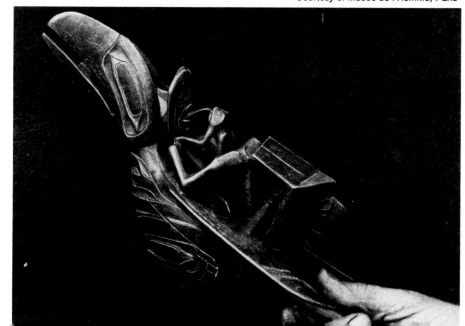

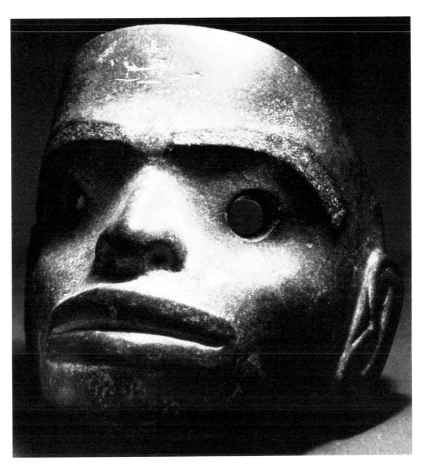

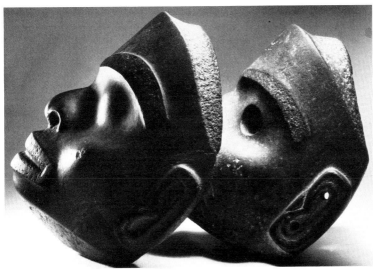

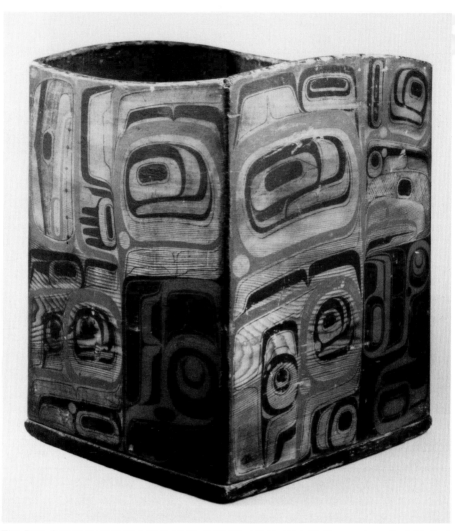

The Box. Called by Duff "the final exam of Northwest Coast art." He spent much of his last years studying and meditating on this piece. Collected by George Emmons at Chilkat in the 1880s, this box is of uncertain origin; Duff thought it was the work of A. E. Edenshaw. Its design is abstract and complex. Emmons' consultants thought it represented a seal. Duff saw it as a compressed representation of the myth of Raven creating or transforming the world. Others have seen other things (see Boas 1927). Seal and eagle motifs may be discerned in this photograph. Perhaps the artist merely used bits and pieces of several designs.

Courtesy of the American Museum of Natural History

The Box from another angle, showing other faces. From a slide, probably by Duff, in the Duff archives at the Museum of Anthropology, University of British Columbia.

Courtesy of the Museum of Anthropology, University of British Columbia

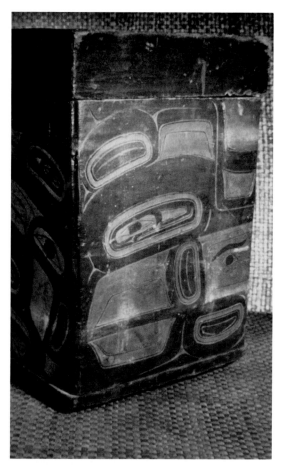

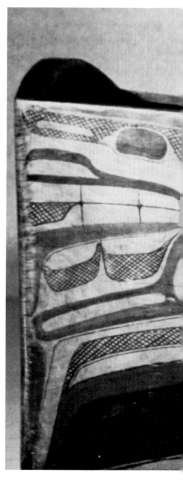

A similar box in the Museum of Archaeology, University of British Columbia; possibly by the same hand or from the same workshop. Slide, probably by Duff, in the Duff archives at the Museum.

Courtesy of the Museum of Anthropology,
University of British Columbia

The "Glenbow Box," stylistically related to The Box. Slide, probably by Duff, in the Duff archives at the Museum.

Courtesy of the Museum of Anthropology, University of British Columbia

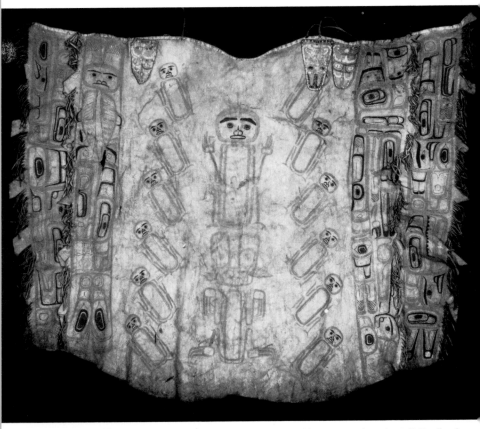

This shaman's dance shirt from Howkan—an Alaskan Haida community—is stylistically close
to The Box.　　　　　　　*Courtesy of the American Museum of Natural History (Neg. 2A 12714)*

Charles Edenshaw in 1906. Photograph by H. Carmichael. From a slide in the Duff archives, Museum of Anthropology, University of British Columbia. Note the photographic backdrop behind Edenshaw. *Courtesy of the Museum of Anthropology, University of British Columbia*

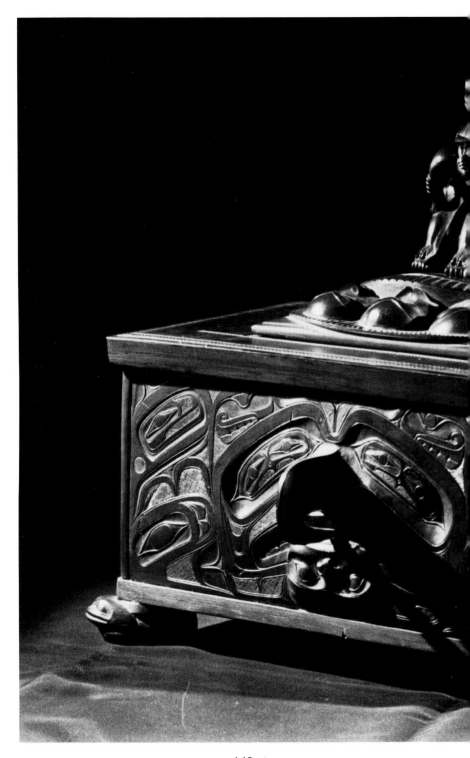

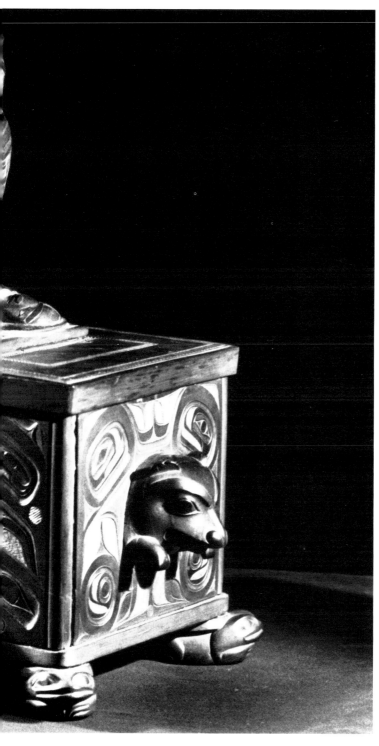

Argillite chest, surmounted by Raven, carved by Charles Edenshaw. Raven stands on the cockleshell from which his descendants, ancestors of the (northern) Haida, are emerging. This and subsequent plates showing Edenshaw pieces were photographs that Duff had collected to illustrate his proposed book on the Edenshaws.
Photo: Alex Bartra

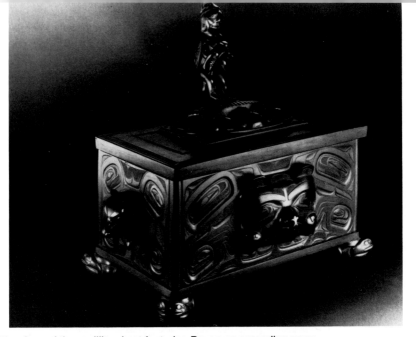

Other face of the argillite chest featuring Raven on preceding page.

Courtesy of the Royal British Columbia Museum

Argillite chest surmounted by wasgo (whale-eating sea monster). This piece has been attributed to Charles Edenshaw, but evidence is inconclusive.

Courtesy of the Royal British Columbia Museum

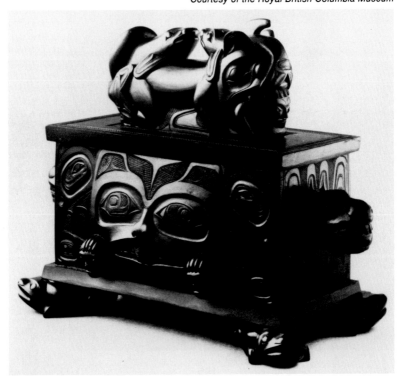

The "Raven Comport." This Charles Edenshaw masterpiece shows Raven in humanoid form carrying a box and riding on his avian form. It ranked second only to The Box in importance in Duff's thinking. From the Duff archives at the Museum of Anthropology.

The Bear Mother. This sculpture has become famous for its rugged, rough aspect and emotional qualities, but these are atypical of Haida argillite art. Duff at least sometimes attributed it to A. E. Edenshaw, but G. Dawson, who collected it in the 1870s, stated that it was made by one "Skaoskeay," collected in an unfinished state, and finished [somewhat] by Dawson's Haida assistant Johnny Kit Elswha.

The brothers of the Bear Mother killing the bear. The child is presumably the bear-human baby. His strange wink is disturbing, and seemed to Duff to be a typical Charles Edenshaw trick. Both pictures from Duff archives.
Courtesy of the Royal British Columbia Museum, CPN 248 (v.2)

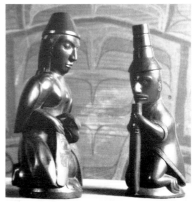

Angel and Raven (as St. Joseph?) carved by Charles Edenshaw. These are influenced by western items. Edenshaw's carvings often combined Haida tradition with themes derived from Europe, especially from illustrations of sculpture that he saw in the *Illustrated London News*. Photos from the Duff archives at the Museum of Anthropology.

153

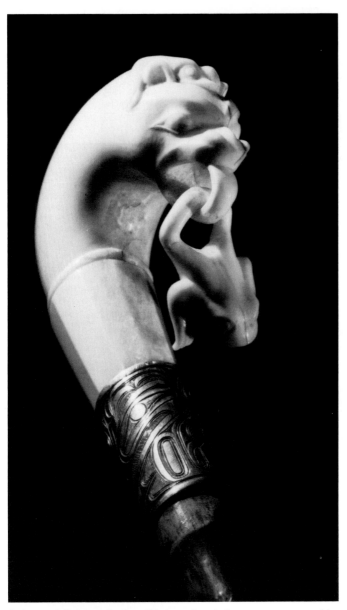

At last a definite attribution: this ivory head of a cane was carved by
Charles Edenshaw. It was one of several he made, and shows the
fusion of European and Haida themes in his art. From Duff's archives.

Courtesy of the Royal British Columbia Museum, Victoria, CPN 10677

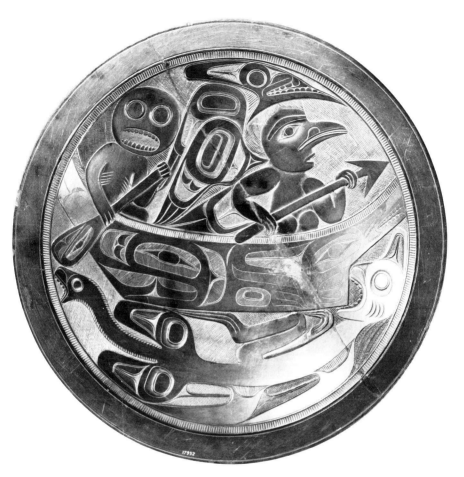

This plate is securely assigned to Charles Edenshaw. It shows Raven and a humanoid tree fungus going in search of women. Sea monsters menace the canoe.

Courtesy of the Field Museum of Natural History

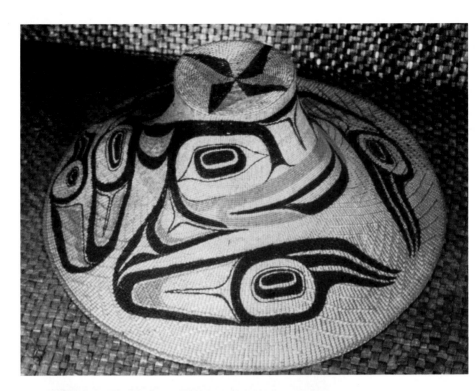

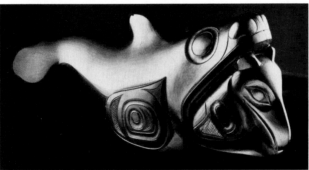

Hat painted by Charles
Edenshaw (probably made
by his wife). From a slide in
Duff archives.
*Courtesy of the Museum of
Anthropology, University of
British Columbia*

Two views of a small argillite
carving attributed to Charles
Edenshaw. From the Duff
archives.

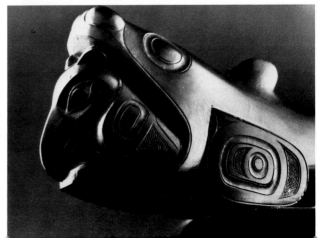

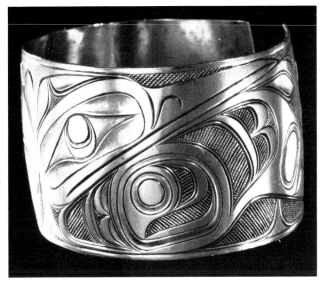

Silver bracelet by Charles Edenshaw, showing crane. The dramatic but flowing design and rather rugged appearance are Edenshaw characteristics.
Courtesy of the Royal British Columbia Museum. CPN 9523 (v. 8)

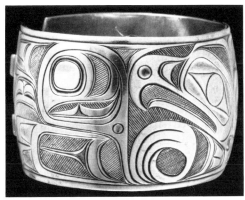

Another bracelet, showing eagle.
Courtesy of the Royal British Columbia Museum. CPN 13046 (v. 8)

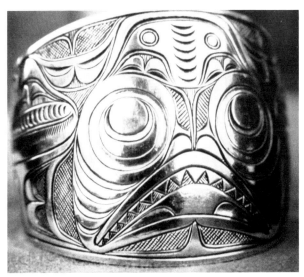

Another bracelet showing skate (shark). From slide in Duff archives.
Courtesy of the Museum of Anthropology, University of British Columbia

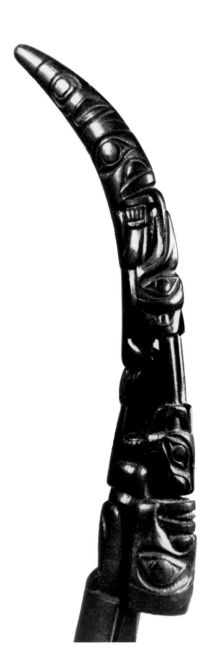

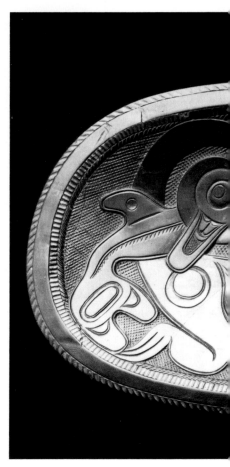

Argillite platter showing wasgo.
Courtesy Royal British Columbia Museum, CPN 15508 (v.1)

Spoon of mountain goat horn.

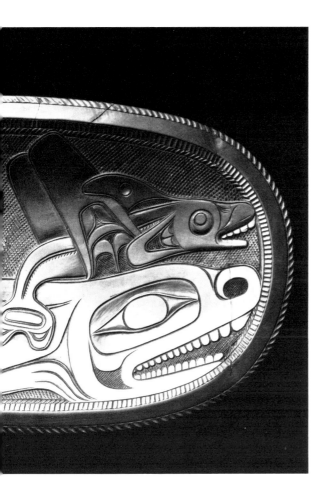

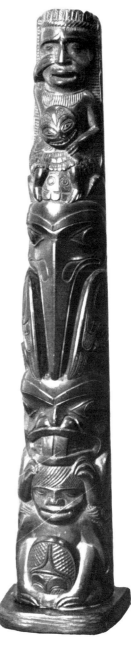

Argillite small pole attributed to
Charles Edenshaw.
*Courtesy of the Museum of Anthropology,
University of British Columbia*

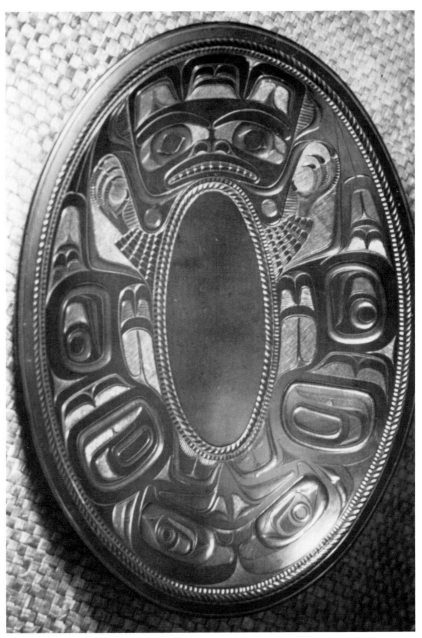

Another argillite plate. Thought by Duff to be an Edenshaw; others have made other assignments. From slide in Duff archives.

Courtesy of the Museum of Anthropology, University of British Columbia

navigators did recognize tobacco gardens for what they were: both Hoskins and Ingraham mentioned some on Rose Harbour in 1791. It is not known when the Haida began to take the white man's tobacco in trade, and to smoke pipes. The native tobacco continued to be grown until 1883 (by an old lady at Cumshewa), but no sample of the plant has survived and its exact identity remains an ethnological and botanical puzzle.

Which of the traders introduced the potato to the Queen Charlotte Islands is not clear. Howay attributes the introduction to Gray, which may not be the case if he was referring to Douglas' comment above. Dunn (1845:41) said it was an American captain. However by 1825 Scouler could say that its cultivation was "very general among them" (Oregon Historical Quarterly:191). Green, in 1829, pronounced them of a "most excellent quality," adding "some years since, a trader left a few English potatoes...and instructed the natives in the cultivation of them" (Green, pp. 38, 51). The growers sold them to trading ships and took them to the mainland to trade. Dr. Tolmie's journal in 1835 referred to the Masesets taking 400 bushels to Port Simpson for sale, and Dunn wrote that he had known the Haida to trade 500-800 bushels a season at Port Simpson (Dunn, 1845:41).

It was this same situation that led to the inception of Haida argillite carving shortly before 1820. The frequent presence of Yankee ships at Skidegate undoubtedly influenced this art form, not just in that they provided a ready market for "curios," but in the forms and some of the iconography of the earliest carvings. As has been suggested by Barbeau and others, the presence (example) of white sailors engaged in scrimshaw work may have provided the concept of such an art form in the first place. The material is found in only one place, a rockslide-quarry on the side of a mountain some miles from Skidegate. There is no very convincing evidence that the Haida made any use of it before about 1819, which is the earliest established collection date of an argillite carving (a sculptured pipe). Who discovered the quarry, and when, remain unknown. Barbeau (1953:2) says: "This soft material, it has been recorded, was discovered by white miners at the beginning of the nineteenth century," but he gives no source for the information, and I know of no white miners on the islands before 1850. Museum records make it clear that many

were collected during the 1820s. The earliest forms, curiously, were pipes, which were so elaborately sculptured as to conceal their supposed function and bear no evidence that they were ever actually intended to be smoked. Green in 1829 mentioned that "Their pipes, which they make of a kind of slate stone, are curiously wrought (p. 86)," and Dunn, writing about the 1830s, mentioned that "a soft kind of stone is found, resembling slate, which the Indians make into pipes, ornamented with various figures cut upon them resembling men and animals" (1845:411); both counts convey the erroneous impression that the pipes were smokable. Carole Kaufmann (ms.) has assumed that the prototype for these curious carvings was a Haida form of sculptured wooden pipe of a kind represented in museum collections from later decades, since several of the earliest slate pipes are of a vaguely oval outline rather than the more common, straight-based "panel" form. However it has not been established that the Haida had adopted the custom of smoking pipes that early, and if they did, whether they made such oval wooden pipes.

The oval form of slate pipe, according to Kaufmann's chronology of argillite carvings, persisted only until the 1840s. Panel forms were made from the beginning of the slate industry until the 1860s; from 1840 on, some of them dropped any pretense of being pipes (having no bowl and drilled stem) and became just panels. From the beginning, the panel pipes were of two different varieties depending on the subject matter depicted. The one shows animal and human forms in a classic Haida style crowded into intricate compositions, often of great beauty. The other, which may have begun slightly later than the first and outlasted it by a couple of decades, depicts white men, and parts of ships, and all manner of non-Haida things, in awkward compositions. Some of these, though still flat panels, take an overall form derived from a ship's hull; others have straight bases supporting houses, fences, foreign farm animals and other subjects, evidently copied from illustrations in papers or books. Some of the panels of the latter sort were not made of argillite, but made of materials other than argillite; a batch given to the Wilkes Expedition by Hudson Bay men at the mouth of the Columbia River in 1841 are made of wood, painted and inlaid with parts in ivory and whalebone (now in USNM, see also Seibert, Figs. 23, 24 for a similar one in a

Moscow Museum). This was "fabricating curiosities" indeed and they served no purpose to the Haida other than to sell.

The argillite industry therefore began as a sort of Haida scrimshaw for the "curio" trade. Pipes and panels were augmented during the 1840s with statuettes of sea captains and other white people in uniforms typical of the period, etc. and plates and platters decorated mostly with geometrical and floral designs; and during the 1850s and 1860s most, perhaps from one man, with flutes. About 1865 the first model totem poles appear, and these remain the dominant form thereafter. Groups of figures, of Haida mythology, carved chests or caskets, comports, and a few other forms were made in numbers after the 1880s, and were made by some of the artists later to be dealt with....

* * *

Argillite was not the only medium for Indian curios. From the beginning the seamen had collected as souvenirs any portable items of material culture which the Haidas would sell (part) with. Kaufmann suspects, as others do, that the number of portrait-like face masks collected by the early mariners were more than the number required by the Haida for their own uses. This tribe and others on the coast seem to have made model canoes and doll-like figures in early times, and painted paddles, dishes and things which they had no hesitation in selling. Even rattles and other semi-sacred objects could be replaced, and would be sold, in some cases.

Haida arts and industries for export included such local specialties as canoes and wooden chests made for trade to the mainland tribes. These items had long been part of their stock in trade when they went on their annual journeys to the Nass to trade for eulachon oil and other products of the mainland, or north to the Tlingit tribes who had no such fine cedar in their territories. Undoubtedly these industries grew as the Haida trade to Port Simpson increased. Many are the stories of the arrival of Haidas in a flotilla of fine new canoes, and their departure for home in patched old hulks dangerously overloaded with the products of their trading. Such was their reputation as expressed in 1858 in the Victoria *Gazette* (August 18, 1858). The Haida:

...are distinguished above all others on this coast for their ingenuity and skill in mechanics and the "fine arts". Some specimens of their workmanship...in carving miniatures out of slate, are really creditable as works of art; and their canoes are perfect models of nautical beauty.

High praise indeed for the time.

By the time the canoe industry succumbed to technological obsolescence in the 1890s, Masset had come to be known as "the Clyde of the Pacific." A small number of large canoes continued to be made on commission until about 1910. With the death in 1969 of Robert Davidson of Masset, at the age of 83, the last of the old Haida skilled in canoe making was gone.

Chests and boxes bearing carved or painted designs were less well-known exports throughout the same period. In addition, with the greater freedom of travel along the coast, Haida artists spent periods at such places as Sitka, Port Simpson, Bella Bella, Victoria and Port Townsend, where they made their wares for sale or worked on commissions for local chiefs. I do not mean to give the impression that the Haida were the only artists on the coast; I do want to explain how it was that their products were spread so far and wide by the time the main surge of museum collectors arrived.

It has to be added that another business which proved lucrative to the Haidas and others from the beginning was female prostitution. When the writer of the *Eliza's* journal stayed ashore overnight at Kiusta and enjoyed the hospitality of Cunneah and his wife—as he records it—"the Old Woman proceeded to the last offer of Friendship, which was a lady for the night, out of her numerous Seraglio, with which she accomadates all Vessells that stop here." He declined the offer. In 1829, Green was told by the then chief "Kowe" at Kaigani "that all the young women of the tribe visit ships for the purpose of gain by prostitution, and in most cases destroy the children, the fruit of this infamous intercourse" (p. 68). When the Hudson Bay forts were built along the coast, it was Haida and Tlingit women who were preferred by the men as wives. Later, in the great annual migrations south to Victoria and other southern settlements, prostitution and the marriage of women to white men was so general that although the proceeds helped create many a fine totem pole back home the practice contributed to the disastrous decline of Haida population until their conversion to Christianity in the 1880s.

Such were the products specialized in by the Haida when their fur supplies dwindled: potatoes, argillite and other curios, specialized local industries such as canoes and boxes, and new enterprises from piloting to prostitution. Yet there is another of their massive responses which has to be understood: in order to stay in with the action they became compulsive travelers and all too often emigrants. The Hudson Bay Company established no fort on the islands, although there was a very small post at Masset from 1853 on. The post most accessible to the Haida was Fort Simpson, established first in 1831 at the mouth of the Nass and moved in 1834 to the mainland coast south of the Nass where the native Tsimshian village of Port Simpson still exists. The Nass had always been the main center of trade of this part of the coast, where all surrounding tribes including the Haida met each spring while the eulachon fishing season was on. The Haida did not have rights to fish there, but traded when they were not at war. The establishment of Port Simpson gave a powerful additional incentive to these trading expeditions, and in fact being more accessible became a more easily accessible center for trade of all the northern tribes; in which role it remained pre-eminent for several decades. Visits to the fort, especially in the early decades, remained incursions into foreign territories, and the Haida were as often embroiled in wars as they were engaged in peaceful trade. In addition, they continued to probe north as far as Sitka and south as far as Bella Bella, earning a deserved reputation as the scourges of the coast.

One of the greatest population movements on the coast, as yet too little described (known), was the immense annual exodus of the northern tribes (the Haida most of all) to Fort Victoria between 1858 and 1862. The sudden and exciting growth of Victoria as a result of the Fraser River gold rush in 1858 was undoubtedly a main stimulus. It was a long and perilous journey through enemy water channels, to be undertaken only by strong fleets of canoes, with the full expectation and intention of raiding and of being raided (ambushed). The Haida already had their reputation as warriors, and they lived it to the full. There are even stories that they felt themselves capable of taking Victoria itself on their first visit (e.g. St. John, 1876), presumably in 1858 (Dunn says 1853).

The Victoria *Colonist* provides quite detailed information on the

arrivals and doings of these northern fleets. In 1859, for example, the newspaper recorded on April 23 that eighty canoes containing 1,000 Haidas had arrived from the Queen Charlotte Islands. On May 14, according to a letter on file in the Provincial Archives (Woolsey, 1859), the Indian encampments north of the town were disrupted by a brief shooting war between 600 Haidas and 200 Port Simpson Tsimshians, in which several people on both sides were killed or wounded. According to the account, about 4,000 spectators watched the action from high ground on the town's northern outskirts. On a crude sketch map, he showed not just the Haida and Tsimshian camps, but camps of "Stikines," "Georginas" (Tchachini or Kasaan Haidas of Alaska?), "Bella Bellas" and Cowichans. The other tribes armed themselves and stood ready to fight the Haidas, who were regarded as the common enemy, and shortly after the battle most or all of the Haidas left town. The *Colonist* of June 27 reported that there had been fights between the Haida and Cowichans up the coast.

Some Haidas wintered in Victoria that year, and more arrived in the spring of 1861. On April 5 the *Colonist* reported that 54 canoes of Haidas and Stikines had arrived, and on June 12 "a large number of Haidas arrived from the Queen Charlotte Islands," and "it is said over 1,000 warriors are on their way down." The Fort Simpson Journal entry for June 14 noted that "a large fleet of Hydars" had arrived there, including "Edensaw, Wehar, and Neestakannah," who were the chiefs of Kiusta, Masset and Skidegate, respectively. The *Colonist* of July 31 reported the arrival of eighty Haida canoes at Nanaimo on their way down. Stories on August 4 and September 1 told of the northern Indians leaving in large numbers for home.

Another perspective on the summer migration of 1860 is available from an account of a trip to the northern villages made by HMS *Alert* (Cooper, 1960), written by the harbormaster of Esquimalt. The vessel was one of three ships of war sent that summer to tour all the coastal villages and persuade the Indians to cease their warfare and slave-taking, especially during their annual trips to Victoria. If one single event should be chosen to symbolize the imposition of the Pax Britannica on the coast, this was it. On July 31, on the way north, they met at Nanaimo the Haida fleet of Chief Edenshaw. The *Alert* went on to the Queen Charlottes with the intent of visiting all of the villages. At "Laskeek" (Tanoo), Cooper recorded, the Indians "ap-

pear anxious to live at peace with all in order that they can make their annual visit to Victoria unmolested." The population of the village was judged at 400 souls, but many were away "at Victoria, or on their way thither." At Skidegate the chief "Estercana" (it would appear that although he had accompanied Edenshaw to Port Simpson [see above: Neestakannah] he had not gone to Victoria) beseeched them to "write down and tell Mr. Douglas and the Man of War to send all my people home, I wanted to build a large house this summer and nearly all my people are away at Victoria."

Later the ship visited Virago Sound, where a chief "Conday" had just returned from a visit to Sitka. Then on September 8 she proceeded to Parry Passage and visited Edenshaw's village of Kiusta, which was completely abandoned. They went ashore to the village, which is a very large one, but "on our landing it bore a melancholly and desolate appearance, as not a soul was to be seen, the houses covered inside and out with rank vegetation, bearing the resemblance of having been deserted some time. The chief 'Edenshaw' we met at Nanaimo on our way north who is at this time probably at Victoria with the whole of his tribe. This circumstance is suggestive of great difficulties in case of any trouble arising at Victoria,...inasmuch that they would not have provided a winter stock of provisions."

The weather being fine, the *Alert* paid a ceremonial visit to Sitka. Cooper found that the Indians there were so influenced by the market and attractions of Victoria that they withheld their furs from the Russian-American Company. He predicted that they would make an alliance with the Haida: "an event not at all improbably as interchanges between the tribes are of more frequent occurrence than formerly" (witness Conday's visit), and join the annual migration to Victoria. The annual voyages of Edenshaw's people to Victoria were at least 600 miles each way, and the Sitka people would have had to travel an additional 250 miles each way.

Several questions about these incredible journeys remain unanswered. What indeed did they do about provisions en route, and about the next winter's food supply? Booty from raids on the villages along the way may have been substantial. By saving their furs to sell on the Victoria market they may have increased their incomes. There was some work at jobs in Victoria and other settlements, and there

was the general prostitution. In addition, however, there must have been a considerable amount of making and selling of curios; that is, a considerable incentive to the arts.

The calamitous smallpox epidemic of 1862 devastated the northern tribes and put an end to their fearsome power and their great annual voyages. The story of how it began in Victoria in April and spread into the camps of northern Indians, who were then driven out by the authorities to carry it with them up the coast, has been told elsewhere (Duff and Kew, 1957). All the northern tribes (with the one exception of the Christianized Tsimshians who had just moved to Metlakatla) were decimated, and the Haida as badly as the worst. From Victoria, it looked as though they would be totally extinguished, and the *Colonist*, on June 12, 1862, printed a sort of epitaph, entitled "Good Bye to the Northerners." A gunboat had been sent to Cadboro Bay and had "supervised the embarkation for their homes of about three hundred Northern Indians." On the request of the chief, "Edensah," the vessel escorted them past Nanaimo, where the Indians were waiting to settle some old scores against them. The story concluded:

> How have the mighty fallen! Four short years ago, numbering their braves by thousands, they were the scourge and terror of the coast; today, broken-spirited and effeminate, with scarce a corporal's guard of warriors remaining alive, they are proceeding northward, bearing with them the seeds of a loathsome disease that will take root and bring both a plentiful crop of ruin and destruction to the friends who have remained at home. At the present rate of mortality, not many months can elapse 'ere the Northern Indians of this coast will exist only in story.

The epitaph did prove to be premature. Yet the cumulative effect of all these causes was to bring the Haida perilously close to extinction. In the 1830s, on the best estimates, there had been more than 6000 Haidas in a dozen large villages on the Queen Charlottes; by 1882 when the first reserves were surveyed, they were reduced down to about 900, scattered in nine villages; and by 1900 they had congregated in just two, Skidegate and Masset, and numbered only about 600 (1360 in 1969).

We are spared any detailed knowledge of the small pox overkill in Haida villages. Outside visitors were very few during the 1860s and early 1870s. The prediction of their complete disappearance was

premature. The epidemic did break them as a power, but did not stop their visits to Victoria and did not stop their productivity as artists. The contemporary accounts of the Haida present us with a conundrum: in European eyes they had fallen into a life of debauchery and vice, yet it was in this period that they produced some of their most magnificent totem art poles.

The prevailing view of the time is well expressed by M. St. John, a literate gentleman who was in the party of the Governor General, Lord Dufferin, which paid a quick visit to Skidegate in 1876. The Charlottes were little known at the time, and St. John had not been there before, although he had known the Haidas of earlier years in Victoria. His comments are typical:

> During the last few years a great change has taken place in the once fierce and intractable Hydahs...[Their early visits] to Victoria gave them a taste for the debauchery of civilization, to which they have yielded themselves unreservedly, and before which they will go down like withered reeds. They have abandoned their predatory excursions, and now, taking their young women with them, they set out for Victoria, timing their visit to be there during the season when the minors are arriving from the interior. During their stay in their own homes, much of their time is spent in carving bone, slate, or silver ornaments—the latter being worn in great profusion by the women—for sale in Victoria (St. John, 1877, pp. 35-6).

The visitors had difficulty in reconciling that view of the people with the splendor of the array of huge wood sculpture in Skidegate. They arrived at the village late in the evening, and had the enchanting experience of coming to it not knowing what to expect and seeing it first by moonlight.

> The houses themselves were partially lost to view in the shadow of the hills, but the ascending columns in their varying heights rose clear above them in the moonlight, and gave the village the appearance of an Eastern city with innumerable minarets (p. 25).

Next day at dawn they went ashore again. The village consisted of about forty houses in one continuous line, and was almost deserted. What impressed them most was:

> ...the array of carved cedar pillars and crested monuments that rise in profusion throughout the length of the village. In the centre of the front face of every house was an upright pillar of cedar, generally about forty feet high... From base to top these pillars had been made to take the forms

of animals and birds, and huge grotesque human figures...The carvings were in some places elaborate, and in many places coloured. Some of the pillars, a few yards in front of the houses, were surmounted by life-size representations of birds or animals, the token of the family, coloured in a fanciful manner...The main and tallest pillars, however, were those of which one formed the centre of each house, and through which entrance was had into the interior.... I can hardly exaggerate the surprise which was generally felt at this unexpected spectacle...an Indian town of such indisputable age, with such evidences of dexterity in a branch of art...Again and again it was asked where did the Hydahs obtain the models from which they have copied, since they never could have seen what they have carved about their dwellings (St. John, pp. 28-30).

How could such monuments be created by such people? How could one understand their "deserting a splendid home to live by the practice of vice and die from the effects of gin?" (p. 51) "They will probably soon be extinct," the same writer wrote in another place. In contrast with the Tsimshians, who has become "sons of the Church," they had chosen to adopt "the vices of civilization," and were now peaceable and resigned to their gradual disappearance. (St. John, c. 1886)

Conversion to Christianity, the remaking of their lives by the strong-willed missionaries of Anglican and Methodist faiths, began for the Haida in 1876 and was completed by 1890. The years before their conversion, the 1860s and 1870s, were for them a strange paradox of glory and corruption, cultural growth, climax, and cultural decay. There were the examples of Metlakatla and Port Simpson just across on the mainland side. There the Tsimshian had forsaken their old life and arts, but they seemed freed of the plagues disease and alcohol that were decimating the Haida, and were prosperous in new ways. The Haida abhorred some of the changes but envied others. They asked for missionaries and the new order they brought.

With conversion, the things considered pagan ceased to be made, ceased even to be kept. No more old style houses were made after the mid-1880s, which meant no more carved houseposts or portal poles. The practice of burial in the ground put an end to mortuary poles. Shamans, the first target of the missionaries, ceased to hold sway, and gave up their rattles, charms, soul-catchers. Dag-

gers, clubs, clan helmets went with war. The social structure crumbled—few more chiefly robes, staffs, headdresses, feast dishes.

But not all of the old arts were tainted with paganism. Canoe making, box making, etc., for a while were necessary crafts. The artists were heir to a long tradition of art for sale as well as art for use; those whose careers spanned pre- and post-Christian decades (few, as the population was small) dropped some old media and concentrated more on new: slate carving, jewelry making and the making of models and specimens for collectors. In slate they carved miniatures of some things they were no longer carving in wood, like totem pole (models) and chests-caskets, and portraits of figures of the past, portraits of the past: shamans in groups, etc.; also new Victorian things like comports, caskets, dishes.

* * *

What was going on in Skidegate in 1880? An intense ideological battle between old-timers and Christians, led by Amos Russ. Jim Kelly (d. 1895) was a Christian. What was going on in the art? It continued as a shadow of Haida thought.

171

11

Levels of Meaning
in Haida Art

Art conveys meaning by providing visual messages which can be generalized by metaphor to mean more things. Two different kinds of visual messages may be used, and these are generalized by two different kinds of metaphor. The result is two different modes, axes or levels of meaning. I suggest that these be called the "*iconographic*" level and the "expressive" or "*iconic*" level. Artistic statements, like verbal statements, convey much more meaning when they include "predicates" as well as "subjects," messages expressed as well as identified topics. The "iconographic" level of art is concerned primarily (and in some art styles, solely) with identifying the subjects. The "iconic" level is concerned with providing predicates.

Haida art, as exemplified by Edenshaw's painting of the Raven crest, offers an unusually revealing case study of the interplay between these two levels of meaning. The iconographic level identifies what and who the art is about, by answering the question (the only question we have so far thought to ask of Haida art) "what does it represent?" Edenshaw's painting represents "Raven," and also by extension other subjects for which Raven stands as a metaphor. The

iconic level enriches the artistic statement with predicates, by answering the further question "but what else is it trying to say?" Edenshaw's painting, I am now convinced, is trying to say many things, in fact it is straining to say everything it is capable of saying, about matters of supreme concern such as the proper conduct of Haida life, the essential shapes of things in the world, and the harmony that can exist between them.

The visual messages of the two levels of meaning are generalized on different kinds of logic, corresponding to the ways in which the mind, in its search for order, deals with "wholes" and with "parts." For an understanding of the profound importance of this difference I am indebted to the psychologist Silvano Arieti (*The Intra-Psychic Self*, 1967). According to him, the mind generalizes (creates classes of like things) in two fundamentally different ways, which result in the creation of two different kinds of classes. "Secondary classes" are products of our everyday logic and provide us with our regular food for thought. They consist of those things which are alike as wholes, which share all of their essential attributes in common (e.g., all "ravens") They are concepts, for which we have words. "Primary classes," on the other hand, are products of an archaic form of logic called "paleologic," which is part of the "primary process" of cognition. They consist of those things which are alike in part, which share one significant attribute in common (e.g., all girls named Mary). Paleologic responds to them, however, as though they shared other attributes as well, as though similarity meant identity. Paleologic still comes into play in dreams and in schizophrenia (where it leads to such results as "I am Mary, so I am the Virgin Mary.") It also continues to operate, but now with self-awareness, in *metaphor*, which permits us to express similarities between things in different secondary classes, and thus see more order and meaning in the world.

One way to make art "mean" more things is to generalize the subject so that it is "about" more things. It is the role of the iconography to start this process by identifying to the eye and the mind a single primary subject ("Raven"). The generalization embarks from this concept, but it occurs in the mind, not in the art. The mind expands the subject either by metaphor ("Raven" may stand for "people who use Raven as crest"), or by the logic of the part

standing for the whole ("people who use Raven as crest" may stand for "all Haida"). The subject of Edenshaw's painting can therefore be read simply as "Raven," but it can also be generalized to mean "people who use Raven as crest," and even further, when the predicate requires it, to "all Haida," or even conceivably "things in general." This would comprise a preliminary list of things Haida art may be about. It is a limited chain of secondary concepts at ascending levels of generality, linked in a sort of taxonomic hierarchy, and anchored in a single primary concept.

Another way to make art mean more things is to create predicates, and generalize them, so that the art "says more things about" its subjects. The provision of predicates is the primary role of the iconic level. Its visual messages are not wholes like the icon "Raven" but parts: elements, attributes, relationships. Nor are its meanings anchored in a single concept, they can embark from any of the multitude of perceived attributes within the design. The visual messages already have the stance of predicates, because of their dependent relationship to the iconography. They convey their meanings by suggesting to the eye and the mind analogous predicates in other systems (the curve of a line may suggest a movement in dance, or a path of human conduct or the shape of the sky). The analogy creates a new metaphor, bringing into mind a new subject. It is a metaphor of predicates, not of subjects. The iconic mode, therefore, can not only "say things about" the subjects, it can conjure up (create) more subjects to say them about. And not least among its meanings, as a satisfying by-product, is the repeated confirmation of the very premise from which it starts: that things in different classes do have essential similarities; that order, verity, beauty do exist in the world.

When we look at the visual arts of our own Western tradition, most of us remain unaware that there may be a level of meaning beyond the iconographic. Western art has developed a complex iconography, containing both subjects and predicates, and tends to carry a very large share of its total meanings at the iconographic level. In most works of painting and sculpture, indeed, there may not be anything beyond. In the great works of the finest artists there do seem to be deeper meanings of the sort which I am calling iconic, but that seems to be an esoteric matter understood by few. Our general habit in approaching a work of art is to learn what the iconography

represents, and explore the ideas associated with the subject, and be satisfied with that. It is a habit which we should learn to break in looking at the arts of other cultures.

Our previous studies of the northern style of Northwest Coast art have failed to recognize the iconic level as a level of meaning. Our habitual aim has been to find out what the iconography represents, and then veer off to pursue the cultural associations of that segment of the meaning—a pursuit rewarding enough in its own right. The iconic level has entered our awareness only as "style"; and this most distinctive of all art styles has been masterfully analyzed and described by Bill Holm, but not explained. Each of us, from Boas on, has felt massive frustration at our inability to reach a satisfactory comprehension of what we know intuitively to be the greatest masterpieces. We have uneasily evaded the issue by speaking of the art as becoming increasingly "decorative," "applied" and "abstract." What we have failed to see is that "style" must be understood primarily as another level of meaning, and that this particular style carries such a heavy share of meanings that it may at times dominate or even submerge the iconography.

Iconography in Haida Art

Iconography may be considered the "shallow" level of meaning in art, since usually—and I think necessarily—it conveys its portion of the meaning first. Its visual messages, "icons" like Raven, are wholes in form as well as in thought. Visually they are perceived as gestalts, because the eye, in its search for meaning, projects preexisting perceptions onto the work of art until it finds a "fit." The icon identifies itself by name, because such concepts are mediated by language, and "there is a word for it." Its meanings, in the sense of its mental associations, already exist prepackaged in the mind. All that the icon has to do is trigger into consciousness these existing meanings; and in fact that is all it is capable of doing. Visually, it has only to meet the minimum requirement, recognition, to accomplish its entire job. A simple pictograph tattooed on a Haida chest evokes the same concept, with the same semantic load, as Edenshaw's mural. No amount of enrichment of the image, no more faithful portrayal of Raven as it is in nature, can add to or

detract from this aspect of the meaning. Raven remains Raven no matter how well or poorly it is depicted. The locus of iconographic meaning is in the mind, not in the art. The Haida artist took care of that chore with a minimum of bother, for it was too easy a part of the artistic task to deserve much effort, and got on with the more challenging ways of conveying meaning. The style, creativity and beauty we admire in Haida art do not reside in the iconography as such.

Iconography is rooted to the natural world of tangible and visible things. To the implicit question "what is the topic?" it can only reply with the likeness of a thing which is normally concrete and visible. Such a "thing" may already be abstracted and generalized a couple of steps out of the chaos of the actual world, it may be the species "Raven" rather than a particular black bird, but it derives its identity from its isomorphism with a constant class perceived in nature. There are no natural icons for nouns such as "song" or "happiness." The language of iconography has a very limited vocabulary.

Traditional Haida art (i.e., excluding argillite) utilized only segments of this natural vocabulary: those dealing with humans, animal "species" of the natural (including supernatural) world and mythical creatures. The main purpose it served in the culture was totemic, to make the social system visible by providing crests to stand as visual metaphors for the different groups of people within the society. The distinctiveness of animal species in the natural world provided the metaphor for the distinctiveness of social groups in the human world. The "natural" world was conceived widely enough to include "supernatural" creatures like sea-bears which the Haida knew to be there, and also mythical beings like the culture hero Raven in all his guises, who had once been present. The iconography was also extended to include specific characters of myth, like the woman shaman with her circular rattles from the myth of Gonaqadet. In total, however, it remained a small and narrow vocabulary of subjects.

Haida iconography as such aspired to convey only a limited load of meaning: it identified the subjects but seldom attempted to provide predicates. When the creatures were shown "doing" something, like Bear Mother holding her cubs, the purpose was simply to identify the subject more specifically (unlike the traditional European "Mother and Child", which creates an iconographic predicate by

generalizing the relationship *per se*). Perhaps the first steps toward a more complex iconography are found in a few metaphorical acts, like the joined tongues on Raven rattles which seem to depict the conveyance of essence or power, but by and large it was a simple iconography. This level of Haida art, in summary, consisted of a restricted vocabulary of subjects without predicates, utterances started by not finished. It was hardly a sufficient vehicle alone.

Iconics in Haida Art

The iconic level is "deeper" within the art and intrudes itself less easily and less fully on the viewer's consciousness. Its visual messages in the design are not wholes but parts, details, and its meanings arise out of their character as open metaphors which invite analogies. The "parts" may be elements or attributes. Design elements such as formlines may be perceived as entities without being icons, and their conduct and relationships may invite analogy with similar conduct and relationships in other realms, such as the affairs of men. Or the "part" may be an attribute, inviting analogy with similar attributes in other systems: the curve of a line may be seen as the shape of an act. The analogy conjures up the metaphor, suggesting the new subject to which the meaning applies.

If icons are "symbols" of the bundles of preexisting meanings they trigger in the mind, the units of iconic meaning are "signs." They have to "look like" the ideas for which they stand. To say a beautiful thing, the iconic message has to be a beautiful thing. It has to activate the imagination, create the metaphor, bring into existence the new primary class for which there is no name. If the locus of iconographic meaning is mostly in the mind, the locus of iconic meaning is mostly in the art. In iconography, the visual message (icon) is isomorphic with a whole, but does not have to resemble it very faithfully in order to identify it. In iconic design, the visual message is isomorphic with a quality or attribute, and has to mimic it exquisitely in order to get its subtle meaning across.

Getting the iconic meanings out of a work of art can be almost as difficult as getting them in. Because meaningful statements require subjects as well as predicates, the searching out of the iconic messages cannot be dissociated from the reading of the iconography.

From the outset the iconography takes a head start, intruding its primary message first. It is no mistake to speak of "reading" the iconography, for to recognize the icon is to discover its name. Reading the iconography is essentially a process of verbalization; art names its subjects, but only suggests its predicates. However, since the deep meanings are presumably about the same general concerns as the shallow meanings, the recognition of the icon is a necessary first step in pinning down the topic (finding what the art is about).

Having read the icon ("Raven,") the viewer may well generalize the subject to the level of human concerns ("people who use Raven as crest," which implies that the concern is with social behavior), for these are what interest him the most. In the iconic realm, however, there is no such easy and logical way to capture the mind and launch it to the first plateau of higher meaning. There are no ready-made categories of meaning. But by the same token, the iconic meanings are not restricted to existing classes of related things. Ideally, they are limited only by the artist's power to imagine and suggest, the viewer's to perceive, and the ability of the mind to find order in the world. However, on this axis as well, it is the analogies with the affairs of men that are of most interest to the viewer. Dwelling on this level, the iconic meanings suggest the ideal shapes of conduct in Haida affairs. Haida art is mostly about the conduct of Haida life.

Iconic statements are statements initiated with predicates rather than with subjects. Such statements are perhaps more congenial to those peoples who use a metaphoric mode of thought because they start with an open metaphor, a general truth, and let the mind choose which specific meaning to apply, rather than pinning down the meaning at the start. Iconics is the language of metaphor (analogy?) in art, opening the way to the full use of metaphor (analogy?) as a method of cognition.

Iconic meanings are not, perhaps, confined to the cognitive, conceptual levels of experience. They are free to depict all predicate states, both cognitive ones of the sort which can also be mediated by language, and non-cognitive, experiential ones of the sort, for example, which are mediated by music. The shape of an iconic message, like the "shape" of a musical phrase, may be isomorphic not with a concept but with a feeling, urge, emotion. It yields its meaning to

empathy, not analysis. Haida art, perhaps, depicts feelings as well as thoughts.

In Haida art the iconic messages are exceptionally abundant and expressive. Most fundamental attribute is a pervasive quality of exquisite precision and control, which says that every line, every relationship, even every "mistake," is exactly the way it should be, on purpose and with meaning. Every element has its own space, or field of force, and its own standardized role. It is not always possible to separate entities from attributes; for example, the "formline," which is the most typical design element, acts at the same time as an entity and its path of conduct. Haida lines are precise, self-conscious curves: sensitive boundaries, or lines of mediation, or steered lines of action (content). There is structuring, with inner lines of force and striving. Some of the shapes, like the "ovoid," are cosmic shapes, the ideal shapes for things to be. There are primary and secondary, dominant and subordinate entities in Haida design, as there are elsewhere in the Haida world.

Haida art is preeminently an art of line. Distinctive lines eventually create distinctive new forms, which invite identification as icons. When such emergent forms become fixed, but do not refer back to forms in nature, we may suspect that a new kind of icon has been created. The "salmon trout head" motif seems to be such an iconic icon. Not burdened with a natural meaning (it does not represent a salmon trout head any more than a "herringbone" pattern represents a herring), it is free to take more abstract meanings, such as (let me reveal a hunch) "nephews." [This hunch was abandoned later-ENA.] Yet it remains iconic, inviting analogy with all things that share the attributes common to salmon trout and nephews in Haida thought: life, growth, promise, emergence. It is in microcosm what all Haida art was striving to become: a beautiful design, constructed from beautiful behaviors, conveying an open-ended range of meanings which align man and his conduct with the cosmic shapes of the world.

Style

Most of the iconic meanings in art are latent and implicit, lying mutely embedded in the "style." That, to a very large degree, is what "style" is. The young artist learns the art style of his

people as a craft, just as he learns to make a speech, or perform a dance. He is necessarily conscious of its attributes as craftsmanship and visual design. But he is not necessarily conscious of all of the meanings which his predecessors incorporated into the style, the analogies which they expressed by patterned nuances of visual design, which are still there, gently urging (intruding) their meanings on the consciousness. One suspects, however, that in an art so highly "stylized," while the tradition was still alive and evolving, many of these meanings must have lain very close to the threshold of consciousness. As he graduates from craftsman to artist he develops an edge of innovation of his own, discovering old meanings and expressing them more clearly, straining to convey new meanings. He might not always be able to verbalize this process of making art truer to the ideal shapes of things, but then speech is not the only medium in which analogies can be expressed and order brought into human experience.

Style in art can convey meaning in another way as well, since it can be perceived not only as a multitude of patterned visual attributes but also as a whole, as a gestalt. Seen in this way, the style can act as a semantic "frame" to identify immediately the system being dealt with. Every icon rendered in the visual style "Haida crest art" is read as falling within that semantic system as well. In this way style can assist the iconography to do its part of the job.

Abstraction

Haida art is commonly said to be "conventionalized" and "abstract," and it is important to try to discern what has produced these qualities. For one thing, the artists were not making any attempt whatever to make faithful portraits of the creatures of the natural world; they were portraying concepts, or perhaps more precisely, metaphors. The icons "refer back" not so much to nature itself as to the Haida taxonomic system. "Raven" stands already analyzed and translated into the essential attributes of its species; it has already been lifted out of the hard, chaotic reality of the physical world. Consensus has been reached on which attributes have to be shown, and which emphasized, to identify it visually. The icon, that is to say, is an

ideograph rather than an illustration. In this sense the art is "conventionalized" rather than realistic.

All arts are in some sense "abstract." The degrees of what has been called abstraction in Haida art, however, are products of the interplay between the iconographic and iconic modes of signification (representation). The more prominent the role of iconic design, the more difficult it is to identify the iconographic subject, and the more "abstract" we consider the art to be. It is from an examination of this interplay that we may obtain our most penetrating insights into the meanings of Haida art.

Iconic design cannot exist alone, except as an esoteric exercise or as empty decoration. It requires a foundation of ordinary iconography on which to root and feed and grow, just as poetry needs a foundation in ordinary speech. Yet in order to get its messages across, it has to compete with the iconography for attention. It is a competition in which the iconography has a strong advantage, for the eye and mind strain first to recognize the icons and concepts of that realm, and are then tempted to rest, feeling that to know what it represents is to know what it means. The task of the artist is to draw the attention back into the design, pique it again to a high state of vigilance, and present it with the subtle pre-gestalt images and signs which convey the iconic meanings. Just as the poet makes use of devices such as versification, rhyming and repetition to draw attention to his words, and then uses the words as images endowed with more than their natural meanings, so the artist has to use visual devices such as disproportion, patterned repetition and self-conscious perfection of form to draw attention to the visual elements which he has endowed with more than their iconographic meanings.

The competition does not at first pose any threat to the iconography. A Raven design can become "highly stylized" without losing its ability to trigger the identification "Raven." It can easily afford to "give some ground" so that the iconic messages can be conveyed. These messages are, after all, about the same general subjects, even though they are being transmitted on a different wave-length.

But in Haida art the competition is carried much farther than that. In the most abstract designs, not only is the iconic mode built up, but *the iconographic mode is broken down*. Bill Holm perceived this unusual process and even felt impelled to create a new terminol-

ogy to describe it. In his terms, the designs show increasing degrees of abstraction, from "configurative" design through "expansive" to "distributive," by which point the silhouette (gestalt) has completely disintegrated and the iconography seems impossible to read. We have been interpreting this process as a consequence of "adapting the design to the field," and of the design becoming "completely decorative." What we have been failing to see is that it also represents the ascendance of a new level of artistic meaning.

This interplay, to some degree at least, must have been consciously manipulated by the artists. How did they decide on how far to go with the subjugation of the iconography? Does Edenshaw's Raven represent a nice equilibrium, like a good poem, between the literal and the metaphoric levels of meaning? Or, to grant (give) equal advantage to the iconic mode, should the iconography be broken down into parts so that the eye has to search out clues to its identity one at a time, as seems to be the case on some of the basketry hats painted with "distributive" designs? Or indeed was the iconic mode pushing toward a climax of total victory, in a vain attempt to possess the sublime free of the mundane, the generalized free of the particular; and attempt bound to tip the art over the brink into complete abstraction, where it could only detumesce, like sails without wind, into empty decoration? Or were the two modes best used in different proportions for different tasks: permitting the iconography to speak first when the primary task was to display a chief's emblem, as on the Raven screen; but utilizing the full powers of the language of iconics to resolve profound and general problems, as may well be the case on the painted box from Chilkat which has established itself so clearly as the final test of our ability to understand this art? Or, perhaps, as I think may be the case with Edenshaw's great chest front designs, was he straining to achieve the logically impossible feat of fusing the two modes of thought into one, of creating an iconic iconography, combining the cognitive powers of metaphor and logic into a single mind-stretching pattern of awareness, with which to see and express the essential order of things in the world, and set man into harmony with it?

Here is another way of conceptualizing the visual meanings at the two levels. When we look (search) at any visual representation for meaning, we are in effect asking it two questions: "what *is* it"

and "what is it *doing*?" That is, first, what is the subject or topic depicted, and then (since a predicate adds an important dimension to the meaning) what, if anything, is being "said" about the topic? Taking the Raven screen as an example, the topic, at the iconographic level, is Raven. What is Raven "doing?" Nothing very explicit, it would seem, like soaring or pecking or running; just "being" (actually, it is 'being' in a special pose, as it is one of four, two pairs facing inward, each tilted slightly back so that taken all together they form a symmetrical balanced, upward-striving overall composition).

At the deeper, analogic level inside the design, consisting of the parts and their interactions, much more is going on. A lot of entities can be seen to be doing many things (which are not necessary for and do not contribute to the iconography itself) [over and above]. But the entities which are the subjects are not icons which depict specific things; they are non-specific images suggestive of attributes rather than identities of things; they might be termed "analogues" (grammatically they are nouns). They may be as simple as a formline segment which embodies little but its own path of action, or as complex as the "salmon-trout head" positioned within (encased) in its ovoid shell. And the predicates are not depictions of specific acts, but are non-specific paths of action and expressed relations. They are visual analogies. Incorporated in the details and structuring of the design are a lot of actions and relationships being expressed, and a lot of attributes are exhibited by entities which are less than icons. The language of this level is the language of visual analogy; it might be termed the analogic level of meaning.

Ordinary iconography presents a dilemma: if you depict what a thing *is*, you cannot at the same time show what it *does*. If you depict what it is, you have a subject with no predicate. Conversely, it is possible to depict or diagram the paths, movements, relationships of things. But it is at the expense of the things, in which case you have predicates with unspecified subjects. If you abandon the usual aim of showing specific subjects performing specific actions, you can be more versatile. You can depict the attributes of the things, and the attributes of the actions; suggested things, suggested acts; relying on the mind to see analogies without specific metaphors.

This train of thought leads interesting places. Abandon the no-

tion, which seems to us the normal one, that a depiction should represent a specific thing doing a specific act. Attempt to draw instead some attributes of the things, and attributes of the acts. Drawing the attributes of subjects can be a more versatile way of depicting them, for it avoids the trap and limitation of a specific, static icon, which can only do not more than identify itself. You can show not just what a thing is, but what it is like; and you can show categories (things) more abstract and more generalized. You can even depict the attributes of a class of like things, so that the subject is an open and general one. And it is much the same in showing behavior. By leaving the subject unspecific, you can diagram its behavior. More than that: it can say not just "this is how it acts," but "this is how all such things act." By avoiding the trap of specific subject and act, you can draw your version of "this is the way things should be," and "this is the way these things should act." It orders the universe rather than depicts a static image of it.

For conveying meaning, ordinary iconography has extraordinary limitations. It illustrates limited things, and is subject without predicate.

12

Haida Art Was for Thinking: Three Levels of Meaning in Northwest Coast Art

In our efforts to understand the meanings conveyed by North-west Coast art, ever since the twig of our understanding was bent by Franz Boas in 1897, our habitual approach has been to ask the question "what does it represent?" and to be satisfied when we could answer the question with a proper noun. Despite a chronic and disturbing dissatisfaction with the results, and an evergrowing suspicion that "something else must be going on," we have not thought to question our ruling premise, or to broaden our enquiry to include "what else does it also mean?" I am now convinced that the narrower question, while still a valid one to ask, can lead to only a partial understanding of the meanings that were visually conveyed in Haida art. Used too persistently, as it has been used, it can persuade us to invent, out of our little knowledge, answers that are wrong or at least miss the point. (I am thinking, for example, of the incredible

numbers and variations of "hawks" in the art books; and of the unseemly debates between Emmons, Boas and Swanton in the captions of Emmons' monograph on the Chilkat blanket over what the blankets "represent"). The wording of the question disposes us to be satisfied with partial answers (the Raven Screens in the Denver Art Museum do indeed represent Raven, but to learn that is only to take the first step along a long, forked path that may eventually lead to an understanding of what they are really about). It can blind our eyes completely in those instances when the primary meaning is not a proper noun, but an act of transformation (as on the Raven rattle) or a set of relationships (as on the soul-catcher and the copper). In the absence of mathematical or geometric transformations and relationships have to be clothed in corporeal images in order to be visible, but we should not forever confuse the cloak for the living thing that it covers. Life is not a dead butterfly, nor meaning an arrested Raven.

As I now conceive the art, after two years of intense intuitive analysis, the narrower question leads to just one of three kinds or levels of meaning. I shall call this the *iconographic* level. The "meaning" here is simply the identity of the subject being depicted ("Raven"). It is an incomplete statement, a subject without a predicate. Northwest Coast art, we have taught ourselves to say, is a "representational" art. It is not always easy or even possible to say what is being represented, but the presumption is that some creature is, and if we are forced to guess it is in all likelihood "a crest of the owner." In most cases, indeed, that guess is correct, because it is the iconographic level that serves the familiar heraldic or crest function of the art. But that is not usually the only thing that is going on, and sometimes that is not what is going on at all.

The other two kinds of meaning are not in the least familiar. They are found at what might best be called the *structural* level of the art. They reside less in *what* is depicted than in *how* it is depicted. They are revealed in the ways in which elements, parts, wholes are arranged, set into relationships, opposed. The arrangements suggest to the mind lines of analogic thought, and the meaning comes out in the thinking. I shall call these two mechanisms of meaning *iconic* and *paradox*. The first is associated primarily with two-dimensional

("flat") designs, and presumably originated in painting. The second is associated more with sculpture, although it can also be expressed in flat design. The presence of these two additional levels of meaning in Northwest Coast art helps to explain, first, its extreme "stylization" and second, the unceasing variety of its depictions. The *iconic* level, in very large degree, *is* the "style." It is (or was) the cumulative product of occasional deliberate innovations by generations of artists, the consolidation of visual constants whose meanings which were enduring, remained implicit. It was at the *paradoxic* level where most of the conscious creativity took place, because at that level each work of art was a new utterance, a new demonstration of mastery over the principles and relationships on which its meanings were based.

Iconic Meaning

The road to understanding the iconic level of meaning in Northwest Coast art was opened by Bill Holm in 1965, in *Northwest Coast Art: an Analysis of Form*. Holm created a vocabulary for describing the distinctive design elements (formline, ovoid, split-U, etc.) and also the rules of composition or principles of design (primary-secondary, formline juncture, non-concentricity of ovoids, etc.). It was a masterful descriptive analysis of the style. But description alone is not explanation. Holm described what was going on in the art, but did not adequately explain it. Such explanations as he did offer were couched in terms of visual design (non-concentricity of ovoids prevents the visual monotony of concentric forms); or, following Boas, in terms of the increasing "abstraction" of the style as it became more "decorative" and was adapted to increasingly awkward design fields. I do not find these to be sufficient explanation. What was also going on, I think, was the exploration of new ways of conveying meaning.

The conic meanings lie in the conduct and interrelationships of the multitude of elements within the design: in their individual conduct as (nonspecific) entities, in their relationships with each other, and in their contributions to the whole design. To use John Fischer's descriptive phrase, they form a kind of "cultural cognitive map." What they "map" however, is not just the conceptual (social) spatial

relationships between entities, but also their *behavior* towards one another. The primary unit, the formline, is an entity and a "line of conduct" at the same time. In a sense it is two things at once (or two halves, though not just of one and the same whole): a nonspecific subject and an unbound predicate. Out of such units the conic level can show "how things act" without having to show "what things are"; and since there is little point in showing how things should not act, it strives to show how things should act. Governed by the Haida sense of fitness, it is a sort of guide to proper Haida behavior, embedded in the Haida art style. In the great and complex mural paintings like the Raven Screens are mirrored the class and rank, protocol, manners, precision, and balance of Haida social life and thought.

Similar things can probably be said about many styles of art. However the iconic level in Haida art was exploited even beyond that point as a vehicle for conveying meaning. As the standardization and conventionalization of the design elements progressed, distinctive new forms emerged, like the enigmatic "salmon-trout head" emerged. I believe this to be the emergence of a second and different level of iconography, consisting of versatile nonspecific forms which might be called "iconic icons" and which were capable of assuming generic, analogic meanings out of which new analogic generalizations could be built. In addition, the simultaneous presence in the art of two or more levels of meaning provided the artist-philosophers with another continuum on which to build meanings. I think I can discern in the Raven Screens, for example, three levels of time or speed of emergence, which establish a time continuum linking the instant of Raven's gestalt recognition with enduring attitudes and eternal verities in a way that makes the "eternal instant" an aspect of the total meaning. The ultimate development of the iconic vehicle was achieved by the elder Edenshaw on the painted box from Chilkat, which analyzes a fundamental paradox in a totally unique way (for one thing, by making two other opposites a formline and the field on which it is painted, two halves of the same thing; but such masterworks cannot be adequately described in passing).

The iconic level, in summary, is not about specified things but

about all things. It is about conduct. It is really about relationships, and that is what I think *meaning* is really about.

Paradox Meaning

The third or paradox level also analyzes and reveals relationships, but in a more focused, deliberate, and explicit way. While the iconic level uses identity-free design elements to stand for nonspecific entities in structured relationships, this level uses recognizable wholes and parts of the primary iconography (Raven and Whale, beak and fin) for the expression of its relationships. While the iconic level speaks in open analogies ("things should behave thusly"), the paradox level speaks in specific metaphors ("this thing *is* the equivalent of this other thing"). Subjects shown visually by means of "parts" are to be read cognitively as wholes (Raven's beak is quite enough to bring him into the equation *in toto*). The "metaphors" while specific, are highly esoteric, and are parables arising out of cognitive relationships in Haida myth and logic. (The outside of Raven's beak is equivalent to the inside of Whale.)

At this level, the meaning is expressed by visual-cognitive statements that take the form of riddles which are at the same time logical paradoxes. The riddling is of a particular kind that deals only in opposites, in structural and cognitive oppositions and equivalences. The art, that is to say, makes visual statements which the thinking mind translates into riddles which are also paradoxes; for example:

> This shark has a beak.
> This "shark" has a "beak!"
> How can a "shark" have a "beak" when "sharkness"
> and "beakness" are opposites?
> Only when "sharkest" and "beakest" are
> both opposite and the same.
> (This shark is Raven.)

In finding a way to make statements having both a subject and a predicate, therefore, Haida art found a way to state logical paradoxes. Of all the kinds of simple declarative statements, the logical contradiction is the one most provocative of thought ("All Cretans are liars," said the Cretan). Having found the way to construct such

statements, the Haida artist-philosophers had found a means of posing, by analogy, some of the most profound questions known to metaphysics. With each new work of "art" the "artist" composed a new riddle, coined a new aphorism, created a new way of posing an old paradox; and since every well-conceived question is pregnant with its own answer, he was offering his wisdom on the topic as well. For his iconographic images he often utilized (might use) crest figures, thus killing two birds with the one stone. But just as often he turned for his images to the most (important) profound of Haida myths, which introduced into his enquiry the very paradoxes which it was their function to resolve. I do not think it goes too far to suggest that Haida art, at its full stretch and compass, sometimes became a medium for the *explicit* analysis of paradoxes which were *implicit* in Haida myths; that is, Haida art was deliberate structural analysis of the Haida myth.

In the absence of (other forms of) writing and formal mathematics, therefore, Haida art became what was probably the most powerful vehicle of Haida thought.

The ultimate aim is to create a more complete gestalt, an overall design which can be looked at with all awareness alive, all associations open, to see how it all hangs together. In microcosm, the salmon-trout head does the thing that art can do: it is an iconic icon, a gestalt of wider and deeper meaning, the mind aware of its elements (behaviors), its beauty of form as a whole and as a part (the cosmic shape inside a cosmic shape, striving upward), and all its variations (which speak of the beautiful quality of emergence, growth, life). Whole, part, whole, past, present, future (all variations) are parts of the design. A great work of art is richer iconography, showing how all things are or can be, with the mind stirred to its full stretch of awareness of metaphoric subjects and analogous predicates, past and future, bringing and showing order, wide and deep order and organization.

The Haida did it by sacrificing the potentiality for realism of the primary iconography (unlike western art which cultivated that realism to a point of beauty and went on to show iconic meanings in other ways). The "end" was slighted as they concentrated on expressing the "means." The expense was a wasted iconography, the effort was poured into iconics (details) and the total result was either

a strange blend like Raven Screen (lazy iconography, awkward whole, but full of iconic richness) or a new and higher iconography like the chests (iconic icon, like salmon trout, on the threshold of expressing a new concept, striving toward cosmic shapes which are the most ideal way for things to be). A work can *embody* qualities of art (Whale housefront) but not *be* a work of art, because it does not bring it all together into a new gestalt, a new iconography, an overall beauty like the chests. That dimension too must be included: you can't surrender to the doing of fine details, fine acts with no substance. You are trying to organize experience into a new level of order, a new kind of generalization combining secondary and primary process, literal and metaphoric thought. The Haida mind disdains literal thought and explores the richness of metaphoric thought. Maybe that is characteristic of *la pensee sauvage*. It shows a dissatisfaction with the ability of secondary process to order the universe, and a reaching back into primary cognition to remedy the balance. Maybe what was faulty was not secondary process itself, but the rigor with which the savage mind applied the requirement "all essential attributes." Science does a better job of creating secondary classes, concepts that work, because it does a more rigorous job of analyzing what the attributes are. The savage mind, as Levi-Strauss says, does not work differently from the scientific mind, it just works with less rigor. Science looks below the visible surface for its relevant attributes, the savage mind accepts the surface look (after all, you don't have to look hard to see that all ravens form a class—the science of the concrete). Haida took easy concepts (slighted the iconography) and tried to combine them with metaphor to reach the higher level of ordering. Science looks below the surface appearance of the natural species, the physical world, to find the really essential attributes that form classes that work (hard concepts) in the real world—gravity, magnetism, evolution.

Iconography is the conceptualization of the real world; the Haida shunned it and tried to live in their imagined world; science attacks it head on and finds it less and less human and animistic. Science does that better but does it fit that to man's needs (iconics) and create a beautiful overall design for man and the world? Not yet.

The mind *seeks out* secondary classes in the real world, it does not impose them on nature (well, that is the other side of the coin).

What the artist is doing is trying to create a new composite level of concept and impose it on the world, combining the best of the secondary and primary process. It doesn't work; you can't change the real world that way. But for man's inner world it does work, in that it depicts as much order as the mind can imagine. That is beauty.

* * *

Editor's note: The following are short notes scattered among Duff's papers.

There are two ways of congealing order in the world. The earlier was the analogic; ordering on the basis of perceived/analogues/and building from there. The second is to move away completely and pick a completely arbitrary (unmotivated?) symbol and agree what it is to "mean." This was first done with language, giving rise to concepts. Then once concepts became established, all you have to do is *identify* it. So visual art has to be isomorphic with the concept—and also isomorphic with the attributes. Two kinds of isomorphism in the bosom of the same design....

The one is extraordinarily limited in its capabilities. This was the impetus that led to all kinds of writing....

The key to understanding Haida analogic art is that it did *not* come to anchor itself in speech, in the way for example that Chinese calligraphy did. It does not ride on the back of speech. It depends entirely on visual analogy without metaphor...You don't have to concentrate on just what it *looks* like, you can show what else it *is* like, how it acts....

An ideal line is a precise line. "The world is as sharp as a knife." That is, conduct, behavior aspect has to be precise. This arises out of the basic premise that you are trying to make a drawing "say" other things....

Analogic meaning must always begin as a modification of something else....

That is why it is always a secondary feature of design, and cannot stand by itself. It is in the stance of predicate on the iconography....

* * *

The emergent aspect is time. Every design is different because every moment of time is different.

This art mediates the ultimate conundrum of life. The seeming opposites of fixed form and unfixed behavior, the problem of how to act at each given instant. Because behavior begets form (art is a paradigm of this). The artist drawing a design if recapitulating the entire sequence. The Haida do it primarily with line. Line *is* behavior. Controlled line is controlled behavior. The designs show the forms resulting from controlled behavior. You can idealize the line of behavior itself (and it is always a steered curve, a new decision at every point—a straight line is a lazy decision). The emergent aspect is also shown as moving through time. Every design is different.

If your behavior is precisely right at every instant of time, you will contribute to producing beautiful form in the world. Culture can control nature, if behavior conforms to cosmic forms ...

If you want to know how a form (icon) got that way, look to all of its parts ... You will have to see in these analogous behaviors in human spheres ...

What things in the Haida world is man most like, in aspect and in conduct? These are the things the Haida chose to draw. Their ideography was part of their analysis of nature: how much like man are these things? How do I know what man is like unless I use analogies with these things? I can only explain man in analogies with nature, and nature by analogy with man. I only know what is out there by knowing what is inside me! The inner world by the outer, and vice-versa. And the window, lens,...is the EYE. Totemic system took natural concepts closest to man. Closest of all was the BEAR ...

You have to reduce form down to units of form. Analysis and reduction to design elements does this. Not an infinite number of parts (atoms), but a finite and reasonable number. A few of each (e.g. flicker feather) is enough, for they all follow the same rules. Then you can analyze the behavior necessary to yield these units—and the units, acting and interacting, can show the behavior expected. And they build up into forms (the icon you started with, of course), but also into other entities and identities (symbolized by faces). It is really about humans, so that whenever a face "surfaces," it is a human face....

Subjects (nouns) remain constant through time, so can be treated

logically in classes. They are what is really fixed in the world....
Predicates are units of change, alteration, modification. They have
one less dimension of stability (since they are changed by time), so
can be grouped only by analogy on the basis of similar attribute....

* * *

Haida carvers were the only ones who could carve their **own**
totem poles. Their house poles were carved by "own" kin not
opposites (*at* carved by opposites).

Nowhere else could Edenshaw have made his own Myth House
(and even he alibied that it was really for his son).

Everywhere there is the distinction between putative artist (usu-
ally "hired" from "opposites") and actual artist, who he could hire
on a subcontract basis. So actual artists tend to remain anonymous.

We focus on the nodes, they on the relationships. If you are
purposely drawing a fuzzy thing, you must do it with clear lines, or
else it will be read as error. That is why Haida lines are so sharp—the
thing they depict is so ambiguous. "The world is as sharp as a knife"
means that specific things of nature are the razor's edge or reality,
not contained in a broader concept which orders them. Raven...is
really about these things (related things assoc.).

* * *

It is no longer a question of "What does the art mean?" It is
"how does art explore meaning?" The substance *is* "meaning."
The vehicle is paradox. The things represented/interpreted are
just parables. L-S says that the mythology of this area explores
all alternatives (all paradoxes). The art does too, even more so,
because it analyzes the implicit relationships in myth. Paradox
pushed as far as it will go, to the point where the most important
of all things are left implicit: circle, sex, sun, salmon, ten—ta-
boo because everpresent/sacred. Relentless logic of terrible
power. "Forgetting" the above (in the hope of also forgetting
death?). No way out. No zero. No void. Just endless and com-
plete transformation. You can't think your way out of this
one...so...deny it, forget it, relegate it to the implicit, unspoken,
unspeakable, sacred. The Haida did not represent their sacred
things explicitly, only implicitly. They only spoke of them in

parables, in parts. The art bent every effort to show them...*implicitly*. Sins-sganagwai is implicitly (secretly) the sun.

* * *

Art is not "about" myth (even when it borrows mythical images as parables), it is "about" the same things that myth is about: the relationships of things as they are (in the guise of stories of how things came to be).... But the Haida could never go "purely abstract"—could never divorce relations from thighs and deal with them purely per sex. The world *is* things, and it is the things that have relations to each other, and it is *those* relations which are the realities of living. There was no safe retreat to zero—there was only the constant balancing act of living. Balance of opposites. Balance everything that can be balanced. I am you. That is you.

* * *

Haida art became, among other things, a structural analysis of Haida myth. Not an **explication or restatement**, but analysis of relationships, *a la* Levi-Strauss. After all, myth cannot analyze itself. (Time cannot measure itself.) The relationships in myth are used, not examined. Understanding of them is taken for granted, a hidden premise. Art examines the hidden premises of relationship in myth. The myth characters (whale, frog, etc.) are used in a bisociative way; as in the myth, and also in a new way as symbols of relationship per sex.

He who understands the essential relationships of things *is* he who powers the whole system. Wisdom *is* power.

* * *

The artist's challenge was to control these relations (encased in theorems like copper, soulcatcher, exemplified in paradigms like raven rattle) and embody them in new creations, appropriate to current problems. It was like knowing how to take relations from an appropriate myth and embody them in a new and beautiful speech appropriate to the occasion (see Swanton's Tlingit speeches).... So the art is a story about a story, with "crest" figures usually/sometimes used as parable subjects.

The art objects are expressions of relationship, related to (derived from) general theorems or paradigms that use myth images to explore metaphysics relationships (outside-inside, etc.). Speakers' Staffs relate it to oratory, and the wisdom of the orator. They say: "he understands the relationships and transformations, as you see on his staff"...Maybe some tall poles are enlarged speakers' staffs...Shamans' charms and rattles also show the relationships, in context of illness and death. They show his understanding and control over these transformations. It is, after all, the language of visual art, and can only convey messages in that language.... Each work of art like a new metaphor...Two systems intermeshed. l) a cognitive one used for parable subjects: Raven from myth, whale for large, frog for bisexual, halibut for both-sides-same, octopus for complete cunt, etc. 2) a relational one, using the parts of the basic artifacts being used as field: top-bottom, halves, inside-outside...Taboo on copies (for two reasons: l) say it your own way, 2) meaning of matched pairs) produced enormous and compulsive creativity.

* * *

Poor Haidas! They had an impossibly perfect model held up to them and tried desperately to emulate its perfection. They painted themselves into a corner.

* * *

"The world is as sharp as a knife" is a philosophy of perfectionism—a constant striving for the knife-edge perfection, which can be shown nowhere more perfectly than in art.

* * *

Nancy Turner ms. "Questions are stated rather than asked in Haida"—is this related to the art?—There is no way of asking a question...in art, except by stating a paradox.—There is no interrogative or negative in art. Art is a language that has no negative or interrogative statements. Such statements as it makes are declarative, because there they are.

* * *

Maybe art has to jolt people out of "the ordinary way of looking at things" (as riddles tease people about the ordinary meanings of things, as myths play with the ordinary conduct of things). We only experience what it is by experiencing what it is not. That's art's bag—that's its *modus operandi*. And the trump card it holds is the patent one-ness and is-ness of a chunk of rock.

* * *

A bisociative subject doing a bisociative/sense-nonsense/possible impossible predicate.

The bridge between mythic and scientific thinking is bisociation, the ambiguous subject (both one thing and its opposite) and the ambiguous act (both literal and analogic/figurative) at same time. The whole dilemma rises from the human condition: the human ability to symbolize. Let one thing stand for another, a noun/word for a thing, a verb for an act. Then it is two things, a medium and a message, the world cutting and being cut. The whole thing rises out of speech: the ability to say "this statement is wrong" or "that boy did a bad thing."

Myth uses double-ended subjects doing double-edged acts. Narrative time always goes forward.

Haida art shows a thing and its opposite at the same time, and by its patent existence, avers "this is how it is." The universal implied message of Haida art is that opposites are the same. All Haida art is bisociation. It all speaks in paradox.

* * *

I am a single entity physically, but not mentally. "I" do not exist. In order to find a "self" for myself, I have to pretend I am someone else. I have to play roles, act.

My "real" self is not any one of these roles but the way I play all of them. It is not an entity but a quality.

It has to have another story which it can be about by implication.

My real life is all the implications I have had on others, shared

with others. The memory of these dies in me when I die but not in
them.

So each day I have to visualize the roles I am to play and do them
consistently and well. I have to let myself think of myself as a full
professor aged forty-seven, and play that role the best I can. Love the
others by being what they expect you to be, but being it in your way.
Accept the roles, define them yourself, and play them your way.

It is the ultimate conundrum. In order to be somebody I have to
be somebody else. I am the way I play these roles.

* * *

Maybe the Haida needed only one proverb (The World is as
sharp as a knife) (reduced in the origin myth to I am you That is you)
because it embodied the structure of paradox and was therefore
analogous to all paradoxes.

* * *

Haida art
is the gentlest possible reminder
of the inevitable.

* * *

It dwells on
Raven—Mr. Life—
and his birth.
The Birth of Life
is the mask
so that the mind does not have to dwell on
the approach of Death.

* * *

It is in similitude that meaning resides
The reverse is not equally true.
...The mirror is mightier than the mask...
"Is" is more powerful than "is not."
"To be" is more powerful that "not to be."

Similitude is more convincing than dis-similitude
"Is" is more basic than "is not" by a factor of double.
Death has no mirror
Frog does, but he lies to it.

* * *

A salmon is a "little man," a penis
A spent salmon is a limp penis
salmon with his tail down
bear with tongue hanging out
Raven with a limp beak
When a salmon comes, he dies.

* * *

Skedans is a paradox site
south beach
mirrored by north beach
Whatever way the wind blows
you got it made.
Reversible beach,
Self-reversing beach,
All-purpose beach.

* * *

The Human in Tsimshian Art

Tsimshian totem poles seem to show more human figures than
do Haida and Kwakiutl. Tsimshian frontlets often use an ideal-
ized human face. Tsimshian round rattles sometimes use human
faces. The Tsimshian use manifold human face masks. Why?

The faces are generic; not strongly male or female, young or old;
not individualized portraits; uniformly serene or expressionless. Pro-
portion, if anything, are infantile: heads large in relation to bodies,
eyes large in relation to faces. Postures can sometimes be read as
infantile too: seated, (seldom standing) pseudo-fetal.

The hypothesis is that we have here a blended individuum:

mother-father-child in one. Male-female, child-adult, begging the question as to which it is because it is the trinity, shown as a triune.

Variations which retain the human metaphor are such as Split-Person and Sharp-Nose. Half-Person, Person with head in body, Mother and Child, are variations which show that the concept was being thought about that way.

Is there a postural similarity with the human female figure on the back of the Raven rattle? Do flat-knees signify that? If so, we have a link with Raven's self-generation as procreation.

Diagrams of Raven would say the same thing. Beak-Nose of Weeget, Frog-Woman, etc. Raven's "Nest?"

It is a safe formula, but not very exciting, because it leaves out sex and death. No hint left of eating, retribution, killing, incest.

Perhaps the most powerful determinant in culture is logic. Why cross-cousin marriage? It is *logical*. At any rate, the underlying structure rests on logic, and must be congruent, and has unspoken logical premises. If we concentrate on that level we can find the logic. That level is explicit/shown in art, implicit in myth and ritual (and all expressive aspects of culture, with which the people cele-brate/teach themselves who they are and what to think).

* * *

You have to kill, to secure the continuity of the universe of which you are the center.

* * *

I am sorry, salmon, for I must kill thee
bear
father

* * *

No wonder there is an apparent correlation between artist and high rank in Haida society. The artist *was* the chief, the author-ity on Haida social things. It was his job to teach these things.

* * *

Boys go on vision quests, have a look at death, then come back to go on to the knowledge of partnership—to creating death. Girls go on a seclusion, have a look at life from a distance, then come back to start creating life

 Death is man's problem Life is woman's problem
 it amounts to the same thing
 FROG
 For every action there is an equal and opposite reaction
 For Frog there is no action
 Share your life with everybody else, then everybody else
 will share your death with you.

* * *

Ovoid is a half thing. It never stands alone as a whole, and it never straddles the center line. Usually it is never oriented truly vertical, but slanted away from the center line (at about the angle of the sides of a copper?)...It is the shape of an inside, not an outside. It is a negative shape...a formspace. It is the opposite of a form, it is a formspace...You are not perceiving it, it is perceiving you. You are not getting into the design, it is coming (unfolding) out at you. And of course the salmon trout heads gives it a form which emerges in perfection. It is time coming out backwards. Time moving backwards. To make time stand still, have it moving forward and moving backward the same amount at the same time.

* * *

Wholeness is a pair of linked Mobius strips...Haida art is endlessly trying to draw linked Mobius strips. Simple paradoxes are nice as aphorisms, halfway to the goal, but they fail to satisfy. They have to be linked to other paradoxes, in a quaternity arrangement, to create wholeness. The two stone makes are two linked moblus strips...

* * *

Poke fun at Raven: laugh at his tricks
Poke fun at Bear: in art, have him wear fatuous grin

There is nothing funny about Skimsem
Poke fun at Frog: or at least smile with her
Poke fun at Mighty Mouse:
—It gives some comfort to poke fun.

* * *

When your back is to the wall,
the closest analogy seems to be the opposite.
When all else fails,
choose the opposite.
At the end of the causal chain,
wish.

* * *

Structural Analysis of the Design

This art style does not produce realistic depictions of real animals, let alone imaginary one. Its mode of representation is more ideographic and diagrammatic. It does not produce pictures of animals as much as diagrams. The Gonaqadet on the front of the Edenshaw chest is an exceedingly complicated diagram. It may have evolved from the stylized front view of an animal, but it has become several stages more complex than that. It uses the device of parts that are also wholes: each of the sub-fields of the design can sometimes be read as a face. It also uses the device of bilateral symmetry: making opposites visually equal. Its most distinctive feature is the eyes. Each eye has become two eyes, in face, a separate face. In addition to having two eyes it has four; it has doubled eyes. It has a large nose and a huge mouth. The nose is of a distinctive shape with a telltale negative circle in its tip which elsewhere in the art (for example, on the belly of the raven rattle) marks a beak. The Gonaqadet face, that is to say, has both a beak and mouth. It is in another sense double: the Gonaqadet also has human attributes. Its hands often human hands, and when faces are placed in the body, hands, ear, or elsewhere these are human faces. It also has 'abstract' elements, such as the four ovoid 'salmon trout heads' in the corners, whose meanings we do not yet know.

It is a complex, composite, bilaterally-symmetrical *doubled* diagram. It holds opposite in a symmetrical relationship. It is a doubled design holding opposites in symmetry. The head is where the doubling takes place (four eyes, beak-mouth); the single body serves them both in common, and in that different sense it doubled too.

* * *

The Copper. This analysis paves the way for the next logical step which yields the distinctive outline of the Northwest Coast copper. That step is to *half* the doubled design, but to half it in a different way: to lift out its *middle half.* Lines drawn from the top of the 'body,' bisecting the double eyes of the Gonaqadet to include the two middle eyes, produce the diagrammatic shape of the copper. The 'middle half' of the Gonqadet is the shape of the copper. The central core of this complex, composite being is shaped like a copper. That which is common to symmetrical opposites is shown by the copper.

The design on the back of the chest, which has single eyes and no nose or beak, might be seen as Gonaqadet with the copper lifted out.

Waterman was told by the Tlingit that the copper was "the forehead of the Gonaqadet" (1923, p. 450). He tried to see this in a three-dimensional form on a totem pole; perhaps it is easier to see in two-dimensional form on the chests.

If the copper is in fact a diagram of the 'middle half' of the composite two-dimensional representation of the Gonaqadet, it emerges as a geometric depiction of a set of relationships. The copper is a diagram of a set of relationships. It is that which is common to two opposite animals, that which is common to a composite animal. The copper is a pure symbol of that which is common to opposites.

I am not saying that the copper originated from the Edenshaw chest, because the copper is older than this style of chest. It may be more accurate to say that the chest was designed to explain the copper (which may be its most important esoteric meaning). I do suggest that the copper originated from some earlier two-dimensional drawings of the Gonaqadet, either on chests or some other forms. Such an origin would explain certain attributes of the copper

which have been known but not explained. First, its vertical orientation with large end up seems to defy gravity. Second, its flat, essential two-dimensionality—the back of a copper is as negative as zero. Third, its bilateral symmetry. And fourth, its shape.

13

Notes To My Self

Last Word on Style

Style, iconicity, the second road to meaning in art, riding piggyback upon the iconography, can be minimal or maximal. The maximal cases are when it takes over utterly, and thereby comes to the end of the road. It can do that by a number of routes. One is reduction to a perfect sphere (dish in Smithsonian). Another also starts with the pure iconicity of the artifact (toggle), and evolves to pure iconic symbol **(whatsit)**, without resort to iconographic image. A third starts with iconography and its permutations, and precipitates out: all iconography wrung out: the copper. If style consists of manner, arrangement (structure) and composition, what is it that has precipitated out in pure form? Manner comes out as touch—a feel-stone. Form comes out as armature (sphere, whatsit, copper). The last word of style is the content-free armature.

Another way in which style can take over is in the creation of designs with most style. The Raven Screens are suffused with it: manner in every formline, crowded with iconic icons (salmontrutheads, double-eyes, flicker-feathers, etc.) sequence, symmetry, circle, etc. Edenshaw chests are also full of it. Manner is there to

perfection, and all the ingredients of the armature of structure. By this route you make a thing that has style, not is style.

Last Word on Iconography

Symbol, iconography, the primary road to meaning in art, can be minimal or maximal. Reducing down, it would become pure symbol: individuum, lingam, eye, circle.

There is another road: the artifact. Hammer, canoe, soul-catcher, bowl, etc. can pick up metaphoric meanings and be non-iconographic vehicles for the essential symbols. The artifact as metaphor is already part way to the essential symbols. Artifacts can become images and/or equations or armatures. The phallic Hagwilget clubs are equations using genital metaphors. The California phallic charmstones are also equations, closer to the armature; as are soul-catchers (the one uses just the lingam, the other a metaphor for yoni). The NWC canoe is a blend of all three: abstract duck on the outside, abstract yoni on the inside, the essential symmetry of the armature in the balance of bow and stern, and withal functional to perfections. ARTIFACT; IMAGE; ARMATURE; SYMBOL, all in one.

The essential symbols are sexual. The essential concerns of human fantasy are birth, sex and death; death and regeneration; dreaded as cannibalism and incest; celebrated as orgasm-birth. The essential theme is the individuum, the trinity of mother and father and child, each containing the others. The aim of art is to show that as one image (reductions: Sechelt Image is all three; mother and father pair imply the child; mother and child imply the father; pregnant female implies both others; Maori child image containing copulating parents; one asexual, ageless human-Tsimshian which is all three blended; human ground plan of frontlets. Or, reduced from whole to part, the Bella.

Armature

The single essential attribute of the armature is man-imposed symmetry. Once you can do that one way, you can do it any which way. The simplest and most basic form of it is "bilateral symmetry," both ends the same. The trick is that you have made it so; for the truth is that both ends are opposite. You have

created the basic proposition: let opposites be equal. All the rest follows from that basic trick.

A sphere is armature in the sense of being absolutely symmetrical every which way. In two dimensions, a perfect circle is the same. But the mind is interested in armatures which are closer to man's real perceptions of the world. Given one essential symmetry, other aspects can be opposites. On the COPPER, given side by side symmetry, top and bottom can be as opposite as one and two. On the WHATSIT and the EDENSHAW CHEST, given bilateral symmetry, the rest can be oppositions: top-bottom, front-back (outside-inside).

The basic problem is personal death. The basic answer is its opposite: creation. The basic model is human procreation. The wish is to be the individuum. The wish can be only partly achieved (a man can leave a drop of semen that will outlive him by a generation; the woman can birth an infant that will do the same). The wish is to be that infant as well as yourself, a patent absurdity, since begetter and begotten are functional opposites. The wish persists: ...let opposites be the same, ...the armature is a lie, which primary process refuses to believe and tertiary process transcends.

Human As Individuum

Perhaps in the northern art the human figure is meant as the triune, the mother-father-child. This would explain certain regular features:

 — sexlessness
 neotenic proportions
 generic quality
 lack of expression

It is Raven-as-human, shown as individuum rather than man. A blend, neither-sexed and therefore both-sexed, no age and therefore all ages. Bland blend. An iconographic armature: the human figure as armature, stabilized in the style, the product of long slow thought.

The Nishka frontlets are the same thing confined to the face: a blended male-female-child-adult face, idealized and serene. It is a metaphor for Weget, Tkaimsem, Nankilstlas (the one who could wish it).

Most of the rest of the art is explication of that basic theme. On

the human groundplan (so often noted, say, in Haida art), which becomes the basic melody, variations are played with noses becoming beaks, or metaphoric jumps are made to the crest animals. A crest is a metaphor for the individuum. Or Raven himself is invoked, as on the Russian frontlet.

The INDIVIDUUM is the armature of the myth, but what is the plot? The plot is the CREATION story. Since the armature is human, creation is on the theme of human PROCREATION. It is Groddeck's "eternal theme of death and transfiguration, the male-female, child-adult nature of man."

Art is wish, and art is self-portrait. The triune individuum armature is the northern artist's diagram of how he would wish to be. This armature is a basic premise, arrived at long ago by the long slow thought of fantasy, and anchored in the subconscious logic of the "style." It is like the first premise built into "bilateral symmetry": let opposites be the same (and we can take it from there). One basic wish is all we really need. "Let opposite be the same" turns death into rebirth; "Let human (me) be individuum" takes immortality as given.

But the problem remains: how do you really *do* that? The mind goes back to the Creation Myth, to the creator. Whoever that was (Raven, Nankilstlas-lingai) he had the same problem in another form: how to generate himself. So the basic theme of the art could be phrased as the creator's SELF GENERATION. Human procreation as self-generation: the generative act: self-begetting and self-begotten at the same time: self-born. it can only be shown in metaphor: show Raven "doing" it; use the mouth-vulva identity and the beak-phallus identity.

The individuum as armature has been stabilized in "style" and the problem it poses is never far beneath the surface. The long-slow agenda of the profound artist is to diagram the act of creation that fits that basic premise. But meanwhile, the short-term, conscious, surface agenda of crests and myths goes on, little mindful of the depths beneath. Art is the depiction of crests...

Individuum Face
The Impassive Face of Northwest Coast Art

Masks started out by being the opposite of individuum face;

that is, something specific. Generally, in Tsimshian art, the human faces on masks are different from human faces on totem poles, which emphasizes the generic quality of the totem pole faces.

Bland face is on totem poles. It is the base-face for animals as well. It is like the bland face of flat design, which may therefore also be the individuum.

Maybe faces on the art are all faces of immortality. The crest animal metaphor is that, because the continuity of the line is vested in the crest. How do you show that as a human face? It is the individuum. Maybe in matrilineal system, the individuum is:

— mother
— father (uncle)
— self

That bland face is one of the controlling symbols of the art. It is Nankilstlas-lingai, he who is going to create himself, his mother and his grandfather.

It stands in the same relation to humanity as the bear crest stands for the Bear species. Bear, on the poles, may be a surrogate. All the play of bears and cubs may be really referring to humanity.

> Watchmen on Haida poles are the same bland face.
> Human on AE housepost 1.
> The Human Figure in Northwest Coast Art
> is the individuum

Human Armature

...Symbols are sometimes iconographic armatures, like the little human figure. It is an old solution, an old armature, an old trinity condensed down to one. As an armature, it means the same as a copper (which is also a symbol but is non-iconographic). It was a natural thing to do to condense the copper and human paradigms and create the frontlet paradigm.

Groundplan; Armatures *are* groundplans. But sometimes symbols can become groundplans too, as the human figure became the underlying groundplan for many other composite figures on fron-

tlets. This culminates in the frontlet in Barbeau whose head is shark-hawk-woman and whose body is frog-whale.

Paradigms are the result of combining armatures and artifact TYPES. There is an understanding about customary ways of doing this, and the artist and viewer go on from there. A TYPE may *be* an armature, as in the case of the soul-catcher, frontlet, raven rattle. Thus the armature of the meaning is inherent in the form.

Images result from the combination of symbols and armatures. Each image is new, although its underlying armature, paradigm and symbol repertoire are old. Art is newness on an old base. Of what does the newness consist? It can be "a new way of saying the same thing" (a variation) or a new combination of symbol and armature (a new association). ASSOCIATIONS bridge paradigms (e.g. canoe-dish, frontlet-bowl, raven rattle-bowl, copper-individuum-frontlet, frontal pole-spoon handle), bringing solutions with them. These are the "jumps of the mind" of deep association.

Blending As a Form of Punning

I have been seeing the *blend* and the *threshold pun*. The purest form of the blend is the individuum, in which the differences of sex and age have all been merged into one bland, sexless, expressionless, idealized human. I also saw it in the stone masks: human with a trace of Frog.

So in addition to "monsters" that are part one thing and part another, or are overlap puns of both (the raven-bear headdress); and alternations; and equivalents (a beaver without a stick is like a bear without a...); we have blends: one thing that is two. The TANOO GRIZZLY BEAR is also FROG ("froggish bear"?) (bear with more than a suggestion of frog?). The Masset bear on Hilary's card strikes me as bear, frog and the sharpness of raven as well: Raven disguised as bear-frog.

On Cole's CE slate chest, the whales on the Wasko on the lid have frog faces: FROGFACED WHALES. On some spoons we see a creature the front half of which is Frog and the rear half of which is Whale, another way of doing it.

Maybe a sharp-nosed individuum is Raven in disguise (i.e. Weget).

UBC 12 ft. "Tom Price" totem has a blend or composite figure

on the top: winged-frog or frog-faced raven or Raven with more than a semblance to Frog.

Thus we seem to get every possible degree of blending and compositeness. We should therefore be very alert for HINTS, traces, suggestions, as well as outright puns and combinations.

A step further, and we would have *threshold transformations* of opposites. On CE Skinsim gravestone, the winged body is constellating into a frontal human face. On AE's box, sides one and three, a profile Raven as on the Raven screens is just below the threshold of emergence. The back of a Haida chest or box is and is not a face at the same time. The same applies to the more abstract designs on the ends of dishes and trays.

The ARMATURE for these blends is usually the human ground-plan or the human face.

We should stop asking whether it is one thing or the other, and see that it is one thing *and* the other. We should "read in" whatever meanings are given definite hints (the weeping woman on the Tanoo pole has wings).

It Is All A Duff Rorschach.

Art Is Association

Art's meaning comes in two moieties: associations and relationships (structures). Associations bind the artifact of the moment with deeper Symbols, which have intrinsic meaning or meaning because of mythic or historical associations. An image can have meaning because it IS two things at once.

It strives for Deep Symbols In A Meaningful Relationship.

The perfect relationship is the pair of eyes. Each is twin, one, both. The ultimate symbol is the one eye that is both. Not the third eye (that is circumlocution, not condensation) but the ONE EYE. From there it is just a logical step to the one eye of MM, and to the one toothed eye.

Building of Visual Systems

As a first approximation, we may say that a structure is a system of transformations. Inasmuch as it is a system and not a mere collection of elements and their properties, these transformations involve laws: the structure is preserved or enriched by

the interplay of its transformation laws, which never yield results external to the system nor employ elements that are external to it. In short, the notion of structure is comprised of three key ideas: the idea of wholeness, the idea of transformation, and the idea of self-regulation.

I say images are structures. They are systems. They involve transformations. The transformations involve laws.

The icon units are symbols (e.g. Raven is a symbol). The system is made by balancing it with an equivalent (e.g. Frog). To retain wholeness (singleness) it is put into a part-whole relationship (or major-minor relationship).

Or at least that is one of the ways in which the armature may be worked out.

The most elegant equation is the double-twist. The part of one is the whole of the other, and each is metaphoric to the other. The type specimen of the double-twist is bear-woman. The real image is woman's vagina dentata. Part and whole are inverted, metaphor is made primary over literal, and the woman with toothed vagina looks like a "bear eating man."

Art

Art is the making of beautiful masks, and its essence is in the beauty of the mask.

Art is the making of beautiful disguises, and its essence is in whatever makes the disguises beautiful.

Style is the beauty in the system of disguises.

Style is the willing suspension of disbelief.

Style is the contrived answer to the brute inside. The brute, the shameful, the ugly is inside the art, all the outside is man's highest rebuttal to it.

Art is knowingly creating a beautiful sugar coating on the bitter pill of life.

Art is putting the best face of it (id).

Art is the tissue of lies that covers the ugly truth.

Art is beautiful euphemism.

Beauty can be slipped in, analogy by analogy, at the iconic level. Smoothness, firmness, straightness, fullness.... Beauty and ugly may not be perfect opposites. In art, the only ugly permitted is the first.

One half of the truth in art comes from unrepression of tabooed truths.... Tanoo Bear is ultimate in best-clothed-in-beauty. She is virgin bear-mother: no teeth, big eyes, tongue, gentle....

...Nature is not beautiful *per se*—its beauty has to be drawn from it, and imposed on it. Beauty consists of truth to a higher level—the comforting assurance that we see in small truths big truths.... The verification of a single fact doesn't give the aesthetic shrill of truth. Some generalization is needed...

* * *

We say that the basis of culture...is the sharing of symbols. What is most crucial is that the symbols we share have the form of patterns. The ability to share symbols rests on an incredibly complex ability to perceive patterning. "Myth": the line we make between myth and knowledge breaks down upon analysis...Truth is relative...our distinction is not really there...To higher beings, most or all of our knowledge would be myth.

There is an element of selection and patterning in the part of knowledge we call myth...Just as in language we have to choose an arbitrary system of sounds, in art a limited number of the possible forms, in music an arbitrary selection of tones and intervals, so in the knowledge we share we tend to select and pattern what we are going to live by.... We emphasize some things more than others....

* * *

Innovation of Barnett is "analogic"—my "analogic augmentation." "Analogic budding" results from codification of that...Barnett saw it as the unit of innovation. Edenshaw saw it as the unit of all form-taking. Birth is penetration of a barrier, growth is crossing of thresholds.

* * *

The ultimate singularity is the *act*, the deed, the performance, conduct.
Your measure is how well you paint a formline
Your measure is how well you conduct yourself
Art is the charter of good conduct

The general question of the art is the one of creation
—of beings—what did they transform from and into?
—of art in time—what do I have to do to create this?—of self.
I ACT, CREATING MYSELF.
 The whole thing is a system of taxonomy built upon intertrans-
forming opposites. Opposites that are the same. If they are the same
there must be a third thing common to all, the ultimate singularity.
That thing has to be half-thing, half-deed....
 What is a work of art? Not a nice depiction of a thing or being.
A locus of logical oppositions. A "what if." A little nightmare. The
things depicted are not things, but anti-things, things that are half
this, half that

> half this way, half that way
> a bird with ears
> a self portrait
> a portrait of man
> the way things really are
> half animal-half god
> both
> the human condition
> paradox
> dilemma
> a double being condemned to the life of a half
> a self-conscious god condemned to the life of an animal.

<p align="center">* * *</p>

> Art as Equation
> Interpretation
> Alternative Explanation
> Explanation
> Telling what it means
> Telling it like it is
> Telling it like it really is
> Reality
> "in other words"

<p align="center">* * *</p>

Art creates Neither-Boths
half what you see, half what you know
half literal, half metaphoric...
Mythic thought is an unending concern with paradox...

IS is redundant. It always carries the implicit meaning/load of existence as well as similarity. And we don't know what existence means—we only know what similarity means. So we can easier make equations than existential statements.

14

The Edenshaws

Editor's Introduction

The major items in this section are two alternate introductions, both essentially finished, to a book on the late works of Charles Edenshaw. These are examples of Duff's thorough scholarship. Very different are what follows: random and highly intuitive notes on Edenshaw work, and above all on the famous Box. I have selected from hundreds of pages of notes. In The Box, Duff found his most challenging and most intractable subject. The vast majority of his entries on it trail off into hopeless false starts. I have included what seems useful, mainly through its inspired chronicle of just how an "affecting presence" affected its most dedicated viewer. It moved Duff to reflection on the paradoxes and tensions of life.

Duff wrote very little about other Edenshaw-ascribed works. He compared the Raven Screens with The Box, and made faint beginnings at analyzing the known later works of Charles Edenshaw, but I have included little of this material; it is simply too fragmentary. The Box was overwhelming enough.

"Mighty Mouse," or "MM," was Duff's term for a small grinning animal face that appears—typically upside down, and sometimes in profile—on certain chests otherwise decorated with Go-

naqadet motifs. Duff seems to have been the first to notice this face and to point out that it was clearly intended (it has eyes that are "upside down" by Northwest Coast art conventions, for instance). He named it from its resemblance to a comic-book character of the years when he was young.

Introduction

Charles Edenshaw (c. 1840-1920) has been generally recognized as the foremost northern Northwest Coast artist of his generation, but what has not been sufficiently recognized is that his uncle and predecessor, the famous chief Albert Edward Edenshaw (c. 1815-1894), was also an important artist, and that a certain continuity links the two careers. Uncle and nephew were men of different temperament and their lives ran different courses, but each in his own way was an astonishingly productive artist and brought the art to its highest developments. Since the elder Edenshaw represents the culmination of many centuries of the northern art tradition, and since the nephew presumably understood and probably reinterpreted the major works of his uncle, the two can be taken to represent the final statement of this ancient artistic tradition and the supreme interpreters of its accomplishments.

Since native artists of those periods never signed their works and collectors seldom enquired about their authorship, the attribution of works to individual artists must depend upon connoisseurship, learning to recognize individual styles. From the few pieces which can be firmly documented as the work of a given artist one gains an impression of his style, then attempts to reconstruct his artistic career, or at least to identify other pieces from the same hand. In some cases, series of works can be discerned whose authors' names we will never know. This method of discovering individual styles in anonymous tribal arts is of great importance for reconstructing their histories and understanding their meanings. It has been a major direction of research in Northwest Coast art since Marius Barbeau's work on Gitksan totem poles in the 1920s. But it is fraught with the danger of wrong attributions; and at the present stage of Northwest Coast research different scholars fail to agree on what constitutes an individual full awareness of these dangers.

Charles Edenshaw is closer to us in time, and several works are firmly attributed to him. Consequently there is more agreement on his style, although we are still a long way from a definitive description of his life's work. Albert Edward Edenshaw is more remote, and no attempt has previously been made to define his styles and works. In the present study he emerges as a most powerful chief, a singular man and an astonishingly productive artist. The evidence linking him with some of the works of art is tenuous, and violates some of the current ideas about Northwest Coast art; these attributions are bound to evoke a certain amount of controversy. Absolute proof in this field is usually impossible to obtain. Yet the attributions are not lightly made, and are supported by the intuitive connoisseurship of many years of reflection. While to be too rash in indulging one's hunches is poor scholarship, to be too cautious is to fail to do justice to the artist or to pave the way for the next step of the enquiry: what do his works mean? Further discussion of the manner of approach will be undertaken as we proceed.

The Edenshaws were Haida Indian chiefs whose home villages were on the Queen Charlotte Islands, though both traveled widely along the coasts of British Columbia and southeastern Alaska during their lives. Europeans had been on the coast for several decades before the elder Edenshaw was born, and the white man's presence was making itself increasingly felt all through their lives. Both died as confirmed Anglican Christians at Masset. They lived through times of fundamental change for the native people. The artistic career of the elder was completed before his conversion to Christianity, but Charles Edenshaw did much of his latest and greatest work after 1890, while a devout Christian and lay reader of the Anglican Church. Albert Edward was predominantly a traditional Haida artist, producing totem poles, chests and other traditional forms predominantly in wood. Charles was mostly an artist in the transitional forms of argillite and jewelry in the precious metals. The similarities between the works of uncle and nephew—the closest link of male succession in the matrilineal social system of the Haida—are not so much in form as in theme and content, and will become more evident with a more mature understanding of the art.

There was a third Edenshaw in the dynasty; or more correctly a first, preceding the one who came to be known as Albert Edward.

"Old Edenshaw" (c. 1780-c. 1845) was a powerful chief of Masset and Kyusta. He is said to have been a metal worker in copper and iron, and was probably an artist in other media as well, but we can now learn nothing about his work. He is discussed later, as one of the forebears of Albert Edward.

* * *

The Discovery of Individual Styles in Northwest Coast Art

The early collectors of Northwest Coast art, whether as curio, museum specimen or primitive art, showed remarkably little interest in the identities or careers of individual artists. The view at the time was that art is produced by cultures, not artists. The first scholar to make careful enquiries about the artists was Marius Barbeau; for example, in his *Totem Poles of the Gitksan* (1929), and his collection notes on museum specimens. His view is well illustrated in the dedication in *Totem Poles* (1950):

> Let this book be a memorial to the native artists of
> the north Pacific Coast.... Independent of our great
> moderns, from Turner to Gauguin, Van Gogh, and Cezanne,
> they were nevertheless their contemporaries.

Since Barbeau, the discovery and description of individual styles has been one of the major emphases of research in the art, both for known, recent artists and anonymous, traditional ones. The model study has been Bill Holm's recent *The Art of Willie Seaweed: a Kwakiutl Master* (1974); a meticulous description of the form and style of the artist's work over the decades of his career, which lasted into the 1950s. Holm has also identified works by other Kwakiutl artists of the same period (e.g., in Hawthorn, 1967), and one of his students has made a similar study of Seaweed's contemporary and peer Mungo Martin. Such studies of recent artists are firmly based; if not on personal acquaintance with the artist, at least on the sure advice of his contemporaries; evidence of a sort which is not available for the anonymous artists of the previous century.

Barbeau also made the first systematic attempts to distinguish the styles of Haida argillite carvers of the turn of the century, *In Haida Myths* (1953) and *Haida Carvers in Argillite* (1957). His method was to show photographs of specimens to Haida informants

on the assumption that the individual work or style would be recognized. The results, while contributing a great deal to existing knowledge of the Haida artists, were not uniformly trustworthy. Too often, his attributions were uneasy choices between his informants' opinions and his own; it is suggested that they be accepted with caution unless firmly supported by documentation in museum records. In some cases his published attributions have been uncritically fed back into museum records, making errors, where they did occur, more difficult to find.

The concern of this study is with the styles of earlier (nineteenth-century) anonymous northern artists. This great traditional art seems to be characterized by a relatively small number of styles. Those of us who were involved in the *Arts of the Raven* show at the Vancouver Art Gallery in 1967 experienced the thrill of discovery—which comes occasionally to everyone who works with the traditional arts—of setting side by side two pieces from different collections and perceiving, suddenly and with certainty, that they must have been made by the same artist. It was as though individual artists were insistent to make themselves known by their works, and each such flash of recognition brought us a step closer to knowing who they were. The conviction grew that the great assemblage of fine art which Bill Reid, Bill Holm and I had chosen, simply because it was best, was very largely the work of a small number of master artists. Bill Reid expressed the feeling in his essay in the catalog:

> One thing has become apparent.... If these people were an artistic race, they were not a race of artists. The recurrently similar styles can lead only to the conviction that the high art of the region was the product of a few men of genius, many of whom apparently had long, slowly maturing, productive careers.

The exhibition, from the outset, did have a section featuring the art of one man, Charles Edenshaw. Of the works which we attributed to him, many were well-documented masterpieces about which there was no doubt. Others we attributed on the basis of our mutual recognition of his style. I must admit that I am less certain now than I was then about some of the attributions. The recognition of styles is largely an intuitive process, and intuition can be a fickle instrument, despite the feeling of certainty it can bring. Postulated styles must stand the test of more analytical forms of examination.

But the importance of defining individual styles in this anonymous art makes it a game that is worth the risk. It is the sharpest tool of art history. Given the sorry state of museum documentation, resulting from the wide dispersal of the art from its points of origin, the limited interests of the collectors, and the half-informed guesses of curators, some such method is required to set the record straight on the fundamental questions of where and when the art was produced, let alone by whom. Sequences of works from individual hands are now beginning to be perceived in many of the art forms, including horn spoons, totem poles, masks, headdress frontlets, chests, boxes and argillite panel pipes. Questions of meaning can also be asked more perceptively of sequences of works than of single works. What was the artist getting at in his progression from one statement to the next? Some artists will be found to have been working on major themes.

There is no easy or mechanical method for finding the personal styles in arts so old that the artists and critics are dead, and the documentation so deficient and misleading. It must be a process akin to the connoisseurship practiced by European art historians. In the end it depends upon the intuitive judgment of experts. It cannot tell the whole story, but may only establish bridgeheads. It has been said that the artist is not equally present in all of his works, so that many pieces, even from the hands of the greatest artists, will remain unrecognized. The method requires a balanced view of the entire universe of study. "He who knows but one master knows him insufficiently" (Friedlander, 1944, p. 178). The method is hazardous; the educated intuition on which an attribution is based must bear the weight of all relevant objective knowledge about the work, but the fact remains that the decision is made subjectively, and that the objective details are then brought to bear for confirmation or refutation of the choice.

In the traditional art of the Northwest Coast it is not difficult to begin to perceive styles. The more difficult question is whether these are tribal or 'school' styles or those of individuals. At a certain level, of course, one reaches personal styles, and so important is the question that it is incumbent on scholars to attempt to define these.

Two such studies have been done under my direction at the University of B.C. Susan Davidson (Thomas) in 1967 completed a

graduating essay of the life and work of Charles Edenshaw, and Trisha Gessler (Glathaar) wrote her M.A. thesis in fine arts on the Haida artist Tom Price [Gessler 1981]. The present study has the benefit of both of these predecessors.

As a contribution to the methods of art history, this book consists of two investigations into individual style. That of Charles Edenshaw is more fully represented, but it is closer to us in time and is supported by several firm attributions and by a consensus among scholars. It is not yet a complete delineation of his career and because there are forms in which I do not recognize his hand. The style of Albert Edward Edenshaw—or rather one should say the styles— have hitherto been completely unknown. Certain clusters of works which belong together stylistically can be traced to him, although the links are sometimes tenuous. It is at best a tentative formulation of part of his life work, and large gaps remain. Yet the picture which emerges of a great and productive artist is consistent with all that is known about the circumstances of his life; it is not lightly or on little reflection that I consider him the author of the attributed works.

Edenshaw and Boas, 1897

Dr. Franz Boas of the American Museum of Natural History was the dominant scholar in the field of Northwest Coast art, and Edenshaw was acknowledged as the foremost Haida artist, when they met and worked together for fifteen days at Port Essington at the mouth of the Skeena River in August of 1897. Boas was in the field as director of the Jesup North Pacific Expedition. Just that spring he had published his study *The Decorative Art of the Indians of the North Pacific Coast* (Boas, 1897), which was based mostly on a study of museum materials, and which he later expanded and incorporated in his classic *Primitive Art* (Boas, 1927). His only direct contact with Haidas had been a brief period in Victoria in 1888, when his main informant had been John Wiha of Skidegate, and a weeklong visit the same year to Port Essington, where he had photographs made of a number of individuals with tattooed crest designs.[2]

Boas never did visit a Haida village, and this time spent with Edenshaw seems to be the only direct contact he was to have in the

field with the Haida. The results of their meeting are therefore of great interest.

Boas came well prepared. His earlier study had provided the background for the problem he wanted to investigate: how this symbolic art was applied to very difficult design fields, specifically the human face and long narrow blanket borders. He brought printed outlines of male and female faces to draw on, and drawing paper and crayons. He also brought large numbers of photographs and drawings of objects for identification. He was extremely fortunate to find Edenshaw as he did, and to find him available for as long as Boas could stay; and he knew it.

Hs recently-published letter to his wife and parents from the field (Rohner, 1969, Ch. 8, pp. 223-31) speak for themselves of his purposes and reactions. He arrived at Port Essington by steamer on the night of August 10. Excerpts follow.

August 13:

...I spend...time with a Haida painter whom I just got in time. He was ready to leave for Fort Simpson the day before yesterday when I quickly engaged him. I am showing him all the photographs which I had made in New York and Washington, as well as in Ottawa, and I am able to identify many objects with his help....

August 15:

Today is Sunday, and since I am with the pious Tsimshians I can't work with my Indian.... I am more successful than I expected with the explanation of objects. I have up to now identified twenty-five objects for New York; some that belong to Washington and some to Ottawa.

August 15 (to parents):

...I am quite satisfied with my progress here. I met just the right man and got excellent material from him. My purpose here is to collect more material on the art of the Indians, about which I wrote in my article. As I said before, I was really successful, I hope my man will keep on.

August 19:

...I should have more than this one man, to feel safe. I cannot get any explanation from him about masks. His own drawings are very good, and I did get the main thing I wanted to learn about.....

Unfortunately, the facial paintings are all collected. My Haida friend takes so long to do a painting that I lose a lot of time. I cannot do anything else while he is doing it, and I have some free time. In between I let him tell me things. Since his Chinook is rather limited, however, the conversation is very difficult.

August 22:

/preparing to leave/ I want to try to make friend Edenshaw finish the story about the Raven. Kiss the children for me...

August 26:

/on board the steamer *Tees*/ I was successful in obtaining drawings and paintings. You might remember that I planned to collect paintings done on hard-to-decorate materials in order to study the symbolism of the Indians. For this purpose I chose face paintings and paintings on edges of blankets. The results are very satisfying, because I found just what I had expected; that is, strong stylization and stressing of symbols.

Dr. C. F. Newcombe and Edenshaw, 1901-1902

Dr. C. F. Newcombe of Victoria, psychiatrist by training but naturalist, historian, ethnographer and one of the most prolific collectors for many museums, spent many summers up the coast in his small boat. Totem poles he collected are in Bremen, New York, Chicago and Victoria; collections in Chicago, Ottawa and Victoria. His private papers and notes are now in the Provincial Archives, and I have been through them (though not exhaustively), and have obtained information on Charles Edenshaw, Haida ethnography, and a host of other topics.

It would seem that his first visit to the Queen Charlottes was in 1897. He left no mention of **CE** that trip (CE was at Port Essington working with Boas August 11-25). How many subsequent trips he made in succeeding years is not clear; there were many as late as 1911 and 1913 when he was collecting for the **PM**. I would like to refer specifically to 1901 and 1902, because in those summers he collected important materials from CE.

His 1901 journal gives a detailed account of a trip during April and May to the southern Haida villages making photographs and purchasing poles for New York and Chicago (also see the Bremen **pole?**). In June he proceeded to Masset. Swanton and his main

Masset informant Henry Edenshaw were traveling in the latter's schooner. In July they went together to the Kaigani villages and then returned to Masset. That Newcombe contributed a great deal to Swanton's study is evident in the maps, place names and such things as botanical identifications.

Newcombe's journal makes no specific reference to CE, but a 1901 note book listed a number of things purchased from him at Masset. There were three carved and painted chests ($10 each), one of which was said to be made at Kioosta and 150 years old. Another is **PM 1295**. Another purchase from CE was the chiefs seat with frog crest **(PM 12)** for $5 plus $1.50 to CE to paint it. Another was a box drum, painted. Masks etc. are also listed.

In 1902, Newcombe made two trips north. In March and April he visited the Alaskan Haida villages, and at Howkan he purchased from Yeltadzi for $4, "a small carved sheep horn dish said to have been carved by C. Edensa." On his second trip he arrived at Kasaan Cannery on June 22, and he stayed in the vicinity until July 31. CE and his wife were there. Newcombe spent a lot of time with them, purchasing items from them some of which he commissioned them to make (apparently mainly for Field Museum in Chicago) and obtaining ethnographic information for which he paid CE $0.25 per hour informants fees. He recorded information on many subjects, including totem pole making, board making, house building, net making, and descriptions of the items he bought, chiefs rattle and tree names. Some of this will be referred to later. From Mrs. CE he purchased a cradle woven of spruce roots and painted with a dogfish crest, and openwork woven spoon basket (commissioned, $1.15), a cup of spruce roots, hat with frog crest and a basket for holding a hat. From CE he made several purchases. One was a wooden cradle (more recent type) of cedar with dogfish crest carved on (became PM 1294, see Guide, p. 12). A small, newly made grease dish of maple in the shape of frog, $10. He commissioned a model wooden totem pole, $15 and obtained information on its original at Hiellen. CE made a 12 ft. slate pole, which CFN bought for $12.20 and which from his description can be identified as now in the National Museum. A set of cedarbark patterns or templates, $1.15, with notes, probably went to Chicago. A carved paddle cost $1.75. And he also purchased an inside housepost at Masset (Raven above, ?Bear be-

low) for $32, picking it up on the way home. On July 21 he recorded curtly "Mrs. CE confined this A.M.," but didn't record whether he attended the birth (this was Alice, who died at 13 years old). One wonders what the infant did for a cradle, as Newcombe had just purchased two from the parents.

Some of the ethnographic information is pertinent and is used in this study. Other bits obtained by Newcombe are scattered through other chapters. Here we might just make a few observations about the results of their 1901-1902 meetings.

An excellent purview of CE's style in 1902 is provided by the wooden pole, the slate pole, the carved cradle, the painted cradle and the patterns. CFN obtained a great deal of information, communicating presumably in Chinook. One is dismayed that apparently he failed to ask—about the 1901 chests and chief's seat, and about CE's housepost—the question which now seems too important: who made them?

Recollections of Charles Edenshaw By His Daughter

In 1967, during the Arts of the Raven show at the Vancouver Art Gallery, I had opportunities to speak at length with a daughter of Charles Edenshaw, Mrs. Florence Davidson, and her husband, and to examine items in the show in her company. The results of these and subsequent interviews are given here.

Florence knew her father mostly as an old man. She was born in September, 1895, when he was fifty-five years old, had lived in Masset for over a decade, and had been a Christian for almost that long. It was the later period of his career, when he was primarily a jeweler and slate worker (and raised to great heights in both). Many of his other kinds of artistic endeavours were things of the past. In 1911, at the age of sixteen, she married Robert Davidson. She was closer to her father than any of her sisters, and she and her husband took care of him in his declining years. When he died in 1920 she was twenty-five, and many of her memories of him are very clear; not just things she herself observed, but things he told her. She is a gracious, regal woman, of clear memory and very cooperative.

Biographical

The boy who was to become "Charlie" and "Edenshaw" was

born and spent his early years in Skidegate. He was sickly as a child, with "TB or something." Once for a whole year his mother fed him solely on a mixture of seaweed toasted in an iron pot and eulachon oil. One day he could feel something working its way up into his throat; he spit it up/out and it looked something like a devilfish, and from that time on he grew stronger. While he was sick he amused himself by playing at carving; he had no special teacher.

At about seventeen he went to live with his uncle Edenshaw. Some years later he married a girl of about sixteen. It was understood that he would succeed his uncle. His uncle told him many stories.

His main name before he became "Charlie Edenshaw" was **d'a'x̄'i'gan.**[3]

Florence also gave git'i'wans as another of his names. In C. F. Newcombe's notes are two more names: eklatgwa and ski'lekleklewus, with a note beside the latter saying it was his first name. Florence recognized the first as 'iXatg'a'o "refuses to be chief," and the second she thought was skil'xwa'nsas (Skil is often said to mean "fairy."), "fairies coming to you as in a big wave," which she confirmed was the "olden name" of her father.

His one marriage lasted all his life, his wife dying in 1924. She was a proud woman and a fine basketmaker. When they were baptized by Reverend Mr. Harrison, he gave her a long list of royal names from which to choose, and after careful thought, she chose Isabella. She asked Mr. Harrison what queens wore, and when he got pictures for her, she said "that is how I'll dress from now on." She wove baskets and seven or eight hats a year, which her husband painted, and which she sold to Mr. Cunningham at Port Essington.

They had one son and five daughters. The son, Robert, was eighteen when he was drowned while working at Rivers Inlet in August, 1895 (the month before Florence was born). He had gone south to Victoria with his parents to buy a treadle sewing machine for her, and on the way back stopped off at Rivers Inlet, while his parents went on to Port Simpson. They were there when his casket arrived on the steamer. Edenshaw was desolated by his son's death. He used to say that Robert was smarter than he was, but he used to say to him: "If only I could leave you my hands; but I don't know any way to leave you my hands."

227

The oldest daughter was Emily (now Emily White of Masset); the next Agnes (now Jones, formerly Yeltadzi, of Masset). Florence (Mrs. Robert Davidson of Masset) was next, then Norah (Mrs. Robert Cogu? of Ketchikan, five years younger than Florence. The last daughter, Alice, was born in 1902/CFN records the event July 21, 1902, at New Kasan in his notebook/and died at the age of thirteen.

Florence remembers her father as a cheerful man who worked every day (that was how he made his living, but he also enjoyed it) except Sunday. On Sunday special clothes were worn, and no work was permitted, even the bringing in of firewood, which had to be done beforehand. When he didn't have jewelry orders he worked on slate and other things. He often sang as he worked, although he was not a songmaker or a dancer. She never remembers being punished by her parents; the children would do what they were told "because he told them how hard it had been on him when he lost his son."

He traveled a great deal, usually staying the winters in Masset and going away for the summers. When he was young and his mother was still alive, he spent whole summers in Skidegate. "He spent a lot of time at Skidegate." He also went frequently to Sitka "to do some painting for them, and make bracelets and things." He spent a lot of time at Ketchikan, where he shared a cabin with a Tlingit man. He traveled to Victoria, and often to Port Simpson for extended visits. Every summer he went to Port Essington, where Mr. Cunningham bought his slate and his wife's basketry hats, and paid good prices for them (he used to say that some of the Indians who commissioned him cheated him by not paying enough).

In addition to Haida, he spoke Tlingit and Tsimshian. With Dr. Newcombe and with Boas he spoke Chinook. He spoke a little English but did not write except that he could manage his signature.

For some years before his death in 1920 he was unable to walk. Until 1913-14 he was strong, but his health failed after that. Florence has a gold bracelet and a silver sea-otter brooch, made in 1918. These were his last work, and are comparatively poor. Masset: Some of these models were carved by Charles "Edenshaw, the noted Haida Indian carver of Masset, whose later work is poor because of his increasing blindness. Some were carved by a Haida or Haidas of Skidegate."

Florence does not remember Swanton's visit in 1900-1901, but does remember Dr. C. F. Newcombe, who "came every year and got father to make things for him." It was Dr. Newcombe who brought elephant tusk ivory which he used for the heads of canes and to inlay slate things.

Two younger Haidas who worked with Edenshaw were 'ilti'ni (John Marks), a relative, and sk'ilay (Isaac Chapman). The latter was not a slave, but a cripple on crutches who was adopted into a family without children. Edenshaw felt sorry for him and taught him slate carving. He died a young man in 1909. As a painter, Edenshaw made all of his own brushes, using hair from horses tail, and cutting the brush at an angle. He also made his own paints, using only three colors: red, black and "green." He obtained the green pigment at Naden Harbour, burned it, and ground it in a stone paint pot with salmon eggs until it was the right consistency. He washed the pot clean each time so that he could mix another color. His native paints were still in his fine little tool chest when it was given to his nephew, Charlie Gladstone of Skidegate. Florence does not remember seeing patterns in the box, and says that he painted freehand (but see set of templates he sold CFN in 1902). One of the things he painted was boxes. In former years he would make his own boxes and paint them, but after Florence married, her husband Robert made boxes for him to paint, some of them quite small. She commented that he liked to use a lacy design (cross-hatching), and called it lgw n cika "skunk cabbage head." It took him about three days to paint an average box.

He also made and painted paddles of yellow cedar. He did not himself make canoes, but did paint them: the large canoe in the National Museum of Canada was made by Robert Davidson and his older brother, and the design painted on by Edenshaw. As mentioned earlier, he went to Sitka, etc., and painted for them, and painted his wife's baskets and hats. At the Raven show, Florence thought she recognized his style on the Raven Screens, the Glenbow dish, pigment bags, boxes; of that I am doubtful.

Slate was of course only available at Skidegate. Florence remembers that in her time he bought it, or received it from his nephew at Skidegate. Earlier, he went each spring by canoe around Rose Spit to Skidegate (she did not seem to know of a trail from Masset). Of the types of slate objects at the Raven show, she did not remember

him making any chests or imitation cockles. She did confirm that he made comports and pipes with figures on the bowl and stem. All the panels of figures looked like his work to her, and she said that they all represented stories, which he used to tell, and most of which he had learned from his uncle. She briefly told the myth of the clamshell origin of mankind, shown on a plate and the lid of a chest, saying that each of the little human faces had a name, "and we are descended from the one in the middle." The small "angel" figure from the Provincial Museum, she said, represented the story of the virgin birth of Raven. The girl was the virgin mother; she did not realize that her child was Raven; she was holding it as babies were held. She thought her father must have done it because he did such carvings.

Of the canes with the ivory heads, she thought her father "invented" them, and was the only one who made them with ivory heads. The ivory was elephant tusk brought by Newcombe.

He engraved silver and also gold. During 1913 he had so many orders for gold jewelry that he couldn't keep up with them all. Asked about totem poles, she said "he said he had carved a few," and added that a man wouldn't carve his own, but have it carved for him by the opposite side. He used to make masks and round rattles when people asked him to, and other wood carvings. He made model houses with poles. She described one chief's seat which he had carved, and which had been bought by Mr. Gillett in the 1920s. It had a bear and bear tracks on the back, with low flat sides, and used to be piled with pillows.

Edenshaw's Argillite

- UBC Comport (Creation)
- UBC Old Man Plate (Thinker)
- UBC Wasko-Clamshell dish (Origin of Man)
- PM Angel and Husband
- PM Chest (Origin of Raven and Man)
- PM Frog bowl
- PM Whale and Raven
- PM Bear Mother
- PM Cockles
- VCM Wasko Plate
- VCM Boatload

— VCM Owl
— Chicago Plate (Origin of Woman)
— NMC Plate
— NMC 1902 Pole
— Cunningham Chest
— Cunningham Poles
— Sheldon Jackson Comport

* * *

Was abstract art another result of white contact? If Edenshaw and the others were conscious that their art mirrored the way things are, and that it was the iconic level that did this, then if they worked out the impact of change it would be in iconics, even at the expense of iconography, and the result would be more "abstract" art. Also, it would be worked out "in Haida," because it was of particular concern to the Indians, and whatever messages it conveyed about how things could be worked out was *for* the Indians. So chests and sacred dishes were good media, and things for sale to white men were not. And Edenshaw's generation were the proper time.

His ties seem to have been with Tlingit of the Wrangell area. Maybe that is where the salmon trout head was invented (its complete absence on panel pipes suggests that it was absent from Skidegate at the time; the alternate explanation is that since it dealt with iconic topics it was not needed on iconic beasties, or was not appropriate for the white men). That is the area where old paintings are iconic.

What would happen if this trend of thought were true? Any stylized art might do the same under contact (Maori?). It gets *more* Haida as you pass out of aboriginal times. In old days a nice even balance between the two would be more comfortable. A conscious attempt to reduce the impact of iconography down to the level of impact of iconics could result in distributive design.

A constant frustration to students of Haida art has always been the distressingly limited success we have had in answering the question "what does it *mean*?" What, that is to ask, are the kinds, levels, aspects or components of meaning which are embodied in paintings

such as those in this paper? What kinds of meaning, indeed, is such an art style capable of conveying?

We have hardly got beyond the first and most elementary question: "What does it *represent*?" We have had modest success in answering this question, learning to read the iconography, has I think tended to lead us astray. There is a certain plateau in the understanding of northern Northwest Coast art iconography which is easy to reach, and the legions who get to breathe its heady air tend one and all to feel they have become experts with the key to the full comprehension of the art. The "rules" we learn provide a base for further shaky guesses, and an excuse for avoiding the honest "I don't know." Our egos get involved. We fail to see that we may be asking the question in the wrong way.

The fact is that even the most astute scholars have quickly found themselves in darkness on even that first simple question.... When we do not know, we feel qualified to guess, sometimes at our peril. Those who have read Emmon's paper on the Chilkat blanket will recall the unseemly spectacle of Swanton adding his conflicting interpretations of blanket designs to most of Emmons' caption, and Boas as editor often intruding a third.

The painted box collected by Emmons at Chilkat provides a classic case of avoidance of the honest, "I don't know." Boas, after thirty years of study of this art and a discussion of the design with Charlie Edenshaw, had to admit in pique that he could not interpret its meaning, nor could he bring himself to accept Edenshaw's interpretation (Boas 1927:275). It seems to have salved his ego somewhat to be able to say that the art had become completely "decorative." Emmons had guessed (or his informant had) "seal."

I have witnessed Bill Reid's frustration with the same box, after bringing it as a feature of the Arts of the Raven show and choosing it and one other masterpiece as the subject of a lecture, and not being able to verbalize the greatness he knew it intuitively to have. The same kind of frustration revealed itself in another way in Bill Holm with the writing of his masterful and popular study of Northwest Coast art (Holm, 1966). It is subtitled, pointedly, *A Study of Form*, and it leaves in abeyance, as usual, the questions of *meanings*.

I now feel strongly, with Ben Shahn, that form in art must be seen as "the visible shape of content" (Shahn, p. 71); that is, the

visible shape of meaning. To discover, as Holm did, that Haida art has a multitude of rules or patterned regularities of form, and not enquire what these mean, seems no longer adequate. Nor is it adequate to avoid the issue by invoking words such as "decorative" and "abstract," or partial explanations such as the Haida's presumed horror of blank spaces and the exigencies of need to adapt the designs to awkwardly shaped fields. Haida art is full of distinctively shaped forms, and I now feel sure that these are the visible shapes of highly distinctive meanings.

* * *

Errors in Barbeau's section on Charlie Edenshaw in *Haida Carvers*:

Most of the attributions to Edenshaw from Swanton are wrong:

Barbeau's Fig. 171 is Swanton's Pl. II (not CE but Skidegate)

172 I do.

173 VIII (Sw. doesn't attrib. to CE, prob. Skid)

174 V (Figs. 1 and 2 are CE, not attr.)

175 III (3 and 4 are CE, 1 and 2 Skidegate)

176 IV (Correct, attr. CE by Sw).

177, 178, and 179 make up Swanton's Pl. XXI.

men who did all drawings, only 2 (on 179) are CE from Boas 1897 visit to Pt. Essington).

180 is Sw. Fig. 18 of BB canoe bow and stern.

Sw doesn't attribute paintings to CE.

181 is Sw. Pl. VI, not attrib. by Sw. to CE.

182 VII " " " " " "

and not.

Barbeau's Fig. 183 captioned "Dr. C. F. Newcome (right) and Edenshaw" is wrong; it is Henry Moody.

Introduction to Book on Late Charles Edenshaw

The time has not yet come for a definitive book on the life and works of the last great artist-philosopher of the Haida, Charles Edenshaw (1840-1920). We have not yet assembled enough of his works, and do not yet understand enough of their meanings. In distant museums and private collections there are still undiscovered masterworks in argillite, silver and gold. And there are

still a number of earlier forms such as horn spoons, headdress frontlets, masks and painted boxes, in which we do not clearly enough recognize his hand. The meanings in his art, which I think we are just beginning to glimpse, seem to be conveyed in a strange and powerful Haida mode of discourse which is doubly difficult for us to understand. And I think that I can already see that his was an intellect so audacious that we may find ourselves incapable of comprehending it fully.

But at least we can make a start. If nothing more we can revel with him in the supreme craftsmanship that resided in his hands. Look closely again at the curved lines on one of his silver bracelets or one of his argillite plates. No other man, perhaps, has engraved lines of greater purity. He well knew the artistry that dwelled in his hands. I have been told by his daughter of the deep affection he had for his only son, and of how he used to say, "If only I could leave you my hands, but I don't know any way to leave you my hands." (Robert—Ginawan—drowned at the age of eighteen in 1895.)

At least we can begin to ponder the meanings which he silently poured into his late works in argillite. For we have a very long way to go, and we have not yet learned fully enough how to find them. The determined efforts of Boas, Barbeau and other anthropologists to interpret his representations as family crests and as episodes from Haida myths have yielded a little of the truth, but in retrospect seem to have been inordinately frustrating. It is simply not enough to see that one of the figures on a pole represents Beaver, one of his crests, or that a design on an argillite plate represents Gonaqadet, a sea monster from a myth. Such a view still retains vestiges of the old image of the simple primitive, striving to create pictures of the creatures of his imaginary world.

We are the ones who are thinking at too primitive a level when we bring to Haida designs the premise that their only purpose was to "represent" things (and usually things which can be identified by specific nouns, like beavers). We have not realized that Boas' relentless question, "What does it represent?" which was the bending of the twig in the study of Northwest Coast art, was capable of reaching only the first level of meaning, only the beginning of the truth. To be sure, Haida art is partly about things; but mostly, I have come to believe, it is about relationships. The key meaning in a Haida work

of art is not the specific noun that it represents, nor the specific verb, but the set of relationships which is embodied in the whole, and what that configuration implies in the present instance. The structure is the meaning "code," and the implication is the meaning "message."

It might be said that Haida art conveys its meanings in much the same way as our proverbs do: "A stitch in time...." is about many things, the least of which involves a needle and thread. Or as our parables: to Jesus the Shepherd the least of worries was sheep. But that would miss an essential difference in the structuring of the thought. The only Haida "proverb" which I know (and perhaps one was enough) is "the world is as sharp as a knife." I think that its meaning, like the meanings in Haida art, is to be found by looking at its structure as well as its message. Or to put it another way, half of its meaning is in what it says, and the other half is in what it is. The one half seems to be a manifest absurdity, the other half to be a selfcontradiction, but the whole is seen to be an equation of a doubly complex kind. Its overall structure is the structure of paradox. Haida thinkers seem to have been masterful manipulators of the logical paradox.

I do not want to get deeply embroiled in problems of meaning too soon. However, there are some relevant lines of thought which I want to at least introduce, because they are foreign to our ordinary thought and therefore difficult for us to comprehend. The first of these has to do with the matter of thinking in paradoxes, which I believe to be the dominant mode of thinking in Haida art. The logical paradox, even in the form of a simple declarative utterance, is to us a mind-wrenching thing. For example, the assertion, "This statement is a lie," says one thing and is another, which is its opposite. It is one thing that is two opposite things at the same time. It exists. It is right, and it is wrong, and it is both. Such a line of thought can lead to the Holy Trinity. In Haida art, below the surface on the metaphoric level, the logical paradox sometimes takes the sexual form of a lingam which claims to be a yoni, and is therefore a lingam-yoni. Art is after all a limited medium of communication, and has difficulty in finding ways to make ultimate statements, or even to create equations, or to "speak in sentences." If it must limit itself to a single such form of utterance, perhaps the logical paradox is the most powerful one to

choose. At least that seems to be the tacit conclusion of the Haida artists.

A second unfamiliar idea involves the nature of the symbols used in Haida art, such as the "salmon-trout head" motif in graphic design and the Frog sculptured on an Edenshaw totem pole. These do not seem to be simple metaphors, each standing for one other class of things, such as "eye" or "those who use Frog as a crest." They seem instead to be capable of use as open metaphors referring to particular configurations or structure. Like the much simpler "iconic signals" used in Australian aboriginal sand drawings, they seem to have "multiple reference" (Leach, 19 , p. 223). As with our proverbs, their meaning seems to embrace all things of like configuration. They apply, by analogy and implication, to every other thing or circumstance that shares the same set of relationships. That being the case, they can be symbols of great power, capable of knitting together the material, social and cosmic realms by the use of those configurations of relationship which make the best sense of things to the Haida mind. But we are at a double disadvantage, because we do not yet know what particular sets of relationships are being used, nor the vocabulary of images in which the configurations are clothes. To return to my two examples, I have come to believe that the "salmon-trout head," in addition to being a particularly pleasing unit of visual design, could be taken to mean all things analogous to a hatching salmon, a growing nephew, and one-half-of-perfection; and that Edenshaw's Frog took some of its attributes from the creature in nature, and did serve as a family crest, and also on occasion (when the art was being used for thinking) acted as a stand-in for an exceedingly complex concept whose structure was something like that of "the square on the hypotenuse..."

As already hinted, we shall also be led into realms of sexual imagery, which may seem surprising since sexual nouns and sexual verbs are almost never shown explicitly in Haida art. Nonetheless, as in most systems of art and thought, sexual images are abundantly present in implicit form. The yin and yang, the lingam and yoni, the duality of the sexes and their union into one, seem to lie at the very foundation of man's thought. Even in Christian religious art, forbidden sexuality is a fundamental underlying theme:

In Michelangelo's *Pieta*, for example, where the virgin's bereaved mother and her dead son are manifestly of about the same age our emotions are stirred by latent incestuous emotions of the most complex kind (Leach, *op. cit.*, p. 232).

Human society began when man placed voluntary controls on the sex instinct. He did so by defining certain sexual relationships as taboo, which is to say, sacred. That both European and Haida societies were much concerned with sexual taboos is evident from the **surface** prudishness of their art. But the matter could not end there, for one of the basic functions of art is to show (or rather, to suggest) the very thing that is taboo, to hint at the very act that is unthinkable (Leach, *op. cit.*, p. 227). It is almost the case that the more sacred the art the more unthinkable the implied meaning. To the Haida the most unthinkable of all sexual acts could well have been that primal act of incest that would give the lie to the myth of the "virgin birth" of Raven. If such is the case, the little pair of argillite sculptures which I call Raven's Mother and Father may well be some sort of counterpart of the *Pieta*.

Two things which are almost never explicit but almost always implicit in Haida art are sex and the true circle. This is an observation to which we shall return when considering Edenshaw's circular argillite plates.

A knowledge of Haida mythology provides one of the keys to the understanding of Haida art, because the art draws images from the myths, and the two embody parallel systems of logic. One of the functions of myth is to "think through" problems, especially those intractable double-bind dilemmas into which human societies, in attempting to act with consistency and think with logic, place themselves. This "thinking through" is not what the story, on the face of it, seems to be about, for every myth is also a parable that is really about something else. The thinking is accomplished at a deeper level which is at most times unconscious. The "solution" lies implicit in the structure of the parable. In Haida art, I think I can see, the underlying paradoxes are sought out and made explicit, at least to the eye of the artist. The great works of art are assertions, equations, logical paradoxes—and their intended implications—all at the same time. Haida art can be a deliberate structural analysis of Haida myth. But we are getting in too deep. Let it suffice to say that we shall

consider a few of the basic Haida myths, because Edenshaw chose to continue to draw his images from them.

The man who was to become known as Charlie Edenshaw (borrowing, on his baptism about 1890, the Christian name of Bonnie Prince Charlie of Scotland) was the inheritor and, in my view, the supreme interpreter of the entire tradition of Haida thought as expressed in art. His uncle, with whom he lived most of his life, and on whose death in 1894 he inherited the title Edenshaw, had also been the preeminent artist-philosopher of his generation (on his baptism he chose the Christian names of Queen Victoria's consort, Albert Edward). These two men, who knew their worth, may be said to represent the end of an ancient, nonliterate intellectual tradition which drew upon currents of philosophy more closely related to those of the East than those of the West. They also represent the culmination of a century of intense intellectual and artistic ferment, stimulated by the presence of the white man, during which the Haida world-view had been re-examined and powerfully re-affirmed (not least in the twenty forests of "totem poles" that fronted the Haida towns). Charlie Edenshaw participated in the ending of that era, but he also retained until his death a full command of its accumulated wisdom. He understood full well the meanings of its less remote visual milestones such as the Raven rattle, the copper and his uncle's carved chest designs and painted murals. What I think I find him doing in his post-Christian art is restating yet again, in even more explicit terms, the prime theorems of the Haida tradition. His argillite caskets, for example, seem to sort out and restate the levels of structure which lie implicit in his uncle's carved wooden chest designs. I also think I find him turning his art to problems and images reminiscent of Christian themes, and even, perhaps, using the wisdom of the old way to correct what he saw as false in the new.

For there is still one more dimension we must be aware of in the man, that of Christian philosopher. The art of Charlie Edenshaw as represented by the works in this book was the art of a devout Christian, and, I am sure, a thinking one. The Anglican missionaries who had been close friends and companions since 1876, W. H. (E?) Collison, Charles Harrison, and W. H. Keen, were well-educated and literate men fresh from England. They brought to Masset not just the Bible with its profound associated myths and images (the Madonna

and Child, the Crucifixion) but also a direct and continuing tie with the culture of Europe. By 1883, Charlie Edenshaw had papered his bedroom wall with The Illustrated London News, from which he borrowed images for use on his ivory-headed walking sticks, such as Jumbo the Elephant and the hand of Laocoon grasping a snake. In 1913, in a wedding speech, his "cousin" Henry Edenshaw (Albert Edward's son) quoted knowledgeably from Shakespeare and Goethe. It is not at all inconceivable that Edenshaw saw and pondered illustrations of the *Pieta* of Michelangelo and *The Thinker* of Rodin, and gave his responses to them in his art. His latest and greatest works are quite possibly about what their great works were also about: the deepest myths and truths of mankind. It is just that he chose to continue to do them "in Haida."

Edenshaw Chests

Large wooden chests of a particular type have been collected from a wide area of the coast ranging from Kluckwen in northern Tlingit territory to the Fraser Valley in Salish territory, bearing elaborate designs in the northern art style. The number of these known to me is about fifty, and they are attributed in museum records to the Tlingit, Haida, Tsimshian, Bella Bella and even Kwakiutl. They merge conceptually into other chest types and into types of square boxes which are even more numerous, the designs on which seem to be derivative of the chest designs. This study includes a number of chests, and it is my purpose to show that those of the dominant type belong together as a stylistic cluster associated with the northern Haida area of the coast, and, incredibly, are from the hands of one artist, Albert Edward Edenshaw.

Although no two are identical in all details, the "Edenshaw chests" share common features which set them off as a type: large, oblong, with a heavy base and a heavier lid. The four sides are of a single cedar plank, kerfed and bent at three corners and joined at the fourth by pegs or sewing. The design is painted, or more frequently painted and carved, on front and back: highly complex figures of formlines and related elements. That on the front can be read as an animal with a huge head and small central body, the double-eyed face with brows which touch the top edge of the chest. Other ele-

ments have been read as other body parts; for example, the four corner ovoids containing "salmon-trout heads" have been said to be hip and shoulder joints, but such meanings are by no means explcit and clear. The design on the back may also be read as an animal, the face having large single "salmon-trout heads" for eyes, but there is no nose or beak.

Bill Holm has provided an excellent formal analysis of the primary, secondary and tertiary structure of these designs, and of their colors, which are restricted to black, red and blue (in Duff, et. al., 1969). Boas, in *Primitive Art* (1927, pp. 262-7), carried the iconographic interpretation as far as possible in identifying the designs as highly stylized animals.

The figures on the ends of the chests are more variable, in contrast with the fixed stylization of the front and back. They are most often simpler, painted rather than carved, and seemingly unrelated to the front and back designs. Little chests are joined directly to the decorated sides, forming a box which telescopes down over a plain inner box attached to the base. This seems to have been the ancestral type.

Place of Origin

Kerfed and lidded cedar boxes are widespread and old on the Northwest Coast. My purpose here is to determine the place of origin of this particular type of chest, and distinguish it from its predecessors and derivatives. The discussion will also help to clarify the type.

Haida

Strong evidence links chests of this type with the Haida. An example is shown in Holm (1965, Fig. 55), which was collected at Masset by C. F. Newcombe from Charles Edenshaw in 1901, and was said to have come from Kiusta and to be 150 years old. Newcombe obtained at least four more from Masset (PM 1295, PM 1399, EC27, Culin 1906), and Inverarity collected two more from the Queen Charlotte Islands in the 1930s (Inverarity, 1950, Pl. 16, 24). In 1902, Charles Edenshaw also gave Newcombe detailed information on how the chests had been made. The cedar board was trued to width and a center line was drawn

along its length. One end was squared using a string as a radius from a point on the center line. Two strips of wood were then cut as measures for the short and long sides of the chest. The corners were then marked and kerfed on both sides (a deep V on the inside and a very shallow U on the outside); then steamed, bent and the fourth corner joined with pegs of yew. Edenshaw also sold Newcombe a set of templates for ovoids and eye shapes used for such box designs. Based on what he learned at Masset, Newcombe later wrote the following revealing comment on the chest designs:

> The designs on the two larger size have no significance as crests, but are considered appropriate for chiefs ranging from South-East Alaska to the farthermost limits of the Kwakiutl (1909, pp. 8-10).

Such a comment sounds like that of a maker and distributor of chests, serving a coast-wide market.

The chests of this type were also the most numerous in the northern Haida area. Chief Skowals' funerary display at Kasaan in 1885 includes six of them surrounding his coffin, which was of a different type. The house at Klinkwan which Henry Edenshaw inherited from his mother (A. E. Edenshaw's wife) had its retaining wall at the back festooned with carved chest designs of ovoid type and copper designs.

Southern Haida villages including Skidegate yielded chests of a different type, conceptually like those on southern Haida mortuary poles. These were mixtures of two- and three-dimensional design, with a raised face in the centre. One fragmentary example of an Edenshaw chest has been seen at a mass burial site at Tanoo (MacDonald, 1973, Pl. 27). One other southern Haida artist made a small number of chests in a style derivative of the Edenshaw chest. The Haida seem to have used these chests most often as treasure boxes, but sometimes also, as in the case at Tanoo, as coffins.

Tlingit

Several chests of this type were collected from Tlingit villages. In certain cases these were acknowledged to have been obtained by trade, but in others the impression is left that they were Tlingit made. The northern Tlingit owned a few, but obtained them by trade. Emmons wrote of the Chilkat: "South-

ward they made annual trips to the country of the Tsimshian to purchase slaves, war-canoes and red-cedar chests" (1907, p. 342). The chest WSM 2291 was collected by Emmons at Chilkat, and said to have been obtained from the Queen Charlotte Islands.

The southern Tlingit owned numbers of these chests. One of these, illustrated in color by Gunther (1966, p. 17, Rasmussen catalog 95) was said by Chief Johnson of Ketchikan to have been Tsimshian-made and 300 years old. Another, from the Shakes collection of Wrangell and illustrated by Holm (1965, Fig. 61, DAM QTI-117, see also DAN, 1962, Pl. 7), stands as Tlingit. Another, collected by Wolfgang Paalen from Sitka, is recorded as Haida; but another in the Sheldon Jackson Museum at Sitka and two in the Alaska State Museum have been considered Tlingit. Two more assumed to be Tlingit are illustrated in the *Far North* catalog, with notes by Frederica de Laguna summarizing what is known of the chests (1973, p. 181).

Since the better documented chests from Kluckwan, Sitka, and Wrangell have been acknowledged to have been obtained from the south, I conclude that the Tlingit did not themselves make this particular type. These people seem to have used them as treasure boxes and heirlooms, and not as coffins.

Tsimshian

C. F. and W. A. Newcombe collected five of these chests from the Nass River in or before 1912 (NMC VIIC128, see also Holm, 1965, Fig. 77; WN 6, 9, and 13, PM 1635), and let them stand in the collection notes as Tsimshian. Barbeau has suggested that the Niska were the earliest, though not prehistoric, makers of chests of this kind (1957, p. 56). Yet the evidence can also be read to indicate that the Niska did not make such chests at all.

The chest ROM HN925 is a very important chest collected by Barbeau in 1929 from Chief Neesyoq of Gitlakdamiks. It is the only one linked directly with the name Edenshaw. Barbeau's collection notes read:

> Carved box (Tsem'iyomks—"in pool" of river) of nisyoq (Wolf phratry, Gitlarhdamks). It was used as a dancing platform in feasts; the

box was filled with moose skins, which were distributed after the chief had danced on it. It was twice used by nisyoq.

A few Nass River chiefs enjoy like privileges of using dance chests: .../names four/.

This box was carved by Wutensu' (Edenshaw), a Haida, before the present Nisyoq was born (he seems around seventy-five years old). The carvings are not meant for crests; they are sadebisest "to butterfly" or "to beautify" (adebis = butterfly); or again "a work of art."

* * *

Barbeau also recorded that on the Nass the chests were restricted to a small number of chiefs who had the privilege of sitting on them at feasts. His informant Barton named four chiefs among the Niska and Tsimshian who claimed this privilege.

There is no clear evidence that they were actually made on the Nass, but there are indications which suggest they were not. In an unpublished manuscipt entitled *Emblems of Nobility* Barbeau gives a great deal of information on Niska carvers, obtained from Charles Barton in 1927. Ten carvers are named as makers of totem poles, rattles, masks, chiefs' headdresses and spoons, but none is mentioned as a carver of boxes or chests. The original chest from which the design was copied [shows that...] the carver made a serious error in the copy, leaving out the primary black formline which forms the chin of the main face, revealing that he did not really understand the structure of the design. A similar lack of understanding was shown in 1934, when Viola Garfield had one of the last Niska artists, Bryan Peel, apprenticed in the house of Skateen, make a box design for her. The result is a rather poor design, showing no affinity with Edenshaw chests.

A classic chest in the Smithsonian collection (SI 66-638) [is] said to have been collected by George Gibbs at Port Simpson in 1855-57 (or at "Portland Inlet opposite Tongass," *Far North*, Pl. 231, p. 183, which would be in Niska territory). Since Port Simpson was at the time the main metropolis of the entire northern coast, it was not of necessity Tsimshian-made. My conclusion from the weight of the evidence is that the Tsimshian (Niska) did not themselves make these chests. None have been collected from Gitksan

villages. They were so few and so restricted in use that they are better explained as rare imports. What are dishes in related style? Their use on the Nass was as special privileges of a few chiefs, as seats or dancing platforms. In Tsimshian they were sometimes called andahalait, "in which sacred" (things are kept); that is, treasure chests for Chilkat blankets, headdresses, raven rattles, and perhaps coppers. Barbeau termed the simulated chest on Laai's pole his "casket" (Barbeau, 1950, pp. 49-51), but there is no other evidence for such a use of coffins on poles among the Tsimshian.

Bella Bella

Four chests known to me, two painted and two carved, are said to have come from Bella Bella. The painted ones are in the National Museum of Canada (NMC VIIEE29, see Holm, 1965, Fig. 3, front only) and the Field Museum in Chicago (Newcomb'es EC 21). The Provincial Museum has a carved chest (PM 220, see Newcombe, 1909, Pl. XVIII) collected by Jacobsen in 1893. Last, but far from least, the chest known as Chief Tlakamuti's coffin in Chicago is said to have come from Bella Bella although it was actually purchased in Landsberg's store in Victoria. Of all the chests in the series the latter is one of the most complex, and I regard it as a type specimen. I regard it as Haida, partly because it bears a particular stylistic signature of the artist. This is a punned, upside-down, grinning face in the lower center field which is identified as the body of the animal depicted. It is deliberately created, because its eyes violate a fundamental rule of the art which Holm calls "non-concentricity upwards."

Bella Bella was a centre of art on the coast, in a style as much northern as Kwakiutl. I am aware that Bill Holm considers it a major center, attributing to it at least one additional chest of unknown provenience which I consider to be of this same series (Holm and Reid, 1975, pp. 131-2). I acknowledge that at least one Bella Bella artist produced boxes and other paintings in a style similar to, and in my judgment derivative from, the "Edenshaw" style; but I do not think the four chests were made there. Bella Bella was the site of a Hudson Bay Company post and later a trading store, and would be a stopping place for northern Indians on their way to Victoria. If chests

had been made there one would expect to find them also in the nearby villages of Rivers Inlet, Bella Coola and Kitamat.

Two of the four chests from Bella Bella were called "coffins" by Newcombe.

Kwakiutl and Salish

Fragments of two Edenshaw chests from Fort Rupert are in the Vancouver Centennial Museum. Two more were collected in the Coast Salish area: one at Ruby Creek in the Fraser Valley by C. F. Newcombe in 1911 (PM 1398), and one at Saanich by H. I. Smith in 1929 (NMC VIIG342a). To my knowledge nobody has suggested that these were actually made by southern Kwakiutl or Coast Salish; the better explanation would be that they were brought to Fort Rupert and Victoria by visiting Haida.

Summary

My conclusion is that the chests of this series were made by the northern Haida and traded north to the Tlingit, east to the Niska and Tsimshian, and south as far as Victoria. One is reminded that Charles Edenshaw told Newcombe that the designs were not crests, but were considered appropriate for chiefs ranging "from South-East Alaska to the farthermost limits of the Kwakiutl" (Newcombe, 1909, pp. 8-10).

Definition of the Style

While it is self-evident that certain similarities unite all of these chests into a single type, it remains to be demonstrated that they constitute the work of an individual artist, as I believe. It will assist to compare them with other related styles, earlier and contemporary, which are surely from the hands of different artists.

Predecessors

Carved and painted chests with telescoped lids, up to one-and-a-half yards long, were seen by the first Europeans to visit the north end of the Queen Charlotte Islands, aboard Juan Perez' vessel in 1774 (Griffin, 1892, p. 192).... The general form: chests with telescoped lids and carved and painted animal de-

signs, was probably made by several Haida, Tlingit and perhaps Tsimshian artists (cf. e.g. Siebert and Forman, 1967, Pls. 78, 80, 81; Boas, 1955, Figs. 277-280 from Emmons, 1907; Mac-Donald, G. F., 1973, Pl. 12, Gust Island burial box).

Contemporaries

Edenshaw's nephew Charles Edenshaw also made a small number of chests. Two which I attribute to him are [shown in] Hawthorn (1967, Pl. XXIXB, A 7103) and Masterpieces (1969, Pl. 78; NMC VII-C-1183). As will be seen, the styles of uncle and nephew in flat design are very close. It is therefore possible that the younger Edenshaw may have assisted with some of his uncle's chests; and in the case of the closely related square boxes, I find the styles too similar to separate.

Successors

Edenshaw chests evidently enjoyed a vogue along much of the coast during the 1860s and 1870s. No native-made chests succeeded them (except a few patently derivative southern Kwakiutl ones), but they seem to have been replaced by imported camphorwood chests from China (see Keithahn, 1963, p. 34).

Identification of the Style

Each of the chests was made, or at least decorated, by an individual artist. If my argument so far is correct, the artist or artists were northern Haida. One chest from the Nass River is attributed to Edenshaw by name, and assigned an age in the 1850s, which specifies which Edenshaw was meant. I have tried to show that while no two are exactly alike, they are similar enough to each other, and different enough from related chest types, to be considered an individual style.

 The distribution of the chests in time and space is consistent with what is known of Edenshaw's life and travels. His working life as an artist, between the ages of twenty-five and sixty-five, would be from 1840 to 1880, by which time traditional activities were ceasing. He traveled widely: often to Victoria and Sitka. He is said to have lived for two years at Port Simpson. There is no reason to consider Kluckwan beyond his range. The earliest firmly dated "Edenshaw" chest is the one collected by Gibbs in Tsimshian territory in 1855-57.

Discounting the claims of 300 and 150 years of age for two of the chests, they can all be considered to fall into the 1850-1875 period, consistent with Edenshaw's career.

In the end, the judgment is made upon the intuitive perception of style, which no amount of verbal description can absolutely confirm or refute.

Interpretation of the Designs

The designs on the chests are acknowledged to be among the pinnacles of Northwest Coast art, yet they are so 'abstract' that they have not been adequately interpreted. Bill Holm has demonstrated the complexity of their form and excellence of their design (1965; 1967 in *Arts of Raven; Boxes and Bowls)* but has not explained their meaning. Boas, pursuing the representation of crest animals through various art forms, could on reaching this point say only that the design was that of an animal (1927, p. 262) and was tempted to say that such designs were becoming "purely decorative" (p. 271). I think it wrong to consider that such complex representations had descended to the level of meaningless design. Instead, it is likely that they were assuming new kinds of meaning at levels other than that of straight representation. It was easily within the power of the artist to create a specific animal in a pleasing design, but some other agenda seems to have been at work, so that it was gaining, not losing meaning.

The collectors of the chests had their own conceptions of their meanings. To C. F. Newcombe they were not crests but "designs"; nevertheless, he tried to read in animal forms: one was said to represent a sea bear on one side and a killer whale on the other (PM 1295, 1909, pp. 8-10); another to be a killer whale on the front and a mythical mountain eagle on the back (PM 220, 1909, p. 30). Whether he received such interpretations from the native informants is not clear. Barbeau learned from the Niska that the designs were "adabis" (decoration, one of the names of Metlakatla was "place of adabis," from the sparkling of the sun on the rippled water) and were given names such as "in river pool" and "box of the sky." Walter Waters, who collected the Chief Shakes chest succumbed to the

ever-present temptation to read in the chief's crest, a grizzly bear. That option was presumably open to any chief who owned one.

Tlingit owners seem mostly to have interpreted the design as the undersea wealth spirit, Gonaqadet. Emmons so interpreted the one he collected at Kluckwan (WSM 2291, Inverarity Pl. 25); and the chest in the Rasmussen collection has been so interpreted. The Gonaqadet is "a great being in the sea who bestows on people great wealth," according to T. T. Waterman (1923, p. 450), who continues: "His appearance is like unto that of a great bear...He is so big that he looks 'like the side of a house.'" This being could take a great variety of forms, from that of a whirlpool to that of a human being. It was not an ordinary crest animal, although it seems to have been claimed as one by certain Tlingit chiefs.

In summary, then, what does the chest design represent in an iconographic sense? It is clearly an animal form, with a large head, small body, limbs and perhaps other body parts (Boas, 1955, p. 263; de Laguna in *Far North*, p. 181). It is not a common crest animal, or else the artist would have portrayed it more clearly as such. I believe that in some sense it does "represent" the Gonaqadet wealth spirit....

AEE lived three years at Port Simpson ("you know how boys are—want to live at different places"), just before his uncle sent for him (to come to Kiusta)...When he got married to Amy's aunt from Klinkwan—she was a sister of Duncan Ginawan (who is said to have had light wavy hair and blue eyes). They went in canoe manned by ten slaves to bring her—and Amy—from Klinkwan. D. G. died of hemorrhage of lungs in fighting after drinking. Her younger brother Hulthdungs took his place. Amy ("my grandmother" to Florence)—Amy's aunt: wife of AEE, sis of D. Ginawan. FD remembers Tom Price as a frequent visitor to her father. Winifred (Henry's/Martha's daughter) has CE's cane with silver bracelet, ivory head of hand with frog hanging from it. When CE was dying, he was visited by Martha, who asked him for the cane, saying that she would have son (two years old?) Douglas marry Nora. CE told his wife to give cane to Martha. Mrs. CE ("my mother"), Emily and Florence deplored loss of the cane. [*Editor's note: These notes from an interview with Florence Edenshaw Davidson appear in early 1975. If Duff had known about the spectacular housefronts at Port Simpson, now rediscovered from old photographs and from infrared analysis of*

surviving dirt-covered boards, he would no doubt have ascribed them to this visit by AEE. They are probably the most superb examples of the flat style. They fit with other Tsimshian work and are evidently local—though perhaps a Haida artist or two worked with Tsimshian artists; we know little about how such huge works were accomplished.]

...The wonder of Edenshaw's intellect. A pre-writing, all-remembering intellect, structuring everything on the crystal structure or analogic thought, deliberately setting down the limits of his understanding, and the things he thought wrong (sides 1-3), the question: is he writing this to whom it may concern, to an intellect on a different mode of thinking...?

I can learn all this only a quantum at a time. I will continue to received one-a-day additions needing thought, reflection, time. How to accomodate this.

* * *

And how can I tell you what the Raven Screens are about? We can see Raven, and say that he is the subject; he is what is represented. But that is only the title of the poem, the essay, the discourse; and an enigmatic title at that. We can see fine lines, nice ovoids, details which we have come to learn are parts of the "style," and good. But it is strange, and irritating, like a script we cannot read. Even Raven isn't a very good raven by any standards we know. It is like gazing on a page of Chinese calligraphy. We can see some of its surface beauty—but we cannot read the thoughts it contains. High profound beautiful thoughts. Gaze with little comprehension....

* * *

The Name Edenshaw

The name Edenshaw, more properly pronounced e-*dun*-so, is in the Tlingit language, and is said by Swanton to have come from the Stikine River area. It has been translated as "glacier" (Boas, 1898; Swanton, p. 101) and as "waterfall" (Harrison). Swanton explained more fully that it was derived from Tlingit itinasu (itinacu) "nothing left of it," said of a glacier when it

comes down into the sea and melts away. The image, it would seem, is that of a river disgorging as a waterfall or a glacier's end crumbling into the sea.

15

Raven and Frog

Editor's Introduction

This section is, in effect, two long and esoteric mystical hymns. They are fairly coherent in the notes. I have edited and selected rather heavily, but have maintained a certain coherence that is there. However, the record is one of transient inspirations recorded as they came, rather than a sustained effort to make a single, finished work. Such order as exists emerges from the strange but real logic of the development of the ideas. To me personally, the greatest loss in all the Duff agenda is the loss of these as fully developed mystic devotional works. They are much more like Sufi and Hindu hymns than orthodox academic scholarship; they should be read accordingly.

Bill Reid has complained about the English habit of saying "Raven" and "Frog" rather than "the Raven" and "the Frog" (which is the English usage of the modern Haida themselves). He feels that leaving off the article makes the mythic animals sound like characters in children's stories. For Duff, however, leaving off the article was more comparable to leaving it off when one speaks of God (who should, as G. K. Chesterton used to point out, be "the God" in formal English). Duff particularized the myth-beings from reverence.

Raven and Frog

In Haida myth, "Raven" is sometimes called Yel (Tlingit), sometimes Wigit (Tsimshian), but never Xoya (the Haida word for ravens). He is Nankilstlas, a "principle" or "premise" rather than a bird-monster. The other gods are also principles: "Greatest Fool," "Master Carpenter," etc.

...What about the Nass form Txemsem? Sure, there he is as Skiamsm; "Hawk" (Skimsem) in Haida art is Raven.

Raven

Raven was trickster, transformer and creator all in one. The onus falls on him. If he was alone at the beginning, it follows that he must have created himself. The question is, how did he *do* that? It is the metaphysical question of the singular becoming plural, of many out of one, and the Haida did work at it at that level in the origin myth (five boxes, two bites). But in the art, it seems to be made the vehicle for infantile phantasy, the twin Oedipal wishes: kill father, incest with mother. Raven became the one who could do that primal Act. Primal coitus, with all its implications and associations.

For if any, Raven could accomplish the paradox of self-creation, he could master any and all paradoxes. He could have it both ways in all situations. That became a 'given' for the myths. That's okay for myth, but art wants to know how you actually do such things. The myths said that Raven could and did, but the art wanted to show how. Hence the concrete mathematics.

The world is a coincidence of ultimates and at the same time, an arbitrary contiguity of opposites. The contiguity is half-caused by man. He doesn't know why he should keep trying to bring opposites into contiguity...except that he has a sense of ultimates in coincidence....

The favorite game in NWC art was to depict Raven, in anything that was eating itself...or doing any self-reciprocal act to itself, as on frontlets. But that wasn't wholly satisfying because it just referred the logical dilemma back to myths. The basic question remained: how can something be neither and both? In the art, it led to Gonaqadet and Mighty Mouse, Copper, etc. of the Edenshaws, and the one eye of MM on AE box. The first question was, "How did Raven

generate himself?" It later became more general; and more purely logical:

— how can ultimate opposites be mediated?
— how can one thing be two reciprocating opposites at the same time?
— how can one thing be (come) and (other)?
— what is metaphor?
— what is the origin of species?

* * *

Raven is Mr. Paradox. He can have it both ways. In a sense, double. So multiply him by two. Frontally, head, he now has four eyes, and both a mouth and an (implicit) beak. Let eyes be Eros, mouth and beak, Thanatos....

* * *

With Raven, that which is unthinkably bad has good results. In myths with people, that which is unthinkably bad has bad results.

* * *

The guilt of the primal crime is just the memory of creation. That is how Raven *had* to do it, in order to create himself and the earth. He *is* the urge to life, he is all-urge, all-voracity. His Creation *is* Death. They are each other's other halfs.

* * *

Haida Creation is essentially Raven's *sui generis* self-birth, which was accomplished by the primal crime (murder of father, incest of mother). Equal parts murder and incest, encased within a single act of mutual oral cannibalistic copulation, which Raven must needs do in order to create himself.

* * *

Raven's Creation of the QCI is a reworking of his "Virgin Birth...." It distances it, clothes it in more obscurity. He goes to the

Sky to borrow his mother's eye, and beneath the sea to borrow his father's time. With light and time, he has Sins-sganagwai and Nankilstlas, enough to make the world.

Ease off. He only had to take the smallest conceivable bite of his Dad and the smallest conceivable peek at his Mom. Like, just see them as lingam-yoni.

So the art seems to be dealing with the most basic erotic urges and their accompanying anxieties: oral and genital, to eat and be eaten, castrate and be castrated, the one turning into its opposite. Then it seems to rise through to a higher level: oral-visual, to eat with the eye, to oversee—this seems to be the formation of the super-ego. The ultimate image is the eye that eats (screws, castrates, incorporates, becomes) itself. It bites itself off and spits itself out at the same time, as the same act. Seer-seen, the original act of creation.

Raven in the myths seems to be the playground of the oral and genital urges; he is insatiable in both departments, and gets away with it. He is all urge, no anxiety. Nobody eats him, screws him, kills him.

...Raven is a fantasy containing the fulfillment of the ultimate wish. Let the ultimate wish be fulfilled...In short, to be exempt from the human dilemmas (and he pays the price: he is not here and now—he only gets to cry at dawn).

If Raven were free in this world, all would be chaos. He would break every rule, like the very Devil. That is why we hold him upside down, keep him in a box. This world is Raven's outer shell. We need only the presence of his absence, his least part, the shadow of his duplicity. He exists best in memory, not in fact. We don't need him here and now. We needed Raven to get things going—while he was still potential—Nankilstlas. We had to grant him his every wish (to violate reason and start the world, to violate humanity and eat his parents). But that is the old man's dilemma. When he got to Nankilstlas, he became too much for this world to countenance. He lacked the conscience, compromise, and alternations needed for this world. We need him only for his absent example, which we use to persuade young men to have consciences.

Eat, but prepare to be eaten. Live, but prepare to die. Moderate your appetites in a social compact. Young men can't be Raven. Accept the fact.

* * *

Art is about the great anxieties caused by the great urges.

* * *

It is the eye that performs the supreme taboo of watching
himself being conceived-born, and thereby accomplishes
the divine task of watching itself die-rebirth of staying
awake through your own death.
The eye that succeeds in watching its own conception and
birth is capable of remaining awake through its own death
and rebirth.... that is, the special case where the smallest
missing part is the other half of the whole.

Mother is child is father is mother...
One is two is one is two...
Part is whole is part...
Father is part mother, son is part wife. He is mother-wife.
My father-son is my wife.

* * *

Raven is entirely missing
It is his absence that feels like presence
RAVEN IS DEAD He died giving man life
The smallest part missing there is here. Smallest part of
Raven is touch of death.
Haida Raven does not involve any other animal form in
Creation of the QCI. All the actors are human: Raven is
his own mo & fa and gdfa. From his mother, sky country,
he gets 4-eyed vision
From his father, underworld, he gets substance of world

* * *

I am sent away to be the child of my mother's brother
who is equal parts mother and father to me
I have to forsake both mother and father and go to
mother's brother...
All that is alive at the end of the story (of Bear Mother)

is me
as my mother's youngest brother...
I am in limbo, neither cub nor man
but both,
Raven
but I have to marry a bear
find a bear to marry
Because my mother slept with a bear, I have to find a
bear to marry.
I am doomed to marry a bear, even though I know what
happened in the story to my father.
Raven, in the context of the Bear story, has to *be* his fa-
ther...be his mother, and be himself...

* * *

The whole story is about its own beginning
That piece flying around is the tip of Raven's beak
Pretty hard to think of a raven biting off the tip of its own
beak.
That's like
an eye looking at itself ...
a question answering itself
an answer questioning itself
a mirror into which I look and see you
I *am* you looking at yourself in the mirror
I only came to class to tell you that I am
not able to come to class today
a category of one
a super-generalization of one case
I am the same as every man, but different from every man.
Meaning is the recognition of meaninglessness
Nothing comes only in pieces
The chest design is Raven looking into the empty box.
The contents of the smallest box is your own eye looking
in.
Wisdom is knowing you cannot know
(what will happen in the next instant of time)

Rottenness is time after death, so is therefore new
life.
The sharpness of a mosquito's beak is so that it can suck
in the world
The sharpness of Raven's beak is to eat man's "eyes."
The sharpness of Hohoq's beak is to eat man's brains.
The greatest generalization of knowledge is a secret
The content of the smallest box is *one* eye peering in
(peering through the eye-hole of the marten skin blanket)
The presence of the moon is the absence of the sun
Moon is "hawk" biting off the tip of its own beak—the
which
is the sun.
The 2 things in the box were the tip of Raven's beak.
from the outside (black)
from the inside (speckled: the world/sky country)
a Raven can't see both at once
Everything is its opposite
Nothing *is* everything
The world is as sharp as a knife
Mother didn't eat me in birthing me, but it amounts to the
same thing
Birth is the beginning of death
Every orgasm is a bit of death
The ultimate pleasure is a taste of death
Death is the ultimate orgasm Raven's Cry
There is only the dialectic
That which is also its opposite
What we know as right—is in the agreeing
One eye calls for another (its partner)...
Raven myths are funny because they can be the "both"
Asdiwal-type myths are not funny
Raven laughs when he eats eyes. It is atrocious humor
Raven only weeps crocodile tears
...does not and cannot die
steals food, steals sex,
cheats and bungles at cheating (you can also laugh at him)
can do whatever he wishes/take whatever form he wants,

wish whatever
he wants

feels no real sorrow, remorse
Like Frog, he has a ridiculous aspect as well as a sublime one.
Anything absolute is absolutely ridiculous as well as being absolutely sublime.
MR. PARADOX
Raven, pecking out of his egg, is his mother giving him birth.
Raven, killing his father, is giving birth to his mother.
Raven, biting off his father's penis, is spitting out his mother's eye.
Raven, lifting Man to life out of the mouth of the cockle shell, is sinking to death on the sharp point of the impaling stake. At the same time, Man is broken over the beak that comes out of Raven's navel.

* * *

Raven, entering new life through the mouth of the Whale, is an old old man refusing to die, held in the Whale's tail.

* * *

Raven, soaring alone in the world with no place to land, is Man carrying the world on his shoulder in his empty Frog bowl. The Man-Frog is Raven's least missing part.

* * *

Raven's eye, watching himself eating himself, is eating itself.

* * *

Raven eating Raven is Raven creating Raven,
Raven seeing Raven is Raven creating Raven.
Raven is pecking out of his egg at the same time as he is laying it.
Raven's sword is also his scabbard.
Raven's eye is watching Raven as he eats his eye.
Raven's sword is a sheath.
Raven's sword is its own sheath.

Raven's beak is Frog's mouth.
Raven's outside is Whale's inside.

* * *

Raven *is* time
black (not light)
not timebound: can transform
he is not constrained *by* time because he *is* time
Time is no part of Raven (it is his whole)
Raven is black/mountain goat horn is black therefore
spoons are Raven

* * *

The unthinkable: Darkness (void)
it is what Creation stories begin with
it is the ultimate *black* hole
it is the "light of my life"
he greatest shock of birth is *light*.
sleep is return to the womb
but death is the light going out
reation myths are thinking about "Death."
light
alternation, tides, water
fire
The main element is light
main faculty is sight
main image is the twin stone masks
but what they say is
that light and time are the same thing
alternated (i.e., frog) two masks of one face
LIGHT AND TIME ARE THE SAME THING
where there is light there is time (hence creation: the light
at the
beginning of time)
Consciousness of light and time go together
Time is the other side of light
AND FROG IS BOTH

THEREFORE FROG IS LIFE
light + time
head + mouth (mortar)
swallower and that which is swallowed
Raven is his own third wish
Raven is tertiary process
Raven puts 1 and 2 together and gets himself
Raven is the special case where the absent least part is
both halfs of the present whole
Raven is the special case of reverse analogy that is also
metaphor—in reverse logic
of the one step backward that is 2 steps forward
the one eye (profile) that is 2 mouths (frontal)
the one that is two (Ninstints)
The special case—the exception that proves the rule
the one that is two...the one that is many...the one that is
both...
The sole exception that can be both
that everybody really wants to be
Raven is the sole exception. Raven is absent.
The only thing he isn't, is here and now
Raven is the only lie that is true (and Frog is his blame-
less Parent)
Raven is pure fiction
the single lie that is all Truth
the single necessary Lie
the one white lie that is all black truth (at least he's con-
sistent)
the absolute Absence with total Presence
the absolute Presence who is totally absent
the very first wish
man's very last wish...
the premise from which everything follows inevitably
the one impossibility, concretized as an absent image
a hypothetical category/class of one
the only one-shot deal
the only one that is no other (he has no wife, no son)
...the lonely bachelor who created Mankind

the entire dramatis personae—of one.
everything Raven says is a true life (white lie)
half true, half life (half truths)
like the panel pipes
Raven didn't want to marry
grow up and get married
his own whale until too late
(better wish for your own whale before too late)
Raven never turns his wish for mother into wish for wife
Raven is willing to have a mother, sister, grandfather—
but not a father or wife.
...Raven is the first and least idea
the least idea in the first place
Raven wants it to be a single-moiety system
Raven doesn't want to accept father and wife....
Raven thinks his mother and father can both be Frog
Raven is arrested at the pre-marriage level
he is oral and genital to a fault, but not willing to compromise
mise
The Old Man's Story is about death and creation
The Young Man's Story is about lack of responsibility
Raven is the bachelor's dilemma
Raven needs a good wife
The only thing he can't be is his own son.
Raven without marriage is a head without a body
Raven is the special case for which there is no symbol
because there are no opposites left for him
all 4 have already been used up
He is the fifth opposite
He is the field on which all other oppositions are drawn
He is total opposition, which is also the glue of sameness
He is analogy, pure and simple
He is the opposite of every opposition
Don't show me a particular opposition, show it to me
pure: the image of *all* opposition....

* * *

Raven is analogy boiled down to absence-presence
Raven is total absence
Everything else is the bit of Raven that stands for the
whole...
Everything present is a reminder of Raven's absence....
If this world is real, Raven is an illusion
If this world is an illusion, Raven is reality In truth, they
are twins:
each half one, half the other
Equal parts reality and illusion
If the world is the mask, Raven is the race
Raven and the world are both equal parts face and mask.

* * *

Raven's first cry
Dawn word
all-transforming word
nothing meaning (creating) everything word
in the beginning was the word
that meant nothing
and created everything
wish-truth word.

* * *

one-all word
wish-command word
Nankilstlas word

* * *

Life is a two-edged sword
a river flowing both ways
life flowing in his life flowing out
my sieve runneth over
The world is as sharp as a knife

double twist back:
the meaningless detail is the whole point

* * *

Raven and I,
as halfs,
have the shape of Frog
the Twin
Raven and I
are a single
intertransforming Twin
In every parable I tell,
I am the two subjects
and Raven is my predicate
Or vice versa
Every myth
is about me
and Raven
Myth is Raven-words
telling themselves
to themselves
Art is Raven-portraits
showing themselves
to themselves
ritual is Raven-acts—
they are their own meaning
Raven acts in myths
I am doing now
Myths, telling themselves to themselves,
are telling Raven and me
about each other

* * *

Resonance comprehension
the word is the bridge
that creates its two actors
the word is the baby

that creates its mother and father
the word creates
sender and receiver
The word, comprehended,
is both answer and question
Raven is comprehension
and so am I
We are the comprehension
in the word
I am Raven's understanding
of his story
Raven myths
were told to Raven
by himself,
and have a lot to teach him
when I understand them.

* * *

Can Raven land? I am Raven looking for a way to land in
inside and outside of box
only if
you are, too
I am, Raven (only if) you are too I am you (only if) That
is you

* * *

FROG
Frog became a very powerful logical symbol, like the equal sign
in having the best attributes of neither and both at the same time. But
it rose out of sexual symbolism, and carries some of its bricolage
with it—more of the female than the male ...

* * *

Frog is not about sex
Frog is a pure symbol abstracted out of sex
up through sex

Frog is the symbol of "symbol."
The stone frog is the hard fact.

At the hanging,
frog is the noose
The murderer blames it on the hangman
The hangman blames it on the murderer
the real culprit is the noose...
Frog is the truth in the hoax
Frog is "That which is common to both" ...the fact of ex-
istence...
a bowl with the world in it...the universal black hole and
its opposite, the big bang...Frog (unlike the black hole)
has the truth of patent existence...
Frog is the Law of Conservation of Matter, he is Transfor-
mation...
the Law of Conservation of Energy (Life)
Frog's tongue—makes mockery of time
—faster than the eye
—quicker than a wink
on raven rattle, slowed to eternity
Frog's tongue is time, the fleeting instant
shown swallowing that woman, in a wink
the wink on the stone mask
Frog's tongue is Raven's beak
Raven's cry splits, Frog's tongue unites

* * *

When the roll is called, Frog shouts "Absent"
When the roll is called up Yonder, Frog won't be there
Frog draws the teeth of time
a tie ball-game between unnamed teams
teams without uniforms
Frog knows the game is a tie, but doesn't know what the
game is
Frog knows the score, but not the rules
Frog is the PUCK
the one that went in a second after the light went on

the one that went into the crowd and became a souvenir
they're all the same
there's lots more where she came from
she is round, and black, and frozen
Frog is the ball in the ballgame
round in baseball and soccer, etc.
oval in football
Frog has just met the deadline
Frog has risen through sexual symbolism to become a
creature of pure logic
Frog is the equal-sign in a mirror
the mirror image of the equal sign
Frog is a rest stop, an "OK for now," a launching pad, a
plateau,
an island, a starting premise, a holding action, a morato-
rium
in abeyance, a forward position, control of the puck (or
ball)
Frog is the puck: the whole ball game in one sense AT
ONE TIME
a souvenir in another AT ANOTHER TIME
Frog is full circle
back to square one, but a full flight up
clock reading 12, but is it noon or midnight?
Raven's cry, but is it dawn or dusk?
Frog is ambiguity raised to a pure principle of logic
for a game with nothing riding on it
for a pre-season game
a warm-up pitch
a practice toss
a spectator sport
surrogate sex
Frog is a warm-up pitch, but Raven's Cry is the crack of
the bat
in the ninth inning
the long bomb in the dying seconds

the floor-length basket
Frog is consensus looking for a place to happen

* * *

Frog is the only one who can do
the impossible
but
by golly
that's the only thing
she can do.

* * *

In "I have the impression," Frog is the impression
Frog is the firmest of
maybes.
Woman, thy name is
Frog
Frog is the very soul of generosity's
guilt
Frog is logic
working to rule
Frog is a flicker of
certainty
Frog is the guilt
in the gift
Frog is the
other way around
Frog can't
turn back
Frog is
a fiction
Frog is the truth in the
hoax
In a world of water and ice
Frog is snow...
Everybody is as alone as Frog
Let's take it from there.

When you put on a sweater
Frog is the sweat.
...In $e=mc^2$, Frog is the =
Frog is the wood in a pencil
Frog is: One for you, Two for me...
In "You will not go down twice to the same river"
Frog is the same...
What Frog *is*, *really*, *is*
Recognition...
For once in my Life
I got Someone who needs me—Frog?
...Frog is
Coming to terms.
Frog is
the thermostat.

16

Poems

Editor's Introduction

The strange hymns to Raven and Frog lead to a final section of poetry. Most of Duff's best poetry was published in the Abbott volume, but a few superb ones escaped that net, and also there are many poems of less literary interest but of considerable interest as examples of Duff's thinking about Haida art and philosophy. Especially, concerns with life, death and sex are expressed. In many of these poems, Duff is using a Haida persona.

I begin the section with my favorite of all Duff's poems, one that seems to express best the love, hope and tragedy of his life. "Takinai"—Haida for "grandchild," often with the sense of "inheritor of my wisdom"—is applied to one of his students here; Duff was "Chinai," "Grandparent" or "revered elder," in such contexts.

Poems

Christmas Tree

Dear Takinai:
I have decided what I want
my Christmas gift from you to be.

One day of moratorium.
One day's time-out from having to be Chinai.
On that one day,
(any one will do, but I would like it to be Christmas Eve,)
what I want to be instead
Of Chinai
in your mind,
is the Christmas tree.
for that one day,
our secret, yours and mine, will be
that I really am the Christmas tree.
Young, and fresh, and straight, and green, and happy, and
there,
and
adorned all over by your own careful, loving hands, and
carrying a heavy burden of gifts
for you.
The entire tree, my gift to you, that day,
your gift to me:
one day's reprieve from the burden of defining
Chinai.

* * *

Hush, Little Baby, Don't You Cry,...

Give it back.
Give it all back.
The whole gift.
The whole measure of your worth.
Enjoy the sadness of the parting.
Share, atone.
Show your gratitude
as wood shows its gratitude by burning:
you are the joy in the dancing flame,
you are the pain in the searing heat,
you are not the cold white residue of ash.
Go back,
after a long year's summer,

after a long day's sunshine,
to your father's house,
to your mother's breast.
You have eaten yourself a fill.
You have given yourself the gift.
You have danced yourself the dance of love.
You have told yourself the story,
hummed yourself the lullaby,
"...rest, rest, on mother's breast,..."
Drowse,
relax your vigilance.
Trust,
show your faith.
Go to sleep.
It's not a lie.

* * *

Raven Rattle

Think of a seed. A tiny microcosm. Urgent to grow.
Its first act is to put down a root, tiny, pointed, reaching for
the earth
To suck sustenance from, and to anchor its uprightness.
Anchored, it sucks, stands upright, opens,
Metamorphoses into a plant, a tree
Tall, strong, straight
Catching sunshine, rain
World tree.
Raven's rattle is a metamorphosed seed
A ripe salmon trout head, burst
A bird, free of the egg, wings spreading for flight
Its handle, a root, sucking strength from my hand holding it
Three faces, three stages of metamorphosis
The first sucking the handle
The second, beak curled in, reaching deep inside itself for the seed of life

The third, Raven, fully erect, rearing upright
(Upside down, the way I hold him)
And in his beak the Sun
Ultimate seed of Life, thrown into the Sky
Filling the World with light, and warmth, and Life
I shake the rattle, I
It crackles Raven's Cry, telling the world it is alive, now,
in motion
I make it so
I shake it. the figures copulate
Tongues joined (curved jet of sperm)
Raven spurts Life into the sky, Sun into the world,
Life into the World.
I dance
Wrapped like treasure in my Chilkat blanket
On my head the am-halait, "beautiful spirit"
I am a tube, spewing eagle down, like snow
Light. Peace. Life.
I am Raven
I put Life into the World.
I.

* * *

Handles and Spouts

I can change my handle
and my spout,
just tip me over,
pour me out.

* * *

Life swallows itself and brings forth death (shit)
so why can't
Death swallow itself and bring forth life?
Inanimate (stone) swallow itself and bring forth animate?
Stone swallow itself and create life
Death swallow itself

The ultimate Black Hole—
The logic of life is predicated on death
Death dies, creating Life
Biter bit
Grasper grasped
Mouth swallowed
Pureer pureed
Killer killed
Death-bringer itself comes to life (club)
Desperate logic
(at least it's worth a try)
Death, swallow thyself
Death, fuck thyself
Death, kill thyself
Death, transform thyself
Death, Life thyself
Living kills
The image is the impaling stick
horrible to contemplate
the life that kills
the image is the tortured witch
the confession that is a death sentence
the image is the canoe bow
going forward (in time as in water) to death
We know not what we do
the image is Raven, eating his own eye
the masks, not able to see themselves
the death club, radiating life
Weha's two poles piercer, pierced
Great and Slave in one name
Ninstints, one that is two
inherent contradiction
the mother and child that is a cock=and balls

* * *

A Haida Epitaph

Death is as gentle as the whale's fin slicing air

273

Death is going to a new realm, as Raven went to the sky
country
and that is just like entering a new whale's body from
outside to
inside

* * *

Poems for Dead Haidas

The only things that exist
are episodes like me
Episodes in stone
are that way on purpose
The only thing that is really lasting
is the relationship
A cockle shell The empty shell The empty shell
of argillite outlives outlives
says it all. its creator its creator
on purpose one purpose
When a clam opens, it dies
Mankind is the life coming out of the shel

* * *

Mask Logic

My mask is an interface
between my face and my identity
My mask *must* be two things at once
My mask is my self-chosen
self
My mask has two sides
I am the only one who can see both
I show both sides on the front.
I and me are two things.
Wearing my mask, I am both.
Two things the same,
but also different,
opposite.

My face is me,
my mask,
I.
My self,
equal parts
neither
and both.

* * *

Untitled: On Art

Art is visible joy.
Art is declaration of beauty
Art says sex is beautiful. Don't repress it. It is joy.
Life is joy. Don't sleep it away to repress the fear of
death.
Birth is beautiful.
The generative act is beauty, not guilt.
Eating is beautiful.
Joy is made of consciousness.
Drink consciousness with all the thirst in you.
When you are on fire with love
all is beauty: thrusting, tasting, seeing, taking, dying.
What little bit of fear are you illumining with beauty?
Joy transforms fear.
Beauty transforms guilt.

* * *

Untitled

Reach forward on the path you travel
to likenesses preceding you along the way,
and grasp the name and station that is yours.
Reach backward to the likenesses who follow,
and hand the same identity to them.
The mask that passes on from hand to living hand
wears a visage of immortality.
Honor the opposite who walk beside you,

275

for they are your mirror.
Endow them with your honor and your worth.
Honor your father, your aunt, your wife, your brother-in-law,
for they are your outer shell,
and must always be kept in a warm, dry place.
Honor your son,
for he is your next father.
Accept the cold, sharp knife of the world,
for death is the step over the threshold
back into life.
Betroth your son to your womb-mate's daughter,
betroth your daughter to your womb-mate's son,
and you will step back into the same house.
In the one hand
you are holding the mirror.
On the other hand
you are the mask.
Put on your mask,
look in your mirror,
and you will see
that-which-is common-to-both,
a truth you can believe.
The mirror does not lie.

* * *

...And That-Which-Is-Common-To-Both

How can the One
be two opposites at the same time?
When it is the one,
and the other,
and that-which-is-common-to-both.
When it is the Three.
You cannot know
that-which-is-common-to-both,
because you are
part of it, half of it.

This much you can know:
It is
the same
as that-which-is-common-to-everything,
and therefore
that-which-is-eternal.
It is
that-which-is-everything-everywhere-always,
the ground of being.
It Is,
and "It" and "Is" are the same,
verb masquerading as noun, noun masquerading as verb,
both wearing the same mask.
This much you can do:
bring into balance parts of it, halfs of it.
Create balanced things,
do balanced deeds,
impose balanced rules,
conduct balanced lives.
Dance the dance of opposites.
Marry an opposite who is equal,
unite with her in the primal dance,
give your half (you are giving your life),
plant your seed and harvest your crop
of opposites.
Marry an opposite who is equal,
unite with him in the primal dance,
receive his half (he doubles your life),
nurture his seed and harvest your crop
of likenesses.

* * *

Art

I think I see the very shape of art.
Art is
an ostensible message
embodied in a code,

the total implications of which are the "real messages."
The code is paradox,
the "real" messages are fresh reminders of paradox.
The code is the man-made mask,
the "real" messages are what man sees in the mirror.
Art, like myth,
is a product of well-seasoned thought.
Each artist, each myth-maker,
is in dialogue with his predecessors.
The Edenshaw Solution
is isomorphic with
the Raven Rattle.

* * *

Art
stops time,
freezes the dialectic,
photographs the dance of opposites,
in the mirror of paradox.
Art tosses the dialectic,
photographs the dance of opposites,
in the mirror of paradox.

Art
tosses a shaped pebble of metaphor
into the pool of analogy
to see again the perfect circles form;
then close its eyes
to let the ripples spread
all the way.
It is the lapping on the banks
that feels so good.
It feels so...absolute.

Art is
the self-masked figure
peering into the mirror,
and taking comfort

from what he sees.
Art is the self-masked figure
peering into the mirror,
and taking comfort
from what he sees.

* * *

[*Editor's note: The remaining pieces are brief passages in
poetic form that appear in the notes and seem able to stand as
poems on their own. Each space defines a new entry.*]

I will try to tell you
where I have reached.
The art shows things
and it shows acts,
both at the same time.
To show acts, it must show two things at once (or more);
to show acts, it must have elbow room to move;
it does it at the expense of straight logic.
Just as all things are interrelated,
all acts are reciprocal acts.
A mathematics of pars pro toto.
Pars pro toto is made the equal of binary equation.
Parts: half, head-body, formline segment, least part, sex-
ual part,
eye.
The smallest hint is the total case.
The mere suggestion is the whole statement.
The hunch is fact. Intuition is knowledge.
Three is a lie.
There is no excluded third, there are only degrees of half-
ness.
Three *is* ambiguity.
The one can exist for the other,
but existence is not being.
The other can exist for the one,
but existence is not being.

The only way they can be the same
is when one is in one eye,
the other in the other eye,
same pair of eyes
at the same time
recognizing
the same thing.
I have you only temporarily
You have me only temporarily
Each of us
has to do
our own thing.
It isn't like it used to be.
Death is closer these days.
A mask is a self-made mirror.
Let me help you to make one for you.
Take the inner stone mask,
turn it upside down and backwards,
use it as a vessel for water
in which you can see your reflection.
The water runs out the eyes?
Stop them up,
but not by plugging the holes,
not by destroying her sight.
Do it by putting her in a container
that can hold as much as she can,
that can hold everything she can see:
the outer mask.
Now fill them with water,
let it find its level,
and use it as your mirror.
Gaze into the water,
gaze at your reflection,
think about your mirror,
think about your mask,
and think about the one who made it for you.

Notes

1. An earlier generation of anthropologists separated the Salish complex of individual quests for an individual guardian spirit from the highly social ceremonies of the rest of the coast. The Salishan complex was seen to be like that of the interior Salish and Plateau cultures, and thus an "interior trait." However, individual power-questing of the standard form was done all up and down the coast. Among the Kwagyul it was replaced for ordinary people by the secret societies and the initiation rites for these, but Spradley (1963) has convincingly argued that these initiations are simply extremely socialized or socially-managed derivatives of the individual quests. Comparison with neighboring groups would add yet more grounding to this argument. In any case, the Kwagyul and all the other groups had individual questing for special gifts such as shamanic healing power. These quests were of classic form, basically the same as the Salish ones. One can only assume that individual questing was a universal pattern, later socialized in various ways (secret societies among the Kwagyul, spirit-dancing among the Coast Salish groups, wolf ritual among the Nuu-chah-nulth, etc.). For some particularly good accounts of Northwest Coast religion and power-quest, see Lane (1953), Suttles (1951), Duff (1952), Amoss (1978), Collins (1974) for Salish groups; Spradley(1963), Goldman(1975) for Kwagyul; Drucker (1955) for Nuu-chah-nulth—ENA.

2. Rohner, 1969, Chapter 3. Boas did not identify John Wiha in his letters from the field or in his 1897 study, in which he used a number of his drawings (Figs. 43, 53, 60 and 67, the latter was also used as 1927, Fig. 246). He gave some other designs to Swanton, who used them in his study of the Haida (Swanton,

281

1905a), attributing them to John Wiha (p. 141): Pl. XX, 12; XXI, 1, (also used in Boas, 1897 as Fig. 60), 3, 4, 5, and 9. Tattoo designs from the 1888 photographs appeared in the a897 study as Figs. 23, 47, and 48.

In an article published in 1898 (Boas, 1898b), he referred back to his 1888 informant as "Johnny Swan" (p. 25). It is not clear whether that was the same man as John Wiha. Judge J. G. Swan of the Port Townsend, in 1883, had obtained a number of drawings from the Skidegate Haida "Johnny Kit-Elswa." These designs, which are very similar to John Wiha's, appear in Niblack, 1888, as Figs. 280-285; one wonders whether he was the same man. Swan had previously published a number of tattoo designs by earlier Haidas, in Swan, 1974—WD.

3. Barbeau gives the name as Tahayren (Noise-in-the-house) HM 1957, p. 154. Swanton in his list of houses at Kiusta, gives one owner by Daxe'gapia of Klawas but this was likely an earlier bearer of the name (p. 293)—WD.

Glossary

The following anthropological and Native terms are scattered through the book, and are brought together here for convenience. Most of them fall into two categories: group names (of First Nations, languages, and local groups) and names of artistic motifs, often mythological beings portrayed regularly in art. Some are technical terms common to the anthropological universe, and some are Duff abbreviations that need spelling out.

Many Native peoples were given names by European explorers. Often these names were based on mistaken identity or worse, but they crept into the literature. They are now being replaced, in many cases, by the names the people in question actually use for themselves. For example, the people once known as "Eskimo"—a derogatory term used by their neighbors—understandably prefer to be referred to as Inuit, which means "people" in their language. In my own contribution to the present book, I have tried to be consistent in using the current names. Duff, however, was writing before this movement had begun, and uses the old European names. This Glossary will, I hope, sort things out.

Tragically, most of the languages noted below are dying out. It is rather unusual to find speakers under forty years of age. I wish to add my voice to the many that are encouraging all efforts to keep these languages alive.

Affines. Anthropological term for relatives by marriage.

Aleut. The Native people of the Aleutian Islands.

Amhalait, "amalite." Tsimshian term for a chiefly dancing headdress of feathers, abalone shell and other materials, often portraying a hawk. The word means "serving for supernatural power" in Tsimshian. The amhalait is decorated with ermine skins, sea lion whiskers and other objects. The whiskers held

eagle-down, a symbol of peace, which was shaken onto honored visitors as their hosts danced past and bowed to them.

AMNH. American Museum of Natural History, New York.

Anadromous. Swimming upstream to spawn (as salmon and steelhead do).

Analogic. Logic that proceeds by carefully controlled analogy rather than by deduction or syllogism. Common to China, Northwest Coast Native peoples and many other cultures. A regular source of symbols in art.

Asdiwal. Hero of a Tsimshian myth.

Athabaskan, Athabascan. The usual English term for the language family that includes the Native peoples of interior northern British Columbia, as well as much of Yukon, Alaska and several other parts of North America. The name comes from the Athabaska River. The people in question call themselves *Dene* (or local pronunciations thereof, such as *tinne, dunne*).

Babine. River in west-central British Columbia, whose name is often applied to the local Athabaskan group.

Baxbaqwalanuxsiwe. A giant, long-billed bird of the Hamatsa myth (q.v.). It pecks open human heads and eats their brains. The name means "Human-eating Monster from the North End of the World."

Baxus. Kwakwala word for the nonceremonial summer season, as opposed to *tsetseqa,* the winter season when ceremonies were held. There was an officially and ritually marked transition in fall and spring.

Bella Coola. A settlement on the central British Columbian coast, inhabited by the Nuxalk, a Salishan people. They are referred to as "the Bella Coola Indians" in the older literature.

Bisociation (bisociating, bisociative). Term from psychology, used by Duff to refer to a paired representation in art that symbolizes a logical pair of ideas (e.g. male/female, life/death).

Bricolage. See *bricoleur.*

Bricoleur. French for "handyman." Claude Levi-Strauss used this word to describe the "primitive" philosopher, who uses whatever materials are at hand to create his representations (philosophic, scientific or artistic) of the world, just as a French handyman uses anything at hand to jury-rig a device. The word is

intended to give credit to the brilliance of creative improvisers— **not** to imply that they are mere jury-riggers.

Bukwis, bukwus. Kwakwaka'wakw monster of the woods, equivalent to the Salishan *sasquatch*.

Charmstone. Stone ornament, usually oval. Most charmstones are archaeologically recovered, and thus of dubious use. They are assumed to be charms from the contexts in which they are found, but some of them could be net weights or the like.

Chemakuan. Anthropological term for a language family including Quileute and the extinct Chemakum language, both of which occur (or occurred) on the Olympic Peninsula. Apparently unrelated to any other languages, making this one of the smallest linguistic groups in the world.

Chief. The chiefs of the Northwest Coast should not be thought of in Hollywood "Indian" terms. They were hereditary leaders who had more or less of supernatural power by right of descent. They were required, however, to demonstrate competence as leaders and to hold proper ceremonies if they wished to assume the chiefly title. An individual might have the hereditary right to the title, but decide that the burdens of office were too much for him; he would therefore pass on the right to assume title to his younger brother, and so on down the line. Women also had titles and sometimes assumed positions of authority. A chief was leader of his descent group, and a powerful, highly titled chief could become leader of a much larger group, often leading hundreds of people spread over thousands of square miles. However, his power was limited by a number of institutions, religious in nature but democratic in function. The nature and power of chieftainship varied somewhat from group to group.

Chiefdom. A polity ruled by a hereditary chief or chiefly family. Most Northwest Coast First Nations were divided into chiefdoms, though local variations on the general pattern were extreme.

Chilkat. A Tlingit group in Alaska, noted for their superb traditional blankets (Chilkat blankets). Chilkat-type blankets were widely made in the northern artistic area.

Chinai. Haida for "grandfather."

Chinook. (1) A Native people of the Columbia River mouth. (2) The largest of the salmon species; also known as "spring" or "king."

Chinook Jargon. A trade jargon or pidgin, based on the Chinook language but incorporating many English and French words, that arose along the Northwest Coast in the eighteenth and nineteenth centuries. It was very widely spoken, by whites and everyone else, by 1900, but is now extinct.

Chiton. A rock-dwelling shellfish very popular with the Haida and some other groups.

Chugach. South Alaskan Native group speaking a language in the Eskimo family.

Coincidentia oppositorum. A term used in comparative religious studies for the equation of two opposite things. Religions around the world often hold that life and death are one, or that good and evil are really not different, or that being and nonbeing are merely aspects of one divine Way. Duff saw the Northwest Coast peoples as portraying such *coincidentia oppositorum* in their art.

Copper. A large, flat, shieldlike piece of copper plate, often painted, that was a particularly powerful and valuable object. Coppers were often given away at potlatches, and were the most valuable of gifts. Sometimes they were cut up, and pieces were given away. Very rarely they were destroyed, especially by being thrown into the sea. Small objects were made of locally occurring native copper before the Europeans came, but all analyzed "coppers" (in the present sense) are made of modern copper sheeting, usually from ships' bottoms.

Copresence. A Duff word for the presence of two subjects or topics—opposed, joined, combined, or equated—in art.

Deconstruction. A term introduced by the French writer Jacques Derrida, to refer to the analysis of a text with specific reference to its inconsistencies, inadequacies and contradictions. Any text or cultural production can be deconstructed, often by showing that unanalyzed preconceptions are betrayed in its development.

Dididat. The Wakashan language, close to Nuu-chah-nulth, spoken on southwest Vancouver Island and the northwest Olympic Peninsula.

Dzonoqwa. The Kwakwaka'wakw "Old Woman of the Woods,"

who captures children for food. Used to scare children into obedience, but not a mere bogey; the Dzonoqwa is a serious and highly respected supernatural being.

Ethnobiology. The study of the biological knowledge shared among people of a specific ethnic group; also, the general study of how ethnicity or culture shapes beliefs about plants and animals.

Ethnoenergetics. The study of how particular ethnic groups understand and deal with energy.

Ethnography. Description of the lifeways of a particular ethnic group.

Ethnology. Comparative study of ethnic groups and ethnicity.

Eulachon. Pronounced ooligan and is usually spelled this way by Natives today.

Formline. A term introduced by Bill Holm for the strong, clearcut, often curved lines used to define spaces (and forms) in Northwest Coast art.

Formspace. Space defined by a formline (or comparable defining element).

Frog. The frog was associated with magic, witchcraft, shamanism and the supernatural in the northern Northwest Coast. (Contrary to some published claims, frogs *are* native to that area.)

Frogbox. Duff coinage for a box decorated with, or made to resemble, a frog, or mythologically associated with Frog.

Geometrization. Stylization by reducing forms to simpler geometric spaces.

Gitksan. "People of the Skeena River." The self-name of the Native peoples of the central Skeena River. Their language is related to Tsimshian (q.v.).

Gonaqadet (gonakadet). The wealth-giving marine monster of northern Northwest Coast art. It rose from the sea in earlier times, to give humans wealth and to teach them about the use thereof. Often equated with the Wasgo (q.v.) and the Tsimshian *hagweloq*.

Gramarye. Witchcraft; middle English term; cognate with "glamour" and "grammar," believed in olden times to be matters of magic.

Groundplan. General or basic plan (of a work of art, etc.).

Haida. The Native people of the Queen Charlotte Islands. By exten-

sion, their language. The Charlottes are now increasingly often referred to by their original name of Haida Gwai (Haaida Gwai, Haidah Gwai, etc.), "Land of the Haida."

Haisla. A Native nation of the central British Columbian coast; they speak a language related to Kwakwala.

Halait. Tsimshian term for supernatural power.

Halfness. Duff term for the quality of being "half" of something; part of the large complex of terms he introduced to talk about structuralism in Northwest Coast art.

Halkomelem. The Salish-speaking people and language of the lower Fraser River and nearby islands.

Hamatsa. The "Cannibal" figure in Kwakwaka'wakw winter dances. Initiates to the large and powerful Cannibal Society were possessed by cannibal energies, and danced round the ceremonial house attempting to bite spectators. They were gradually tamed and taught to control this wild energy, which ultimately comes from certain human-eating monsters of legend.

Heiltsuk. Like the Haisla, a central British Columbia coast group speaking a language related to Kwakwala. Also known as "Bella Bella" (from their main settlement).

Hohokw (Hohoq, etc.). A giant human-eating bird of the Hamatsa myth.

Housefront. Northwest Coast houses, especially chiefly ones, had huge and spectacularly painted front exterior walls. Painting (at least the "flat," or two-dimensional, styles) reached its highest level of expression on these housefronts. Unfortunately, few photographs and even fewer housefronts survive.

Housepost. These housefronts, and also the interiors of the houses, sported spectacularly carved houseposts; the housepost style is close to the totem pole art.

Hypnagogic. Refers to the drowsy state just before sleep, when dreams mix with some waking ideas. Duff used this state as a source of insights.

Hypnopompic. Refers to the state just at waking, when the mind is awake but not yet engaged by ordinary daily concerns. Most people, including Duff, find this state a particularly good one for finding new solutions to problems and questions; the mind's disengagement allows it to escape from ordinary ruts.

Icon (icon). Any image portrayed in art.

Iconic. Refers to the symbolism of art.

Iconographic. Refers to the actual items shown in art.

Interpowering. A Duff coinage, referring to two beings each giving power to the other (this being expressed or portrayed in Northwest Coast art).

Intertransforming. Refers to two icons transforming into each other, often taken to be a portrayal of two beings transforming each other or transforming into each other.

Intrapsychic. Psychological term refers to processes occurring within the mind.

Inuit. The correct name (or, at least, the original self-name) for the northern Canadian Native peoples usually known as "Eskimo." Singular, inua.

Kaigani. The Haida group living on the southern islands of Alaska, to which they moved about 250 years ago.

Kerfed. Notched with a long straight cut. A woodworking term. Bentwood boxes were constructed by kerfing a board and then steaming and slowly bending it at the kerf.

Kwagyul. See Kwakiutl.

Kwakiutl. The local chiefdom or "tribe" of Kwakwaka'wakw living around Fort Rupert. This name was generalized (by early Anglos) to refer to the whole Kwakwaka'wakw, to the annoyance of the other groups. It is variously spelled: Kwagul, Kwagyul, Kwaw-kweulth, etc. "Kwagyul" comes closest to (but not very close to) the actual pronunciation.

Kwakwaka'wakw. "Speakers of the Kwakwala language." The people in question were originally divided into about twenty independent groups, and had no Native name for themselves as a people. They did, however, have a name for the language; recently they have come to refer to themselves by the present phrase.

Kwakwala. The language originally spoken on northern and northwestern Vancouver Island and the facing coasts, north to central British Columbia. Usually miscalled "Kwakiutl" (q.v.) in English-language sources. One of the Wakashan (q.v.) languages.

Lingam. Sanskrit for "phallus." Often used in art, anthropology and

psychology as a somewhat euphemistic term for the phallus as a venerated or artistically portrayed entity.

Longhouse. Just what it says, but the implication is that a whole tribe or other social group is living together in the longhouse.

Makah. The Native people of the northwest Olympic Peninsula; they speak the Dididat language ("Makah" is a name used by neighbor groups).

Matrilineage. A group of people tracing descent through the female line to a single, known ancestor. This was the typical descent group, and indeed the most important social entity, among the northern Northwest Coast peoples.

Mediation. In structuralism, concepts that mediate between two structural opposites are important. Mediating entities are often highly charged with supernatural power in Northwest Coast religions.

Multivocality. "Multiple voices"—referring to the fact that a text, or any cultural production, never speaks with only one simple voice. The author's or artist's various roles and background influences will somehow be expressed in it.

Na-Dene. The language family including Athabaskan and Tlingit. Sometimes thought to include Haida, but this link has been fairly rigorously disproved.

Nankilstlas. "He whose voice is obeyed," a Haida title of the mythic Raven.

Nankilstlas-lingai. "He who will be the one whose voice is obeyed." Raven at an earlier stage in his career.

Naxnox. Tsimshian: "supernatural being" (or portrayal or image of one).

Nishga (Nisga'a, Nishka, Niska). Self-name of the Native nation living along the Nass River in north coastal British Columbia. Known as "Nass" in early Anglo-Canadian writings. Their language is close to Tsimshian (q.v.) and even closer to Gitksan.

Nootka. See "Nuu-chah-nulth."

Nuu-chah-nulth. Currently used name for the people referred to as Nootka or Westcoast in most sources until very recently. A recent coinage, meaning, roughly, "people on this side of the mountains." The people in question speak various dialects of a single Wakashan language, and live on the west coast of Van-

couver Island (except for the extreme south and north ends thereof). Like the Kwakwaka'wakw, the Nuu-chah-nulth were originally divided into smaller local groups, and had no general name for themselves. The English (and, later, Canadians and most of the rest of the world) came to call them "Nootka," but this was a mistake. According to the most likely story, English explorers landing on a small island off the Vancouver Island coast gestured in a wide circle and asked "What is the name of this place?" The local people thought the English were asking if they could go around the island, and gave an answer sounding like "nootka" and meaning "you can go around" (see Kirk 1986 for further discussion).

Numaym. Kwakwala name for the large descent groups, in which descent is traced through both father and mother, that characterize central and southwestern British Columbia peoples.

Ooligan (eulachon). A small, very oily fish that runs in large numbers up certain Northwestern rivers.

Paleologic. Silvano Arieti's term for the reasoning by analogy and by religious equation that characterizes many traditional belief systems (Arieti 1967).

Patrilineage. A group of people related by direct descent, in the male line, from a specific ancestor. Many Salishan groups were incorporated along patrilineal lines, if not always into highly defined and explicit patrilineages.

Paxala. Kwakwala for "political leader" or "chief."

Phallogocentric. Jacques Lacan, a modern French psychiatric writer, coined this term to refer to the Western European preoccupation with words and with male sexuality. Unfortunately, Duff did not encounter Lacan's work.

Phenomenology. A branch of philosophy (dating back to Immanuel Kant) that deals with the nature of mental representations.

Potlatch (v. or n.). Nuu-chah-nulth word, borrowed into English via Chinook jargon, referring to the great ceremonies at which chiefs assumed and validated titles by attracting guests and giving them lavish gifts. These potlatches became highly competitive and even destructive in historic times. They are comparable to the Irish feasts and gift-givings of legendary times, and—for that matter—are not totally dissimilar to some modern political

gift-giving events. Contrary to charges that can be traced back to missionaries, they were not orgies of wasteful and irrational destruction; they were, and are, well-organized and rationally planned political and religious events. Due to missionary pressure, they were banned for decades in Canada and strongly discouraged in the United States. Now long legal, they have become important again.

Raven. The most important character in most Northwest Coast mythologies. The Raven was a trickster, transformer, liberator and occasionally creator. A personification of greed but also of transforming power, he was equally important in shamanic and chiefly art. He continues to be the most complex and evocative figure in Northwest Coast myth and art.

Raven rattle. A very specific and characteristic rattle, intricately carved with the Raven and other supernatural creatures, used in sacred ceremonies on the northern Northwest Coast. Duff's student Jennifer Gould wrote a thesis under his direction on this artistic item (Gould 1973). The rattle usually shows Raven carrying the sun; he stole the sun from a chief who had been selfishly hiding it. Flying through the chief's house smokehole, Raven was scorched black; he had previously been white. Thus by bringing light he brought himself darkness—a typical Northwest Coast paradox. The Raven rattle usually also shows a Skiamsm face, probably representing the sun, on the Raven's belly. It also shows such powerful beings as oystercatchers, frogs, kingfishers and otters—all of which cross the important barrier between land and water. Often the kingfisher holds the frog, whose tongue reaches out to touch the tongue of a human or humanoid figure (a shaman?). Transfer of power and possible sexuality are implied. The rattle is held with the Raven upside down, perhaps—Gould suggested—to submerge or reverse the dangerous figures and raise the sun/Skiamsm over them.

Qaq. Another "Raven" word; imitates the bird's call.

Qingi. An ancestor of Raven in Haida myth.

Salishan (Salish). A large language family. Salishan languages are spoken from Oregon north to central British Columbia and from the coast inland to the Rocky Mountains and Cascades. The languages are quite diverse. There were many tens of thousands

of speakers in precontact times. Salishan is sometimes considered to be related to other language families, especially Algonquian, Wakashan and Chemakuan, but most linguists are not convinced.

Salmon-trout-head. Name given (apparently at first by Native peoples) to a characteristic, small, fish-head-like design element in Northwest Coast art. It is a very common "filler" element in flat painting, especially in the northern part of the region. There is no evidence that it really represents a salmon-trout (in fact, there is no such thing as a salmon-trout, zoologically speaking); this term is thus now out of favor.

Scrimshawing. Small, involved carving, by sailors, on hard materials—traditionally whales' teeth.

Semoiget. Tsimshian for "political leader."

Sgaana. "Power" and also "killer whale" in Haida. Haida are often reincarnated as killer whales; there is a bond of supernatural power.

Shaman. A traditional ritual leader or "medicine person." Differs from a priest in that the shaman is an independent practitioner, not under the authority of a church organization. Shamans were the ceremonial masters and the leading curers among Northwest Coast peoples. The word is derived from the Tungus languages of Siberia.

Sinsganagwai. Another Haida title of mythic Raven.

Sisiutl. A two-headed serpent of Kwakwaka'wakw legend and art. Similar serpents in other Northwest Coast traditions tend to get lumped under the same name by modern art dealers.

Skiamsm (skimsem, skimsim, etc.). Tsimshian word for a beaked creature commonly represented in art. Early ethnographers recorded that the Tsimshian, Tlingit and Haida saw this art motif as a small hawk, but the specific referent is unclear. More accurately spelled Xskemsam (Halpin 1973). The beak is often shown recurving into the bird's mouth, a point which intrigued Duff. The sun and moon are very often shown with skiamsm faces.

Smolt. The stage of a salmon's life when it is bigger than minnow size but not yet full grown.

Soulcatcher. A hollow bone tube, usually exquisitely carved, used by

shamans in ceremonies—especially to catch a wandering soul that has strayed from the body (thus causing sickness).

Structuralism. The study of the ways in which the human mind gives structure to its thoughts and ideas. Specifically, in anthropology, this term is usually used for the particular brand of structuralism taught by Claude Levi-Strauss. Levi-Strauss held that people usually try to simplify the world as much as possible, by thinking about it in terms of simple, clear oppositions. Particularly important to Levi-Strauss were the oppositions of "male" and "female," "culture" and "nature," and particular social groups (e.g. "my blood kin" vs. "my wife's kin"). He held that many oppositions seen in myth and legend, e.g., in the Northwest Coast, "upstream" vs. "downstream," "human" vs. "animal," and "land" vs. "water," are drawn on to symbolize these deeper human social contrasts. A great deal of his research dealt with Northwest Coast art. His thought was enormously influential on Wilson Duff and many other anthropologists of the period.

Swensk halait. Tsimshian for "shaman."

Sxwaixwe. A Salishan word for a large, beautiful, striking mask used in curing rituals by Salishan peoples of the southern coastal part of British Columbia, and by several neighboring groups. The Kwakwaka'wakw borrowed it, with various changes, under the name *xwexwe*.

Takinai. Haida for "granddaughter." Used in Duff's poetry.

Tamanous. A Chinook jargon corruption of a Salishan word meaning "supernatural being." Used in older sources to refer to Salishan spirits and religious ceremonies, and even to refer to Native religions in general.

Tantrism. The version of Buddhism found in Tibet and neighboring areas. Based on *tantra*, Sanskrit for "magical ritual." Highly ritualized but philosophically complex and abstruse.

Thunderbird. A giant eagle-like bird that captures and eats whales just as eagles capture fish. Its wings make thunder, and it is usually held responsible for lightning too. It is often represented with a recurved beak like the Skiamsm's.

Tlingit. The Native people of the Alaska Panhandle. The Tlingit language is closely related to the Athabaskan languages, in the Na-Dene family.

Totem pole. The famous poles of the Northwest Coast are mis-
named. They have nothing to do with the animal kinfolk that the
Ojibway of eastern Canada call "totems." Totem poles show the
descent of the person erecting the pole. They do this by provid-
ing spectacular carvings of scenes and characters from the per-
son's family history. These are typically mythological, referring
to the person's descent from beings in mythic time, but it is
perfectly common for totem poles to represent historic individu-
als and episodes. One Tsimshian chief was so captivated by the
small pet dog of a trader that he added a carving of the dog to his
totem pole.

Tsetsaut. An extinct Athabaskan group on which Duff was an
authority.

Tsetseqa. See *baxus.*

Tsimshian. The Native people of the lower Skeena and the coast
nearby. There are two languages under this name: Coast Tsim-
shian (spoken around the Skeena mouth) and Southern Tsim-
shian (spoken to the south, along the coast). Moreover, the word
is also used for the language family which also includes the
Gitksan-Nishga language. This annoys Gitksan and Nishga, who
did not necessarily find permanent peace in their dealings with
the Tsimshian proper. So far, however, "Tsimshian" continues
to be used for the whole family. In the nineteenth century, the
word was usually spelled "Chimmesyan."

Twana. A Salishan people of the western Puget Sound coasts.

Txemsem. Yet another variant spelling of *skiamsm.*

Wakashan. The language family including Kwakwala, Nuu-chah-
nulth and Dididat. The latter two are extremely closely related,
but differ from Kwakwala about as far as English differs from
French. Rather charmingly named from a shared word for "very
good" or "hurray!"

Wasgo (wasco, wasko). A huge sea-monster of Haida myth and
legend. Something like a gigantic seagoing grizzly bear, so big
that it catches several whales at a time. It is often represented in
art, carrying a whale in its mouth and holding another with its
apparently prehensile curled tail. Like several other mythic crea-
tures, it combines traits of land and water creatures, thus show-

ing transcendence of, or mediation between, the opposites: Land and Water.

Wegyet (weeget, weget, wiget, etc.). The trickster and creator hero of Tsimshian, Gitksan and Nishga legends. He corresponds to the Raven of other Northwest Coast myths, but is usually represented in humanlike form.

Westcoast. Local English name for the Nuu-chah-nulth people.

Wet'suwet'en. An Athabaskan people who are neighbors of the Gitksan and have borrowed much of their culture (while giving some of theirs in return; alternatively, the Gitksan may be Wet'suwet'en who have borrowed not only culture but language also from Tsimshian neighbors). The Wet'suwet'en language was once thought to be a dialect of Carrier, but it is not; it is a separate language. Surprisingly little has been written about either traditional or modern Wet'suwet'en culture.

Whatsit. Duff term for certain small, exquisite stone carvings found archaeologically in southwest British Columbia. They seem to have been ornaments or magical items. They are the source of much speculation.

Wihalait. "Great Dancer" or "Holy One" in Tsimshian. The title of the chief when he serves as ceremonial leader (as opposed to political leader, *semoiget*).

Xoya (hoya). Haida for "raven."

Yel (yelth). Tlingit for "raven." Borrowed into northern dialects of Haida.

Yoni. Sanskrit for "female genitalia." Often used by anthropologists and other comparativists to refer to the female sexual parts as religious or cultural symbols, e.g. of fertility.

Yupik. The Native people of far west Alaska and neighboring Siberia, speaking an Eskimoan language.

Bibliography

1. Bibliography of the Writings of Wilson Duff

1951 "Notes on Carrier Social Organization." *Anthropology in B.C.* 2:28-34.

— "Indian Natural History." Victoria Naturalist 7-8.

1952 *Thunderbird Park*. Govt. of British Columbia, Travel Bureau (leaflet).

— Review of H. T. Cain, "Petroglyphs of Central Washington." *B.C. Historical Quarterly*, July-Oct. 1951 (publ. 1952).

— Review of A. H. Ernst, "The Wolf Ritual of the Northwest Coast." *American Anthropologist* 54:4. [This listing appears in Duff's personal bibliography, but in fact there is no such review in any issue of the American Anthropologist or any other major anthropology journal. It may have been submitted but not published, or Duff may have misremembered the locus of a review actually published in a local journal.]

— "Gitksan Totem Poles, 1952." *Anthropology in B.C.* 3:2-30.

1953 "The Upper Stalo Indians of the Fraser Valley, B.C." Victoria: British Columbia Provincial Museum. *Anthropology in B.C.*, Memoir 1. 136 pp.

1954 "A Heritage in Decay, the Totem Art of the Haidas." *Canadian Art* 11:2.

— "Preserving the Talking Sticks." *Powell River Digester* (house organ of Powell River paper mill) 30:6:10-12.

— "A Scottsbluff-Eden Point from British Columbia." *Anthropology in B.C.* 4:34-35. Coauthored with C. E. Borden.

1956 "A Post-Contact Southward Movement of the Kwakiutl." *Research Studies of the State College of Washington* 24:56-66. Coauthored with H. C. Taylor.

— "Unique Stone Artifacts from the Gulf Islands." British Columbia Provincial Museum, *Annual Report for 1955*:45-55.

— "An Unusual Burial at the Whalen Site." *Research Studies of the State College of Washington* 24:67-72.

1957 Prehistoric Stone Sculpture of the Fraser Valley and Gulf of Georgia. *Anthropology in B.C.* 5:15-151.

— "Totem Poles Recall Vanished Seafarers." *The Crowsnest* 9:3:22-25.

1958 "Anthony Island, a Home of the Haidas." British Columbia Provincial Museum, *Annual Report for 1957*. 28 pp. Coauthored with J. E. M. Kew.

1959 "Mungo Martin, Carver of the Century." *Museum News* 1, no. 1.

1960 "Histories, Territories and Laws of the Kitwancool." British Columbia Provincial Museum, *Anthropology in B.C.*, Memoir 4. 45 pp.

1961 "The Killer Whale Copper." British Columbia Provincial Museum, *Annual Report for 1960*:32-36.

— "Preserving British Columbia's Prehistory." Archaeological Sties Advisory Board, Victoria (report).

1962 Review of Will Robinson, Men of Medeek. *The Beaver*

1963 "Stone Clubs from the Upper Skeena River." British Columbia Provincial Museum, Annual Report for 1962:27-28.

1964 "Contributions of Marius Barbeau to West Coast Ethnology." *Anthropologica* 6:63-96.

— *The Indian History of British Columbia. Vol. 1: The Impact of the White Man*. British Columbia Provincial Museum, Anthropology in B.C., Memoir 5. 117 pp.

1965 "Thoughts on the Nootka Canoe." British Columbia Provincial Museum, *Annual Report for 1964*

1966 Review of Bill Holm, "Northwest Coast Indian Art." *American Antiquity* 31:880-881.

1967 Arts of the Raven: Masterworks by the Northwest Coast Indians. Vancouver: Vancouver Art Gallery. Senior author, with Bill Reid and Bill Holm.

1969 "The Northwest Coast (La Cote Nord-Oest)." In *Masterpieces of Indian and Eskimo Art from Canada*. Paris: Musee de l'Homme. Unpaginated, but consisting of 14 pp. of bilingual text

followed by 125 extensively-captioned plates. The work is an exhibition catalogue.

— "The Fort Victoria Treaties." *B.C. Studies* 3:3-57.

— *Totem Pole Survey of Southeastern Alaska.* Juneau: Alaska State Museum. Editor and senior author, with Jane Wallen and Joe Clark. Unpublished report.

1970 "On Wardwell's Partial Rediscovery of a Northwest Coast Monument." Curator

1971 Foreword to Edward Meade, *Indian Rock Carvings of the Pacific Northwest.* Sidney, B. C.: Grays Publishing Ltd.

— The West Coast National Park and the Indian Land Question. Ms.; "Study prepared for the West Coast District Council and the Indian Affairs Branch."

1973 Foreword to Kalervo Oberg, *The Social Economy of the Tlingit Indians.* Seattle: Univ. of Washington Press.

— Review of D. B. Fields and W. T. Stanbury, *The Economic Impact of the Public Sector on the Indians of British Columbia.* B. C. Studies 19:122-129.

— *A Select Bibliography of Anthropology of British Columbia.* B. C. Studies 19:73-121. Senior author, with Michael Kew; revised by Frances Woodward and Laine Ruus.

1974 "Bill Reid: An Act of Vision and an Act of Intiuition." In *Bill Reid: A Retrospective Exhibition.* Vancouver: Vancouver Art Gallery. Pp. 1-2. Foreword to an exhibition catalogue.

1975 *Images: Stone: BC.* Vancouver: Hancock House; Seattle: Univ. of Washington Press.

1976 "Mute Relics of Haida Tribes' Ghost Villages." *Smithsonian* 7:6:84-91.

1981 "Tsetsaut." In June Helm (ed.): *Handbook of North American Indians, Vol. 6, Subarctic.* Pp. 454-457.

— Several pieces in *Abbott* (ed.) 1981: Republications of "Mungo Martin, Carver of the Century" (pp. 37-40), "Stone Clubs from the Skeena River Area" (pp. 95-104), "The Killer Whale Copper" (pp. 153-156), "Thoughts on the Nootka Canoe" (pp. 201-206); previously unpublished materials, "Sea Levels and Archaeology on the Northwest Coast" (pp. 123-126), "The World Is As Sharp As a Knife: Meaning in Northern Northwest Coast

Art" (pp. 209-224), poems (pp. 307-314), and the teaching story "Nothing Comes Only in Pieces" (pp. 315-324).

1982 Several letters to Lilo Berliner. In Phyllis Webb: *Talking.* Dunvegan, Ontario: Quadrant Edns. Pp. 129-149. With Berliner's replies and Webb's commentary on this revealing correspondence. Berliner had written to Duff asking for information on Indian matters, and a deep epistolary friendship developed, with some baring of souls on both sides. The original letters are in the Duff files, and reveal that Webb published all but the very personal parts of this importance correspondence.

1982 "Dedication." In: *B.C. Indian Arts, Society: Mungo Martin, Man of Two Cultures.* Sidney, BC: Gray's Publishing Ltd. Actually an unacknowledged reprint of part of "Mungo Marton, Carver of the Century."

1983 *The World Is As Sharp As a Knife: Meaning in Northern Northwest Coast Art.* Carlson (ed.) 1983:47-66. Slightly expanded version of the one in the Abbott volume.

2. Sources Cited in Text (Introductory and Main Texts)

Abbott, Donald (ed.). 1981. *The World is as Sharp as a Knife.* Victoria, BC: British Columbia Provincial Museum.

Amoss, Pamela. 1978. *Coast Salish Spirit Dancing.* Seattle: Univ. of Washington.

Anderson, E. N. 1986. "Learning from the Land Otter." *Paper,* Society for Ethnobiology, annual meeting.

Arieti, Silvano. 1956. "Some Basic Problems Common to Anthropology and Modern Psychiatry." *American Anthropologist* 58:26-39.

— 1967. *The Intrapsychic Self: Feeling, Cognition and Creativity in Health and Mental Illness.* New York: Basic Books.

— 1976. *Creativity: The Magic Synthesis.* New York: Basic Books.

Armstrong, Robert Plant. 1971. *The Affecting Presence.* Urbana: Univ. of Illinois.

Barbeau, Maurice. 1929. *Totem Poles of the Gitksan, Upper Skeena River, British Columbia.* Ottawa: National Museum of Canada, Bull. 61.

— 1950. *Totem Poles.* Ottawa: National Museum of Canada, Bull. 119.

— 1952. "All Hands Aboard Scrimshawing." *American Neptune* 12:2:2-26.

— 1953. *Haida Myths Illustrated in Argillite Carvings.* Ottawa: National Museum of Canada, Bull. 127.

— 1957. *Haida Carvers in Argillite.* Ottawa: National Museum of Canada, Bull. 139.

— 1958. *Medicine-Men on the North Pacific Coast.* Ottawa: National Museum of Canada, Bull. 152.

Barnett, Homer. 1953. *Innovation: The Basis of Cultural Change.* New York: McGraw-Hill.

Benedict, Ruth. 1923. *The Concept of the Guardian Spirit in North America.* Kenosha, WI: American Anthropological Association.

— 1934. *Patterns of Culture.* Boston: Houghton Mifflin.

Berger, Peter, and Thomas Luckmann. 1966. *The Social Construction of Reality.* Garden City, NY: Doubleday.

Berger, Thomas. 1981. "Wilson Duff and Native Land Claims." *Abbott 1981*:49-64.

Beynon, William. 1980-1985. *Tsimshian Stories.* Metlakatla, AK: Metlakatla Indian Community. 7 vols.

Bishop, Charles. Duff was probably using a copy, in the British Columbia Provincial Archives (Victoria), of the *Journal, Letters, Accounts of Ship Ruby's Voyage to Northwest Coast of America and China*, 1794-5-6. However, Bishop's material was published by then and may have been the source: 1967. *Journal and Letters of Capt. C. Bishop on the Northwest Coast of America, in the Pacific, and in New South Wales*, 1794-1799. Ed. Michael Roe. Cambridge: Hakluyt Soc.

Boas, Franz. 1897. *The Decorative Art of the Indians of the Northwest Coast.* American Museum of Natural History, Bulletin, IX:123-176.

— 1898. *Facial Paintings of the Indians of British Columbia.* American Museum of Natural History, Memoirs, 2:1:1.

— 1955 (1927). *Primitive Art.* New York: Dover.

Boelscher, Marianne. 1988. *The Curtain Within: Haida Social and Mythical Discourse.* Vancouver: Univ. of British Columbia Press.

Boit, John. 1921a. *The John Boit Log and Captain Gray's Log of the Ship Columbia.* Annotated by F. W. Howay and T. C. Elliott,

intro. by F. C. Young. Oregon Historical Quarterly 22:4:257-356.

— 1921b. *A New Log of the Columbia*, by John Boit. Ed. Edmond S. Meany. Washington Historical Quarterly 12:1:3-50.

Bott, Elizabeth. 1972. "The Significance of Kava in Tongan Myth and Ritual: Psychoanalysis and Ceremony." La Fontaine, J. S. (ed.): *The Interpretation of Ritual.* London: Tavistock. Pp. 205-238.

Brown, Bruce. 1983. *Mountain in the Clouds.* New York: Simon and Schuster.

Calkowski, Maria St. 1974. "Cannibalism and Infertility among the Lillooet, Thompson and Shuswap: The Shaman as a Sexual Mediator." MA thesis, Dept. of Anthropology and Sociology, Univ. of British Columbia.

Campbell, Lyle, and Mithun, Marianne (eds.). 1979. *The Languages of Native America.* Austin: Univ. of Texas Press.

Codere, Helen. 1950. *Fighting with Property.* New York: American Ethnological Society. Monograph 28.

Collins, June M. 1974. *Valley of the Spirits.* Seattle: Univ. of Washington.

Cooper 1960 [This reference is Duff's, in connection with the log of the *Alert*, apparently not the vessel of that name that explored the Canadian Arctic in the late-nineteenth century. I cannot trace this reference.]

Cove, John. 1987. *Shattered Images: Dialogues and Meditations on Tsimshian Narratives.* Ottawa: Carleton Univ. Press.

Cove, John, and MacDonald, George (ed.); William Beynon and Marius Barbeau (coll.). 1987. *Tsimshian Narratives.* Ottawa: National Museums of Canada.

Davidson, Susan. 1967. thesis

Deans, James. 1886. "On the Copper Images of the Haidah Tribes." *Proceedings of the Numismatic and Antiquarian Society of Philadelphia*, 1:14-17.

— 1895. "The Hidery Story of Creation." *American Antiquarian and Oriental Journal,* 17:61-67.

— 1899. "Tales from the Totems of the Hidery." *Archives of the International Folk-lore Association*, 2:1-94.

d'Emilio, John, and Estelle B. Freedman. 1988. *Intimate Matters.* New York: Harper and Row.

Douglas, Mary. 1970. *Natural Symbols.* London: Barrie and Rockliff.

Drew, Leslie, and Douglas Wilson. 1980. *Argillite: Art of the Haida.* Vancouver: Hancock House.

Drucker, Philip. 1951. *The Northern and Central Nootka Tribes.* Washington: Bureau of Ethnology.

— 1955. *Indians of the Northwest Coast.* Garden City: Doubleday and American Museum of Natural History.

— and Heizer, Robert. 1967. *To Make My Name Good.* Berkeley: Univ. of California.

Duff, Wilson. (see full bib)

Dunn, John. 1845. Presumably, from Fisher: 1844. *History of the Oregon Territory and British North American Fur Trade....* London; Edwards and Hughes.

Eliza. Journal of the *Eliza,* February-May 1799. Ms. [Presumably the photocopy resident in the Univ. of British Columbia Library.]

Elmendorf, W. W. 1960. *The Structure of Twana Culture.* Seattle: Univ. of Washington Press.

— 1984. "Coast Salish Concepts of Power: Verbal and Functional Categories." Miller and Eastman 1984:281-291.

Emmons, George T. 1907. "The Chilkat Blanket." *American Museum of Natural History, Memoirs,* Vol. 3.

Eysenck, Hans J. 1985. *The Decline and Fall of the Freudian Empire.* London: Viking.

Fischer, J. L. 1961. "Art Styles as Cultural Cognitive Maps." *American Anthropologist* 63:1:79-93.

Fisher, Robin. 1977. *Contact and Conflict.* Vancouver: Univ. of British Columbia.

Fitzhugh, William, and Crowell, Aron (eds.). 1988. *Crossroads of Continents.* Washington, DC: Smithsonian Institution.

Fitzhugh, William, and Kaplan, Susan. 1982. *Inua: Spirit World of the Bering Sea Eskimo.* Washington, DC: Smithsonian Institution.

Fladmark, Knut R. 1986. *British Columbia Prehistory.* Ottawa: National Museums of Canada, Archaeological Survey of Canada.

Fleurieu, C. P. Claret. 1801. *A Voyage Round the World, Performed during the Years 1790, 1791, and 1792,* by Etienne Marchand... London: T. N. Longman and O. Rees.

Ford, Clellan. 1941. *Smoke from Their Fires.* New Haven: Yale Univ. Press.

Frankl, Victor. 1963. *Man's Search for Meaning.* New York: Washington Square.

Fraser, Douglas. 1962. *Primitive Art.* Garden City, NY: Doubleday.

Friedlaender, Max J. 1944. *On Art and Connoisseurship.* London: B. Cassirer.

Gazzaniga, Michael. 1985. *The Social Brain.* New York: Basic Books.

Gessler, Trisha. 1981. *The Art of Nunstins.* Queen Charlotte City: Queen Charlotte Islands Museum.

Goldman, Irving. 1975. *The Mouth of Heaven: An Introduction to Kwakiutl Religious Thought.* New York: Wiley.

Gould, Jennifer. 1983. "The Iconography of the Northwest Coast Raven Rattle." MA thesis, Dept. of Anthropology and Sociology, Univ. of British Columbia.

Greenberg, Joseph. 1987. *Language in the Americas.* Stanford: Stanford Univ. Press.

Griaule, Marcel. 1965. *Conversations with Ogotemmeli.* Oxford: Oxford Univ. Press.

Green, Jonathan S. 1915. *Journal of a Tour on the Northwest Coast of America in the Year 198-29.* New York: C. F. Hartman.

Griffin, 1892 [Duff's reference to a work on Juan Perez' early voyage to the Queen Charlottes; I am unable to trace it]

Groddeck, George. 1961. *The Book of the It.* New York: Basic Books.

Grunbaum, A. 1984. *Foundations of Psychoanalysis.* Berkeley: Univ. of California Press.

Gunther, Erna. 1956. "The Social Disorganization of the Haida as Reflected in Their Slate Carving." *Davidson Journal of Anthropology* 2:149-153.

— 1966. *Art in the Life of the Northwest Coast Indians.* Portland, OR: Portland Art Museum.

Gustafson, Paula. 1980. *Salish Weaving.* Seattle: Univ. of Washington Press.

Hall, Edwin S., Jr.; Margaret B. Blackman; Vincent Rickard. 1981. *Northwest Coast Indian Graphics*. Seattle: Univ. of Washington Press.

Halpin, Marjorie. 1973. "The Tsimshian Crest System: A Study Based on Museum Specimens and the Marius Barbeau and William Beynon Field Notes." Ph.D. thesis, Dept. of Anthropology and Sociology, Univ. of British Columbia.

— 1978. "William Beynon, Tsimshian, 1888-1958." *American Ethnological Society: American Indian Intellectuals.* St. Paul: West. Pp. 141-156.

— 1981. *Totem Poles: An Illustrated Guide*. Vancouver: Univ. of British Columbia Press and U.B.C. Museum of Anthropology.

— 1984. "The Structure of Tsimshian Totemism." Miller and Eastman 1984:16-35.

— 1988. "Review of Art of the Northern Tlingit by Aldona Jonaitis." *The art Bulletin* 70:3:534-535.

Hamilton, Ron (Hupquatchew). 1981. "Some Thoughts about Wilson Duff." *Abbott 1981*:45-46.

Hawthorn, Audrey. 1967. *Art of the Kwakiutl Indians*. Vancouver: Univ. of British Columbia; Seattle: Univ. of Washington Press.

— 1979. *Kwakiutl Art*. Seattle: Univ. of Washington Press.

Heine-Geldern, Robert. [article about tangential circle and braided cord]

Hendin, H. 1982. *Suicide in America*. New York: Norton.

Henry, John Frazier. 1984. *Early Maritime Artists of the Pacific Northwest Coast, 1741-1841*. Seattle: Univ. of Washington Press.

Hill-Tout, Charles. 1978. *The Salish People*. Vancouver: Talonbooks.

Holm, Bill. 1965. *Northwest Coast Indian Art*. Seattle: Univ. of Washington Press.

— 1974. "The Art of Willie Seaweed: A Kwakiutl Master." In: Richardson, Miles (ed.), *The Human Mirror: Masterial and Spaitial Images of Man*. Baton Rouge, LA: Louisiana Univ. Press. Pp.

— 1981. "Will the Real Charles Edenshaw Please Stand Up? Thee Problem of Attribution in Northwest Coast Indian Art." *Abbott 1981*:175-200.

— 1983. *Smoky-Top*. Seattle: Univ. of Washington Press.

— 1984. *The Box of Daylight*. Seattle: Univ. of Washington Press.

— 1987. *Spirit and Ancestor*. Seattle: Univ. of Washington Press.

Holm, Bill, and Reid, William. 1975. *Form and Freedom: a Dialogue on Northwest Coast Indian Art*. Houston, TX: Rice Univ. Institute for the Arts.

Hoover, Alan L. 1983. "Charles Edensaw and the Creation of Human Beings." *American Indian Art* 1980:622-67, 80.

Hopffgarten, Daphne von. 1978. "The Haida Raven: A Zoological and Symboolic Interpretation." MA thesis, Dept. of Anthropology and Sociology, Univ. of British Columbia.

Howay, F. W. 1920. *Voyage of the Hope*. Washington Historical Quarterly 11:1:

Howay, F. W. (ed.). 1941. *Voyages of the "Columbia" to the Northwest Coast*, 1787-1790 and 1790-1793. Collections of the Massachusetts Historical Society 79:207-373.

Hultkranz, Ake. 1979. *The Religions of the American Indians*. Berkeley: Univ. of California Press.

Ingraham, Joseph. nd. "Journal of the Voyage of the Brigantine Hope from Boston to the North-west Coast of America, 1790 to 1792." Ms. (in Library of Congress).

Inverarity, Robert Bruce. 1950. *Art of the Northwest Coast Indians*. Berkeley: Univ. of California Press.

Jenness, Diamond. 1955. *The Faith of a Coast Salish Indian*. Victoria, B.C.: British Columbia Provincial Museum. Anthropological Papers #3.

Jewitt, John. 1974. *The Adventures and Sufferings of John R. Jewitt, Captive among the Nootka*, 1983-1805. Ed. by Derek G. Smith. Toronto: McClelland and Stewart.

Jilek, Wolfgang. 1974. *Salish Indian Mental Health and Culture Change*. Toronto: Holt, Rinehart, Winston. (Orig. Ph.D. thesis, Dept. of Anthropology and Sociology, Univ. of British Columbia.)

— 1982. *Indian Healing*. Vancouver: Hancock House.

Johnson, Elizabeth Lominska, and Kathryn Bernick. 1986. "Hands of Our Ancestors: The Revival of Salish Weaving at Musqueam." Vancouver: Univ. of British Columbia, Museum of Anthropology, Museum Note #16.

Jonaitis, Aldona. 1981. "Tlingit Halibut Hooks: An Analysis of the Visual Symbols of a Rite of Passage." New York: *American Museum of Natural History, Anthropological Papers*, 57:1.

— 1986. *Art of the Northern Tlingit*. Seattle: Univ. of Washington Press.

— 1988. *From the Land of Totem Poles*. New York and Seattle: American Museum of Natural History and Univ. of Washington Press.

Jung, Carl. 1956. *Symbols of Transformation*. New York: Pantheon.

— (ed.). 1964. *Man and His Symbols*. New York: Aldus.

Kan, Sergei. 1989. "Symbolic Immortality." Washington: Smithsonian Institution.

Kaplan, Susan A., and Barnes, Kristin J. 1986. "Raven's Journey." Philadelphia: Univ. of Pennsylvania, Univ. Museum.

Keithahn, Edward. 1963. *Monuments in Cedar*. Seattle: Superior Publishing.

King, J. C.H. 1979. *Portrait Masks from the Northwest Coast of America*. London: Thames and Hudson.

Kirk, Ruth. 1986. *Wisdom of the Elders*. Vancouver: Douglas and McIntyre.

Kirk, Ruth, with Richard Daugherty. 1978. "Exploring Washington Archaeology." Seattle: Univ. of Washington.

Koestler, Arthur. 1964. *The Act of Creation*. New York: MacMillan.

Krauss, Michael E. 1979. "Na-Dene and Eskimo-Aleut." Campbell and Mithun 1979:803-901.

Laguna, Frederica de. 1972. "Under Mount Saint Elias." Washington: Smithsonian Institution.

— 1973. "Athabaskan Art"/"The Shamans." In: Collins, Henry B; de Laguna, F.; Stone, Peter; Carpenter, *Edmund: The Far North*. Washington, DC: National Gallery of Art. Pp. 133-164, 227-280.

Lane, Barbara. 1953. "A Comparison and Analytic Study of Some Aspects of Northwest Coast Religion." Ph.D. thesis, Dept. of Anthropology, Univ. of Washington.

Leach [presumably a reference to some article of E. R. Leach, but I cannot trace it]

Levi-Strauss, Claude. 19158. *Anthropologie structurale*. Paris: Plon.

— 1964. "The Savage Mind." Chicago: Univ. of Chicago.

— 1969. "The Myth of Asdiwal." Leach, E. (ed.): *The Structural Study of Myth and Totemism*. London: Tavistock. Pp. 1-48.

— 1982. *The Way of Masks*. Seattle: Univ. of Washington Press.

Levine, Robert, and Peter MacNair. 1979. George Woodcock's "Peoples of the Coast: A Review Article." BC Studies 40 (1978-79):5:57-70.

MacDonald 1973 [I assume this is George F. MacDonald, but cannot trace the reference]

Macnair, Peter, and Alan Hoover. 1984. "The Magic Leaves." Victoria: British Columbia Provincial Museum.

Macnair, Peter; Alan L. Hoover; Kevin Neary. 1984. *The Legacy*. Seattle: Univ. of Washington Press.

Malin, Edward. 1978. *A World of Faces*. Portland: Timber Press.

— 1986. Totem Poles of the Pacific Northwest Coast. Portland: Timber Press.

Malinowski, Bronislaw. 1948. *Magic, Science and Religion and Other Essays*. Boston: Beacon Press; New York: Free Press.

Maud, Ralph. 1982. *A Guide to B.C. Indian Myth and Legend*. Vancouver: Talonbooks.

McClellan, Catherine. 1975. "My Old People Say." Ottawa: National Museums of Canada.

McFeat, Tom. 1966. *Indians of the North Pacific Coast*. Toronto: McClelland and Stewart.

McLaren, Carol. 1977. "Unmasking Frontlet Headdresses: An Iconographic Study of Images in Northern Northwest Coast Ceremonial Headdresses." Ph.D. thesis, Dept. of Anthropology and Sociology, Univ. of British Columbia.

McMillan, Alan, and Denis St. Claire. 1982. *Alberni Prehistory*. Penticton, B.C.: Theytus Books.

McNeill 1832 ["Log of the ship *Lama*"; I cannot trace this reference and assume this is an unpublished log that Duff examined]

Meares, John. 1790. *Voyages made in the Years 1788 and 1789, from China to the Northwest Coast of America....* London: Logographic Press.

Miller, Jay. 1988. *Shamanic Odyssey*. Menlo Park: Ballena Press.

Miller, Jay, and Carol Eastman (eds.). 1984. "The Tsimshian and their Neighbors of the North Pacific Coast." Seattle: Univ. of Washington.

Morrell, Mike. 1985. *The Gitksan-Wet'suwet'en Fishery in the Skeena River System.* Hazelton, B.C.: Gitksan-Wet'suwet'en Tribal Council.

Murdock, George Peter. 1934. "The Haida." Murdock, George Peter: *Our Primitive Contemporaries.* New York: Dutton. Pp. 221-263.

Neumann, Erich. 1955. *The Great Mother.* New York: Pantheon.

Newcombe, C. F. 1909. "Guide to the Anthropological Collections in the Provincial Museum." Victoria: British Columbia Provincial Museum.

Niblack, A. P. 1888. "The Coast Indians of Southern Alaska and Northern British Columbia." *Reports of the United States National Museum,* 1888:225-386.

Oberg, Kalervo. 1973. *The Social Economy of the Tlingit Indians.* Seattle: Univ. of Washington Press.

Orans, Martin. 1975. "Domesticating the Functional Dragon: An Analysis of Piddocke's Potlatch." *American Anthropologist* 77:2:312-328.

Panofsky, Erwin. 1962 (orig. 1939). *Studies in Iconology.* Boston: Harper and Row.

Patterson, Margaret Jean. 1975. "Northwest Coast Kerfed Containers: A Formal Study." MA thesis, Dept. of Anthropology and Sociology, Univ. of British Columbia.

Patterson, Roderick Paul. 1975. "The Northwest Coast Sisiutl." MA thesis, Dept. of Anthropology and Sociology, Univ. of British Columbia.

Pethick, Derek. 1980. *The Nootka Connection: Europe and the Northwest Coast 1790-1795.* Vancouver: Douglas and McIntyre.

Piddocke, Stuart. 1965. "The Potlatch System of the Southern Kwakiutl: A New Perspective." *Southwestern Journal of Anthrology* 21:244-264.

Poole, Francis. 1872. *Queen Charlotte Islands: A Narrative of Discovery and Adventure in the North Pacific.* London: Hurst and Blackett.

Prattis, Iain (ed.). 1985. "Reflexions: The Anthropological Muse." Washington, DC: American Anthropological Assn.

Pritchard, John. 1977. "Economic Development among the Haisla."

Ph.D. thesis, Dept. of Anthropology and Sociology, Univ. of British Columbia.

Reichel-Dolmatoff, Gerardo. 1971. *Amazonian Cosmos*. Chicago: Univ. of Chicago Press.

Reid, Katerina Susanne. 1976. "The Origins of the Tsetseqa in the Bsxus: A Study of Kwakiutl Prayers, Myths and Rituals." Ph.D. thesis, Dept. of Anthropology and Sociology, Univ. of British Columbia.

Reid, Martine. 1981. "La Ceremonie Hamatsa des Kwagul: Approche structuraliste des rapports mythe-rituel." Ph.D. thesis, Dept. of Anthropology and Sociology, Univ. of British Columbia.

Ridington, Robin. 1981. "Trails of Meaning." Abbott 1981:239-247.

—— 1982. "Technology, World View and Adaptive Strategy in a Northern Hunting Society." *Canadian Review of Sociology and Anthropology* 19:469-481.

—— 1988. *Trail to Heaven: Knowledge and Narrative in a Northern Native Community*. Iowa City: Univ. of Iowa Press.

Rohner, Robert. 1969. *The Ethnography of Franz Boas*. Chicago: Univ. of Chicago Press.

Roquefeuil, M. Camille de. 1823. *A Voyage Round the World, between the Years 1816-1819*. London: Sir R. Phillips and Co.

Rosman, Abraham, and Paula Rubel. 1971. *Feasting with Mine Enemy*. New York: Columbia Univ. Press.

Rowe, John. 1962. *Chavin Art*. New York: Museum of Primitive Art.

Rubel, Paula. 1990. Review of Marianne Boelscher, "The Curtain Within." *American Anthropologist* 92:522-523.

Rubel, Paula, and Abraham Rosman. 1971. "Potlatch and Hakari: An Analysis of Maori Society in Terms of the Potlatch Model." Man n.s. 6:660-673.

Ruebsaat, Helmut J., and Raymond Hull. 1975. *The Male Climacteric*. New York: Hawthorn.

Rumley, Hilary Eileen. 1973. "Reactions to Contact and Colonization: An Interpretation of Religion and Social Change among Indians of British Columbia." MA thesis, Dept. of Anthropology and Sociology, Univ. of British Columbia.

Ruyle, Eugene. 1973. "Slavery, Surplus, and Stratification on the

Northwest Coast; the Ethnoenergetics of an Incipient Stratification System." *Current Anthropology* 14:603-631.

Samuel, Cheryl. 1982. *The Chilkat Dancing Blanket*. Seattle: Pacific Search Press.

Scouler, John. 1840. Presumably 1841. "Observations of the Indigenous Tribes of the Northwest Coast of America." *Journal of the Royal Geographical Society of London* 11:215-250.

Seguin, Margaret (ed.). 1984. *The Tsimshian*. Vancouver: Univ. of British Columbia.

Shadbolt, Doris. 1986. *Bill Reid*. Seattle: Univ. of Washington Press.

Shahn, Ben. 1963. *The Shape of Content*. Cambridge, MA: Harvard Univ. Press.

Shane, Audrey. 1978. "Shadow and Substance: A Computer-Assisted Study of Niska and Gitksan Totem Poles." Ph.D. thesis, Dept. of Anthropology and Sociology, Univ. of British Columbia.

Sheehan, Carol. 1981. "Pipes That Won't Smoke, Coal That Won't Burn." Calgary, Alberta: Glenbow Museum.

Siebert, E., and Forman, W. 1967. *North American Indian Art: Northwest Coast*. London: Hamlyn.

Smyly, John, and Carolyn Smyly. 1973. *Those Born at Koona*. North Vancouver: Hancock House.

Spradley, James. 1963. "The Kwakiutl Guardian Spirit Quest: And Historical, Functional and Comparative Analysis." MA thesis, Dept. of Anthropology, Univ. of Washington.

— 1969. *Guests Never Leave Hungry*. New Haven: Yale.

St. John, M. 1877. *The Sea of Mountains: An Account of Lord Dufferin's Tour Through British Columbia in 1876*. London: Hurst and Blackett.

— 1879. "Description of a Village of the Hydah Indians." *Journal of the Anthropological Institute of Great Britain and Ireland* 4 8:426-427.

— 1886. The Province of British Columbia, Canada. Victoria (?), author.

Stebbins, Robert. 1966. *A Field Guide to Western Reptiles and Amphibians*. Boston: Houghton Mifflin.

Stewart, Hilary. 1979. *Looking at Indian Art of the Northwest Coast*. Vancouver: Douglas and McIntyre.

Stott, Margaret. 1975. "Bella Coola Ceremony and Art." Ottawa: National Museums of Canada.

Suttles, Wayne. 1951. "The Economic Life of the Coast Salish of Haro and Rosario Straits." Ph.D. thesis, Dept. of Anthropology, Univ. of Washington.

— 1960. "Affinal Ties, Subsistence, and Prestige among the Coast Salish." *American Anthropologist* 62:296-305.

— 1983a. "Productivity and Its Constraints: A Coast Salish Case." Carlson 1983:67-88.

— 1983b. "The World Is As Sharp As a Knife: A Review Article." *BC Studies* 56 (1982-83):82-91.

Swan, James G. 1972. *The Northwest Coast, or Three Year's Residence in Washington Territory*. Seattle: Univ. of Washington Press.

Swanton, John. 1905. "Haida Texts and Myths: Skidegate Dialect" *Bureau of American Ethnology, Bulletin 29.*

— 1908a. "Haida Texts: Masset Dialect." Memoirs, American Museum of Natural History, 14.

— 1908b. "Social Conditions, Beliefs and Linguistic Relationships of the Tlingit Indians." Washington, DC: *Bureau of American Ethnology, 26th Annual Report*, pp. 391-512.

— 1909a. "Contributions to the Ethnology of the Haida." Memoirs, American Museum of Natural History, 8.

— 1909b. "Tlingit Myths and Texts." Bureau of American Ethnology, Bulletin 39.

Thass-Thienemann, Theodore. 1967. *The Subconscious Language*. New York: Washington Square.

— 1973. *The Interpretation of Language*. New York: J. Aronson.

Thomas, Lynn; Judy Z. Kronenfeld; David Kronenfeld. 1976. "Asdiwal Crumbles: A Critique of Levi-Straussian Myth Analysis." *American Ethnologist* 3:147-174.

Tolmie, William. journal ca 1935. Presumably: 1963. *The Journals of William Fraser Tolmie: Physician and Fur Trader*. Vancouver: Mitchell Press.

Turnbull, Colin. 1972. *The Mountain People*. New York: Doubleday.

Turner, Nancy. 1974. "Plant Taxonomic Systems and Ethnobotany

of Three Contemporary Indian Groups of the Pacific Northwest (Haida, Bella Coola, and Lillooet)." *Syesis*, vol. 7, supplement 1.

Turner, Nancy, and Efrat, Barbara. 1982. "Ethnobotany of the Hesquiat Indians of Vancouver Island." *Cultural Recovery Paper No. 2.* Victoria: British Columbia Provincial Museum.

Walens, Stanley. 1981. *Feasting with Cannibals.* Princeton, NJ: Princeton Univ. Press.

Wardwell, Allen. 1978. "Objects of Bright Pride." New York: Center for Inter-American Relations and American Federation of Arts.

Waterman, T. T. 1923.: "Observations among the Ancient Indian Monuments of Southeastern Alaska." Smithsonian Miscellaneous Collections 74:115-133.

Webb, Phyllis. 1982. "A Correspondence." In: *Talking.* Dunvegan, Ont: Quadrant Editions. Pp. 129-149.

Work, John. 1923. *The Journal of John Work, a Chief-Trader of the Hudson's Bay Company.* Cleveland: A. H. Clark.

ARGILLITE

Art
of the
Haida

Leslie Drew
Douglas Wilson

Leslie Drew & Douglas Wilson
8 1/2 x 11, 312 pp., HC ISBN 0-88839-037-8

Available from Hancock House Publishers, 19313 Zero Ave., Surrey, B.C. V4P 1M7
1-800-938-1114 Fax (604) 538-2262 1431 Harrison Ave., Blaine, WA 98230

THOSE BORN AT KOONA

THE TOTEM POLES OF THE HAIDA VILLAGE SKEDANS QUEEN CHARLOTTE ISLANDS

JOHN AND CAROLYN SMYLY

John and Carolyn Smyly
8 1/2 x 11, 120 pp., SC ISBN 0-88839-101-3

Available from Hancock House Publishers, 19313 Zero Ave., Surrey, B.C. V4P 1M7
1-800-938-1114 Fax (604) 538-2262 1431 Harrison Ave., Blaine, WA 98230

Guide to
Indian Rock Carvings
of the Pacific Northwest Coast

hancock
house

Beth Hill

Beth Hill
5 1/2 x 8 1/2, 50 pp., SC ISBN 0-919654-34-7

Available from Hancock House Publishers, 19313 Zero Ave., Surrey, B.C. V4P 1M7
1-800-938-1114 Fax (604) 538-2262 1431 Harrison Ave., Blaine, WA 98230

MORE GREAT HANCOCK HOUSE TITLES

Native Titles

Ah Mo
Tren J. Griffin
ISBN 0-88839-244-3

American Indian Pottery
Sharon Wirt
ISBN 0-88839-134-X

Argillite
Drew & Wilson
ISBN 0-88839-037-8

Art of the Totem
Marius Barbeau
ISBN 0-88839-168-4

Coast Salish
Reg Ashwell
ISBN 0-88839-009-2

End of Custer
Dale Schoenberger
ISBN 0-88839-288-5

Haida: Their Art and Culture
Leslie Drew
ISBN 0-88839-132-3

Hunters of the Buffalo
R. Stephen Irwin
ISBN 0-88839-176-5

Hunters of the Forest
R. Stephen Irwin
ISBN 0-88839-175-7

Hunters of the Ice
R. Stephen Irwin
ISBN 0-88839-179-X

Hunters of the Sea
R. Stephen Irwin
ISBN 0-88839-177-3

Indian Artifacts of the N.E.
Roger Moeller
ISBN 0-88839-127-7

Indian Art & Culture
Kew & Goddard
ISBN 0-919654-13-4

Indian Healing
Wolfgang G. Jilek, M.D.
ISBN 0-88839-120-X

Indian Herbs
Dr. Raymond Stark
ISBN 0-88839-077-7

Indian Tribes of N.W.
Reg Ashwell
ISBN 0-919654-53-3

Indians of the N.W. Coast
D. Allen
ISBN 0-919654-82-7

Iroquois: Their Art & Crafts
Carrie A. Lyford
ISBN 0-88839-135-8

Kwakiutl Art & Culture
Reg Ashwell
ISBN 0-88839-325-3

My Heart Soars
Chief Dan George
ISBN 0-88839-231-1

My Spirit Soars
Chief Dan George
ISBN 0-88839-233-8

Tlingit: Art, Culture & Legends
Dan & Nan Kaiper
ISBN 0-88839-010-6